MW01073271

*Japan and the Culture of the Four Seasons*

# Japan

*and the*

# Culture

*of the*

# Four Seasons

Nature, Literature, and the Arts

## HARUO SHIRANE

Columbia University Press   *New York*

Columbia University Press
*Publishers Since 1893*
New York   Chichester, West Sussex

Copyright © 2012 Columbia University Press
All rights reserved

Library of Congress Cataloging-in-Publication Data
Shirane, Haruo, 1951–
    Japan and the culture of the four seasons : nature, literature, and the arts /
Haruo Shirane.
        p.   cm.
    Includes bibliographical references and index.
    ISBN 978-0-231-15280-8 (cloth : alk. paper)
    ISBN 978-0-231-52652-4 (e-book)
        1. Japanese literature—History and criticism.   2. Seasons in literature.
3. Arts and society—Japan.   4. Philosophy of nature in literature.   5. Seasons in
art—Japan.   6. Japan—Civilization.   I. Title.
    PL721.S4S555 2012
    895.6'0936—dc23

                                                          2011033921

Columbia University Press books are printed on permanent and durable acid-free
paper.
This book is printed on paper with recycled content.
Printed in the United States of America
c 10 9 8 7 6 5 4 3 2 1

References to Internet Web sites (URLs) were accurate at the time of writing. Neither
the author nor Columbia University Press is responsible for URLs that may have ex-
pired or changed since the manuscript was prepared.

For Sakae

# Contents

# Illustrations

## Figures

## Plates

# Preface

The ubiquity of nature in Japanese culture is difficult to overlook even in today's highly urbanized, technological age. Nature appears not only in poetry, painting, and the traditional arts (such as ikebana [flower arrangement] and the tea ceremony [*chanoyu*]), but in many aspects of daily life: the decoration of kimono as well as the names of colors, such as peach color (*momo-iro*) and yellow kerria/Japanese rose color (*yamabuki-iro*); of traditional cakes (*wagashi*), such as warbler cake (*uguisu-mochi*) and bush-clover cake (*ohagi*); and even of rooms in hotels and inns, such as Heartvine Room (Aoi no ma). Equally important, traditional Japanese architecture relies heavily on natural materials, such as tatami (straw matting), paper partitions (*fusuma*), and, most of all, bare wood.[1]

Almost every letter written in Japan begins with a reference to the current season, whether it is the approaching winter cold or the first signs of spring. This custom of seasonal greetings (*aisatsu*) can be traced back to the early eighth century and the seasonal poems in the *Man'yōshū* (*Collection of Ten Thousand Leaves*, ca. 759), many of which are elegant greetings to guests and hosts at banquets and other social occasions. In modern letters, as in

ancient poems, the seasonal reference not only establishes the time and setting, but makes the greetings more elegant and polite. This is but one of the innumerable examples of the ways in which the seasons have been incorporated into social communication and cultural expression over thousands of years in Japan. When, where, and why did this phenomenon occur? In what ways was it manifested? How did it evolve with time, place, and social community?

I became interested in these questions as a result of my extended encounter with *haikai* (popular linked verse) and *saijiki* (poetic seasonal almanacs), which are essential to the study and composition of Edo-period *haikai* and modern haiku. I was struck profoundly by the comprehensiveness of and detail in the *saijiki*, which systematically categorize almost all aspects of nature and much of human activity by the cycle of the four seasons. The seasonal almanacs, which often include exemplary poems for each seasonal word (*kigo*), reflect a shared, comprehensive, and highly encoded representation of nature as it related to Japanese everyday life; this representation, in turn, could be said to provide the foundation for much of Japanese literary and visual culture.

The seasonal almanacs, which first appeared in the Edo period, were preceded by large and thematically organized poetry anthologies (beginning as early as the eighth century with the *Man'yōshū*), a major characteristic of East Asian literature, as well as by *waka* (classical poetry) and *renga* (classical linked verse) treatises that, like the *saijiki*, organized poetic topics and poems by the cycle of the seasons. Over the years, the encoding of the seasonal topics (*kidai*) and words became even more detailed. By the time of the publication of *Haikai saijiki* (*Haikai Seasonal Almanac*, 1803), a monumental compendium of more than 2600 seasonal topics edited by Kyokutei Bakin (1767–1848), the seasonal almanac had become a cultural encyclopedia that, drawing on Chinese and Japanese encyclopedias, integrated the latest information from such diverse fields as botany, astronomy, and geography into a worldview organized by the seasons. In other words, the seasons had become a fundamental means of categorizing the world and everyday life.

My initial inquiry emerged from the question of how the *saijiki* originated and what historical circumstances and sociocultural forces had converged to produce them. Why had the seasons come to play such a major role not only in poetry, but in a wide range of cultural phenomena, from

painting to food? This led to an impossibly large question, which can be addressed only in part here: How were the seasons represented or constructed in literary and visual culture, particularly by poetry? How did depictions of and references to the seasons in various genres and media—ranging from ikebana and noh to folding screens and confectionary—relate to those in Japanese poetry? What kinds of changes occurred from one historical period to the next and from one subculture or social community to another? What were the social, religious, aesthetic, and ideological functions of the culture of the four seasons?

The most immediate answer provided by modern books and articles on this subject is that the Japanese have a long-standing and close affinity with nature, rooted in a deep and influential agricultural heritage centered on wet-field rice farming, and that the climate and geography of Japan brought about a profound sensitivity to the cycle of the four seasons. The most prominent arguments for this view are found in modern Japanese climate-culture (*fūdo*) studies, beginning with Watsuji Tetsurō's (1889–1960) *Fūdo* (*Climate*, 1935), which became popular in Japan in the postwar period, particularly in the 1980s when there was, concomitant with the economic "bubble," a boom in Nihonjin-ron (studies of the Japanese character). This explanation, while sometimes helpful, draws heavily on modern notions of national identity and hides the more complex historical differences among artistic genres, social communities, and cultural environments.

While writing *Japan and the Culture of the Four Seasons*, I was energized by the recent emergence of ecocriticism, which examines how concepts or images of nature are constructed in different subcultures and institutions and are expressed through a variety of literary, cultural, and social practices. To quote Ursula Heise, "Ecocriticism analyzes the ways in which literature represents the human relation to nature at particular points in history, what values are assigned to nature and why, and how perceptions of the natural shape literary tropes and genres. In turn, it examines how such literary figures contribute to shaping social and cultural attitudes toward the environment."[2] As we shall see, each major medium—reflecting the values of its producers, consumers, and distributors, as well as the conventions of the genre—provided its own perspective on nature, which took on different functions in various social contexts. However, one genre in particular, the thirty-one-syllable *waka*, stood in a dominant position from at least the tenth century and had such a far-reaching influence that by the Muromachi

and Edo periods, its representations of nature and the seasons had come to be identified with those of Japan as a whole.

Modern Japanese climate-culture studies posit a direct cause–effect relationship between climate and culture, attempting to explain Japanese culture through the climate and topography of Japan. Ecocriticism, by contrast, focuses on the gap between the environment and culture, a gap that is often deliberately obscured by cultural and literary representations of nature. Modern Japanese climate-culture studies generally assume a mimetic function in culture, as directly reflecting material reality or physical environment, when in fact reconstructions and depictions of nature were often the opposite of reality: what aristocratic society or culture wanted nature to be rather than what it actually was. As we shall see, the first extensive cultural re-creation and codification of nature in Japan occurred during the transition from rural to metropolitan culture in the early eighth century.

In her book *What Is Nature?*, Kate Soper defines three notions of nature as they appear in Western philosophy: metaphysical, realist, and lay. In the metaphysical concept, nature is the non-human, which is opposed to the human or cultural. In the realist concept, nature is the "structures, processes, and causal powers that are constantly operative within the physical world, that provide the objects of study of the natural sciences." This view, on which the natural sciences are based, does not divide the human from the non-human. In the lay concept, which is how the word "nature" is used in this book, nature is "used in reference to ordinarily observable features of the world: the natural as opposed to the urban or industrial environment (landscape, wilderness, countryside, rurality), animals, domestic and wild, the physical body in space and raw materials."[3] This perspective establishes a topographical contrast between urban and rural. As we shall see, the lay view of nature, at least as it has been conceived in Japanese traditional arts, is not regarded as being opposed to the human, as is the metaphysical concept, as much as being an extension of the human, with nature becoming embedded in the urban landscape.

Why, then, are nature and the seasons so prevalent in Japanese literature and culture, particularly in classical poetry, the most canonical of literary genres? How and in what types of visual and textual forms is this seasonality expressed? How do the use and presentation of seasonality differ according to media, genre, and social community? In what ways was seasonality related to power and social hierarchy? In addressing these very wide-ranging

questions, I do not attempt to cover every major social group and genre. Instead, I take up representative and sometimes episodic examples as a means to examine larger, broader phenomena. This book takes a historical approach to the study of nature and the seasons in Japanese culture, but the Index of Seasonal and Trans-Seasonal Words and Topics can serve as a valuable reference for readers who want to know the basic cultural associations. *Japan and the Culture of the Four Seasons* is based almost entirely on Japanese primary and secondary sources, but English-speaking readers who want to pursue the subject further can consult the Bibliography of Recommended Readings in English.

# Acknowledgments

I have worked on *Japan and the Culture of the Four Seasons* on and off for many years and have accumulated many debts. I would like to thank Horikiri Minoru for being my host at Waseda University when I began to research this book and the late Ogata Tsutomu for many years of mentorship. Okuda Isao, who has been both a longtime mentor and a friend, helped me in ways that are too numerous to recount. Komine Kazuaki has also been a constant intellectual companion. I cannot thank enough Andrew Watsky, who read the full manuscript not once but twice and offered extremely detailed and helpful comments, particularly in areas of painting and tea ceremony. I am grateful to Wiebke Denecke, Matthew McKelway, David Atherton, and Jennifer Guest, all of whom read the manuscript and gave me invaluable feedback. I am thankful to Lewis Cook, who went over the entire manuscript multiple times as a fellow scholar and close friend. I must mention Kitamura Yuika, who, in translating parts of the early manuscript, carefully checked the contents and references.

The questions that I was asked and the responses that I received at public lectures at the University of Alberta, the Asia Society, Columbia University,

Emory University, Japan University (Nichidai), Kyoto University, the University of Michigan, Ochanomizu University, Rikkyō University, the University of Virginia, and Waseda University were also immensely helpful. Specifically, I want to thank Akazawa Mari, David Bialock, Steven Carter, Anne Commons, Michael Como, Cheryl Crowley, Torquil Duthie, Fujiwara Katsumi, Hirano Tae, Hiroki Kazuhito, Ii Haruki, Kanechiku Nobuyuki, Kusaka Tsutomu, Christina Laffin, Yukio Lippit, David Lurie, Melissa McCormick, Julia Meech, Max Moerman, Joshua Mostow, Mieko Murase, Nagashima Hiroaki, Nakamachi Keiko, Noda Ken'ichi, Ogawa Yasuhiko, John Rosenfield, Shang Wei, Shinohara Susumu, Henry Smith, Sen So-oku, Suzuki Jun, Wendy Swartz, Tanaka Yukari, Toeda Hirokazu, Tokuda Kazuo, and Watanabe Kenji. For research assistance, I must mention David Atherton, Jennifer Guest, Nan Hartmann, Katherine Robinson, Satoko Naito, Shiho Takai, Christina Yi, and Chi Zhang. My thanks to Michiko Tsuneda, who worked for me as an editorial assistant; to Nayon Cho, who designed the cover; and to Milenda Lee, who designed the book.

I would like to thank John Weber for allowing me to use his screen painting for the jacket. I was also aided by Sarah Thompson at the Museum of Fine Arts, Boston, and Sinead Kehoe and Masako Watanabe at the Metropolitan Museum of Art, New York. The anonymous readers for Columbia University Press were immensely helpful and generous in their feedback. I was blessed to have Irene Pavitt as editor: her enormous dedication to the manuscript in all phases and aspects was an incredible labor of love. Once again, I express my gratitude to Jennifer Crewe at Columbia University Press for her many words of advice and for having changed the course of my career. Last but not least, I thank Tomi Suzuki for being a constant source of intellectual inspiration and support.

# Historical Periods, Romanization, Names, Titles, and Illustrations

## Major Historical Periods

| | |
|---|---|
| Ancient | Beginnings to 784 |
| Nara | 710–784 |
| Heian | 794–1185 (1192) |

### MEDIEVAL

| | |
|---|---|
| Kamakura | 1185 (1192)–1333 |
| Northern and Southern Courts | 1336–1392 |
| Muromachi | 1392–1573 |
| Warring States | 1477–1573 |

### EARLY MODERN AND MODERN

| | |
|---|---|
| Edo (Early Modern) | 1600–1867 |
| Meiji | 1868–1912 |

# Romanization

The romanization of both modern and classical Japanese words is based on the Hepburn system, giving the modern pronunciation as found in the *Kōjien*, 5th ed. (Tokyo: Iwanami shoten, 1999). The only exception is the rendering of the case particle を as *wo* instead of *o*. The romanization of Chinese words follows the pinyin system without giving the tones.

# Names

Personal names are given in the Japanese order: surname first, followed by the given or artistic name. After their first mention, artists and poets are often referred to by their artistic name or pen name. Thus Matsuo Bashō is referred to by his *haikai* name (*haigō*), Bashō, and not by his family name, Matsuo. Through the mid-Edo period, names often appear with "no" between the surname and the given name, as in Ki no Tsurayuki; this indicates "of," as in Tsurayuki of the Ki clan or family. This usage has been retained.

# Poetry Anthologies

All titles of poetry collections are given by their commonly used titles—leaving out the middle term *waka* (classical poetry)—rather than by their official titles. Thus the title *Kokinshū* is used instead of *Kokinwakashū*; *Gosenshū*, instead of *Gosenwakashū*; *Shūishū*, instead of *Shūiwakashū*; *Senzaishū*, instead of *Senzaiwakashū*; *Shinkokinshū*, instead of *Shinkokinwakashū*; *Kokin rokujō*, instead of *Kokin waka rokujō*; and so forth.

All references to poems in the first eight imperial waka anthologies (*chokusen wakashū*), from the *Kokinshū* to the *Shinkokinshū*, are to the editions in the Shin Nihon koten bungaku taikei series, published by Iwanami shoten (1990–2005), and all references to the *Man'yōshū* are to the Nihon koten bungaku zenshū series, edited by Kojima Noriyuki, Kinoshita Masatoshi, and Satake Akihiro and published by Shōgakukan (1971–1975). For details, see the Selected Bibliography of Primary and Secondary Sources in Japanese.

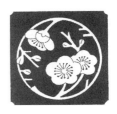

# Secondary Nature, Climate, and Landscape

The ubiquity of nature and the seasons in Japanese literature is apparent in too many ways to count. One has only to turn to *The Tale of Genji* (*Genji monogatari*, early eleventh century) to discover that most of the female characters—such as Kiritsubo (Paulownia Court), Fujitsubo (Wisteria Court), Lady Aoi (Heartvine), Lady Murasaki (Lavender), Suetsumuhana (Safflower), Oborozukiyo (Misty Moonlit Evening), and Hanachirusato (Village of Scattered Flowers)—are named after natural objects and phenomena, usually flowers and plants, each of which is associated with a specific season. Indeed, a fundamental grasp of *The Tale of Genji* requires an understanding of the literary implications of a wide variety of plants, flowers, atmospheric conditions, and celestial bodies that provide not only the names of the characters but also the settings in which they appear (figure 1). Furthermore, the associations of these natural objects are closely linked to those found in the thirty-one-syllable *waka* (classical poetry).

*The Tale of Genji*, in fact, is often given as a prime example of the intimate connection between Japanese culture and nature. However, it is also true that when *The Tale of Genji* was written, aristocratic women rarely

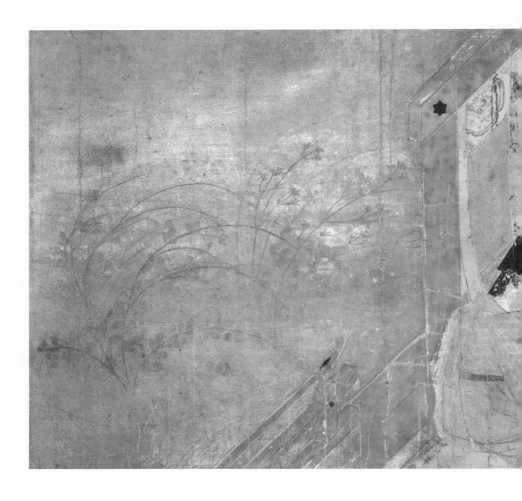

ventured out from behind the multiple layers of standing screens, curtains, and sliding doors that separated them from the external world. On rare occasions, they went on pilgrimages to the surrounding hills or temples, but for the most part, the only nature that such women encountered was in the gardens of their palace-style (*shinden-zukuri*) residences; was represented extensively indoors, in picture scrolls (*emaki-mono*), screen paintings (*byōbu-e*), and door or partition paintings (*fusuma-e*); and permeated the *waka* that they wrote day and night. In other words, "nature" in *The Tale of Genji* and in the lives of eleventh-century aristocratic women was pervasive both spatially and psychologically, but much of it was carefully reconstructed in gardens

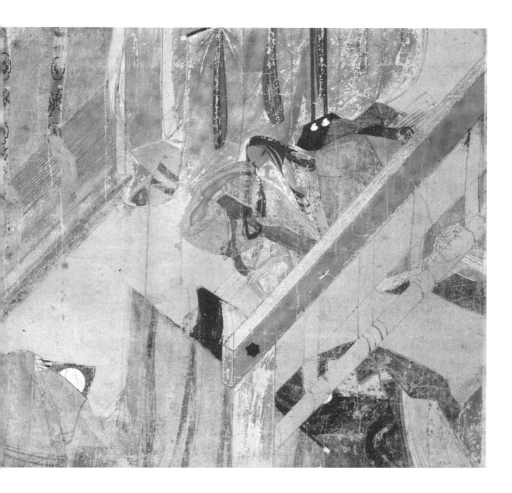

FIGURE I

INTERIOR AND GARDEN IN A HEIAN-PERIOD RESIDENCE

Set on an autumn evening, this scene from the "Rites" (Minori) chapter in *The Tale of Genji Scrolls* (*Genji monogatari emaki*, ca. twelfth century) shows Genji (*center*) and the Akashi empress, Lady Murasaki's adopted daughter (*lower right*), visiting the dying Murasaki (*upper right*), who, in a poetry exchange transcribed on the same scroll, compares herself to the dew on the bush clover. Using the open-roof (*fukinuki yatai*) technique, the illustration shows both the interior and the garden, making nature (bush clover, miscanthus grass, and the fragile dew in the autumn wind) a metaphor for the emotional and physical state of the characters. (Courtesy of the Gotō Museum of Art, Tokyo)

FIGURE 2

INTERIORIZED NATURE IN A HEIAN-PERIOD RESIDENCE

In this scene from "The Eastern Cottage" (Azumaya) chapter in *The Tale of Genji Scrolls* (*Genji monogatari emaki*, ca. twelfth century), a female attendant (*center*) reads aloud a court tale while Ukifune (*upper left*) looks at the accompanying illustrations. Nakanokimi (*lower left*), Ukifune's half sister and patron, is having her hair combed by another attendant. The illustration shows how nature was "interiorized" in the aristocratic residence of the Heian period. Landscape and the seasons appear in the partition paintings, on the interior walls, and on the "curtain of state" (*kichō*), which was used to divide the room, in the center. (Courtesy of the Tokugawa Reimeikai Foundation, Tokyo)

or visually and textually depicted in paintings, furniture, dress, poetry, and illustrated tales (figure 2). This kind of re-created or represented nature, which I refer to as secondary nature (*nijiteki shizen*), was not regarded as being opposed to the human world so much as an extension of it. Indeed, this secondary nature became a substitute for a more primary nature that was often remote from or rarely seen by the aristocrats who lived in the center of Heian (Kyoto), the capital of Japan during the Heian period (794–1185). This book explores how this secondary nature was constructed over many centuries, particularly in an urban environment, and the implications that it has for understanding space and time in Japanese culture from the Nara period (710–784) through the Edo period (1600–1867).

# The Myth of Harmony with Nature

Even today, there is a widespread belief that the Japanese have an inherent affinity with nature and that this affinity is one of the major characteristics of Japanese culture. Typical of this view, which is held even in the age of extensive urbanization and technology, is a passage in "The Special Characteristics of Japanese Literature: Fusion with Nature," from a widely used high-school textbook on Japanese literature and language:

> Japan is an agricultural country; the Japanese are an agricultural people. Since agriculture is controlled by the seasons and the climate and since the climate in Japan is warm and mild, Japan is characterized by the leisurely change of the seasons. In contrast to the Westerners who fight with and conquer nature, the Japanese live in harmony with nature and desire to become one with it.
>
> The literature that is born from such a climatic conditions [*fūdo*] naturally emphasizes unity with nature. First of all, in the ancient period Japanese poetry [*waka*] emerged from a careful observation of nature, which was used to express emotions. In the Heian period, this tendency extended to prose writing. The miscellany *The Pillow Book* is an excellent example. In *The Tale of Genji*, too, nature has an important symbolic function. The medieval period produced such poets as Saigyō, who questioned the meaning of nature. The idea that nature was the source of various human endeavors resulted in recluse literature in which the writer retreated to nature. Edo-period *haikai* is a literary form that cannot be conceived without nature, and its strong emphasis on seasonal topics continues into modern haiku.[1]

This particular view of Japanese literature, as embodying the close relationship of the writer or reader to nature, appears as early as Ki no Tsurayuki's (872–945) kana preface to the *Kokinshū* (*Collection of Japanese Poems Old and New*, ca. 905) and has been repeated over the centuries into the twenty-first.

Haga Yaichi's *Kokuminsei jūron* (*Ten Essays on the Character of the Nation*, 1907) reveals how this view of nature was articulated in the Meiji period (1867–1912). Haga (1867–1927)—who became a professor at the University of Tokyo, the president of Kokugakuin University, and one of the founders of the field of modern Japanese literary studies—wrote the following in 1907,

in the aftermath of the Russo-Japanese War (1904–1905), after his return from studying in Germany. This is from the beginning of the fourth essay, "Loving Trees and Plants, Enjoying Nature":

> The climate is mild. The rivers and mountains are superb. The land-scape of the four seasons, from the flowers to the bright leaves, is truly beautiful. It is only natural that the inhabitants of this kind of land be-come attached to everyday life. Since the surrounding landscape that lies directly in front of us in all four directions is smiling, there is no one who does not smile. It is only to be expected that the people who love this world and who enjoy human life, love heaven and earth, the rivers and mountains, and are attracted to nature. In regard to this point, the people of the various countries of the east, when compared to the Europeans of the north, can be said to receive the treasures and virtues of heaven. In particular we Japanese are close to the flowers and the birds, the wind and the moon; this is apparent in our lives wherever one looks.[2]

Haga sees one of the unique features of the Japanese people (nation) as their love of and respect for nature, which, he believes, distinguishes them from Westerners, who lack this attitude and who fight with and attempt to con-quer nature. Like Masaoka Shiki (1867–1902) and Takahama Kyoshi (1874–1959), the two leading haiku poets of the Meiji period, Haga goes on to make an important link between this love of nature and the widespread practice of Japanese poetry (*waka* and haiku), which is regarded as the em-bodiment of the respect for and closeness to nature. This view of Japanese culture continued unabated in prewar and postwar Japan and has infiltrated Western studies of Japanese culture.[3]

Haga's position, which reflects the rise in aesthetic nationalism that fol-lowed the Russo-Japanese War, was influenced by Johann Gottfried Her-der's (1744–1803) notion that climate informs national character; it was also built on a long tradition, beginning with Tsurayuki's kana preface to the *Kokinshū*, probably the most influential single statement on Japanese poetry:

> The songs of Japan take the human heart as their seed and flourish as myriad leaves of words. As long as they are alive to this world, the cares and deeds of men and women are endless, so they speak of things they hear and see, giving words to the feelings in their hearts. Hearing the

cries of the bush warbler among the blossoms or the calls of the frog that lives in the waters, how can we doubt that every living creature sings its song? Without using force, poetry moves heaven and earth, makes even the unseen spirits and gods feel pity, smoothes the bonds between man and woman, and consoles the hearts of fierce warriors.[4]

The kana preface stresses the central role of nature both as a stimulus to poetry and song and as an expression of human thought and emotion. It also emphasizes the close relationship between humans and nature, the universality of poetic composition or song, and the ability of poetry to bring about social harmony—all of which were to become fundamental elements in the mythology of *waka*-based nature. Significantly, the two representations of "nature" are the warbler and the frog, both considered to be elegant seasonal topics (of spring) by the Heian-period aristocracy and both associated with sound (singing or crying).

In the twelfth century, Fujiwara no Shunzei (1114–1204), probably the most influential poet of his time, took the role of nature-based *waka* to another level in his poetic treatise *Koraifūteishō* (*Collection of Poetic Styles Old and New*, 1197):

As stated in the preface to the *Kokinshū*, Japanese poetry takes the human heart as its seed and grows into myriad leaves of words. Thus without Japanese poetry, even if one were to seek out the cherry blossoms in the spring or look at the bright foliage of autumn, there would be no one who would recognize the color or the scent. . . . As the months pass and the seasons change, and as the cherry blossoms give way to bright autumn leaves, we are reminded of the words and images of poems and feel as if we can discern the quality of those poems.[5]

If Tsurayuki established what we might call the expressive-affective model, in which nature is the key means to articulate emotions and thoughts, then Shunzei established a highly influential cognitive, intertextual model, in which the knowledge of nature-based poetry is necessary for humans to see and respond to nature, to recognize its colors and scents. In this view, *waka* cultivates us, giving us the heart to respond to nature.

When writers from Ki no Tsurayuki to Haga Yaichi speak of the close relationship between humans and nature, they are speaking of a view of nature

that, over the centuries, permeated almost all levels of literate society and that came to be regarded as a "national" trait. This association of harmony with nature and national character appears as early as the Heian period. The standard graphs for *waka* (和歌) literally mean "the poetry/song (*uta*) of Yamato" (大和, 倭), which first referred to the Nara basin but by the Heian period had come to mean "the country of Yamato" (Yamato no kuni), or Japan as it was conceived at that time. The *wa* in *waka* came to mean *yawaraka* or *yasashi* (soft, gentle) and implied harmony, a significance that was expanded by Fujiwara no Kiyosuke (1104–1177) in his poetry treatise *Ōgishō* (*Collection of Inner Truths*, ca. 1135–1144) and made explicit by Fujiwara no Teika (1162–1241) in his poetry treatise *Maigetsushō* (*Monthly Collection*, ca. 1219):

> First of all, since poetry [*uta*] is a style of *wakoku*, the country of harmony [*wa*], in the writings of earlier masters, it has been repeatedly noted that poetry should be composed in a gentle and emotionally moving fashion. Truly, since poetry is a unique product of our country, our predecessors have carefully noted in poetic treatises that poetry should be composed with elegance and with deep feeling [*mono no aware*]. No matter how frightening a thing may be, when one writes about it in Japanese poetry, it must sound graceful and elegant. What would be the point of taking something that was originally elegant such as the cherry blossoms or the moon and composing poetry on them in a frightening way?[6]

The implication is that the essence of *waka*, which is gentle and deeply moving, is in the style of a country that is harmonious in all things.[7] In other words, high cultural value was placed on gentleness and harmony. The stress was not on what nature is but on what it should be; particularly in *waka*, it should be a graceful and elegant form.

This tradition of regarding nature as harmonious, close, and a means to view the world is largely a construction of aristocratic, capital-centered culture and of metropolitan genres, particularly *waka*. Equally important, *waka* was an urban genre, born of the city and meant for social communication among educated elites, and it coexisted with a number of related metropolitan, capital-centered genres, such as screen painting (*byōbu-e*), palace-style (*shinden-zukuri*) gardens, and twelve-layered robes (*jūni hitoe*) worn by aristocratic women. These kinds of genres and media—which in the medieval period (1185–1599) came to include ikebana (flower arrangement), bonsai, and

the tea ceremony (*chanoyu*)—reconstructed nature in elegant form, creating what I call secondary nature (*nijiteki shizen*), which became a surrogate for more primary nature for urban inhabitants. The so-called Japanese closeness to or harmony with nature as described by modern critics is, I will show, largely the result of the prevalence of this secondary nature, which influenced almost every major cultural form in the premodern period.

## Climate and Cultural Inversion

The culture of the four seasons as it was developed in Heian classical poetry and related genres was both a reflection of the climate of Japan and an inversion of it. In the winter, the main island of Japan came under the influence of a cold-air mass that extended from the Baltic Sea to Mongolia. As the cold air moved south from Siberia and then crossed the Japan Sea, it ran into moist air moving north that, when it hit the Japan Alps, dropped heavy snow. As a result, Japan (as it is presently configured) had one of the heaviest snowfalls of all the countries in the world. In the summer, Japan was dominated by a tropical air mass now called the Ogasawara high-pressure system, which came from the southeast, from the Pacific Ocean, and brought high heat and humidity. The main island of Japan thus had very heavy precipitation in both the summer and the winter. The quantity of rain during the summer was, in fact, equal to that of many tropical countries. The forest of broad-leaved evergreen trees behind Kasuga Shrine in Nara, where the primary forest is still preserved, is identical with that of a tropical jungle, with thick evergreen oaks (*kashi*) and their roots wrapped in tree ferns (*shida*) and terrestrial orchids. One consequence is that Japan is home to plants and animals—broad-leaved evergreen trees, dense bamboo grass (*sasa*), windmill palm (*shuro*), and monkeys— normally associated with tropical areas. As we shall see, the high humidity in Kyoto and Nara fostered a poetic culture that focused heavily on atmospheric conditions: mist (*kasumi*) became a marker of spring; the long rains (monsoon) were a major feature of summer; autumn was known for its mists (*kiri*), dew, and typhoons; and the hallmark of winter was snow and frost.

Needless to say, the climate differed according to the geographical area and historical period.[8] In the pre-Meiji period, during which a luni-solar calendar was used, spring consisted of the First, Second, and Third Months; summer of the Fourth, Fifth, and Sixth Months; autumn of the Seventh,

Eighth, and Ninth Months, and winter of the Tenth, Eleventh, and Twelfth Months.[9] At the beginning of the twenty-first century, according to the modern (solar) calendar, the traditional four seasons are as follows:

| | |
|---|---|
| Spring | February 4–May 4 |
| Summer | May 5–August 6 |
| Autumn | August 7–November 6 |
| Winter | November 7–February 3 |

Converting from the premodern calendar to the modern calendar is a complex calculation. The luni-solar calendar sometimes required a leap year that added one month, resulting in thirteen months in that year. As a general rule, however, roughly five to six weeks are subtracted from the solar calendar to get the approximate seasonal equivalent in the luni-solar calendar.

For those living in Kyoto in the premodern period, spring (First through Third Month in the luni-solar calendar) arrived around the middle of what is now February. In northern Europe and the northern United States, spring is relatively late, gradually appearing in March with the emergence of the new growth of various plants. By contrast, in Kyoto, the spring mist (*kasumi*) appears in the mountains from around February 10, together with the buds of new grass in the withered fields. The blossoming of the cherry trees, which has been the highlight of spring from the Heian period onward, occurs in what is now the middle of April. Historical records show that the average peak of the cherry blossoms in the Kyoto area was April 17 in the eleventh to thirteenth centuries.[10]

Summer (Fourth through Sixth Month in the luni-solar calendar) now begins on May 5 and ends on August 6. Summer is extremely hot in the Kyoto and Nara region, with the temperature equal to or greater than that in many Southeast Asian countries. The heat reaches 90 degrees Fahrenheit in August, and the humidity climbs to over 65 percent during the rainy season.[11] When the front of the southern warm-air mass from the Pacific Ocean moves north over the land, the fresh, balmy air of early summer suddenly turns moist, marking the beginning of the monsoon (*tsuyu*) season, which lasts from around June 10 to the middle of July in Kyoto. The hot, dry weather that immediately follows—now called the post-monsoon (*tsuyu-ake*) period—extends from mid-July to the first week of August, lasting more than

twenty days. The extensive summer rain enables wet-field rice agriculture, but it also results in floods and landslides in a country dominated by mountains. So distinct is the monsoon season in Japan that the climatologist Kira Tatsuo has argued that Japan has five seasons: spring, monsoon season, post-monsoon season, autumn, and winter.[12]

In the modern calendar, autumn (Seventh through Ninth month in the luni-solar calendar) extends from August 7 to November 6. At the start of fall, the Ogasawara high-pressure system begins to retreat to the south and the cool winds from the continent start to arrive,[13] but the atmosphere remains hot—a long, lingering summer—until the third week of August. Autumn in Kyoto also overlaps with the typhoon season, which extends from August through November and brings heavy precipitation.[14] The first half of autumn is still very hot, and many of the early-autumn poems in the *Kokinshū* are about lingering summer heat. It was not until the middle of September (around the middle of the Eighth Month in the luni-solar calendar) when the typhoons, coolness, and sound of insects associated with autumn finally arrive. Heian-period *waka* focus on both the sad and the bright sides of autumn, particularly the colorful foliage, which begins in Kyoto in autumn and continues into winter.

Spring and autumn in Japan are relatively mild, very similar to these seasons in the Mid-Atlantic region of the United States, but climatically they are sandwiched between two long and severe seasons. Although summer ends around August 6 under the modern calendar, in terms of climatic conditions, summer in Kyoto continues at least until the end of August. When the monsoon and post-monsoon periods are combined with the hot weather of August, summer lasts for roughly one-third of the year. Viewed in this larger perspective, spring and autumn are transitional seasons between the cold continental weather and the hot Pacific Ocean weather.[15] These severe climatic conditions contrast starkly with the widely held view of Japan's climate as mild, elegant, and harmonious. In an inversion of the actual climatic conditions, Nara- and Heian-period aristocratic culture made spring and autumn the supreme seasons, which were celebrated in literature and the visual arts, as they were in early China, and around which a wide range of religious, social, and cultural associations developed. This disjunction between the actual climate and the poetic culture of the four seasons can be traced to several factors.

First, the location of ancient (before 784) and Heian Japanese culture was in the Nara and Kyoto basins, where the winter was relatively mild compared with that in other parts of the country. The view of "nature" found in *waka* and in Japanese classics such as the *Kokinshū*, *The Tales of Ise* (*Ise monogatari*, ca. 947), and *The Tale of Genji* reflects almost entirely the conditions in these two inland basins. As a result, the winter depicted in classical Japanese literature is mild, with gently falling snow, which, as a harbinger of a rich harvest, was regarded as auspicious. In the rest of Honshū, particularly on the Japan Sea side and in the northeast, snow was considered a serious hardship and a hazard. The severe snows of the area facing the Japan Sea, the so-called Snow Country, do not figure in classical literature and poetry. It was not until the emergence of *haikai* (popular linked verse) by poets like Kobayashi Issa (1763–1827), a peasant from the Shinshū (Nagano Prefecture) area, in the early nineteenth century, that heavy snow appears in poetry.

Second, summer in early and medieval Kyoto was in reality a time of extreme heat, pestilence, and death. The result was a large number of local and major festivals in the capital (such as the Gion Festival and the Hollyhock [Aoi] Festival) and in the provinces intended to appease the gods and to exorcise sin and dangerous elements. For example, the famous Gion Festival in Kyoto, which was held in the first half of the Sixth Month in the premodern period, at the beginning of the post-monsoon season and at the height of summer heat, originated in the mid-Heian period as a prayer to the god of the Gion Shrine for protection from pestilence and natural disasters. These negative aspects of summer were not considered the proper subject matter for classical poetry and generally do not appear in *waka*, particularly those of the imperial *waka* anthologies, which were intended to manifest the harmony of the state and the cosmos. Court poetry of the Heian period thus did not reflect the actual climate so much as create a highly aestheticized and, as we shall see, ideological representation of the four seasons. Imperial *waka* anthologies, such as the *Kokinshū*, selected the most appealing aspects of the seasons as they conformed to aristocratic standards and for which there was often a Chinese literary precedent. The heavy weight placed on spring and autumn (two books each) and the brief representation of summer and winter (one short book each) in the *Kokinshū* thus reflect a utopian view of nature.

Finally, when it came to the unpleasant or difficult seasons, summer and winter, aristocratic poetry and culture sought to depict not what nature was

actually like but what it ought to be. For example, one of the most important summer topics in Japanese poetry (*waka*, *renga* [classical linked verse], and *haikai*) was summer night (*natsu no yo*), which was thought to bring coolness and relief from the heat and was deemed to be all too short. In the Edo period, a *hokku* (opening verse of a *renga* sequence) that suggested a cool residence was considered to be complimentary to the host. Japanese traditional confectionary and cakes (*wagashi*), ikebana, the tea ceremony, rockand-sand gardens, and the architecture of palace-style (*shinden-zukuri*) and parlor-style (*shoin-zukuri*) residences are all designed to give a feeling of coolness, precisely because the summer is so hot and humid in central Japan. As Sen no Rikyū (1522–1591) notes in *Nanbōroku* (*Records of the Words of Rikyū*, 1593) in regard to the tea ceremony, "In summer impart a sense of coolness, in winter a feeling of warmth."[16] In other words, one of the functions of secondary nature in the capital was to create an ideal environment through linguistic, visual, tactile, and alimentary means.

## Provincial Farm Villages

Two fundamental forms of secondary nature are evident in Japanese culture: one that was developed in the capital (first Heijō [Nara] and then Heian [Kyoto]) by the nobility, and one that I refer to as the *satoyama* (literally, "village mountain") paradigm, which emerged in the mid- to late Heian period in farm villages in the provincial landed estates (*shōen*). These estates initially were owned by aristocrats, temples, and the imperial family but were cultivated by commoners and lower-level samurai.[17] These two representations of secondary nature intersect at key points in the Heian and the Kamakura (1185–1333) periods, and by the Muromachi period (1392–1573) overlap in a number of cultural genres.

From the ancient period, the Japanese were engaged in the "reclamation" of wilderness for rice farming. The opening of new rice fields was of utmost importance for the provincial *shōen* system, which began in the ancient period and grew in the Heian and later medieval periods. In converting wilderness to rice fields, there was no hesitation about chopping down giant trees, clearing forests, or killing animals to create more cultivatable land. As the provincial gazetteers (*fudoki*) reveal, untamed nature was

regarded as the sphere of violent gods (*araburu kami*). The Saka District (Saka no kōri) section of the *Hizen no kuni fudoki* (*Hizen Province Gazetteer*) describes the gods who prevented the cultivation of land on the Saka River:

> To the west of the county, there was a river. The name of it was Saka
> . River. The river had sweetfish [*ayu*]. The river originated in the moun-
> tains in the north of the country and flowed to the south, where it emp-
> tied into the sea. At the upper reaches of this river were violent gods
> [*araburu kami*] who let live half of the people who came and killed the
> other half.[18]

A similar example is the river serpent in the *Kojiki* (*Record of Ancient Matters*, 712) and the *Nihon shoki* (*Chronicles of Japan*, 720) who destroys the crops and requires that a young woman of the village be sacrificed each year. The river serpent, whom the god Susano-o vanquishes, represents the danger of flood-ing and the overflowing river for wet-field rice agriculture. Susano-o symbol-izes the ability to control the unruly waters of the river. As the early chronicles and provincial gazetteers suggest, a divide existed between the violent gods of nature and the world of human beings, who built shrines at the base of the surrounding mountains to honor and pacify these dangerous gods.

From the mid- to late Heian period, a significant shift occurred in the attitude toward nature. As Iinuma Kenji has shown through archaeological excavation, many of the hitherto violent gods, who had thwarted or resisted the opening of the land to agriculture, were transformed into gods of rice agriculture.[19] They became gods of water, dams, and irrigation; they be-came guardian gods (*chinju*) who protected the local village and who were worshipped through such rituals as *ta-asobi* (literally, "play in rice field") or prayers for a rich rice harvest. The shrines to these gods, which had been located on the periphery, were now constructed within the grounds of the *shōen*, symbolizing a more cooperative relationship with nature (from the human perspective). This change also reflected greater technological control over nature, particularly management of water and irrigation.

This type of environment marked the beginning of what is now referred to by ecologists as the *satoyama*, an ecosystem that continued into the twen-tieth century (figure 3; see also figure 17). Farm villagers lived next to a river, which was used to irrigate the rice fields, and harvested not only the

FIGURE 3

A *SATOYAMA*

This representation of a *satoyama*, painted by Nagai Kazuo in 2007, shows the basic topography of the farm village: in the background is the mountain (*yama*), which provides fuel (brushwood and trees); at its foot is the village and the wet rice fields; and in the foreground is the river, which provides water and irrigates the rice paddies, and the wild fields (*no*), which also provide valuable fuel. (Oil; 20.9 × 25.6 inches. Courtesy of the artist)

rice fields but the surrounding grasslands and woodland, which provided fertilizer for the rice fields, fodder for oxen and horses, construction materials, and firewood and pine needles for fuel. In medieval anecdotal literature (*setsuwa*) and folktales, the characters (such as the woodcutter [*kikori*]) typically "go to the mountain to cut brushwood" (*yama ni shibakari*), a standard phrase that indicates going into the bush or forest to cut firewood or to gather undergrowth or fallen tree leaves for fertilizer. The *satoyama* became a type of secondary nature, in that both the rice fields and the surrounding hills were constantly harvested and recycled, but it was fundamentally

different from the secondary nature found in the capital, which tended to be elegant, physically compact, centered on birds and insects, and oriented around color and scent.[20]

The *setsuwa* "How a Young Lad from the Country Wept on Seeing the Cherry-Blossom Falling" (1:13), which appears in the *Uji shūi monogatari* (*A Collection of Tales from Uji*, early thirteenth century), foregrounds the difference between the attitudes toward nature in the farm village and in aristocratic society:

> Again, long ago a young lad from the country had entered the monastery on Mount Hiei and noticed one day when the cherry blossoms were at their most beautiful that there was a strong wind blowing, and he began to cry bitterly. A priest happened to see him and went gently up to him to ask, "What are you crying for, my boy? Are you sad because the cherry blossoms are falling? They don't last more than a short time, and soon fall, as you see. But there's more to it than that. There's nothing anyone can do to prevent the cherry blossoms falling." "That's not what grieves me," said the lad. "The reason I am sad is that I am thinking how the flowers will be knocked off my father's barley and the grain will not set." And he set up a great sobbing and wailing. Really, this was taking things a little far.[21]

The story humorously contrasts the priest's aristocratic, *waka*-based view of nature, which prizes cherry trees for their blossoms and regrets their scattering, with that of the son of a farmer whose only concern is the fate of barley (*mugi*), a crop that was vital to the subsistence of village farmers but that almost never appears in *waka* or court tales.

These two fundamental attitudes toward nature emerge in the difference between the *waka*-based genres, such as the Heian-period court tales (*monogatari*) and literary diaries (*nikki*), and such genres as the early chronicles, provincial gazetteers, anecdotal literature, and war tales (*gunki-mono*). The historical chronicles and *setsuwa* collections, such as the *Nihon ryōiki* (*Record of Miraculous Events in Japan*, ca. 822) and the *Konjaku monogatari shū* (*Tales of Times Now Past*, ca. 1120), describe a wide variety of animals: dogs, wolves, badgers, foxes, cats, tigers, bears, horses, cows, deer, boars, sheep, flying squirrels, mice, rabbits, monkeys, and even elephants. Many of these animals were hunted for food, used in agriculture, or lived in the *satoyama*.

By sharp contrast, in the imperial *waka* anthologies and *monogatari*, the world of animals is largely confined to certain pets (such as cats) and to deer, singing birds, and crying insects. In court poetry, nature is an elegant world in which neither wildlife nor farm animals play a significant part. The result is a close harmony between the natural and human spheres, with the two becoming metaphors for each other. The birds, insects, and deer that appear in *waka* are generally prized for their lexical associations (such as *matsumushi* [pine cricket; literally, "waiting insect"]) or their sounds. As the frequently used verb *naku*, which means both "to cry" and "to weep," implies, these animals are the exterior embodiment of interior, affective states. Since *setsuwa* and war tales usually were written or compiled by aristocrats or educated priests, to some extent the *satoyama* image was also filtered through court culture, but the differences in attitudes and perspectives toward nature remain stark.

Needless to say, the village farmers in the Heian and medieval periods did not have the luxury of enjoying poetry, painting, and gardens, nor did they engage in such cultural practices as the tea ceremony and flower arrangement. In short, there was a significant difference between the romanticized mountain village (*yamazato*) that appears in *waka* and court literature, which we might call a pastoral mode, and the actual life of farm villages. In contrast to the *waka*-esque portrayal of the *yamazato*, which generally represents a space of peace and solitude, the rural farmers who appear in the *setsuwa* and other non-aristocratic genres constantly face potential natural disasters: earthquakes, floods, drought, disease, and famine. Unlike the insects and birds found in the elegant world of *waka*, most insects and birds (both of which ate the rice crop) are regarded as pests. Farmers had to kill insects and other animals that harmed their rice fields. This led to the widespread practice of praying for the spirits of slaughtered animals, including insects. By contrast, insects that protected the crops—such as the dragonfly, which gave its name to Japan, "the land of the dragonflies" (*akizushima*), and which ate other insects—were worshipped.

As Japanese folklore (*minzoku-gaku*) scholars have shown, there is a long tradition of *mushi-okuri* (ritual sending off of insects). Farm villagers, in order to get rid of harmful insects that damaged the harvest, lit pine torches (*taimatsu*) and rang bells. This was followed by *mushi-kuyō* (offerings to the spirits of deceased insects). Similar *kuyō* were carried out for whales, fish, boars, deer, and other hunted animals. Numerous medieval *setsuwa*, popular

tales (*otogi-zōshi*), and noh plays reveal this fundamental conflict between the need to control nature—particularly the pressure to hunt, kill harmful animals and insects, and clear forests—and the desire to appease and worship nature, which was believed to be a realm filled with gods. This tension was made even more complex after the adoption of Buddhism, with its injunction against killing certain animals, in Japan.

## The Trajectory of the Chapters

This book argues that the oft-mentioned Japanese "harmony" with nature is not an inherent closeness to primary nature due to topography and climate, but a result of close ties to secondary nature, which was constructed from as early the seventh century and based in the major cities. This secondary nature took many forms and appeared in such diverse genres as poetry, screen paintings, gardens, flower arrangement, and the tea ceremony. Of seminal importance was *waka*, the thirty-one-syllable Japanese classical poem, which became a fundamental form of social communication among the urban aristocracy and whose seasonal associations influenced almost all major literary, artistic, and design-based forms and genres in Japan. As a result of the ubiquity of *waka*, flora and fauna as well as the atmospheric conditions of the four seasons became heavily encoded; for example, summer rain (*samidare*), or monsoon, became associated with melancholy or tedium, and the autumn dew became linked to tears. A number of these associations were indigenous, but many, such as autumn dew and tears, derived from Chinese poetry (*kanshi*), which was also composed extensively in the Nara and Heian periods.

Chapter 1 examines how the seasonal topics of *waka* were established, in the *Man'yōshū* (*Collection of Ten Thousand Leaves*, ca. 759); how they evolved into the core of poetic topics in the imperial *waka* anthologies in the Heian period, particularly the *Kokinshū*; and how they broadened from a spring–autumn axis in the Nara and Heian periods to embrace winter, which became a medieval favorite. Each seasonal topic developed a specific set of cultural associations, thus heavily encoding nature not only in poetry but in a wide variety of related media, beginning with screen paintings (*byōbu-e*) and picture scrolls (*emaki*) in the Heian period. In the *Kokinshū*, a close correspondence also arose between the topic of love (*koi*) and those of the sea-

sons, the two main pillars of classical poetry, with nature being the primary vehicle for expressing private emotions.

The *Kokinshū*, the first imperial *waka* anthology, contains about forty-five seasonal topics. The number of canonical topics gradually increased over time to about sixty in the *Shinkokinshū* (*New Anthology of Poetry Old and New*, 1205), the eighth imperial *waka* anthology, and these topics and their established associations, in turn, became the foundation for medieval *waka* and *renga*, which flourished in the Muromachi period. From the mid- to late Heian period, poets placed increasing emphasis on annual observances, celestial bodies (particularly the moon), atmospheric conditions, and the time of day (such as dawn and dusk). Seasonal topics, poetic diction, and natural motifs formed a complex system of representations, with the topics, the images, and their associations functioning as a rich cultural "vocabulary" to be used for a wide range of purposes—from love to political protest to personal lament.

Chapter 2 looks at the impact of *waka* on visual culture, examining the manner in which its seasonal topics and their associations were manifested in various media, beginning with the twelve-layered robe (*jūni hitoe*) and screen paintings of the Heian period and extending to medieval tea utensils and the illustrated card games of the Edo period. The twelve-layered robe literally wrapped nature and the season around a woman's body through its colors. Heian nobles were also surrounded by four-season and famous-place paintings that combined poetry with painting. With the development of the twelve-month painting (one painting or independent panel for each month), the associations between nature and the seasons became even more refined, matching specific birds and flowers with specific months. Famous places were also linked with particular seasons and natural motifs. For example, the Tatsuta River, which became famous as a result of a series of autumn poems in the *Kokinshū*, was linked with bright foliage to the extent that the combination of water and colorful leaves in paintings and on ceramics, lacquerware, and clothing immediately suggested the Tatsuta River. The power of *waka* was such that tea masters began to use phrases from *waka* to "name" tea utensils, thus bestowing poetic and seasonal associations on unadorned objects.

This *waka* tradition was carried on by *renga* (classical linked verse), which became the dominant poetic genre in the Muromachi period. *Renga* not only transmitted the seasonal associations developed in *waka* but further refined

them, linking seasonal topics with specific months or phases of the seasons. Each combination of prior verse and added verse (read together as a single poem) had to be identified by season or non-season, and *renga* became a means by which the participants journeyed through the four seasons. *Renga*, like the *waka* anthologies before it, also followed a cosmological system referred to as the Three Realms (Ten-chi-jin)—Heaven, Earth, and Humanity—which created a topographic and cosmological order that directly linked the natural and human worlds. *Renga* manuals, which list seasonal words and their associations, became one of the primary conduits by which the seasonal associations of *waka* were absorbed into noh, which came to the fore in the Muromachi period and reconstructed the Heian classics for a newly powerful warrior class. *Renga* also appropriated the mountains-and-rivers (*sansui*) landscape of ink painting, which had been imported from Song China (960–1279) and became very popular in the Muromachi period. Distant views of high mountains and open waters became an integral part of landscape in Japanese poetry, as they did in rock-and-sand gardens (*kare-sansui*), miniature tray (*bonseki*) gardens, and Zen ink paintings.

This secondary nature was also "interiorized" within the medieval residence, particularly in the form of ikebana (flower arrangement) and other arts of the alcove (*tokonoma*). Chapter 3 examines the architectural forms that linked the exterior to the interior and then, in the Muromachi period, moved the garden and flowers inside the residence in the form of ikebana and bonsai. The Heian-period palace-style (*shinden-zukuri*) residence, with its open pillar construction, opened the interior directly to the garden, a trend that continued in the Muromachi period with the parlor-style (*shoin-zukuri*) residence. Its main feature was the alcove, a vertical open space that became the stage for a wide range of arts: tea ceremony, painting, *renga*, *waka*, *kanshi*, calligraphy, incense, and flower arrangement. The Muromachi- and early Edo–period art of standing-flower (*rikka*) arrangement carried out many of the socioreligious functions that *waka* had earlier: social communication, elegant salutation, celebration of the season, and prayer. In the Muromachi period, with the development of the *kare-sansui*, which minimized or eliminated the use of flowers, the flowers literally moved indoors. But in the Edo period, live flowers returned to the gardens of both urban commoners and upper-rank samurai, who favored "grass flowers" (such as chrysanthemum and morning glory) over the "tree flowers" (cherry, plum, wisteria, and mandarin orange) that had been the main features of the

Heian-period palace-style garden. Spring cherry blossoms, autumn foliage, and winter moon continued to be the main attractions at the so-called famous places (*meisho*) that sprang up in and around Edo (present-day Tokyo) and Kyoto in response to the desire for seasonal viewing, which became a major form of recreation for urban commoners.

Chapter 4 considers the contrast between the *waka*-based secondary nature of the capital and the farm-based secondary nature of the *satoyama*, as depicted in such genres as the early chronicles, anecdotal literature (*setsuwa*), war tales (*gunki-mono*), and Muromachi popular tales (*otogi-zōshi*). A major characteristic of the *satoyama* landscape, with its farm village near a river at the base of a mountain, was the belief that gods resided in different aspects of nature and that birds and animals served as intermediaries between this world and the other world of gods and the dead, which existed in and beyond the mountain. In the medieval period, these two types of landscapes intersected with increasing frequency. One of the most notable examples is noh, which emerged in the Muromachi period and whose repertoire came to include a large number of plays about trees and other plants. Significantly, most of these plays derive from seasonal topics and images originally found in *waka*—such as cherry blossoms and wisteria—but instead of being elegant metaphors for the human condition, the dramatic focus in noh is on the spirit of the plant or flower, which, like human beings, is often caught in a Buddhistic conflict between attachment to this world and the need for salvation. These plays, like many of the *otogi-zōshi* of the time, view the world from the perspective of the plants or animals that are sacrificed and that suffer, usually at the hands of human beings.

Nature in classical poetry is generally linked with seasonality and impermanence, but as chapter 5 reveals, talismanic (magical protective) functions and trans-seasonality—the association of a natural image (such as pine, crane, bamboo, and turtle) with the ability to transcend time and season—are of equal cultural significance. In the Nara period, as is evident in the poetry of the *Man'yōshū*, nature (in the form of flowers and green plants) had a talismanic function, either to expel evil elements (such as plague, pollution, and death) or to pray for good fortune (bountiful harvest, good health, and longevity). As such, nature played a major role as an intermediary between humans and the gods, who could be either benevolent or malevolent. Aristocratic spring rituals (such as gathering young herbs or pulling up the roots of small pines) sought annual renewal of life through nature as

it was found in wild fields (*no*) in and around the cities. Classical poetry and screen paintings also featured continentally inflected images such as pines and cranes, both of which symbolized longevity. In the imperial *waka* anthologies, the talismanic and trans-seasonal topics tend to be concentrated in the "celebration" (*ga*) volume. The present Japanese national anthem is based on a *Kokinshū* celebratory poem about such everlasting aspects of nature. In the *satoyama*, the talismanic function took the form of village shrines, festivals, and prayers (such as *ta-asobi*), which paid respects to the gods of agriculture and nature, who could either protect or destroy. Trans-seasonal and talismanic themes also play a prominent role in a wide variety of genres— from the god plays (*waki-nō*) in noh to the so-called celebratory tales (*shūgimono*) in Muromachi popular tales. Talismanic function and trans-seasonality were also expressed topographically, in the "islands in the sea" constructions found in temple, shrine, and *shinden-zukuri* gardens from the Nara period and in the four-seasons–four-directions gardens, which became a utopian image from the Heian through the Edo period. All these natural images, which were urban reconstructions of nature, implicitly point to the constant threat posed by the wild, uncontrolled aspects of nature and the need to defend against them.

Chapter 6 examines the important role that annual observances, particularly those that originated at the imperial court, played in the representation of the seasons in *waka* and related genres. Most annual observances, whether of court or of provincial origin, had talismanic functions: usually to dispel evil and to pray for good health, long life, and a rich harvest. For example, early spring became associated with new herbs (*wakana*), which were gathered in wild fields and then cooked and eaten as a prayer for rejuvenation and new life. The Five Sacred Festivals (Gosekku) were an integral part of the seasonal topics of *waka*. These kinds of annual court observances, which derived in large part from Chinese customs, differed radically from those held in peasant villages, which were usually indigenous in origin and related to wet-field rice agriculture. A good example of the latter is *ta-asobi* (prayers for a rich rice harvest), usually held at the beginning of the year, in which farmers, treating the temple-shrine grounds as a rice field, imitated hoeing paddies, planting rice seedlings, driving away harmful birds, and so forth, thereby praying for a rich harvest. By the Edo period, each artistic or performance community— for example, kabuki—held its own set of annual observances, which integrated its cultural activity into the larger cycle of the four seasons.

The ancient rituals that sought to renew life through contact with nature also evolved into a form of communal entertainment and release, as exemplified by the widespread custom of cherry-blossom viewing (*hana-mi*), which first appeared among aristocrats and spread to urban commoners in the Muromachi and Edo periods. This aspect of secondary nature in the cities is manifested in the rapid growth in the eighteenth century of so-called famous places (*meisho*)—centered on traditional motifs, such as the cherry blossoms of spring and the colorful leaves of autumn—which became favorite spots for short excursions for urban commoners.

The way in which different representations and functions of nature and the seasons intersected and evolved in the Edo period is the subject of chapter 7. *Haikai* (popular linked verse), the foremost poetic genre of the Edo period, both inherited the seasonal associations developed by *waka and* broke away from that classical tradition, poking fun at its long-held conventions. *Haikai* played a major role in making classical poetry and prose literature accessible to urban commoners and educated farmers, thereby popularizing the culture of the four seasons. *Haikai* masters edited and printed annotated editions of Heian-period classics (such as the *Kokinshū*, *The Tales of Ise*, and *The Tale of Genji*) so that their students could absorb the diction and poetic associations so critical to the process of linking verse. At the same time, *haikai* enlarged the natural landscape to include everything from flies to food and added such humorous seasonal topics as cat's love (*neko no koi*), the squealing sound of cats mating in the spring. In contrast to *waka* and *renga*—which had created a highly codified, elegant, and harmonious view of nature—*haikai*, which used both vernacular and classical Japanese as well as Chinese loanwords, played off the disjunction between the elegant world of classical poetry and the everyday lives of commoners. *Haikai* moved in two fundamental directions:

1. It sought out the low in the high, parodying or vulgarizing classical Japanese or Chinese topics, as did sophisticated *shunga* (erotic ukiyo-e) prints.
2. It sought out the high (spiritual overtones, poetic depth) in the low (contemporary, commonplace), as did the *haikai* of Matsuo Bashō (1644–1694).

A similar process is evident in ukiyo-e, as in Suzuki Harunobu's series "Eight Parlor Views" (Zashiki hakkei, 1766), which parodies the classical

"Eight Views of Ōmi" (Ōmi hakkei). In short, the culture of the four seasons spread widely, in expanded form, throughout popular culture, where it manifested itself in a wide variety of media and genres.

In the Edo period, fish and food (particularly vegetables), two topics that almost never appear in the world of *waka*, became seasonal words (*kigo*). The tea ceremony, in the form of vegetarian cuisine (*kaiseki*) and Japanese sweets (*wagashi*), helped to elevate food to the level of art, where it became part of the culture of the four seasons. With the geographical shift from an inland (Nara and Kyoto) to a port culture (Osaka and Edo), fish and shellfish became an important part of Japanese poetry and visual culture, appearing in bird-and-flower (*kachōga*) ukiyo-e from the mid-Edo period. Significantly, the visual representation of fish, like that of plants and terrestrial animals, came under the influence of medical botany (*honzōgaku*). This is most dramatically demonstrated in the depictions of nature found in books of *haikai* and *kyōka* (comic poetry; literally "wild poetry"). The *haikai* seasonal almanacs, which became encyclopedic handbooks of the Edo period, drew heavily on *honzōgaku*, which created new zoological categories for insects, reptiles, birds, and mammals and placed flora and fauna under a microscope. In *kyōka ehon* (illustrated books of *kyōka*), which became popular in the late eighteenth century, fish, plants, and birds were drawn in a highly naturalistic, scientific manner even as the accompanying *kyōka* parodied classical seasonal topics.

In summary, this book moves more or less in chronological order, beginning in the eighth century and ending roughly in the nineteenth century. It begins with an examination of the development and spread of the poetry-based, capital-centered view of nature in various literary genres and media, and then analyzes how that view intersected with the farm-village perspectives, particularly in the Muromachi period. It then turns to the fate of the poetry-based culture of the four seasons in the Edo period: its popularization through popular linked verse, its adaptation into the culture of the pleasure quarters, its manifestation in urban commoner entertainment and newly constructed famous places, and its complex function as the object of parody and humor in ukiyo-e prints and popular culture. The conclusion summarizes the implications of this evolution, drawing together the diverse threads in a larger historical context, and ends with a note on the ways in which this multilayered culture of the four seasons is expressed in twenty-first-century Japan.

# Poetic Topics and the Making of the Four Seasons

One of the major reasons for the prominence of nature and the four seasons in Japanese literary and visual culture is the impact of Japanese poetry, particularly the thirty-one-syllable *waka* (classical poetry), the main literary genre of the premodern period. Indeed, all the major types of Japanese poetry—*kanshi* (Chinese-style poetry), *waka*, *renga* (classical linked verse), and *haikai* (popular linked verse)—use natural themes extensively.

## Nature as Metaphor

In an East Asian tradition going back to the Six Dynasties period (220–589) in China, poetry was generally expected to do one of three things: express emotions or thoughts (*jō*) directly, describe a "scene" (*kei*) directly, or express emotion or thought through a scene. Since it was generally preferable in the Heian period (794–1185) to express emotions and thoughts indirectly, elegantly, and politely, the third option became the primary mode of social exchange. Love poetry is often associated with the first technique, and

nature poetry with the second, but the third became the preferred mode for both nature and love poetry. Even those poems that appear on the surface to describe only landscape or nature serve to express particular emotions or thoughts. Japanese poetry rarely uses overt metaphor (for example, "My love is a rose"). Instead, the description of a flower, a plant, an animal, or a landscape became an implicit description of a human or an internal state. Metonymy, especially the construction of a larger scene from a small detail, also played a crucial role, particularly in short forms like *waka* and seventeen-syllable *hokku* (opening verse of *renga* sequence). From the perspective of the reader, all such poetry will potentially have a surface (literal) meaning and a deeper meaning. Representations of nature in aristocratic visual culture—whether painting, poetry, or design—are thus seldom simply decorative or mimetic; they are almost always culturally and symbolically encoded, and that encoding tends to evolve with time and genre.

The "harmony" between the natural and human spheres that exists in *waka* and *waka*-related genres and media derives in part from a prominent rhetorical feature that we might call doubleness, in which the text operates at two levels simultaneously. One of the major features of *waka* is the frequent use of puns (*kakekotoba*) and *engo* (words culturally or phonetically linked), which allows two levels (usually human and natural) to coexist in a compact form. Mount Fuji, for example, which appeared in poetry from as early as the eighth century, was associated with *omohi* (melancholy thoughts), which had a homophone suffix *hi* (fire) that implied both volcanic fire and smoldering passion. Thus to compose a poem in the Heian period on the smoke of Mount Fuji, which was a live volcano at that time, was implicitly to compose on the topic of love. The two primary topics in *waka* were the seasons and love, with love being implicit in the seasonal poems and the seasons and nature being the primary expressions of love.

Two major Chinese poetry anthologies, dating to the Six Dynasties period, that had a huge impact on Heian and subsequent Japanese poetry were the *Yutai xinyong* (Jp. *Gyokudai shin'ei*; *New Songs of the Jade Terrace*), compiled by Xu Ling (507–583), and the *Wen xuan* (Jp. *Monzen*; *Selections of Refined Literature*), compiled in the Liang era (502–557). The seasons, particularly autumn and spring, are important in Six Dynasties poetry, and many of these seasonal associations would emerge in Japanese poetry. Chinese poetry anthologies were organized by author, genre, and style, a pattern that Japanese poetry anthologies initially followed, but a significant difference

emerged in that Japanese *waka* anthologies, beginning with books 8 and 10 of the *Man'yōshū* and culminating in the *Kokinshū* and subsequent imperial *waka* anthologies, also carefully arranged the poems on an elaborate temporal and seasonal grid so that attention was paid to all phases of the seasons. The prominence of seasonal poetry is evident in the *Kokinshū*, whose first five books are devoted to the seasons.

In the course of the Heian period, a broad range of natural objects acquired specific seasonal associations. The result was that much of Japanese nature poetry became seasonal poetry. For example, deer (*shika*) live in Japan all year round, but in classical Japanese poetry the image of the deer became associated with autumn and with the mournful, lonely cries of the stag looking for his mate. The deer thus became the embodiment of a particular emotional state as well as a seasonal marker of autumn and was coupled with other autumnal topics, such as bush clover (*hagi*) and dew, to form part of a larger grammar of seasonal poetry. Each seasonal topic generated a cluster of associations, and the seasons themselves (along with famous poetic places) developed associative clusters that became part of a cultural vocabulary.

## The *Man'yōshū* and the Emergence of Seasonal Poetry

The seasonal associations were first developed by *waka* poets in the Nara period (710–784) and then refined and systematized by *waka* poets in the Heian and Kamakura (1185–1333) periods, before being inherited by *renga* (classical linked verse) poets in the Muromachi period (1392–1573) and then radically expanded by *haikai* (popular linked verse) poets in the Edo period (1600–1867). There is little seasonal poetry until the mid-seventh century, in the ancient songs of the two early chronicles, the *Kojiki* (*Record of Ancient Matters*, 712) and *Nihon shoki* (*Chronicles of Japan*, 720), or in the earliest songs and poetry of the *Man'yōshū* (*Collection of Ten Thousand Leaves*, ca. 759). Seasonal poetry began to emerge only in the late seventh century and finally came to the fore in the eighth century, particularly after the move to the new capital at Heijō (Nara) in 710. The seasonal poems collected in books 8 and 10 of the *Man'yōshū*, which date mainly from the first half of the eighth century, were organized by season and by topic. These seasonal topics, which remained remarkably consistent over the next thousand years, gradually increased and evolved over time.

A wide variety of plants are identified in early texts up through the reign of Emperor Tenji (626–671; r. 668–671). They serve a broad range of practical purposes—from food; through medicine, building materials, and dyes; to clothing. But in poetry, the focus is on evergreens and flowering trees, both of which were believed to have special magical powers. The only seasons to draw attention are spring and autumn, notably in the famous *chōka* (long poem [*Man'yōshū*, 1:16]) by Princess Nukata (fl. late seventh century), in which she debates the relative merits of spring and autumn. The early prominence of spring and autumn can probably be traced to two causes: the prominence of these two seasons in Chinese poetry, and the agricultural roots of seventh-century society. Spring was the time for planting, while autumn was the season for harvesting the five grains (*gokoku*). Various annual observances were carried out in the spring (such as land viewing [*kuni-mi*], gathering new herbs, and fence poem fests [*utagaki*]) to pray for prosperity, a rich harvest, long life, and fertility;[1] in the autumn, another set of annual observances was performed to offer thanks for the harvest.

In the mid-seventh century and even earlier, spring was the more prominent season than autumn, probably because of its connection to various rituals related to the New Year and prayers for fertility. However, Princess Nukata's long poem, which favors autumn, suggests that by the reign of Emperor Tenji, autumn had come to overshadow spring. The impact of Chinese poetry, which is partial to autumn, probably played a major role in this shift of interest. Significantly, Nukata focuses only on bright yellow leaves (*momichi*) as the representative image of autumn and does not mention bush clover (*hagi*), the autumn moon, wild geese, or autumn mist (*kiri*), all of which became major autumn topics in the late seventh and eighth centuries.

The number of seasonal poems grew in the so-called second *Man'yōshū* period (672–710), including one on the movement of the seasons attributed to Empress Jitō (645–702; r. 690–697): "It seems that spring has gone and summer has arrived: hanging out to dry, the white hemp robes at Heavenly Kagu Mountain" (*Haru sugite natsu kitaru rashi shirotae no koromo hoshitari Ame no Kaguyama* [1:28]). Another characteristic of poetry of this period is the combination of seasonal motifs: "Small cuckoo, do not sing so much! Not until I can pass your voice through the jewels of the Fifth Month" (*Hototogisu itaku na naki so na ga koe wo satsuki no tama ni aenuku made ni* [8:1465]).[2] The poet tells the small cuckoo (later to be a major summer topic)

that it should not cry until its voice can pass through the fruit (jewel) of the mandarin orange (*tachibana*), which became the primary poetic plant of summer. These seasonal poems also show empathy toward animals and plants, as in this poem attributed to Emperor Okamoto, whom scholars believe to be Emperor Jomei (593–641; r. 629–641): "The deer at Ogura Mountain, which cries when evening arrives, appears to have fallen asleep tonight without crying" (*Yū sareba Ogura no yama ni naku shika wa koyoi wa nakazu inenikerashi mo* [8:1511]). The deer, presented as a lonely stag seeking his mate, becomes an implicit metaphor for the poet's internal state. Speculation on the movement of the seasons, the use of different seasonal motifs, and empathy for or identification with a plant or an animal—all became enduring features of Japanese nature poetry.

Seasonal poetry did not come into its own until the early eighth century, particularly in the Tenpyō era (729–749) and the so-called third *Man'yōshū* period (710–733), when Chinese poetry flourished in Japan, bringing with it a strong awareness of the seasons, particularly spring and autumn. Most of these poems are found in books 8 and 10 of the *Man'yōshū*, which are divided into miscellaneous poems (*zōka*) and love poems (*sōmon*). The love poems use images of nature and the seasons to express longing and love, as in this spring poem: "(*A poem sent by Ōtomo no Yakamochi to the daughter of the Sakanoue family*) How I wish the seeds of the pink that I planted in my garden would quickly turn to flower—I will watch them as if they were you" (*Wa ga yado ni makishi nadeshiko itsushika mo hana ni sakinamu nasoetsutsu mimu* [8:1448]). The pink (*nadeshiko*), a flower that homophonically implies "stroked/petted (*nade*) child (*ko*)," is planted in the spring with the expectation of blossoms (fruition of love) in the autumn. In contrast to book 8, which names the authors of the poems, thus providing a historical backdrop to the development of seasonal poetry,[3] the poems in book 10 are basically anonymous and are organized by such topics such as birds, spring mist, willow, flowers, moon, and rain.

Books 8 and 10 of the *Man'yōshū* represent a major break from the earlier books of the anthology, which were structured around three basic genres: *zōka* (miscellaneous poems), *sōmon* (love poems), and *banka* (elegies).[4] In the early books of the *Man'yōshū*, the miscellaneous poems, which are often long poems, were composed at the imperial palace or on imperial excursions, particularly to detached palaces at Yoshino and Naniwa, where homage

was paid to high royalty and to sovereigns, who were treated as gods. When these miscellaneous poems became private banquet poetry, around the Tenpyō era, the poetry, increasingly in the short, thirty-one-syllable *waka* form, came to focus on seasonal animals, plants, and atmospheric conditions—such as bush warbler, small cuckoo, mandarin orange, bush clover, and mist—instead of the gods and high royalty who had been celebrated earlier.

The series of thirty-two plum-blossom poems composed at the residence of the courtier Ōtomo no Tabito (665–731), in the First Month of 730, is the earliest recorded seasonal banquet poetry in the *Man'yōshū* (5:815–846). More than thirty people attended this banquet, which followed the model of *kanshi* (Chinese-style poetry) banquets on plum blossoms and which was held in Dazaifu, in Kyushu, which was a bridge to continental culture at the time.[5] A good example from this banquet is: "Plum blossoms mixing with the lingering snow, do not scatter quickly even if the snow disappears!" (*Nokoritaru yuki ni majireru ume no hana hayaku na chiri so yuki wa kenu tomo* [5:849]).[6] In a manner that anticipates Heian-period *waka*, the poem personifies nature and addresses it as though it were a friend or lover.

The degree to which books 8 and 10 of the *Man'yōshū* were read in the Heian period is unclear, but there is no doubt that the custom and tradition of composing and collecting seasonal poems began in the early eighth century, providing the initial cluster of seasonal associations, and continued to grow in the Heian period to the point where it became the dominant poetic practice.

## The *Kokinshū* and the Establishment of Seasonal Poetry

The organization and content of the seasonal poems in the *Kokinshū* (*Collection of Japanese Poems Old and New*, ca. 905), the first imperial *waka* anthology, became the model for the culture of the four seasons for the next thousand years. The *Kokinshū*, which was the object of poetic reference and allusion throughout the Heian period and had become the most influential classical text by the early thirteenth century, opens with six books (*maki*) on the seasons: two on spring, one on summer, two on autumn, and one on winter. The editors of the *Kokinshū*, no doubt drawing inspiration from books 8 and 10 of the *Man'yōshū*, arranged the seasonal books (with a total of 342 poems) around topical clusters, but they did not label them, as had the editors of book 10 of the *Man'yōshū*.[7] Instead, the topics are implicit but

carefully organized, laid out in temporal sequence to create a larger temporal and cosmological order:

SPRING

Book 1. Beginning of spring, spring mist, bush warbler, snow, new herbs, green willow, returning wild geese, plum blossoms, cherry blossoms

Book 2. Scattering cherry blossoms, flowers in bloom, scattering flowers, wisteria, yellow kerria, passing spring, end of spring

SUMMER

Book 3. Waiting for the Fifth Month, small cuckoo, mandarin-orange blossoms, deutzia flowers, lotuses, summer rain, summer night, pinks, end of summer

AUTUMN

Book 4. Beginning of autumn, autumn wind, Star Festival, autumn moon, insects, pine crickets, cicadas, wild geese, deer, bush clover, white dew, yellow valerian (maiden flower), boneset, miscanthus grass in ear, autumn grasses

Book 5. Storm, bright foliage, chrysanthemums, fallen leaves, late autumn, end of Ninth Month

WINTER

Book 6. Beginning of winter, snow, plum blossoms in snow, end of the year

The cycle of the seasons in the *Kokinshū* is not a reflection of the natural environment. Extensive attention is given to spring and autumn (two long books each), with a heavy concentration of poems on a small number of topics—plum blossoms, cherry blossoms, small cuckoo, autumn moon, bright foliage, and snow—which occupy more than half of the six seasonal books. The summer (thirty-four poems) and winter (twenty-nine poems) books

are extremely short and are dominated by small cuckoo and snow, respectively. In short, the editors of the *Kokinshū* did not attempt to represent the actual seasonal plants and animals but instead concentrated on the topics and seasons that they considered to have the highest cultural and poetic value.

## The Creation of Spring

Spring came at the beginning of all the imperial *waka* anthologies, giving it extreme political and cultural importance, particularly because the emperor or retired emperor, who commissioned the anthologies, was their most important reader and patron. Early spring also coincided with the New Year, a major annual observance and a felicitous time, as is evident in the poems on new herbs (*wakana*) and "pulling up the small pine" (*komatsu-hiki*) on the first Day of the Rat (Nenohi). Under the luni-solar calendar, spring began on the first day of the First Month and finished at the end of the Third Month (the equivalent of February 4 to May 4). The weather at the start of spring was thus very cold and resembled that of winter.

In the *Kokinshū*, four topics mark the arrival of spring: snow (Spring 1, nos. 3–9), the bush warbler (nos. 10–16), spring mist, and thawing ice. The most prominent of these is the bush warbler (*uguisu*), a small sparrow-like bird with a white belly and feathers of an *uguisu* color (a mix of green, brown, and black), which in spring descended to the city from the surrounding hills and valleys, where it was thought to hide during the winter (figure 4). As a

FIGURE 4
*BUSH WARBLER ON RED PLUM BRANCH*

The bush warbler and plum blossom became a major icon of the arrival of spring as early as the time of the *Man'yōshū* and appears repeatedly in almost every visual and textual genre. This ukiyo-e (1843–1847) by Utagawa Hiroshige (1797–1858) focuses on the red plum (*kōbai*), rather than the white plum (*hakubai*) blossom, which was the standard in the Nara period. The woodblock print exemplifies the way in which poem and image, tree and bird, have been closely integrated as seasonal topics since the ancient period. The *hokku* reads: "The bush warbler: this year too, the voice has not grown old" (*Uguisu ya kotoshi mo koe no furukarazu*). (Color woodblock print; 13 × 4.4 inches. Courtesy of the Museum of Fine Arts, Boston, William S. and John T. Spaulding Collection, 1921, no. 21.8078)

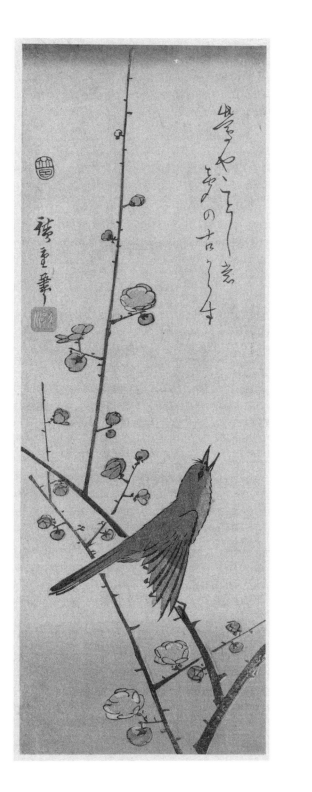

poem by Ōe no Chisato notes, the voice of the bush warbler was thought to signal the arrival of spring: "Without the voice of the warbler that comes out of the valley, how would we know the arrival of spring?" (*Uguisu no tani yori izuru koe naku wa haru kuru koto wo tare ka shiramashi* [Spring 1, no. 14]). Mist (*kasumi*) also meant the coming of spring: "On the Heavenly Hills of Kaguyama, the mist trails this evening—spring must have arrived!" (*Hisakata no Ame no Kaguyama kono yūbe kasumi tanabiku haru tatsu rashimo* [*Man'yōshū*, 10:1812]).[8] By the time of the *Shūishū* (*Collection of Gleanings*, 1005–1007), the third imperial *waka* anthology, mist had become the primary marker of the advent of spring (Spring, nos. 1–4), arriving via the mountains, a stance characteristic of subsequent imperial *waka* anthologies.[9] As Kawamura Teruo has shown, spring was envisioned as coming by way of the famous mountains (such as Mount Kagu and Mount Kasuga) in the Yamato basin, the former capital at Shiga (Ōtsu), and Yoshino, a detached imperial palace to the south of present-day Nara visited thirty-three times by Empress Jitō,[10] thus paying homage to the old capital (*furuki miyako*) and to the former sites of imperial glory.

In the *Kokinshū*, the arrival of spring is followed by the budding of the green willow (Spring 1, nos. 26 and 27), the return north of the wild geese (nos. 30 and 31), and the scent of the plum blossoms (nos. 32–48).[11] The buds of the willow (*aoyanagi*), which turn into flowers in the spring, symbolize new life.[12] The plum blossoms, generally thought of as white flowers with five round petals, were admired because they are able to withstand the cold, and in spring poetry they appear with snow. A famous example is Ōtomo no Tabito's poem composed at the banquet at his residence: "The flowers of the plum tree scatter in my garden—a shower of snow from the heavens!" (*Waga sono ni ume no hana chiru hisakata no ame yori yuki no nagare kuru kamo* [*Man'yōshū*, 5:822]). This kind of comparison (later called *mitate*) of the scattering plum blossoms to falling snow appears frequently in Six Dynasties poetry as well as in Tabito's own *kanshi* in the *Kaifūsō* (*Nostalgic Recollections of Literature*, 751]), the oldest anthology of Chinese-style poetry in Japan. These poetic conventions continued into the *Kokinshū*, but in contrast to the *Man'yōshū*, where the stress is on the color of the plum blossoms, the overwhelming focus of plum-blossom poems in the *Kokinshū* is on the scent.[13] This olfactory emphasis may have come from the new Heian-period incense culture or from the mid-Tang poetry of Bo Juyi (772–846) and other

Chinese poets who wrote about the "floating dark scent" of the plum blossoms. A common conceit in the *Kokinshū* is that neither darkness nor distance can cut off the scent of the plum blossom, as in this poem by Ōshikōchi no Mitsune: "(*Composed on the plum blossom on a spring night*) The darkness of the spring night makes no sense: the color of the plum flower may not be visible, but can its scent be hidden?" (*Haru no yo no yami wa ayanashi ume no hana iro koso miene ka ya wa kakururu* [Spring 1, no. 41]). According to one interpretation, the darkness of the spring night represents the parents who attempt to block a suitor from seeing their daughter (plum blossoms), but the suitor (the narrator) claims that they cannot hide her beauty (the scent).

The cluster of topics on early spring (mist, bush warbler, new herbs, willow, and plum) in the *Kokinshū* is followed by a massive body of poems on cherry blossoms: twenty poems on the cherry trees blooming and twenty-one poems on the cherry blossoms scattering, followed by another fourteen on blossoming flowers and fifteen on scattering flowers. In the *Man'yōshū*, the word "flower" (*hana*) refers to a wide range of grass and tree flowers. The most popular of these was the plum blossom, with the cherry blossom coming in second. In the Heian period, by contrast, the main flowers of spring became the cherry, plum, and yellow kerria. In the spring books of the *Kokinshū*, *hana* refers primarily to the cherry blossom (*sakura*), indicating that it had become the supreme flower of spring.[14]

The first large group of *hana* poems in the *Kokinshū* explores the glory of the cherry blossoms. Cherry trees, which were planted in gardens and throughout the city, become a symbol of the beauty of the capital, leading to the phrase "flower of the capital" (*miyako no hana*) or "capital of flowers" (*hana no miyako*), as in this poem by Priest Sosei: "(*Composed upon looking over the capital while the cherry blossoms were at their peak*) When I look afar, the willow and the cherry blossoms mix together, making the capital a brocade of spring" (*Miwataseba yanagi sakura wo kokimazete miyako zo haru no nishiki narikeru* [Spring 1, no. 56]). By contrast, the main interest of the cherry blossoms in the second major group of *hana* poems is the fading and scattering of the flowers, as in Ono no Komachi's famous poem: "While I gaze out during the long rains, the color of the cherry blossom fades, much like my life, which passes in vain" (*Hana no iro wa utsurinikerina itazura ni wa ga mi yo ni furu nagame seshi ma ni* [Spring 2, no. 113]). Unlike the

plum blossom, which endures even in the snow, the cherry blossom lasts for only a short time, and from the tenth century onward cherry blossom also appears in lament poems (*aishō-ka*).

The spring books of the *Kokinshū* come to a close with wisteria (Spring 2, nos. 119 and 120), yellow kerria (nos. 121–125), and the passing of spring (nos. 126–134). The *Man'yōshū*, which has twenty-seven poems on wisteria (*fuji*), generally focuses on its flowers, with frequent use of the word *fuji-nami* (wisteria waves), thus associating wisteria with water—a connection that continues into the *Kokinshū*. In the spring, yellow kerria (*yamabuki*), sometimes translated as "yellow rose" since it belongs to the rose family,[15] bears small five-petaled yellow flowers at the tip of its slender green trailing branches (figure 5). The name *yamabuki* (literally, "mountain blowing") is said to come from the fact that its branches are weak and easily blown by the wind. In the *Man'yōshū*, which contains seventeen poems on yellow kerria, the flower is frequently found on the bank of a river, often with crying frogs (*kawazu*): "The yellow kerria is probably blooming now, its reflection in the Kamunabi River, where the frogs cry" (*Kawazu naku Kamunabikawa ni kage miete ima ka sakuramu yamabuki no hana* [8:1435]). In the *Kokinshū*, the *yamabuki* continues to appear on the edge of the water, where its flowers are reflected, as in this poem by Ki no Tsurayuki: "(*Composed on the yellow kerria blooming on the banks of the Yoshino River*) On the banks of the Yoshino River, the yellow kerria, blown by the wind, have scattered even on the water bottom" (*Yoshinogawa kishi no yamabuki fuku kaze ni soko no kage sae utsuroinikeri* [Spring 2, no. 124]).[16]

FIGURE 5

*YELLOW KERRIA AND FROGS*

This ukiyo-e (early nineteenth century) by Utagawa Hiroshige (1797–1858) combines yellow kerria, clear river water, and crying frogs—an associative spring cluster that emerged as early as the time of the *Man'yōshū* and has appeared in multiple media. The *waka* reads: "The frogs cry, lamenting that even though the spring showers fall there is not even one fruit [raincoat] of the yellow kerria" (*Harusame no furu hi nagara mo yamabuki no mi no hitotsu dani naku kaeru kana*), which plays on the words *mino* (straw raincoat) and *mi* (fruit) and parodies a famous poem in the *Goshūishū* (*Later Collection of Gleanings*, 1086): "How strange that though the seven-layered, eight-layered flowers bloom, there is not even one fruit [raincoat] of the yellow kerria" (*Nanae yae hana wa sakedomo yamabuki no mi no hitotsu dani naki zo ayashiki* [Miscellaneous, no. 1154]). (Color woodblock print; 14.8 × 6.5 inches. Courtesy of the Museum of Fine Arts, Boston, William S. and John T. Spaulding Collection, 1921, no. 21.6793)

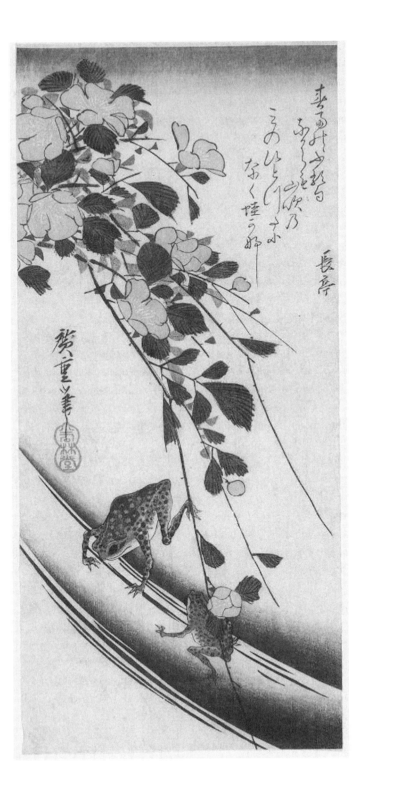

The summer book of the *Kokinshū*, much like the summer sections in books 8 and 10 of the *Man'yōshū*, is very short, with summer functioning more like a transitional period between the two major seasons: spring and autumn.[17] In the luni-solar calendar, summer extended from the Fourth Month through the Sixth Month (the equivalent of May 5 to August 6). The arrival of summer was marked by intense heat and high humidity in the Nara and Kyoto areas. *Koromogae* (changing to summer clothes), the annual custom that marks the arrival of summer, is a time of regret: "Regretfully taking off the sleeves dyed by the colors of the cherry blossoms—how sad it is today, changing to new clothes" (*Hana no iro ni someshi tamoto no oshikereba koromogae uki kyō ni mo aru kana* [*Shūishū*, Summer, no. 81]).

In the *Kokinshū*, the small cuckoo (*hototogisu*) dominates the summer, with twenty-eight of the thirty-four summer poems focusing on this bird—a pattern followed by subsequent imperial *waka* anthologies. Indeed, the cuckoo came to represent summer much as the cherry blossom came to represent spring; the moon, autumn; and the snow, winter. Since the *hototogisu*, which has a gray back and a white belly with black-spotted stripes, arrived in the Fourth Month, its singing was thought to mark the beginning of summer, and poets looked forward to its first cry (*hatsune*). The song of the *hototogisu* was also thought to increase one's longing for a lover, as in this poem by Ōtomo no Sakanoue no Iratsume (Lady Sakanoue): "Small cuckoo, please don't cry so hard! I sleep alone, and when I hear that voice I find it too much to bear" (*Hototogisu itaku na naki so hitori ite i no neraenu ni kikeba kurushi mo* [*Man'yōshū*, 8:1484]). From as early as the *Man'yōshū*, the *hototogisu* was also associated with nostalgia and longing for the past: "When I hear the voice of the small cuckoo, I long even for the village that I left behind" (*Hototogisu naku koe kikeba wakarenishi furusato sae zo koishikarikeru* [*Kokinshū*, Summer, no. 146]).

The main flower of summer in the *Kokinshū* is that of the mandarin orange (*tachibana*). The mandarin orange is often paired with the small cuckoo, much as the bush warbler is paired with the plum blossom in spring.[18] The *tachibana*, a medium-size evergreen tree with thorny branches, has five-petaled white flowers that have a strong fragrance in the summer. In the *Man'yōshū*, the *tachibana* was treated primarily as an auspicious plant, with a focus on its evergreen leaves and golden fruit, which were thought to possess magical powers. But in the Heian period and in the *Kokinshū*, poets

began to point to the scent of the flower, which became associated with memory: "When I catch the scent of the orange blossoms waiting for the Fifth Month, I am reminded of the sleeve of that person of long ago" (*Satsuki matsu hanatachibana no ka wo kageba mukashi no hito no sode no ka zo suru* [Summer, no. 139]).[19] As a result of this famous poem, the mandarin-orange flower, somewhat like the small cuckoo, became closely associated with personal memory and nostalgia.

Summer rain (*samidare*) is the most prominent atmospheric topic of summer in the *Kokinshū*, comparable to mist in spring and snow in winter. The long, oppressive rains of the Fifth Month (monsoon season)[20] first became a major topic in the Heian period, when they became associated with melancholy thoughts. The homophonic association between *samidare* and *midare* (troubled) linked the summer rains to depression (*mono-omohi*) and "tangled" (*midare*) hair. In short, the summer book of the *Kokinshū* combines the image of the *hototogisu* with those of the *tachibana* and *samidare* to create an emotionally textured landscape associated with love, memory, and depression.

In contrast to the cold of winter or of early spring, *waka* poets did not write about the heat of summer, perhaps because it was too unbearable as a topic of composition. Instead, from the mid-Heian period onward, poets turned to the opposite: the topic of coolness in summer or cooling off (*nōryō*): "(*Cooling off at the base of a spring at the Kawara-in*) Scooping the water of the well in the shadow of the pines, I think of a year without summer" (*Matsukage no iwai no mizu wo musubi-agete natsu naki toshi to omoikeru kana* [*Shūishū*, Summer, no. 131]). Poets gravitated to the summer evening, which was seen as a time of cooling off, as in this poem from the *Goshūishū* (*Later Collection of Gleanings*, 1086), the fourth imperial *waka* anthology: "How cool the summer evening! The light of the moon appears to be white frost in the garden" (*Natsu no yo mo suzushikarikeri tsukikage wa niwa shirotae no shimo to mietsutsu* [Summer, no. 224]). In these poems, the summer nights were thought to be all too brief. No sooner has one fallen asleep than dawn appears.

### The Dominance of Autumn

Autumn is the most emphasized season in the *Man'yōshū*, the *Kokinshū*, and subsequent imperial *waka* anthologies. By the time of the *Shinkokinshū* (*New Anthology of Poetry Old and New*, 1205), the eighth imperial *waka*

anthology, poems about autumn outnumber those on spring by almost three to two. Under the luni-solar calendar, autumn extended from the Seventh Month through the Ninth Month (the equivalent of August 7 to November 6). The beginning of autumn is marked by the lingering and stifling heat of summer, which continues to the end of the Seventh Month. Even *tsuki-mi*, the annual rite of viewing the harvest moon (*meigetsu*), which comes in the middle of the Eighth Month, was thought of as an opportunity for cooling off in the Edo period. The coolness associated with autumn in North America and Europe does not come until the latter half of autumn, in the Eighth and Ninth Months.

In the *Kokinshū*, the arrival of autumn is foreshadowed by wind, as in this noted poem by Fujiwara no Toshiyuki: "Though it is not clear to the eye that autumn has arrived, I find myself surprised by the sound of the wind" (*Aki kinu to me ni wa sayaka ni mienedomo kaze no oto ni zo odoro-karenuru* [Autumn 1, no. 169]). Autumn is also ushered in by the Star Festival (Tanabata), a major annual observance held on the seventh day of the Seventh Month. According to Chinese legend, two stars, the Herdsman (Kengyū [Altair]) and the Weaver Woman (Shokujo [Vega]), were lovers, but they were punished for a transgression and separated by the Milky Way (Ama-no-gawa). On the seventh day of the Seventh Month, the stars were allowed to meet for one night only. Of the poems on Tanabata in the *Man'yōshū* (8:1518–1529; 10:1996–2093), a large number were probably composed at Tanabata banquets at the private residences of Ōtomo no Tabito and other courtiers.[21] The poet often takes the position of the Weaver Woman or the Herdsman and expresses passionate feelings, as in this example by Yama-noue no Okura: "Facing each other across the River of Heaven, it sounds as if the person I love is coming—I shall loosen my sash and wait" (*Ama no gawa ai-muki-tachite aga koishi kimi kimasu nari himo tokimakena* [*Man'yōshū*, 8:1518]). In the *Kokinshū*, Tanabata continues to be a major topic, ranking in number of poems behind only bright foliage among autumn topics. One result is that Tanabata serves to integrate the theme of love into early autumn, much as the *hototogisu* does for early summer.

The full arrival of autumn in the *Kokinshū*, however, comes with the appearance of the light of the autumn moon in the night sky, which is described as eliciting melancholy thoughts from as early as the *Man'yōshū* (10:2226). However, it was this poem in the *Kokinshū* that clearly established

this image's poetic essence: "When I see the light of the moon leaking through the trees, I know that the heart-wrenching autumn has arrived" (*Ko no ma yori morikuru tsuki no kage mireba kokorozukushi no aki wa kinikeri* [Autumn 1, no. 184]). Although the moon appears in all four seasons, the association of the moon with autumn was so strong in the imperial *waka* anthologies that eventually the moon came to symbolize autumn itself.

Adding to the sorrow of the autumn moonlight were the cries of the wild goose (*kari*). The *Man'yōshū* has sixty-seven poems on the wild goose, making it second only to the small cuckoo among birds. A good example of the association of loneliness and wild geese is: "Midnight—it seems that the night has grown old. One can see the moon crossing a sky filled with the sound of crying wild geese" (*Sayo naka to yowa fukenurashi karigane no kikoyuru sora wo tsuki wataru miyu* [9:1701]). The "crying voices" (*karigane*) of the wild geese came to refer to the geese themselves. In the *Kokinshū* (Autumn 1, nos. 206–213), the visual image of wild geese flying in formation also took on importance, as also in this poem: "One can even count the number of wild geese flying wing to wing across a sky of white clouds—the moon on a clear autumn night!" (*Shirakumo ni hane uchikawashi tobu kari no kazu sae miyuru aki no yo no tsuki* [Autumn 1, no. 191]).

In the *Kokinshū* (Autumn 1, nos. 196–205), the sounds of insects (*mushi*)—particularly the katydid (*kirigirisu*), pine cricket (*matsumushi*), and cicada (*higurashi*)—also add to autumn's loneliness and sorrow: "Katydid! Do not cry so intensely! The melancholy of the long autumn night overwhelms me" (*Kirigirisu itaku na naki so aki no yo no nagaki omoi wa ware zo masareru* [Autumn 1, no. 196]). The same is true of the cries of the stag (Autumn 1, nos. 214–218), which is always presented as looking for his mate: "When I hear the stag crying as it makes its way through the bright leaves deep in the hills, autumn is truly sad" (*Okuyama ni momiji fumiwake naku shika no koe kiku toki zo aki wa kanashiki* [Autumn 1, no. 215]).

Another major topic in the first autumn book of the *Kokinshū* is the autumn grasses (*akikusa*), commonly known as the seven grasses (*nanakusa*), which are listed in the *Man'yōshū* as bush clover (*hagi*), miscanthus grass in ear (*obana*), kudzu-vine flower (*kuzu*), pink (*nadeshiko*), yellow valerian or maiden flower (*ominaeshi*), boneset (*fujibakama*), and morning glory (*asagao*). From as early as the *Man'yōshū*, an implicit contrast existed between these

grass flowers (*kusa no hana*), which had a melancholy and wistful tone, and the flowers of spring, such as the cherry and the plum, referred to as the tree flowers (*ko no hana*), which were all bright. The most prominent of the autumn grasses was *hagi*, a deciduous bush that grows about five feet high, with small leaves clustered in threes and narrow branches that bend in elegant arches down to the ground. The character for *hagi* (萩) is a *kokuji* (graph of Japanese origin), which combines the radical for "grass" (*kusa*) with the graph for "autumn" (*aki* 秋), creating an association between the two that is so strong that the plant is often referred to as autumn bush clover (*aki-hagi*). The *Man'yōshū* has 140 poems on *hagi*—more than for any other plant. The most prominent pairing of images is that of stag and bush clover, as in this poem by Ōtomo no Tabito: "The stag has come to my hill, looking for its flower wife—the first bush clover" (*Waga oka ni saoshika kinaku hatsuhagi no hanazuma toi ni kinaku saoshika* [8:1541]). This implicit love pairing, between the deer and the bush clover, continues in the *Kokinshū* and subsequent imperial *waka* anthologies.

The theme of love is also integrated into autumn in the *Kokinshū* through the topic of *ominaeshi* (Autumn 1, nos. 226–238), or yellow valerian (often translated as "maiden flower"), a perennial grass that grows in wild fields and on hills. At the beginning of autumn, the small yellow flowers of yellow valerian, shaped like upside-down umbrellas, bloom at the top of its straight and narrow stems, which grow to a height of about three feet.[22] The identification of yellow valerian with women begins in the *Man'yōshū* (10:2115), where *ominaeshi* is written with the graphs for "beautiful woman" (美人部師). In the Heian period, *ominaeshi* was written with three graphs (女郎花) that literally mean "woman flower." The poetic associations for *ominaeshi* were established in the *Kokinshū* by a series of poems beginning with this one by Priest Henjō: "I was drawn to the name and broke it off, maiden flower! Don't tell anyone I've fallen this far!" (*Na ni medete oreru bakari zo ominaeshi ware ochiniki to hito ni kataru na* [Autumn 1, no. 226]). The word "fallen" (*otsu*) implies that the priest has broken his vow of celibacy. In another poem from the same series, the *ominaeshi* bends in the autumn wind, suggesting a loose or frivolous woman: "The woman flower bends wherever the wind blows in the autumn fields. Whom does the person of one heart favor?" (*Ominaeshi aki no no kaze ni uchinabiki kokoro hitotsu wo tare ni yosuramu* [Autumn 1, no. 230]).

The word for "autumn" (*aki*) was homophonous with the word for "bright" (*aki* 明), and from the seventh century, autumn was thought of as the season in which the tree leaves turned bright colors and the five grains (*gokoku*) were harvested. However, during the Tenpyō era, under the heavy influence of Chinese poetry (in which autumn is associated with personal frustration, aging, and death), autumn began to acquire overtones of sorrow, and by the ninth century, in the Heian period, autumn had become a season of sadness. This dark side of autumn, particularly the sense of mortality and impermanence, begins to appear in late *Man'yōshū* poetry and in the *Kaifūsō*. By the time of the *Kokinshū* (Autumn 1, nos. 184–190), in the early tenth century, sadness had come to be one of the major themes or associations of autumn. The key word is *utsurou* (to change color or fade): "In all things autumn is sad—when I think of what happens when the tree leaves turn color and fade" (*Monogoto ni aki zo kanashiki momijitsutsu utsuroiyuku wo kagiri to omoeba* [Autumn 1, no. 187]). The famous *chōka* (long poem) in the *Man'yōshū* (1:16) by Princess Nukata on the relative merits of spring and autumn comes out in favor of autumn, but it does not give a clear explanation. The reason became more explicit in Heian poems such as this one: "When it comes to spring, the cherry trees simply bloom in profusion; but when it comes to the pathos of things autumn is superior" (*Haru wa tada hana no hitoe ni saku bakari mono no aware wa aki zo masareru* [*Shūishū*, Miscellaneous 2, no. 511]).

At the same time, the "bright" aspects of autumn expanded dramatically in the Heian period. *Momichi* (*momiji* in the Heian period), the ancient word for "bright foliage," was written with the graphs for "yellow leaves" (黄葉).[23] In the Nara period, at banquets, aristocrats broke off branches of bright yellow leaves to decorate their hair. The colored leaves, which are usually portrayed as yellow in the *Man'yōshū*, become crimson in the *Kokinshū*, matching the colorful cherry blossoms of spring. If autumn grasses dominate the first autumn book of the *Kokinshū*, bright foliage is the main focus of the second autumn book (nos. 249–267). Colorful foliage came to be associated with brocade (*nishiki*), as in this poem about fallen leaves (*ochiba*): "It appears that the bright leaves flow down the Tatsuta River in disarray. If one crossed the water, the brocade would break in half" (*Tatsutagawa momiji midarete nagarumeri wataraba nishiki naka ya taenamu* [Autumn 2, no. 283]). The metaphor of brocade implies that autumn is a colorful and bright season,

even more so than spring: "As for spring, I see one grass, which is green; as for autumn, there are flowers of myriad colors" (*Midori naru hitotsu kusa to zo haru wa mishi aki wa iroiro no hana ni zo arikeru* [Autumn 1, no. 245]).

The chrysanthemum (*kiku*), which appears in the second autumn book of the *Kokinshū* (nos. 268–280), also contributed to the bright side of autumn. Not a single chrysanthemum poem appears in the *Man'yōshū*, but from the Heian period the chrysanthemum became the most prominent autumn flower in Japanese poetry, surpassing even bush clover and yellow valerian.[24] A perennial plant that blooms for an extended period, the chrysanthemum had become a symbol of long life in China and it appears in the *Kaifūsō*. As an elegant flower with what was regarded as a pure fragrance, it became a flower of high status. At the Chrysanthemum Festival (Chōyō), a Chinese-derived annual observance adapted by the court of Emperor Kanmu (737–806; r. 781–806) and held on the ninth day of the Ninth Month, chrysanthemum wine was imbibed in the hope of attaining long life. Most of the thirteen poems on the chrysanthemum in the *Kokinshū* are related to this association with reinvigoration and immortality, as in this poem by Ki no Tomonori: "The chrysanthemum, let me break it off, still wet with dew, and place it in my hair, so that the autumn will never grow old" (*Tsuyu nagara orite kazasamu kiku no hana oisenu aki no hisashikarubeku* [Autumn 2, no. 270]). Here, dew is a metaphor for chrysanthemum wine.

The last major autumn topic in the *Kokinshū* (nos. 281–305) is fallen leaves (*ochiba*), which returns to the theme of bright foliage, but with the leaves in a scattered state, as in Ki no Tsurayuki's famous *waka*: "With no one to see it, the bright foliage scattering deep in the hills is a brocade in the night" (*Miru hito mo nakute chirinuru okuyama no momiji wa yoru no nishiki narikeri* [Autumn 2, no. 297]). The two groups of *momiji* poems establish a correspondence with the two main topics of spring: cherry trees blooming and cherry blossoms scattering. In short, autumn in the *Kokinshū* is anchored, on the one hand, by autumn grasses, the loneliness of which is enforced by the light of the moon, insects, wild geese, and the stag. On the other hand, we have the chrysanthemum, often believed to hold the power to transcend time. Between these two poles stands the topic of colorful foliage, which can either be brilliant or evoke a sense of wistfulness and transience. So valued was autumn that Japanese poets looked forward to the season and regretted its departure, developing the theme of "regret at the departure of autumn" (*sekishū*), the counterpart to "regret at the passage of spring" (*sekishun*).

## The Associations of Winter

Winter may have been the most severe season for people in the ancient period due to the combination of cold, frost, and snow. Under the luni-solar calendar, winter spanned the Tenth, Eleventh, and Twelfth Months (the equivalent of November 7 to February 3), alternatively called Kannazuki (Godless Month), Shimotsuki (Frost Month), and Shiwasu (Teacher Running), respectively. The harsh conditions are probably why winter was of relatively little poetic or aesthetic interest in the *Man'yōshū*. Books 8 and 10 of the *Man'yōshū* have 172 poems on spring, 105 on summer, 441 on autumn, and only 67 on winter. The situation is similar in the *Kokinshū*, which has only 29 poems on winter out of a total 342 seasonal poems. In the *Kokinshū*, winter is essentially regarded as cold and lonely: "As for the mountain village, the loneliness only grows in winter, especially when one realizes that visitors and grasses fade away" (*Yamazato wa fuyu zo sabishisa masarikeru hitome mo kusa mo karenu to omoeba* [Winter, no. 315]). The dying of the grasses coincides with the fading of human activity.

The winter book of the *Kokinshū* begins with sudden showers (*shigure*) and the bright leaves at Tatsuta River (nos. 314–316), works its way through a long series on snow (nos. 317–333), takes up plum blossoms in snow (nos. 334–337), and then finishes with poems on the year's end (nos. 338–342). This topical sequence shows that for tenth-century *waka* poets, winter was, like summer, essentially about the loss of one major season and the anticipation of another. The opening winter poem in the *Kokinshū* (no. 314), about the brocade of bright leaves on the Tatsuta River, is about the remains of autumn; and in the last part, snow is visually confused (*mitate*) with flowers (*hana*), as in Ki no Tsurayuki's famous poem on snow, which implies that snow is beautiful because it looks like cherry blossoms: "When the snow falls, flowers unknown to spring bloom on both the grass and trees that have been dormant all winter" (*Yuki fureba fuyugomoriseru kusa mo ko mo haru ni shirarenu hana zo sakikeru* [Winter, no. 323]).

## The Structure of the Seasonal Books

In the *Kokinshū*, each of the four seasons is divided into three phases: early, middle, and late.[25] The first and last poems of each season focus, respectively,

on the arrival and the departure of the season—for example, the last poem in the summer book, by Ōshikōchi no Mitsune: "(*Composed on the last day of the Sixth Month*) On the corridor in the clouds, summer and autumn are passing each other: no doubt a cool breeze is blowing on one side" (*Natsu to aki to yukikau sora no kayoiji wa katae suzushiki kaze ya fukuramu* [Summer, no. 168]). The early phase, particularly for spring and autumn, has two stages: anticipation and arrival. Lingering snow and the bush warbler anticipate spring, while the gathering of new herbs, mist, and green willow signify its arrival. Likewise, the wind anticipates autumn, and the sadness of the moonlight marks its arrival. The middle phase is generally signaled by insects and other animals (such as birds and deer), followed by plants. In the middle phase of spring, returning wild geese and crying frogs are followed by the plum, cherry, wisteria, and yellow kerria. In summer, the small cuckoo is followed by the mandarin-orange blossoms (*hanatachibana*) and deutzia flower (*unohana*). In the autumn books, poems on the cries of the insects and wild geese precede poems on autumn grasses, bright foliage, chrysanthemums, and fallen leaves.

Throughout the seasonal books, the birds, insects, and deer (which both "cry" and "sing") are perceived almost entirely through their songs, sounds, or voices. Flowers, by contrast, are admired for their color and fragrance. The favorite Heian color was white, as is evident in the cherry blossom, plum blossom, deutzia flower, and chrysanthemum. Moonlight, dew, frost, and snow were almost always considered white. Another admired color was crimson, the color of bright foliage and crimson plum blossom (*kōbai*), which became popular in the Heian period.

Five major elements appear in the seasonal books of the *Kokinshū*: atmospheric conditions, birds and other animals, flowers and trees, celestial bodies, and annual observances. The emphasis on atmospheric conditions—particularly spring mist (*kasumi*), rain, autumn mist (*kiri*), and snow—may have been due to the humid climate of Japan, but it also reflects a strong preference for obscured sight and veiled landscape, as is evident in such topics as misty spring moon (*oborozukiyo*) as well as a tendency to attach emotions to certain atmospheric conditions. There are, for example, at least three major types of rain—drizzle (*harusame*), long rains (*samidare*), and passing showers (*shigure*)—each of which came to be associated with a season and a specific psychological state: spring (romance), summer (melancholy), and autumn and winter (uncertainty), respectively.

# Love and the Four Seasons

In books 8 and 10 of the *Man'yōshū*, each season is divided into love poems (*sōmon*) and miscellaneous poems (*zōka*), indicating, from the beginning of the *waka* tradition, a fundamental link between seasonal and love topics. As we have seen, many of the major seasonal topics in the *Man'yōshū* and the *Kokinshū*—such as *hototogisu* (small cuckoo), *samidare* (long rains), Tanabata, *ominaeshi* (yellow valerian), and deer—had major "love" associations. A strong parallel also emerges between the structure of the six seasonal books and the five love books of the *Kokinshū*. Most of the poems in the first and second love books of the *Kokinshū* are implicitly composed from the perspective of the pursuing man. In the third, fourth, and fifth love books, by contrast, it is generally the woman who is neglected and who waits in vain for the man to visit. This narrative of love has a direct parallel in the seasonal books of the *Kokinshū*, where the poet longs for the arrival of a season or a particular bird or waits impatiently for the flowering of a tree or another plant. Equally important in the love books is regret and resentment over the unexpectedly quick departure or loss of a lover. Longing takes the form of desire for something yet to be obtained or desire for something lost, both reflected in the verb *shinobu*, which can mean either "to suppress desire" or "to look back on the past with regret." This is also a familiar stance in the spring and autumn books, where regret about the passage of spring or autumn is a major topic. Similarly, the focus of poems about cherry blossoms is not so much on the flowers at their peak as on the anticipation of the cherry blossoms and the regret at their scattering.

One result of the personification of nature that occurs frequently in the *Kokinshū* is that plants and animals are often gendered. Many flowers, trees, and other plants are associated with women, particularly yellow valerian (maiden flower), willow (linked with arching eyebrows and long hair), plum blossom, cherry blossom, wisteria, yellow kerria, deutzia flower, morning glory, bush clover, and pink. Morning glory (*asagao*; literally, "morning face"), for example, is associated with the face of a female lover in the morning. Pink (*nadeshiko*; literally, "child that I stroke") becomes a girl who has been raised by a man. By contrast, birds, many of which which seek out flowers, are often associated with men, a tendency that reflects the duolocal marital system in which the man commuted to the woman's residence. The deer is a stag longing for his wife, often represented by the bush clover. The sound of

insects, particularly the pine cricket (*matsumushi*; literally, "waiting insect"), often becomes that of a lonely woman waiting for a man's visit. In short, birds, insects, and other animals often express the same emotions as those found in love: frustration, a sense of betrayal, loss, resentment, and loneliness.[26]

Another striking parallel is between the arrival of autumn and the fading of love. If spring corresponds with the beginning of love, then autumn echoes the sorrow of separation or abandonment. A poem by Priest Henjō reveals the "autumnal" nature of love: "Cold showers are falling on my sleeves before their time. Has autumn already arrived in your heart?" (*Wa ga sode ni madaki shigure no furinuru wa kimi ga kokoro ni aki ya kinuramu* [*Kokinshū*, Love 5, no. 763]). Autumn (*aki*), implying the homophone *aki* (weariness), has come unexpectedly early to the heart of the loved one, a change that brings tears (*shigure* [sudden cold showers]) to the poet. This kind of close association between love and the seasons, the two most important topics in the *Kokinshū* and in classical Japanese literature in general, is part of the larger scene/emotion (*kei/jō*) double structure typically found in *waka*, but is also manifested in the topical arrangement of the anthology itself.

## The Diversification of Seasonal Topics

The seasonal topics first appeared in the *Man'yōshū* and became firmly established in the *Kokinshū*, but they continued to evolve and increase in number even as their circle of associations became solidified with time. Two fundamental modes emerged. Poems could be composed freely on private occasions as a form of elevated dialogue or soliloquy, or poems could be composed (as they increasingly were from the late tenth century onward) on given or fixed topics (*daiei*) for banquets; screen paintings (*byōbu-e*), in which the poet was usually expected to take the perspective of a figure in the painting; poetry contests (*uta-awase*); and poems on one hundred fixed topics (*hyakushu-uta*).

### Evolution in the Imperial Waka Anthologies

Some seasons became more important with time, and their focus evolved. The expanding importance of autumn is evident in the number of poems

for each season in the first eight imperial *waka* anthologies (see appendix). In the *Kokinshū*, the spring (134 poems) and autumn (145 poems) books are roughly the same size, but in the *Shinkokinshū*, autumn (266 poems) far outstrips spring (174 poems), thereby foregrounding autumn, with particular focus on autumn evenings and the autumn moon. Poets increasingly favored autumn topics but showed less interest in bright leaves as they became more concerned with the depth beneath the natural surface. In this famous poem by Fujiwara no Teika, considered by many to be the embodiment of the ideal of *yūgen* (mysterious depth), the bright leaves are marked by their absence: "When I look afar, there are neither flowers nor bright leaves— autumn evening in a thatched hut by the bay" (*Miwataseba hana mo momiji mo nakarikeri ura no tomaya no aki no yūgure* [*Shinkokinshū*, Autumn 1, no. 363]). Medieval poets gravitated toward the somber, subdued, lonely beauty of autumn, with an emphasis on twilight and evening, creating a monochromatic aesthetic that stood in implicit contrast to the brilliance of Heian court culture, represented by colorful foliage and cherry blossoms. This aesthetic implied a spiritual depth that transcended sight and physical phenomena. If Heian classical poetry was concerned with the brilliant but changing colors of autumn (*utsurou aki*), then medieval *waka* was drawn to the "deep autumn" (*fukaki aki*) and the "deepening" of the day: "Autumn has deepened—cry now, cricket in the frosted night! The light of the moon over thick weeds is gradually growing colder" (*Aki fukenu nake ya shimoyo no kirigirisu yaya kage samushi yomogiu no tsuki* [*Shinkokinshū*, Autumn 2, no. 517]).

Interest in winter also grew in the late Heian and Kamakura periods. The *Senzaishū* (*Collection of a Thousand Years*, 1183), the seventh imperial *waka* anthology, includes eleven poems on the "first (sign of) winter" (*hatsufuyu*), the word "first" (*hatsu*) indicating that some aspect of winter was eagerly anticipated, much like the first cherry blossoms. Mid- to late Heian poets expanded the topical scope of winter to include waterfowl (*mizutori*), birds that live along the banks of rivers and lakes, particularly the wild duck or mallard (*kamo*), the mandarin duck (*oshidori*), and the plover (*chidori*), as in this *waka* by Murasaki Shikibu, which puns on *uki* (floating) and *uku* (to be sorrowful): "Can we regard the waterfowl on the surface of the water as separate from ourselves? I too float uncertainly, leading a sorrowful existence" (*Mizutori wo mizu no ue to ya yoso ni mimu ware mo ukitaru yo wo sugushitsutsu* [*Senzaishū*, Winter, no. 430]). Particularly prominent is the mandarin duck, a winter bird that was thought to sleep on water so cold

that frost and ice formed on its feathers, as in this poem in the *Gosenshū* (*Later Collection*, 951), the second imperial *waka* anthology: "Since the night is cold, I wake up and listen to the mandarin duck crying—is it because it can't brush the frost off its wings?" (*Yo wo samumi nezamete kikeba oshi zo naku harai mo aezu shimo ya okuran* [Winter, no. 478]).[27]

In the *Shinkokinshū*, the most influential medieval imperial *waka* anthology, winter is almost the equivalent of spring in the number of poems. The light of the winter moon becomes part of a new medieval aesthetic of purity (*kiyoshi*) and coldness, as in a poem by Fujiwara no Kiyosuke: "How cold the moonlight that falls on the frost of the decayed leaves of a forest withered by winter!" (*Fuyugare no mori no kuchiba no shimo no ue ni ochitaru tsuki no kage no samukesa* [Winter, no. 607]). Here, the cold and pure light of the winter moon falls on the mundane world, which is implicitly in "decay." Medieval *waka* and *renga* poets developed similar notions of coldness (*hie*), cold sadness/loneliness (*hiesabi*), and slenderness (*yase*). Winter topics— particularly cold showers, snow, frost, ice, and the translucent moon— constructed a monochromatic landscape that shares much with Muromachi ink painting (*suibokuga*) and rock-and-sand gardens (*kare-sansui*).

### Fixed-Topic Composition

The evolution of seasonal topics continued in the poetry contest (*uta-awase*), in which two poets composed on the same fixed topic (*dai*), with a judgment being handed down on each round, either a "draw" or a "win." The most famous of the early *uta-awase* was the *Tentoku yonen sangatsu sanjūnichi dairi uta-awase* (*Poetry Contest in the Imperial Palace on the Thirtieth Day of the Third Month of the Fourth Year of Tentoku*, 980), which had only twelve topics:

Spring mist, bush warbler, willow, cherry blossoms, yellow kerria, wisteria, end of spring, early summer, deutzia flower, small cuckoo, summer grass, love

The judgments in these *uta-awase*, which became increasingly popular and elaborate, reveal the expectations and associations surrounding specific poetic topics. In the decision on yellow kerria in the *Tentoku uta-awase*, for example, the judge criticized the loser for having depicted *yae-yamabuki*

(multilayered yellow kerria) as opposed to *hitoe-yamabuki* (one-layered yellow kerria) in the winning poem.[28] On the topic of wisteria, the judge noted that the loser had used the word *fujinami* (waves of wisteria), but had failed to place the wisteria next to water, thus disqualifying the poem.[29] The word *fujinami* triggered the association of *fuji* (wisteria) with the water's edge or a pond, which the poet could not ignore. When a poet composed in private, he or she was not as restricted in the use of seasonal topics, but the increasingly popular practice of fixed-topic composition from the mid-Heian period onward institutionalized these seasonal associations, which could be either consciously followed or deliberately twisted or violated.

Another major milestone in the expansion of seasonal topics was the *Roppyakuban uta-awase* (*Poetry Contest in Six Hundred Rounds*), held in the autumn of 1193 at the residence of Fujiwara no Yoshitsune (1169–1206), with Fujiwara no Shunzei (1114–1204) presiding as judge.[30] The *Roppyakuban uta-awase* contains fifty seasonal topics and fifty love topics, with six rounds (each consisting of two paired poems) for each topic, resulting in twelve hundred poems (see appendix). Four seasonal topics on the time of day—spring dawn, summer night, autumn evening, and winter morning—are placed at the climactic point of each season. These four topics derive from the famous phrases that open Sei Shōnagon's *Makura no sōshi* (*The Pillow Book*, ca. 1000): "As for (the best part of) spring, it is dawn" (*haru wa akebono*), "as for summer, night" (*natsu wa yoru*), "as for autumn, the evening" (*aki wa yūgure*), and "as for winter, early morning" (*fuyu wa tsutomete*).[31] Subsequently, autumn evening (*aki no yūgure*) became a major topic in the *Shinkokinshū*, resulting in the famous "three evening poems" (*sanseki*), including Teika's: "When I look afar, there are neither flowers nor bright leaves—autumn evening in a thatched hut by the bay."

The selection of seasonal topics in the *Roppyakuban uta-awase* stands in stark contrast to that in the *Kokinshū*, in which the seasons revolve around the plum, cherry, autumn moon, and snow. Instead, the *Roppyakuban uta-awase* focuses on atmospheric topics, such as the simmering heat wave, evening shower, typhoon, lingering heat, autumn rain, and sleet, which—together with the new time-of-day seasonal topics—had a deep impact on subsequent imperial *waka* anthologies, particularly the monumental *Shinkokinshū*.

Another important development in the history of poetic topics was the emergence of the *hyakushu-uta* (poems on one hundred fixed topics), in which each participant usually composed a hundred poems, one on each

fixed topic.[32] The most influential of these was the *Horikawa hyakushu* (*Horikawa Poems on One Hundred Fixed Topics*, 1105), which was composed by fourteen poets centered on Fujiwara no Toshiyori, the editor of the *Kin'yōshū* (*Collection of Golden Leaves*, ca. 1127), the fifth imperial *waka* anthology, and was presented to Emperor Horikawa (1079–1107; r. 1087–1107) in 1105. The fundamental difference between the poems in the *Horikawa hyakushu* and those in topically organized anthologies such as the *Kokin rokujō* (*Six Books of Japanese Poetry Old and New*, 976–987) is that the anthologies collected *waka* that had been composed on various occasions and arranged them by topic, while the poems in the *Horikawa hyakushu* were composed on assigned topics.

The hundred topics in the *Horikawa hyakushu* are divided into spring (twenty poems), summer (fifteen), autumn (twenty), winter (fifteen), love (ten), and miscellaneous (twenty) (see appendix). The forty or so seasonal topics found in the *Kokinshū* were expanded to about seventy to give a much broader view of the four seasons.[33] Even more striking is the emergence of a kind of pastoral, an idealized landscape of farming,[34] with topics such as rice-seedling bed (*nawashiro*),[35] mountain rice field (*yamada*), young rice seedlings (*sanae*),[36] kangaroo grass (*karukaya*), and charcoal-making oven (*sumigama*). Beginning in the late eleventh century, aristocrats from the capital traveled to the provinces or to their summer residences outside the capital, where they had the opportunity to see farm life, which they began to incorporate into their poetry, thus expanding the landscape to include both farm villages (*satoyama*) and mountain villages (*yamazato*).

## Seasonal Identity and Ambiguity

The seasonalization of nature in *waka* was largely a cultural construction. The deer exists all year around in Japan, but in classical poetry it became an autumn topic. Not surprisingly, poets often had difficulty fixing a plant or an animal to a particular season. For example, the iris (*kakitsubata*), which gained fame as a result of its appearance in a famous poem composed at the Eight Bridges in Mikawa Province in section 9 of *The Tales of Ise* (*Ise monogatari*, ca. 947), bloomed from the spring through the summer, leading to considerable debate. The *Man'yōshu*, *Gosenshū*, and color scheme of the Heian-period twelve-layered robe (*jūni hitoe*) place *kakitsubata* in the summer,

but the *Kin'yōshū* and the *Fūgashū* (*Collection of Elegance*, ca. 1346–1349) categorize it as a spring topic. The editors of the influential *Horikawa hyakushu* made the key decision to place *kakitsubata* in the spring and *shōbu* (*ayamegusa* [Siberian iris or sweet flag]), a key feature of the Tango Festival, held on the fifth day of the Fifth Month, in the summer, probably in order to avoid confusion between the two similar plants. That choice had a lasting impact on later topical anthologies, such as the *Fuboku wakashō* (*Fuboku Japanese Poetry Collection*, ca. 1310). However, *waka* poets continued to compose on iris in the summer, and by the time of *renga* and *haikai* in the Muromachi period, it had returned to summer.[37]

Once established, seasonal topics followed a strict temporal order.[38] Within this larger frame, new topics were added or faded away. For example, yellow valerian (*ominaeshi*) is very popular in the *Kokinshū*, with thirteen poems in the first autumn book, but it gradually diminished as a topic and does not appear even once in the *Kin'yōshū*. A newcomer is azalea (*tsutsuji*), which makes its debut in the *Goshūishū* and reappears in the *Kin'yōshū*, but then is absent from subsequent imperial *waka* anthologies. New seasonal topics took time to settle into an established time slot. For example, summer grass (*natsukusa*) appears sporadically in the *Man'yōshū* and in Heian-period *uta-awase* (poetry contests) as a Sixth Month, late-summer topic, but in the *Eikyū yonen hyakushu* (*Poems on One Hundred Fixed Topics in the Fourth Year of Eikyū*, 1116) and the *Roppyakuban uta-awase*, it is in the Fourth Month, marking the beginning of summer, where it is placed in the *Shinkokinshū*.[39]

Seasonal associations were also consolidated with time. In the *Kokinshū*, the word *hana* (flower) could refer to either cherry blossoms or plum blossoms, but by the time of the *Gosenshū*, it came to mean only "cherry blossoms." Similarly, the moon appears in all seasons, but by the time of the *Kin'yōshū*, the word *tsuki* (moon) had become associated specifically with autumn, unless indicated otherwise by a modifier (as in *natsu no tsuki* [summer moon]). In the *Man'yōshū*, the plover (*chidori*), which lives on the seashore or at the mouth of rivers and swamps, appears in spring (19:4146 and 4147) and summer (6:925). The bird's exclusive poetic association with winter is not established until the *Shūishū*, as a result of a screen-painting poem (*byōbu-uta*) by Ki no Tsurayuki: "When I go out in search of my love, unable to bear my longing, I hear the plovers crying in the cold river wind on a winter's night" (*Omoikane imogari yukeba fuyu no yo no kawakaze samumi*

*chidori naku nari* [Winter, no. 224]). The *Shinkokinshū* includes eleven plover poems in the winter book, revealing that by the Kamakura period it had become a major winter topic, associated with loneliness and the difficulty of bearing the cold.

As we can see, the seasonal landscape in the *Kokinshū*, as in most of the subsequent imperial *waka* anthologies, has no wilderness, wild animals, snakes, or wild boars—almost none of the animals that we find in anecdotal literature (*setsuwa*) from the Nara, Heian, and medieval (1185–1599) periods. Neither does it have the plants (such as barley) harvested in the farm villages. In the *Kokinshū*, poets do not climb the mountains or fish in the lakes and streams. The tree flowers and grass flowers are almost entirely those that grow in aristocratic gardens, in the capital, or in the suburbs. There are no fires, earthquakes, famines, floods, or droughts. Instead, the world of the *Kokinshū* is a largely harmonious universe in which nature—in the form of carefully selected animals, insects, flowers, trees, and atmospheric conditions— functions as an elegant and often highly nuanced expression of human thought and emotion.

This worldview, which is brought into sharp focus by the imperial *waka* anthologies compiled in the Heian period, is intimately related to what I call the ideology of the four seasons. The *waka* anthologies, which were commissioned by the emperor and offered to the emperor, were ultimately a celebration of imperial rule. The harmony of the natural world and that between the human and natural spheres thus directly reflected the nature of imperial rule. In this regard, the seasonal cycle in the *Kokinshū* functioned in a way similar to that of the annual observances held at court, such as the Five Sacred Festivals (Gosekku), which were also celebrations of imperial rule and prayers for peace and harmony in the land. At the peak of his power in *The Tale of Genji*, the protagonist constructs the Rokujō-in, a four-season, four-garden grand residence in which he places his most important women, with Akikonomu (One Who Loves Autumn; Genji's direct link to imperial power) in the autumn quarter and Murasaki (Lavender; Genji's great beloved) in the spring quarter. The two most important women (and the two most important seasons) occupy the southern and most important side of the Rokujō-in. The ideology of the four seasons, which is implicit in the *Kokinshū*, is evident in the ten Tamakazura chapters, which depict the cycle of the four seasons as they unfold at the Rokujō-in, thereby celebrating

Genji's rule. The downfall of Genji and the Rokujō-in is foreshadowed in the storm that marks the "Nowaki" (Tempest) chapter, in which Genji's son, Yūgiri, catches a direct and erotic glimpse of Murasaki. As is evident in the "Akashi" and "Usugumo" (A Rack of Cloud) chapters of *The Tale of Genji*, celestial disturbances (*tenpen*)—such as lightning, tornado, natural disaster, and solar eclipse—were taken as signs of moral or political disorder, particularly imperial rule gone wrong. This form of thought, which can be traced to China and ritual texts such as the *Liji* (Jp. *Raiki*; *Book of Rites*), one of the five Confucian classics, implies not only that harmony with nature, especially atmospheric conditions and celestial bodies, was a mark of superior imperial rule, but that each season had its appropriate human activities. As we shall see, the use of poetic places (*utamakura*) in imperial anthologies also implied a spatial rule over the land, much as the seasonal topics implied a temporal rule.

*Waka* was, first and foremost, a poetry of affect in which certain images evoked specific emotions. This encoding was reinforced and institutionalized by the practice of fixed-topic composition (*daiei*), which came to the fore in the mid- to late Heian period and imposed strict rules on the range of associations. For the aristocracy, Buddhist priests, and educated samurai, this secondary nature became a shared cultural vocabulary—a rich repository of emotionally charged images and metaphors—that was used for and, indeed, became indispensable for a wide range of social, political, and religious functions. The close association of *waka* with the imperial court and with the emperor also gave it special status, as a kind of royal genre, whose use took on high cultural value. Moving beyond their origins, the seasonal topics of *waka* and their associations spread to a wide range of visual media, particularly painting and design.

*Chapter Two*

# Visual Culture, Classical Poetry, and Linked Verse

*Waka* (classical poetry) reached its zenith as a genre in the Heian (794–1185) and Kamakura (1185–1333) periods and continued to be widely practiced even as its popularity waned in the Muromachi (1392–1573) and Edo (1600–1867) periods. In the Muromachi period, *waka* was finally superseded by *renga* (classical linked verse), which became the most popular late medieval poetic form. *Renga*, in turn, was surpassed by *haikai* (popular linked verse), which came to the fore in the seventeenth century. The seasonal associations developed by *waka* were inherited and disseminated by both *renga* and *haikai*, but in contrast to *renga*, which maintained the elegant diction and traditional topics of *waka*, *haikai* also embraced popular culture and non-classical diction, including Chinese.

All three poetic forms had a huge impact on visual and material culture. *Waka* was critical to the genres of Heian-period four-season paintings, twelve-month paintings, and famous-place paintings—not to mention the scroll paintings (*emaki*) that depict Heian court tales. Eventually, the seasonal and natural associations developed by *waka* were used in the designs

for women's clothing, ceramics, lacquerware, furniture, tea ceremony utensils, and flower arrangement—to mention only the most obvious. *Renga* carried on the tradition of *waka*, refining its topics and diction even further and bringing it into contact with other late medieval genres such as noh.

## Wearing the Seasons

The manner in which the seasonal associations of *waka*, particularly those of flowers and plants, permeated Heian aristocratic culture is perhaps most dramatically demonstrated in the design and colors of the woman's multi-layered kimono now referred to as the *jūni hitoe* (literally, "twelve-layered dress") (figure 6). Each layer (*kasane*) of the robe had a specific color combination (*irome*), appropriate for each season:[1]

### SPRING

| | |
|---|---|
| Crimson plum (*kōbai*) | Bright red surface, dark reddish-purple interior |
| Cherry blossom (*sakura*) | White surface, pinkish-maroon interior |
| Yellow kerria (*yamabuki*) | Light tan surface, yellow interior |
| Wisteria (*fuji*) | Light lavender surface, dark green interior |

### SUMMER

| | |
|---|---|
| Deutzia flower (*unohana*) | White surface, green interior |
| Mandarin-orange blossom (*hanatachibana*) | Withered leaf–patterned surface, green interior |
| Iris (*kakitsubata*) | Scallion-patterned surface, crimson interior |
| Sweet flag (*shōbu*) | Scallion-patterned light green surface, purple interior |
| Pink (*nadeshiko*) | Crimson surface, light lavender interior |

| | |
|---|---|
| Withered leaf (*kuchiba*) | Russet surface, yellow interior |
| Bush clover (*hagi*) | Dark red surface, green interior |
| Yellow valerian (*ominaeshi*) | Yellow surface, dark green interior |
| Bright foliage (*momiji*) | Reddish-brown surface, brown interior |
| Fading chrysanthemum (*utsuroigiku*) | Light lavender surface, blue-green interior |

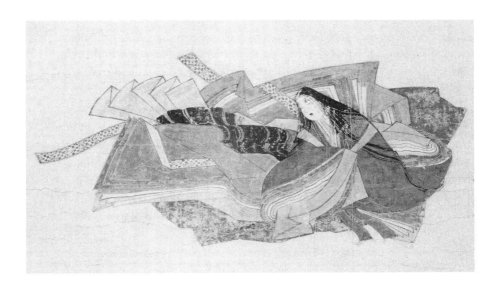

FIGURE 6

MULTILAYERED HEIAN-PERIOD KIMONO

In this detail from the *Picture Scroll of the Thirty-six Poetic Geniuses* (*Sanjū rokkasen emaki* [*Satake-bon* variant]), Kodai no Kimi (Koōkimi, mid-Heian period), one of the female poetic geniuses (*kasen*), is portrayed in a Chinese robe (*karaginu*) with multilayered unlined kimono (*jūni hitoe*) and a detachable skirt (*mo*). The layers of the kimono and the colors that distinguish them are visible in the right sleeve and in the hem. The poems in the scroll were selected by Fujiwara no Kintō (966–1041). The paintings are attributed to Fujiwara no Nobuzane (1176–ca.1265) and the calligraphy to Fujiwara no Yoshitsune (1169–1206). (Color on paper; 14 × 23.3 inches. Courtesy of Museum Yamato Bunkakan, Nara)

| | |
|---|---|
| White chrysanthemum (*shiragiku*) | White surface, green or dark red interior |
| Withered field (*kareno*) | Yellow surface, light green or white interior |
| Ice (*koori*) | Light gray surface, white interior |

TRANS-SEASONAL

| | |
|---|---|
| Grape (*ebi*) | Dark reddish purple surface, dark green interior |

Almost all the *kasane* names derive from seasonal plants that are also prominent in *waka*. Each name refers to a color combination that was used not only in clothing but also in decorative paper for letters, poems, and picture scrolls.[2]

With only a few exceptions (such as "grape," which could be worn year-round), each *kasane* color combination represented a specific season and sometimes a specific month. In this fashion, Heian aristocrats brought *waka*-related "nature" into their everyday lives. At the beginning of spring, when the crimson plum tree blossomed, it was customary for an aristocratic woman to wear a "crimson plum" *kasane* robe, with bright red on the outside and dark reddish-purple on the inside, and to write letters on paper decorated with the "crimson plum" color combination. Likewise, when autumn arrived and the tree leaves withered and scattered, an aristocratic woman was expected to wear a robe with the "withered leaf" color combination of faded red or russet on the outside and yellow on the inside. In the section "Susamajiki mono" (Awful Things) in *Makura no sōshi* (*The Pillow Book*, ca. 1000), Sei Shōnagon lists the following: "Dogs howling at noon, a fishing weir in spring, and a crimson plum robe in the Third and Fourth Months." Dogs were expected to howl at night, the weir was used to catch fish in the winter, and the "crimson plum" robe was supposed to be worn when the crimson plum tree was in bloom, which was early spring, in the First and Second Months. What was "awful" was wearing it in late spring (Third Month) or in early summer (Fourth Month).

The impact of *waka* on women's high fashion in the Edo period is also evident in the design of the *kosode* (now referred to as the kimono). The *kosode* (literally, "small sleeve"), which is a form of wearable art, has a simple construction based on straight lines: sleeve panels are sewn onto the body panels to produce a flat surface like a painter's canvas. Edo-period *kosode*, worn by upper-level samurai and wealthy urban commoner women, are decorated with different designs—auspicious motifs, classical literary subjects, famous places in *waka*, and so forth—but the dominant design elements are seasonal flowers, trees, and other plants, based largely on the associations found in classical poetry. (The same was true of the kimono worn by high-ranking courtesans [*oiran*] in the pleasure quarters.) Typical spring designs are the first blossoms of the plum, willow, camellia (*tsubaki*), cherry tree in bloom, and waves of wisteria blossoms. Noted autumn designs are chrysanthemum in the hedge, Musashi Field (covered with autumn grasses and flowers), and the Tatsuta River (bright foliage).

One popular technique was to embed a *waka* in the form of scattered writing (*chirashi-gaki*) in the design of a *kosode*. Often only several characters were sprinkled across the robe, leaving the rest of the poem to be recalled by the discerning viewer. A few of the graphs were clear, but the others were buried in the design, as in reed hand (*ashide*) writing, in which the calligraphy is part of the image. A typical example is a *furisode* (literally, "swinging sleeve"), or long-sleeved kimono, from the mid-Edo period that is decorated with yellow kerria on waves (figure 7). The scattered graphs refer to Fujiwara no Shunzei's (1114–1204) poem in the *Shinshūishū* (*New Collection of Gleanings*, 1364), the nineteenth imperial *waka* anthology: "The bottom of the Tama River at Ide, reflecting the image above, is so clear that the flowers of the yellow kerria add layer upon layer" (*Kage utsusu Ide no Tamagawa soko kiyomi yae ni yaesou yamabuki no hana* [Spring 2, no. 177]). In the Nara period (710–784), Tachibana no Moroe (684–757) is thought to have planted *yamabuki* on the banks of the Tama River in Ide (in present-day Kyoto Prefecture), and the Tama River subsequently became famous as an *utamakura* (poetic place) on which many classical poems were based. In the twelve-layered robe of the Heian period, the color combination, named after a flower and its color, reflected the phase of a season. But in the *kosode* of the Edo period, the design referenced not only a specific season, but a specific poem and place. In this way, the *kosode* designs enhanced the beauty

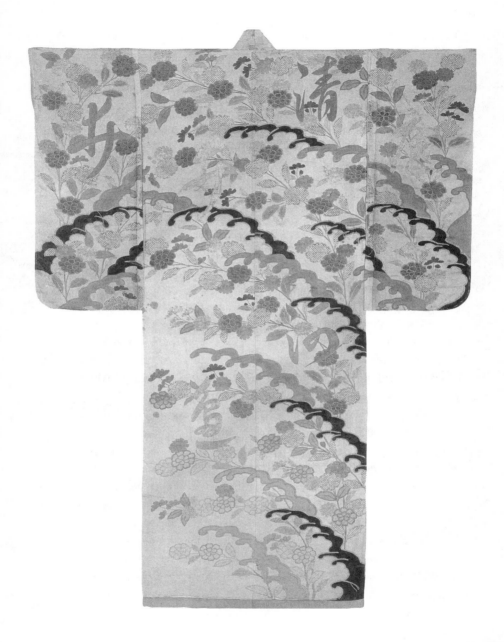

FIGURE 7
YOUNG WOMAN'S KIMONO WITH YELLOW KERRIA

This white figured-satin, long-sleeved dress for a young woman (*furisode*) from the mid-Edo period is embroidered with a design of golden-yellow waves and yellow kerria (*yamabuki*), interwoven with fragmentary calligraphy of Fujiwara no Shunzei's noted poem on the *yamabuki*. (Courtesy of the Matsuzakaya Collection, Nagoya)

of the wearer and expressed her taste and education, particularly her cultural sensitivity to the seasons.

The colors of the Heian *kasane* robe and the designs of the Edo *kosode* could also anticipate the next season. This was particularly true for winter, when it was not unusual to don spring color combinations that signaled that the wearer was waiting for spring, much as the last winter poems in the *Kokinshū* (*Collection of Japanese Poems Old and New*, ca. 905) anticipate spring by "mistaking" the white snowflakes for cherry blossoms. Similarly, the Edo-period *kosode* meant for summer wear were marked by two major characteristics: a sense of coolness (light colors and light fabric), and autumn motifs such as morning glory, dew, bush clover, and yellow valerian. By wearing autumn designs in the summer, a woman showed that she was waiting for the coolness of autumn. The wearer of a twelve-layered *kasane* robe could also show appreciation for the autumn that was ending by choosing, for example, the "fading chrysanthemum" (*utsuroigiku*) combination of light lavender on the outside and blue-green on the inside. When the white chrysanthemum passes its peak, its petals are tinged with crimson—an aspect alluded to in the dark red interior of the "white chrysanthemum" color combination, which is worn in winter and thus expresses the wearer's regard for the autumn that has just passed.

## Painting the Seasons

In the Heian period, aristocrats not only "wore" the seasons, but were surrounded by *waka*-based seasonal references inside their palace-style (*shinden-zukuri*) residences. As Takeda Tsuneo has argued, one of the most salient features of the Yamato-e (Japanese-style painting) that emerged in the mid-Heian period was an emphasis on the four seasons, specifically in the three major painting genres: four-season painting (*shiki-e*), twelve-month painting (*tsukinami-e*), and famous-place painting (*meisho-e*).[3] The *shiki-e* presents four scenes, one for each season, while the *tsukinami-e* depicts one scene for each of the twelve months, and the *meisho-e* portrays famous places with seasonal associations drawn from *waka*, such as Kasuga Field and the Tatsuta River. These three subgenres appear as screen paintings (*byōbu-e*) and door or partition paintings (*fusuma-e*). Typically, a poet would compose a *waka* on a scene depicted in a screen painting, often from the point of view of a figure in the

scene, or would compose a *waka* as a viewer of the screen. The *waka* was then written on a poetry sheet and pasted onto the screen painting.

The *Yoshinobu shū* (*Yoshinobu Collection*, ca. 979), a private *waka* collection of the noted poet Ōnakatomi no Yoshinobu (921–991), records the scenes on one such twelve-month screen painting (*tsukinami-byōbu-e*), with twelve poems by Yoshinobu, one for each month:[4]

| First Month | Pulling up pines on the Day of the Rat |
| Second Month | Preparing a rice field |
| Third Month | Regret at the scattering of the cherry blossoms |
| Fourth Month | Visiting a mountain retreat with the cherry blossoms still in bloom |
| Fifth Month | Thatching sweet flag on the fifth day of the Fifth Month, small cuckoo |
| Sixth Month | Performing an exorcism (*harae*) |
| Seventh Month | Celebrating the Star Festival (Tanabata) |
| Eighth Month | Greeting Horses (Komamukae) |
| Ninth Month | Harvesting rice at a provincial residence |
| Tenth Month | Fishing weirs and bright foliage |
| Eleventh Month | Celebrating a god festival (*kami matsuru*) |
| Twelfth Month | Falling snow |

This kind of twelve-month screen painting became very popular in the mid-Heian period. In this particular painting, the seasonal topics include both agricultural activities and annual observances. The remaining topics are plants, birds, and atmospheric conditions commonly found in imperial *waka* anthologies. Since Heian aristocratic women rarely went out, screen and partition paintings, decorated with small sheets of *waka*, became, along with the garden, a surrogate for nature. The women often composed poems not on the actual small cuckoo that they heard in the garden, but on the *hototogisu* painted on a screen painting or partition.

In the Kamakura period, a new form of seasonal painting emerged: the painting album (*gachō*), which was much smaller than the multiscene screen painting, usually with one scene per painting. One of the most popular subjects for this new format was Fujiwara no Teika's (1162–1241) *Jūnikagetsu kachō waka* (*Poems on Flowers and Birds of the Twelve Months*, 1214), which presents one flower poem and one bird poem for each of the twelve months:[5]

| | FLOWER | BIRD |
|---|---|---|
| First Month | Willow | Bush warbler |
| Second Month | Cherry blossoms | Pheasant |
| Third Month | Wisteria | Skylark (*hibari*) |
| Fourth Month | Deutzia flower (*unohana*) | Small cuckoo (*hototogisu*) |
| Fifth Month | Mandarin orange | Marsh hen (*kuina*) |
| Sixth Month | Pink (*tokonatsu*) | Cormorant (*u*) |
| Seventh Month | Yellow valerian (*ominaeshi*) | Magpie (*kasasagi*) |
| Eighth Month | Bush clover | First wild geese (*hatsukari*) |
| Ninth Month | Miscanthus grass (*susuki*) | Quail (*uzura*) |
| Tenth Month | Late chrysanthemum (*zangiku*) | Crane (*tsuru*) |
| Eleventh Month | Loquat (*biwa*) | Plover (*chidori*) |
| Twelfth Month | Early plum blossom | Waterfowl (*mizutori*) |

Significantly, Teika's *Jūnikagetsu kachō waka* reflects a level of seasonal specificity and imagistic association (matching classical birds with classical plants) even more pronounced than that in Heian screen paintings. From the late Heian period, poems on each month of the year (*tsuki-nami waka*) had been composed at monthly gatherings (*utakai*) at the Office of Poetry (Waka-dokoro) and at the residences of prominent *waka* poets. By the Northern and Southern Courts period (1336–1392), this custom had spread to various other classes. As part of this trend, Teika's *Jūnikagetsu kachō waka* became a very popular subject for painting that was frequently taken up by Tosa and Kanō school painters as well as by Ogata Kenzan (1663–1743), a ceramics artist of the Rinpa school who created twelve square dishes decorated with these poems and their illustrations.[6] The result was that Teika's twelve-month bird-and-flower poems and paintings based on them appeared not only on screens and partitions and in painting albums, but also on ceramics and clothing.

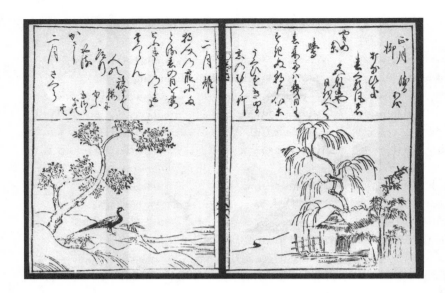

FIGURE 8

FLOWERS AND BIRDS OF THE TWELVE MONTHS

Fujiwara no Teika's *Poems on Flowers and Birds of the Twelve Months* (*Jūnikagetsu kachō zu*, 1214), a poetic matching of birds and flowers to specific months, was widely illustrated, as in this example from *Snipe Preening Its Feathers* (*Shigi no hanegaki*, 1691, 1781): (*right*) First Month, with willow and bush warbler, and (*left*) Second Month, with cherry blossoms and pheasant. (Courtesy of the author)

Teika's *Jūnikagetsu kachō waka* remained a popular painting topic through the Edo period. A good example is the series of woodblock prints from *Shigi no hanegaki* (*Snipe Preening Its Feathers*, 1691, 1781), a *waka* handbook and anthology that contains two poems (one on a bird and the other on a flower) per page (figure 8). The willow poem for the First Month reads: "Is it the color of the wind that comes with spring—the threads of the green willow are dyed greener with each passing day" (*Uchinabiki haru kuru kaze no iro nare ya hi wo hete somuru aoyagi no ito*). The poem at the top and the picture at the bottom of the page evoke the classical associations of early spring: the new green of spring, the green willow (*aoyagi*), and its thin new branches bending in the wind.

In the Edo period, the elegant world of birds and flowers spread to urban commoners' cultural sites, particularly the pleasure quarters and kabuki (what were called the *akushō* [bad places] in the major cities), and became part of a world of "drink and sensuality," to use the words of Asai Ryōi in the preface to his *Ukiyo monogatari* (*Tale of the Floating World*, 1666). Indicative of the spread of the *kachō fūgetsu* (flower and bird, wind and moon) tradition was the popularity of flower cards (*hanafuda* or *hana-garuta*), a card game that appeared in the seventeenth century. Flower cards centered on twelve flowers, trees, and grasses representing the twelve months: pine (First Month), plum blossoms (Second Month), cherry blossoms (Third Month), wisteria (Fourth Month), iris (Fifth Month), peony (Sixth Month), bush clover (Seventh Month), miscanthus grass with moon (Eighth Month), chrysanthemum (Ninth Month), bright autumn leaves (Tenth Month), willow (Eleventh Month), and paulownia (Twelfth Month). There were four cards for each plant (each with a different number of points), creating a total of forty-eight cards.[7] With the exception of the peony, which entered the poetic canon in the Edo period, all the images are from classical poetry of the Heian period and reflect urban commoners' knowledge of the poetic and cultural associations of the months.[8]

## Poetic Places

Poetic places associated with classical poetry (*utamakura*) were the spatial or topographic equivalent of seasonal topics (*kidai*).[9] As Fujiwara no Tameaki suggests in *Chikuenshō* (*Collection from a Bamboo Garden*, 1285), in classical poetry the circle of poetic associations, which was called the poetic essence (*hon'i*), took precedence over the actual appearance of the place:

> In composing poetry on Naniwa Bay, one should write about the reeds even if one cannot see them. For Akashi and Sarashina, one should compose so that the moon shines brightly even if it is a cloudy evening. As for Yoshino and Shiga, one composes as if the cherry trees are in bloom even after they have scattered.[10]

Shōtetsu (d. 1459), a *waka* poet of the Muromachi period, writes in *Shōtetsu monogatari* (*Conversations with Shōtetsu*, 1448):

If someone were to ask me what province Mount Yoshino is in, I would answer that for cherry blossoms I think of Mount Yoshino, for bright autumn leaves, I think of Mount Tatsuta, and that I simply write my poems accordingly, not caring whether these places are in Iga or Hyūga Province. It is of no practical value to remember which provinces these places are in. Though I do not attempt to memorize such things, I have come to know that Yoshino is in Yamato Province.[11]

As these remarks reveal, the *waka* poet should not be concerned with the actual physical appearance or location of the *utamakura*, but with its poetic essence. Thus the Bay of Naniwa was associated with reeds; Akashi and Sarashina, with the autumn moon; Yoshino and Shiga, with cherry blossoms; Tatsuta Mountain, with colorful autumn leaves; and the Ōyodo River and Sumiyoshi, with pines. Indeed, for classical Heian poets, who rarely, if ever, left their homes in the capital, *utamakura* were often a means of enjoying the pleasures of travel without traveling.

The connection between a famous place and the seasonal motifs from *waka* became so close that a single motif in a painting could evoke a specific place and its seasonal associations. For example, the place-name Yoshino immediately elicited cherry blossoms and snow; Kasuga, an *utamakura* in Yamato Province (present-day Nara Prefecture), brought to mind young herbs (*wakana*) and deer; bright foliage on a river recalled the Tatsuta River; yellow kerria (*yamabuki*) on water referred to the Tama River in Ide; autumn grasses (particularly miscanthus grass [*susuki*]), a moon, and a wild field signaled Musashino Field, an *utamakura* in the Kantō region; and a bridge and willows stood for the bridge at Uji.[12]

A good example of this phenomenon is the painting *Blossoming Cherry Trees in Yoshino* (sixteenth century), which depicts the blossoms of cherry trees scattering deep in the mountains at Yoshino (figure 9). Yoshino, referring to both the mountain and the river that flows at its base, was an *utamakura* in Yamato Province (present-day Nara Prefecture). As a result of numerous poems in the *Kokinshū* and subsequent *waka* anthologies, Yoshino became closely associated with cherry blossoms and snow; and in the late Heian period, it also became linked with reclusion. The simple combination of a mountain, a river, and cherry blossoms signaled to the viewer of this screen that the scene was of Mount Yoshino and the Yoshino River, calling to mind a plethora of classical poems on the topic.

In similar fashion, bright foliage on a river meant the Tatsuta River in the autumn. Indeed, by the Edo period, the combination of cherry blossoms at Yoshino and bright foliage at Tatsuta—representing spring and autumn, respectively—became a popular painting topic called clouds-brocade (*unkin*), based on a pair of visual transpositions (*mitate*): cherry blossoms mistaken for clouds, and bright foliage taken for brocade. The *Yoshino–Tatsuta Screen Painting* (Nezu Museum, Tokyo) consists of a pair of screens, one filled with cherry blossoms and the other with bright foliage: this combination alone meant Mount Yoshino/Yoshino River and Tatsuta River.[13] A colorful Nabeshima ware dish, with green and red maple leaves over blue waves on a white background, is an example of how the Tatsuta River became a ubiquitous design motif in ceramics (figure 10). No label or text indicates that this is Tatsuta, but the combination of colored leaves and waves leaves no doubt about its autumn identity.

## *Waka* Naming

Since a single word or phrase from a classical poem had the power to evoke a specific poem, a cluster of poems, or a particular poetic topic, *waka* names (*uta-mei*) were used in a broad range of arts, from *bonseki* (sand-and-stone landscape on a tray) to *chanoyu* (tea ceremony). They even extended to sumo wrestlers, who were often given *utamakura* names such as Kasuga-yama (Mount Kasuga), a mountain to the east of Kyoto.

A good example of this phenomenon is the *bonseki*, a miniature landscape constructed on a black lacquer tray with small stones and sand, which became popular in the Muromachi period and was often used in *chanoyu* and ikebana (flower arrangement). *Bonseki*, which were called matchbox gardens (*hakoniwa*) in the Edo period, were given names such as *Yume no ukihashi* (*Floating Bridge of Dreams*), drawn from a famous poem by Fujiwara no Teika, or *Zansetsu* (*Lingering Snow*), suggesting a physical resemblance to a *waka*-esque image of nature. They were also named after *utamakura* such as Kurokami-yama (Black-Haired Mountain) and Mount Fuji. The result was a kind of double visual transposition in which the *bonseki* represented a particular landscape in miniature while evoking associations through a *waka* name or word.[14]

The associative power of *waka* is also evident in the practice of naming (*nazuke*) tea utensils. The tea ceremony pioneer Kobori Enshū (1579–1647),

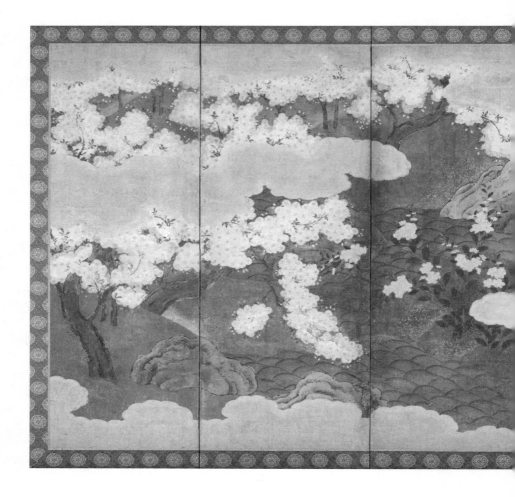

FIGURE 9

*BLOSSOMING CHERRY TREES IN YOSHINO*

In this sixteenth-century screen painting, a mountain stream runs through a valley dense
with cherry blossoms, a hallmark of Mount Yoshino. There is a graceful stand of golden-
yellow kerria (*yamabuki*) on an islet in midstream. The rippling water is outlined in silver,
now oxidized, and the blossoms are modeled with powdered white shell. (Six-panel folding
screen, ink, color, silver, and gold leaf on paper, 147.3 × 351.4 cm [58 × 138.3 inches], John C.
Weber Collection, Photo: John Bigelow Taylor)

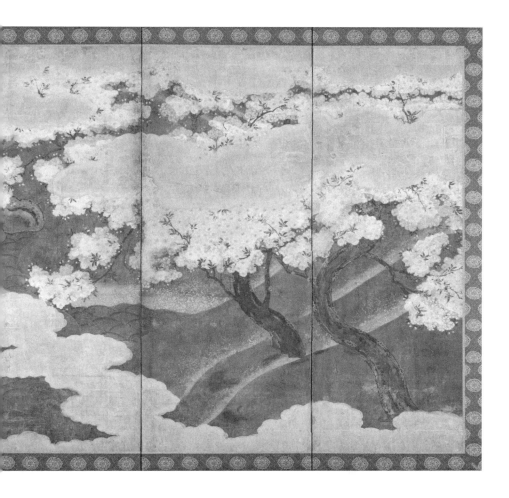

who had studied the classical poetry of Teika, was influential in populariz-
ing the practice of naming tea bowls and other tea utensils, such as the tea
scoop (*chashaku*) named *Matsu no midori* (*Shōroku; Green of the Pine*) by the
well-known *waka* poet Kinoshita Chōshōshi (1569–1649) (figure 11). The
name derives from a poem in the *Kokinshū*: "The everlasting green of the
pine, when spring arrives, becomes a still more superior color" (*Tokiwa naru
matsu no midori* mo haru kureba ima hitoshio no iro masarikeri [Spring 1,
no. 24]). The *waka* observes that the green of the pine, an evergreen and a
symbol of the unchanging, becomes even more intense with the arrival of

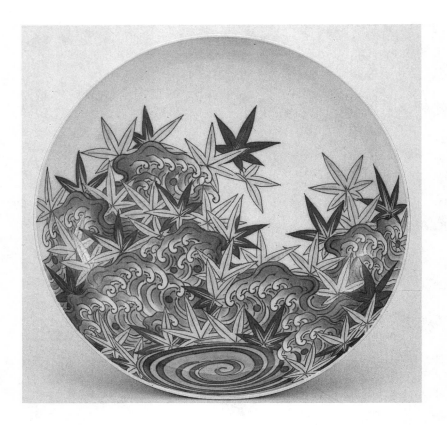

FIGURE 10

NABESHIMA WARE DISH WITH TATSUTA RIVER

On this Nabeshima ware dish (late seventeenth or early eighteenth century), the bright design—blue waves and crimson, yellow, and green leaves—alludes to the Tatsuta River, on which so many autumn poems were written and which became synonymous with autumn. (Ceramic, 7.8 × 4.2 × 2.2 inches. Courtesy of the Suntory Museum of Art, Tokyo)

early spring. The name thus transforms a piece of undecorated bamboo (used for scooping tea powder) into a cultural object that recalls this or similar *waka*. Typically, in the course of a tea ceremony, the tea master would select these named tea utensils in conjunction with the hanging scroll in the alcove, the decorated ceramics, and the occasion itself to weave a "narrative" of the seasonal moment.[15] *Chanoyu*, which centered on the preparation and presentation of tea, also involved the presentation, "naming," and

FIGURE 11

TEA SCOOP WITH CASE

The poet Kinoshita Chōshōshi named this tea scoop *Green of the Pine* (*Matsu no midori* or *Shōroku*). This practice of "naming (tea utensils and tea houses) after classical poems" (*uta-mei*) exemplifies the manner in which the poetic tradition was utilized in the tea ceremony, which came to the fore in the Muromachi and early Edo periods. (Courtesy of the Suntory Museum of Art, Tokyo).

consumption of sweets (*wagashi*) such as Kōbai (Crimson Plum Blossoms) and Ochiba (Scattered Tree Leaves), which also embodied the seasonal moment.

## *Renga* and the Seasons

In the Muromachi period, *waka* was superseded in practice by *renga*, which became the most popular late medieval poetic form, flourishing from the fourteenth to the sixteenth century. The seventeen-syllable opening verse of a *renga* sequence, known as the *hokku* (which eventually became an independent genre called haiku), required a seasonal word, and each subsequent verse (*tsukeku*) in the sequence (usually of thirty-six, fifty, or a hundred verses) had to be identified as either seasonal or non-seasonal. In order to ensure the necessary change or movement in the linked-verse sequence, rules were established to make certain that the sequence passed through the four seasons in a regulated fashion. In Muromachi-period *renga* manuals, each season is divided into three phases—early, middle, and late—or into months. In *waka*, for example, hail (*arare*) is a winter topic, but in Satomura

Jōha's (1525–1602) *Renga shihōshō* (*Shihōshō; Collection of Treasures*, 1586) and in such early Edo *haikai* handbooks as Matsue Shigeyori's (1602–1680) *Hanahigusa* (*Sneeze Grass*, 1636) and Kitamura Kigin's (1624–1705) *Zōyamanoi* (*Additional Mountain Well*, 1667), *arare* is listed specifically under mid-winter, or the Eleventh Month. That is to say, *renga* was even *more* precise about seasonal associations than *waka* (including Teika's *Jūnikagetsu kachō waka*) had been.

A distinction was also made between seasonal topics (*kidai*), which had an established cluster of poetic associations, and seasonal words (*kigo*), which were simply words identified as belonging to a particular season. As *renga* handbooks suggest, the number of seasonal topics in *renga* ranged from 160 to 180, about the same number as existed in *waka*, but the number of seasonal words reached over 300. At the end of *Hekirenshō* (1345), one of the first *renga* manuals, Nijō Yoshimoto (1320–1388) gives a comprehensive list of 115 "topics for the twelve months." The following is the repertoire for spring:[16]

> FIRST MONTH: Beginning of spring [*risshun*], Day of the Rat [Nenohi], picking parsley [*seri tsumu*], new herbs, bush warbler, melting ice, melting snow, burned fields, cold wind, plum blossoms (through the Second Month)
>
> SECOND MONTH: Kasuga Shrine Festival, willow, cherry blossoms, bracken [*warabi*], returning wild geese (from the fifteenth day of the Second Month to the beginning of the Third Month), pheasant, digging up the rice paddies [*tagaesu*], rice-seedling beds [*nawashiro*]
>
> THIRD MONTH: Frog, spring horses, skylark, cuckoo [*yobukodori*],[17] iris [*kakitsubata*], yellow kerria [*yamabuki*], azalea, late cherry blossoms, wisteria, end of spring [*boshun*][18]

This list closely resembles the topics in the *Horikawa hyakushu* (*Horikawa Poems on One Hundred Fixed Topics*, 1105), the collection of poems on a hundred fixed topics (*hyakushu-uta*) that was so influential in establishing seasonal topics for late Heian and early Kamakura *waka*. *Renga* poets worked with essentially the same set of topics while slowly adding a limited number of new ones. It was not until the appearance of *Renga shihōshō*, which includes more than 300 seasonal topics, that the number increased significantly, with the addition of such topics as pear blossoms (*nashi no hana*).

In composing on a set topic (*dai*), as in a poetry contest (*uta-awase*) or the *hyakushu-uta*, the *waka* poet was expected to know the established associations of the topic, referred to as the poetic essence (*hon'i*), and to work within those parameters. This "poetic essence" is emphasized in *Renga shihōshō*: "*Renga* follows what are called poetic essences [*hon'i*]. For example, even though a strong wind or a thunder shower may occur in spring, the wind and the rain must be quiet. That is the natural essence of spring."[19] Jōha stresses that the season itself has a poetic essence, which must not be violated. On the topic of summer night, the *Renga shihōshō* notes: "The poetic essence of the summer night is brevity. In a poem, when night arrives, it immediately becomes dawn."[20]

Even if the poet feels that the summer night is long, it must be described as short. This requirement was based on poetic precedent going back to the *Kokinshū*, which had established a core of associations that were refined in subsequent imperial *waka* anthologies. In other words, the *renga* poet looked not to nature but to classical precedent to understand the "poetic essence" of the seasonal topic. This heavy reliance on established associations was not regarded as a restraint so much as a rich foundation and a bridge to the audience, who could travel into the literary past through the shared topic.

## The Three Realms and Cosmological Order

Seasonal topics not only followed a highly calibrated sequence, but were informed by a complex cosmological order, commonly referred to as the Three Realms (Ten-chi-jin): Heaven, Earth, and Humanity. Three Realms cosmology is evident in the topical sequence of the miscellaneous poems in books 8 and 10 of the *Man'yōshū* (*Collection of Ten Thousand Leaves*, ca. 759). For example, under spring miscellaneous poems in book 10, the topics implicitly move from Heaven (atmospheric conditions) to Earth (birds and plants) to Humanity (joy of meeting). A similar kind of cosmological hierarchy appears in Chinese dictionaries and Chinese topical encyclopedias (Jp. *ruisho*, Ch. *leishu*) that were imported to Japan from the Nara period onward. For example, the *Yiwen leiju* (Jp. *Geimon ruijū*; *Literary Encyclopedia*, 624), an early Tang (618–907) encyclopedia with literary examples, is divided into forty-five (or forty-six) categories and fills a hundred volumes. It begins with celestial (Heaven) categories (astronomical phenomena [*ten*]

and seasonal phenomena [*saiji*]); followed by terrestrial (Earth) subjects (land [*chi*], states [*shū*], prefectures [*gun*], mountains, and water); moves to human affairs (Humanity), which range from emperors to weapons; and ends with such topics as trees, land animals, sea creatures, insects, felicitous events, and disasters. This type of organization is also evident in topical poetry collections of the Heian period, such as the *Kokin rokujō* (*Six Books of Japanese Poetry Old and New*, 976–987), *Wakan rōeishū* (*Japanese and Chinese-Style Poems to Sing*, ca. 1012), and *Senzai kaku* (*Superior Verses of a Thousand Years*, 947–957).[21] For example, the *Kokin rokujō*, a major topical *waka* collection from the mid-Heian period, consists of six volumes:

Book 1. Seasonal phenomena (*saiji*) and Heaven (*ten*)
Book 2. Mountains, rice fields, wild fields, the capital, houses, people, Buddhist matters
Book 3. Water
Book 4. Love, celebration, parting
Book 5. Various thoughts, clothing, color, brocade
Book 6. Grass, insects, trees, birds

Heaven, Earth, and Humanity appear in sequence and are followed by plants, animals, and insects. The *Jūdai hyakushu* (*One Hundred Poems on Ten Topics*, 1191), a hundred-poem set (*hyakushu*) composed by four poets, including Fujiwara no Teika, has ten sections (topics) with ten poems each. The sections are arranged in a related but slightly different order from those in the *Kokin rokujō*, beginning with Heaven, Earth, dwellings, grass, trees, birds, animals, and insects, and ending with Shinto matters and Buddhist matters—that is, with Humanity coming last.[22]

Sequencing in classical linked verse was based on the intersection of these two configurations: seasonal topics and cosmological order. As Mitsuta Kazunobu has shown, the elaborate rules of seriation in *renga* apply to two types of topics: major topics drawn from the imperial *waka* anthologies and topics drawn from the Three Realms. *Renga* masters developed very complex rules (*shikimoku*) for the distribution of topics in linked verse. For example, spring and autumn had to continue for a minimum of three verses and for a maximum of five verses, and there had to be nine verses before another verse could be composed on the same season. Distinctions were also

made among major topics (maximum of five successive verses), medium topics (maximum of three successive verses), and minor topics (maximum of two successive verses).

Imperial *waka* anthology–type topics
    Major (five successive verses): spring, autumn, love
    Medium (three successive verses): summer, winter, complaints, Shinto matters, Buddhist matters, travel
Three-Realm cosmology-type topics
    Medium (three successive verses): mountains, water, dwellings
    Minor (two successive verses): luminous objects, times of day, human affairs, ascending objects, descending objects, famous places, animals, plants, clothing[23]

Astronomical phenomena (such as the sun, moon, and stars) appear here as "luminous objects" (*hikari-mono*), while atmospheric phenomena (*tenshō*) are divided into "ascending objects" (*sobiki-mono*) (such as autumn mist [*kiri*], clouds, spring mist [*kasumi*], and smoke) and "descending objects" (*furi-mono*) (such as rain, snow, frost, and dew). Topics from these categories had to be separated by at least three verses before they could appear again.[24] All other cosmological categories had to be separated by five verses. These include plants (*ue-mono*) and animals (*ugoki-mono*) as well as the key triad of "mountain-related things" (*sanrui*), such as mountain peak, hill, and waterfall; "water-related things" (*suihen*), such as sea, bay, and waves; and "dwellings" (*kyosho*), such as village and hut. These elements were sometimes subdivided further by the criteria of stasis (*tai*) and movement (*yū*), in which, for example, the sea and bay were considered to be static, while waves, water, ice, and salt were considered to be mobile.[25] More important, cherry blossoms (*hana*), representing spring; the moon, representing autumn; and love were required to appear at regular intervals in the linked-verse sequence.[26] The result is that the major *waka* topics (centered on spring and autumn), followed by the medium *waka* topics (such as summer, winter, complaints [*jukkai*], Shinto matters, Buddhist matters, and travel), formed the essential building blocks of *renga*. At the same time, as is evident in the rules on celestial objects and atmospheric conditions, linked verse was designed to make the participants travel through the Three Realms, journeying through time and space.

The opening of *Minase sangin hyakuin* (*One Hundred Verses by Three Poets at Minase*), a famous Muromachi-period *renga* sequence composed by Sōgi (1421–1502), Shōhaku (1443–1527), and Sōchō (1448–1532) in 1488, on the twenty-second day of the Third Month, shows how these various elements were brought into play.[27]

1. While it is snowing,
   spring mist rises at the mountain foot
   in evening.

   Sōgi

   *Yuki nagara yamamoto kasumu yuube kana*                    [Spring][28]

2. Flowing water in the distance,
   a village with the scent of plum blossoms.

   Shōhaku

   *Yuku mizu tooku ume niou sato*                             [Spring][29]

3. In the river breeze,
   spring appears
   amid a clump of willows.

   Shōchō

   *Kawakaze ni hitomura yanagi haru miete*                    [Spring][30]

4. Dawn when one can clearly hear
   the sound of the boat's oars.

   Sōgi

   *Fune sasu oto mo shiruki akegata*                          [Miscellaneous][31]

5. Is the moon
   still lingering in the night
   covered by autumn mist?

   Shōhaku

   *Tsuki ya nao kiri wataru yo ni nokoru ran*                 [Autumn][32]

6. Autumn comes to an end
   in a wild field of frost.

                                                        Sōchō

*Shimo oku nohara aki wa kurekeri*                      [Autumn][33]

7. Oblivious to the heart
   of the crying insects,
   the grass fades.

                                                        Sōgi

*Naku mushi no kokoro tomo naku kusa karete*            [Autumn][34]

8. When I ask about the shrub fence,
   there is nothing but a bare road.

                                                        Shōhaku

*Kakine o toeba arawa naru michi*                       [Miscellaneous]

In verse 1, snow falls, but spring mist rises at the foot of the mountain, indicating the transition from winter to spring. In verse 2, which is read together with verse 1, water is flowing in the distance, signaling that the mountain snow has melted. Verse 3, which continues the spring scene, adds movement: the willow leaves are blowing in the river breeze. Verse 4, which is miscellaneous, or non-seasonal, prepares the transition from spring to autumn and places a boat on the river: the sound of the oars can be heard in the quiet of the dawn. Verse 5, which is the required moon (autumn) verse, returns to atmospheric phenomena, but instead of a descending object (snow), it presents an ascending object (autumn mist). Verse 6 makes the moon of the previous verse into a lingering late-autumn moon of the Ninth Month. Verse 7 brings us to the end of autumn, with the crying of insects and withering grass. The eight-verse sequence moves from a nature-centered landscape (spring snow, plum blossoms) to a human-centered landscape (village with willows, boat on a river), to a nature-centered landscape (autumn moon, frost, insects), and back to a human-centered one (question about shrub fence). Temporally, a night sequence (verses 4 and 5) is sandwiched between two daytime sequences.[35] Needless to say, without a knowledge of

the classical seasonal associations, a participant could not follow the subtle seasonal or spatial movement that lies at the heart of such a sequence.

The opportunity to experience each of the four seasons as well as to move from one to the next was a major attraction of a *renga* session. In *Tsukuba mondō* (*Questions and Answers at Tsukuba*, 1372), a major treatise on *renga*, Nijō Yoshimoto, one of the founders of classical linked verse, observes: "When you think it is yesterday, today has passed, and when you think it is spring, it is autumn. When you think that the flowers have bloomed, things shift to the bright autumn leaves."[36] Responding to the question of whether *renga* can be an aid to enlightenment, Yoshimoto notes that to see nature in this fashion—the flowers coming into full bloom and the leaves withering and falling (*hika-rakuyō*)—is to realize the impermanence of this world.

As Mitsuta Kazunobu has argued, these various topics and categories, as they appear in *Renga shinshiki* (*New Rules for Linked Verse*, 1372), are in pairs and can be divided into two worlds, the natural world and the human world, which correspond in symmetrical fashion:

NATURAL WORLD

Luminous objects, time
Descending objects, ascending objects
Mountain things, water things
Plants, animals

HUMAN WORLD

Shinto, Buddhism
Love, personal grievances
Travel, famous places
Dwellings, clothing

Not only are major *waka* topics combined with elements of the Three Realms, but the human and natural worlds correspond in subtle ways. For example, in the human world, Shinto and Buddhism stand over human beings, just as light and time stand over the Earth in the natural world. Love and personal grievances connect humans to gods and buddhas,

much as descending and ascending objects connect Heaven and Earth. People travel to famous places, which are marked by mountains and water. Dwellings and clothing represent the human world in the way that animals and plants stand for the natural world.[37] As noted earlier, this cosmology was inherited from earlier topical *waka* anthologies and Chinese topical encyclopedias, with the main difference being that *Renga shinshiki* divides atmospheric phenomena into two categories: ascending objects and descending objects.

This topical categorization of the universe continued into the Edo period, in *haikai* (popular linked verse) handbooks, and remains in the modern period in the form of *saijiki* (seasonal almanacs) for modern haiku poets. The *Haiku saijiki* (*Haiku Seasonal Almanac*, 1959), one of the most popular seasonal haiku almanacs in the postwar period, lists seven categories for the four seasons plus New Year (*shinnen*)—seasonal phenomena (*jikō*), such as the Eighth Month or late autumn; astronomical and atmospheric phenomena (*tenmon*), such as the harvest moon; terrestrial phenomena, such as autumn mountains; human activity, such as Tanabata and fireworks; religious activity, such as Higan (Buddhist services during the vernal and autumnal equinoxes); animals; and plants—a structure that directly echoes that of the early Chinese encyclopedias, such as the *Yiwen leiju*.[38] The *Shinsaijiki* (*New Seasonal Almanac*, 1951), a well-known *saijiki* edited by the haiku poet Takahama Kyoshi, has six categories—seasonal phenomena, astronomical and atmospheric phenomena, terrestrial phenomena, human activity, animals, and plants[39]—eliminating the ambiguous distinction between human activity and religious activity. A similar topical arrangement is found in the *Nihon daisaijiki* (*Great Japanese Seasonal Almanac*, 1982), edited by Mizuhara Shūōshi, Katō Shūson, and Yamamoto Kenkichi.[40] In short, with some variation, the same fundamental categories continue to appear over a 1400-year span.

## Contrasting Landscapes

Not only did Japanese poetry, particularly *waka*, have a profound effect on visual culture, but painting and other visual media had a huge impact on poetry and its representation of nature and the seasons. The landscape of

medieval *waka* and *renga*, for example, was greatly influenced by Chinese ink-painting styles of the Song period (960–1279). Japanese landscape ink painters were drawn to the works of Mu Qi (Jp. Mokkei [d. ca. 1280–1294]) and other Chinese artists whose paintings of tall, distant, mist-covered mountains drew attention to the atmospheric and light conditions surrounding high mountains and bodies of water.

Kazamaki Keijirō has persuasively argued that the most prominent feature of the seasonal *waka* poems in the *Gyokuyōshū* (*Collection of Jeweled Leaves*, 1312), a noted imperial *waka* anthology edited by Fujiwara (Kyōgoku) Tamekane (1254–1332) in the late Kamakura period, is their focus on such atmospheric conditions as light breaking through the clouds, spring mist, spring evening after rain, and evening sunlight in autumn—with natural light often playing a major role.[41] This trend reached a peak with the *Fūgashū* (*Collection of Elegance*, ca. 1346–1349), another important imperial *waka* anthology that continued the style of the Kyōgoku school into the Northern and Southern Courts period, as exemplified by such poems as this one by Fujiwara no Tamekane: "On the mountain edge, where the setting sun has just vanished, a peak beyond the mist-covered mountain has appeared!" (*Shizumihatsuru irihi no kiwa ni arawarenu kasumeru yama no nao oku no mine* [Spring, no. 27])."[42]

A similar kind of landscape appears in *renga* of the Muromachi period, particularly that by Sōgi, as in verse 1 of *Minase sangin hyakuin*. Okuda Isao has noted the distant perspective on the mountains and water—for example, looking up at the mountain enshrouded in mist in verse 1 and taking a distant view of the flowing water (the confluence of the Yodo and Katsura rivers at Minase) in verse 2. A key verb is "to look from afar" (*miwatasu*), as found in a poem in the *Shinkokinshū* (*New Anthology of Poetry Old and New*, 1205) by Retired Emperor GoToba, alluded to in verse 1 of *Minase*: "When I look from afar, foothills of the mountain wrapped in spring mist, the river at Minase—why did I think evening was best in autumn?" (*Miwataseba yamamoto kasumu Minasegawa yuube wa aki to nani omoikemu* [Spring 1, no. 36]). The boatman or fisherman on the water, enveloped in spring mist, a familiar trope in ink painting, also appears in *Minase*, as it does elsewhere in the linked-verse sequence (nos. 51 and 52).[43]

*Renga* is a poetry of overtones: each verse leaves open an infinite number of possibilities for textual extension, thus stimulating the poetic imagina-

tion. The enshrouded waters and distant mountains of Chinese and Japanese ink paintings similarly excite the viewer's imagination by visual indirection. This kind of landscape is also prominently featured in "Eight Views of the Xiao and Xiang" (Shōshō hakkei) paintings, which became very popular in the Muromachi period, particularly among Japanese Zen priests. The "Eight Views" in their classical order are

Clearing Storm over a Mountain Village
Sunset over a Fishing Village
Sails Returning from Distant Shores
Night Rain on the Xiao and Xiang
Evening Bell of a Temple in Mist
Autumn Moon over Lake Dongting
Descending Geese at a Sandbar
Evening Snow on a River

The "Eight Views" focus not only on mountains and open waters, but on atmospheric conditions and time of day, which also had interested Kamakura-period poets such as Fujiwara no Shunzei and Fujiwara no Teika. A good example of an "Eight Views of the Xiao and Xiang" painting done by a Japanese artist is a screen painting by the priest-painter Zōsan (figure 12). Scenes like these, with tall mountains and bodies of water enveloped in different atmospheric conditions, inspired many Zen Buddhist poets composing *kanshi* (Chinese-style poetry) to write on the topic of the Xiao and Xiang and on its Japanese equivalents, such as "Eight Views of Ōmi" (Ōmi hakkei), the scenery surrounding the coast of Lake Biwa.

Medieval *renga* poets also found the relationship among the scenes in "Eight Views of the Xiao and Xiang" paintings to be an apt metaphor for the linking of verses, in which the added verse combines with the previous one to create a new scene but also pushes off from the scene generated by the two previous verses to create both temporal and spatial movement.[44] In other words, the different scenes in the "Eight Views" were regarded as both contiguous and semi-autonomous, the fundamental assumption behind linking verses in *renga*. Equally important were the movement from one season to the next and from one time of day or atmospheric condition to another. "Eight Views of the Xiao and Xiang" screen paintings, as they evolved

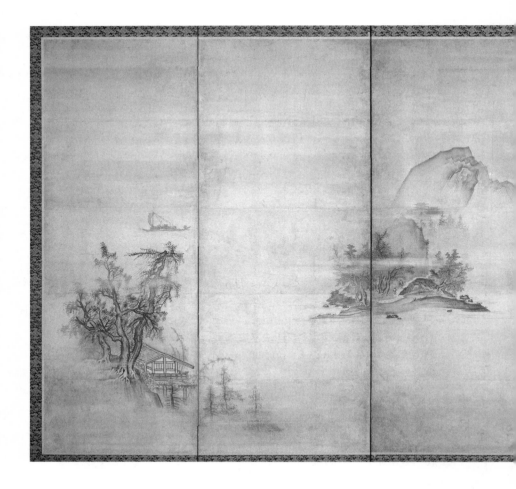

FIGURE 12

EIGHT VIEWS OF THE XIAO AND XIANG

The right-hand screen of a pair of six-panel folding screens painted by Zōsan in the first
half of the sixteenth century depicts the first four of the "Eight Views of the Xiao and
Xiang": (*right to left*) "Clearing Storm over a Mountain Village," "Sunset over a Fishing
Village," "Sails Returning from Distant Shores," and "Night Rain on the Xiao and Xiang."
This Chinese-derived topic, which became highly popular in Japan, exemplifies the kind of
monochromatic landscape that came to the fore in the medieval period, particularly the
high mountains and large bodies of water enveloped in different kinds of atmospheric
conditions, each of which indicates a specific season. The scenes begin with spring on the
far right of the right-hand screen and end with winter on the far left of the left-hand
screen. (Light color, ink, and gold on paper; 62.2 × 143.8 inches. Courtesy of the Museum
of Fine Arts, Boston, Fenollosa-Weld Collection, 1911, no. 11.4150)

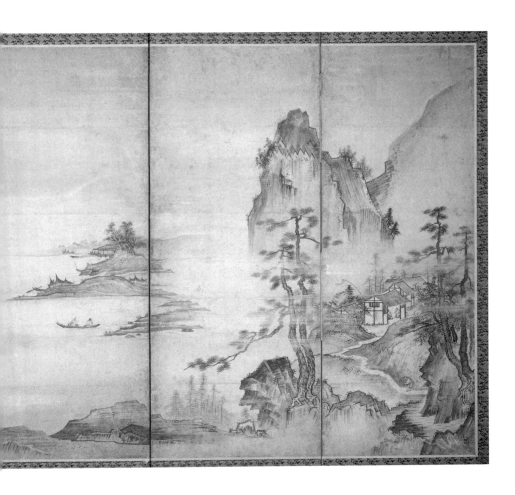

in Muromachi Japan, moved from spring on the far right, through summer and autumn, and ended with winter on the far left, affiliating them with the four-season screen paintings, which originated in the Heian period.

Classical poetry and its successor, classical linked verse, had a profound influence on the visual arts from the Heian to the Muromachi period, from screen paintings to tea ceremony, with multiple genres (such as painting and *waka*) often working together in an interactive fashion. By the late medieval period, the phases of the seasons and other aspects of nature became increasingly codified to the point where *renga* masters were necessary to guide

the practitioners in both the associations and the complex rules. As the notion of topical poetic essences (*hon'i*) and the elaborate cosmology developed by *renga* poets suggest, medieval poetry was not aimed at consistently realistic representation of nature so much as at re-presentation of both distant worlds (such as an imagined China or Heian court) and contemporary scenes (such as farmers in the rice field, warriors in battle, priests in the provinces). In *renga*, the participants freely traveled from one world to another, from country to city, and from one historical period to another. *Renga* became extremely popular among educated samurai and warlords during an era of constant warfare, particularly in the Warring States period (1478–1582). In the years after the Ōnin War (1467–1477), which destroyed the capital and its physical representations of the classical past, poetry offered a way to recapture a lost history. For educated warlords, disenfranchised nobles, and traveling poet-priests, the world of *renga* also served as a temporary escape from the bloodshed and harsh realities outside. In this sense, it had some similarities with the tea ceremony, which developed under Sen no Rikyū (1522–1591) and others in the Muromachi period: the tea room provided a respite from the distractions of the city and the everyday world.

The same was frequently true of the ink paintings that depict recluses in the mountains, which hung in the alcove of the parlor-style (*shoin-zukuri*) residence, or the rock-and-sand garden (*kare-sansui*) first developed by Zen priests; these cultural forms often served as a world away from the world. Landscape, especially monochromatic landscape, as epitomized by Fujiwara no Teika's famous poem on an autumn evening—"When I look from afar, there are neither flowers nor bright leaves: evening in autumn at a thatched hut by the bay" (*Miwataseba hana mo momiji mo nakarikeri ura no tomaya no aki no yuugure* [*Shinkokinshū*, Autumn 1, no. 363])—attempted to look beyond the phenomenal world, often to enter into a transcendental or meditative state that could be embodied in the light of the winter or autumn moon or the shade of the pines in the mountains.

The tension between the mountain as the landscape of bright colors and the mountain as the topos of retreat appeared as early as the *Kaifūsō* (*Nostalgic Recollections of Literature*, 751), the first major anthology of *kanshi*, in the Nara period and extended through the Heian period in both poetry and prose. The opposition is articulated most famously by the *waka* poet-priest Saigyō (1118–1190), who writes of Mount Yoshino both as physically beautiful (with its cherry blossoms and snow) and as a representation of spiritual

retreat from phenomenal and human bonds. The dynamic contrast was further deepened by the spread of Song ink painting and Zen-based views of the world, which resulted, by the Muromachi period, in two fundamental types of landscapes: the Heian landscape of cherry blossoms, bright foliage, and snow, and the medieval landscape of distant mountains and open expanses of water, typically represented by the rock-and-sand garden. Both of them came to manifest themselves in architecture, gardens, and flower arrangement and other arts of the alcove.

# Interiorization, Flowers, and Social Ritual

It is not only classical Japanese poetry and its affiliated forms that created a sense of harmony with nature. Japanese architecture, beginning with the design of the palace-style (*shinden-zukuri*) residence of the Heian period (794–1185), also created a sense of intimacy with nature, which was carefully reproduced in the gardens of the house and which became the topic of much poetry. The *shinden* structure, in which the interior rooms opened directly onto the garden, created what we might call a veranda or "beneath the eaves" (*nokishita*) culture, occupying a space between the interior and the exterior that became the site of much of Heian court culture. In the medieval period (1185–1599), in the parlor-style (*shoin-zukuri*) residence, the same kind of interior–exterior continuity was maintained, but with the garden enclosed and greatly reduced in size. Even more important, the *shoin* residence featured a parlor with an alcove (*tokonoma*), a recessed space with a raised floor for the display of a hanging scroll and various offerings, which became the stage for a wide range of arts—tea ceremony, painting, *renga* (classical linked verse), *waka* (classical poetry), *kanshi* (Chinese-style poetry),

FIGURE 13
HEIAN-PERIOD PALACE-STYLE RESIDENCE

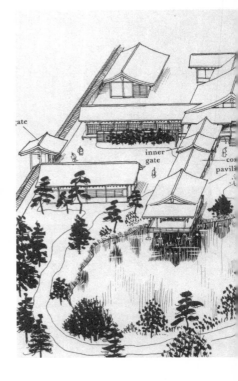

The palace-style (*shinden-zukuri*) residence of the Heian period typically had a central hall (*shinden*) to the north; two flanking buildings and two open corridors that extended south on both sides and were anchored by pavilions on the water; a large garden in the middle; and a lake, in which was a small island, to the south. The extensive use of verandas, open corridors, and open-pillar construction allowed most of the interior spaces to open directly onto the garden and the connecting passages to traverse the garden, thereby integrating the interior with the exterior and making the lake and island a central visual feature. (From Kazuo Nishi and Kazuo Hozumi, *What Is Japanese Architecture? A Survey of Traditional Japanese Architecture*, trans. H. Mack Horton [Tokyo: Kodansha International, 1985], 65–65. Courtesy of Kodansha International)

calligraphy, incense, *bonseki* (sand-and-stone landscape on a tray), and flower arrangement. The alcove, the main display space for flower arrangement, literally brought nature into the residence and juxtaposed it with paintings and other visual arts. What, then, was the role of the garden, the *tokonoma*, and flower arrangement in the construction of a secondary nature?

## The Interior–Exterior Continuum

The palace-style residence of the Heian period created a direct sense of continuity between the interior and the garden, which was laid out to the south of the residence and was centered on a lake with an island (*nakajima*) (figure 13). The east and west corridors, which flanked the central hall (*shinden*), ran from the north (back of the house) to the south, directly to the lake, allowing the inhabitants to sit just above the water.

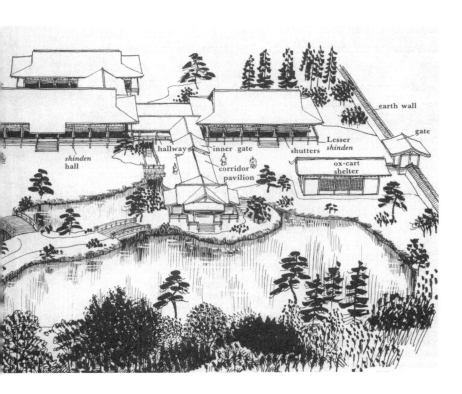

Kawamoto Shigeo, a noted architectural historian, has argued for two paradigmatic types of Japanese architecture: the walled-space type, in which the space is enclosed by a wall, door, or window; and the pillar-space type found in palace-style architecture, which creates direct spatial continuity between the interior of the building and the exterior court or garden.[1] The walled-space type was imported from China in the Nara period (710–784) and was widely used in Buddhist temple and hall architecture. By contrast, the pillar-space type,[2] which is of indigenous origin and was originally developed as a space for rituals, was the fundamental structure of the *shinden-zukuri* residence of the Heian period.

This "open" architecture, with its exterior–interior continuum, is evident in scenes on picture scrolls, such as the *Kitano tenjin engi* (*Kitano Tenjin God Scroll*, early thirteenth century), which shows the garden between the central hall and the east corridor, with the garden stream (*yarimizu*; a convention of the *shinden*-style garden) emerging from underneath the connecting

hallway and flowing south. The garden and the living quarters are closely integrated so that the inhabitants pass over and through the garden by way of the covered but open hallways. In this kind of residence, the garden stream represents, in miniature, a meadow or valley with a river winding between rolling hills, thus bringing a rural landscape into the garden.

Architectural space usually is divided into the inside and the outside, with the peripheral wall as the barrier, but as the architectural critic Itō Teiji has argued, the palace-style residence and its parlor-style successor, which became the model for the traditional Japanese house, had one prominent feature that elides this division, what he calls the *nokishita* (beneath the eaves). The eaves, which extended over the sides of the building and the covered hallways, were originally designed in response to the monsoon climate, to protect the interior and the wall from the heavy and continual rain. In the summer, they also served to shield the interior from intense sunlight. The veranda, which was constructed directly under the eaves and was a major feature of both the *shinden*-style and the *shoin*-style residence, was regarded as an extension of the interior when used as a hallway or porch, but was considered part of the exterior when used as an adjunct to the garden. In other words, the Heian-period palace-style residence was constructed in such a way as to make living quarters and nature appear to share a continuous space.

This continuity between the interior and the exterior was enhanced by an assortment of movable interior structures—such as the sliding screen or partition (*shōji*), the hanging bamboo screen (*misu*), and the latticed shutter (*shitomi*)—all of which were designed to redefine the space in a room and allow air to circulate.[3] For example, the parallel-door track system (*hikichigai*) allowed the partitions, both in the interior and on the periphery of the building, to slide behind one another, thus opening up the walls and interior of the house so that it was visually and spatially continuous with the exterior garden. "Nature" was also brought indoors in the form of screen paintings (*byōbu-e*) and door or partition paintings (*fusuma-e*). In *The Tale of Genji* (*Genji monogatari*, early eleventh century) and other Heian court tales (as well as in Heian picture scrolls [*emaki-mono*; see figure 1]), the garden is a direct reflection of the interior state of a given character. Poems composed on, for example, the bush warbler or plum blossom in the garden often represent the thoughts or emotions of the literary character or painted figure. Fujitsubo (Wisteria Court), Yūgao (white-flowered gourd or moonflower; literally, "Evening Faces"), and other female characters in *Genji* are

named after their gardens or the plants that adorn their residences, and these gardens or plants came to symbolize the characters. This double (nature/human) structure is most dramatically demonstrated in the *Genji monogatari emaki* (*The Tale of Genji Scrolls*, ca. twelfth century) with the blown-roof (*fukinuki-yatai*) convention (see figure 1), which allows the viewer to see both the inside and the outside of the residence at the same time.

The cultural and poetic function of the garden is evident from the fact that Heian aristocrats filled their palace gardens with flowers, trees, and insects familiar from *waka*. In autumn, for example, they had gardeners plant miscanthus grass (*susuki*), yellow valerian or maiden flower (*ominaeshi*), pink (*nadeshiko*), and bush clover (*hagi*)—the most popular topics in autumn poetry. As revealed in the poetry contest (*uta-awase*) sponsored by Princess Kishi and held in a garden on the twenty-eighth day of the Eighth Month in 972,[4] they also captured insects such as the bell cricket (*suzumushi*) and pine cricket (*matsumushi*) and released them into their urban gardens. The *Kokon chomonjū* (*Collection of Things Heard and Written from Past and Present*, 1254), an encyclopedic collection of anecdotes about court culture edited by Tachibana Narisue in the Kamakura period (1185–1333), describes Princess Kishi's garden:

> On the twenty-eighth of the Eighth Month of Tenroku 3 [972], Princess Kishi had miscanthus grass, orchid, aster, fragrant grass [*kusa no kō*], maiden flower, bush clover, and other plants planted in her garden at Nonomiya, the Shrine in the Fields, and then had pine crickets and bell crickets released into her garden. When she asked for immediate poetic compositions on these objects, each person wanted to be the first do so. In the garden, they created a hedge in a mountain village where a stag could approach; in another place, they created a spot where cranes could land on a rocky beach. Here grass was planted, and even insects were made to cry.[5]

Princess Kishi's garden contained not only plants and insects, but also wild fields or a moor (*no*), a mountain village, and a seashore—all of which were represented in miniature on a portable island stand (*shima-dai*), also re-ferred to as a cove beach stand (*suhama-dai*). The *suhama-dai*, an elaborately decorated landscape display used for poetry contests, was a small-scale re-production of an island in the sea, featuring a sandy shoreline or cove beach.

It could also be used to represent, as it did in Kishi's garden, a mountain village and wild field, which were also components of "nature" in *waka*. During the poetry contest, the stand was placed inside the central hall and decorated with small replicas of creatures such as the bush warbler and crane, the topics on which the poetry contest participants had composed. At the end, the poem strips were pinned onto the appropriate part of the *suhama-dai*, literally fusing the poem with the landscape.[6]

A different kind of spatial continuity between the natural and human worlds is apparent in drama of the Muromachi period (1392–1573). In the noh theater, which became popular at that time, the stage is bare with almost no props; only the image of a pine decorates the back of the stage. The *waki* (side character) enters from stage left over the bridge and symbolically travels through the countryside in the so-called *michiyuki* (traveling song) section. The setting and season are established by the narration, the *waki*, the *shite* (protagonist), their attendants, and the chorus members, who sit stage right and often narrate in the third person. The minimal sets maximize the role of the narration, particularly *waka*-laced narration, which constructs a natural world in the mind of the audience. These noh plays are almost always set in a specific season, with a dominant seasonal motif that is directly related to the main topic, and are performed in that season. In the Kanze school, for example, *Oimatsu* (*Old Pine*) is performed in the First Month (early spring, New Year); *Ume* (*Plum Tree*) and *Kochō* (*Butterflies*), in the Second Month (mid-spring); *Saigyō-zakura* (*Saigyō and the Cherry Blossoms*), in the Third Month (late spring); *Kakitsubata* (*Iris*) and *Fuji* (*Wisteria*), in the Fourth Month (early summer); *Bashō* (*Plantain Tree*) and *Ominaeshi* (*Maiden Flower*), in the Eight Month (mid-autumn); *Momiji-gari* (*Bright-Foliage Viewing*) and *Kiku jidō* (*Chrysanthemum Child*), in the Ninth Month (late autumn); and so forth.[7]

Unlike the bare stage of noh theater, the kabuki stage of the Edo period (1600–1867) had props and stage sets, but the architectural structure on the stage (usually a residence) reveals both the exterior and the interior (*oku*) at the same time, making the audience aware of the season even when the main action is indoors. The external space is further reinforced by the *hanamichi* (literally, "flower path"), a walkway that extends into the audience area and allows the actors to approach the main stage through the audience from the front of the theater, literally passing from outside to inside

or vice versa. The action even within a strictly urban setting thus moves back and forth from the interior to the exterior, with the seasons being highlighted.

*Kanadehon chūshingura* (*The Treasury of Loyal Retainers*, 1748 [puppet-play version]), probably the most popular of the kabuki plays, consists of eleven acts: the first through fourth acts are set in spring; the fifth and sixth acts, in summer; the seventh act, in autumn; and the eighth through eleventh acts, in winter—when the climactic revenge is finally carried out. On rare occasions, the entire play is performed in one day, but Edo-period kabuki troupes, like those of today, usually performed those acts that correspond to the actual season. For example, the first act of *Benten musume meo no shiranami* (*Benten Kozo and the Five Thieves*), first performed in 1862, is staged in the early spring (First Month), since the noted second scene (on the bank of the Iwase River) takes place under the cherry trees in full bloom. The kabuki dances (*shosagoto*) that provide important musical interludes are also linked to specific seasons. For example, *Kagami jishi* (*Mirror Lion*) and *Fuji-musume* (*Wisteria Daughter*) are spring dances, while *Kiku jidō* (*Chrysanthemum Child*) and *Momiji-gari* (*Bright-Foliage Viewing*) are autumn dances.[8] To watch either noh or kabuki over the course of a year is to experience the unfolding of the four seasons to the accompaniment of song and dance.

## The Alcove and Flower Arrangement

By the early Muromachi period, the large-scale aristocratic palace-style (*shinden-zukuri*) architecture had been replaced by the much smaller parlor-style (*shoin-zukuri*) architecture, widely used in temple living quarters, guest halls, and mansions of the military elite. The parlor-style residence, the prototype of the traditional-style Japanese house, was named after the reading room or parlor (*shoin*), which faced the garden and served as a reception room. The parlor centered on an alcove (*tokonoma*), which became the symbolic focus for a wide range of cultural practices from *renga* to ikebana (flower arrangement).

The early Muromachi period witnessed a huge influx of paintings and decorative arts from Song (960–1279) and Yuan (1271–1368) China, bringing a new array of landscape paintings (featuring dragons, tigers, herons,

and mandarin ducks) and portraits of Shakyamuni Buddha; the bodhisattvas Kannon, Fugen, and Monju; the Seven Sages of the Bamboo Grove; and others. Heian-period painting formats, such as the *emaki-mono* and *fusuma-e*, required little or no space, and the *byōbu-e* could be moved around the room. But the Song and Yuan paintings, which were hanging scrolls (*kake-jiku*), had to be hung on a wall. This led to the development of the alcove, a recessed space for the display of hanging scrolls, incense burners, ceramics, and flower arrangements.

The architectural precursor to the *tokonoma* was the *oshiita* (raised area of the parlor), which was decorated with an image of the Buddha on the wall and three offerings to the Buddha—incense, flowers, and candles—in front of the image. An incense burner was placed in the center of the alcove, in front of the hanging scroll, with a flower vase to the left and a crane-and-turtle lamp, holding a candle that was lit as an offering, to the right. Later, with the development of the full *tokonoma*, the portrait of the Buddha was replaced by secular landscapes, bird-and-flower paintings (*kachōga*), or calligraphic texts, and the flower–incense–candle triad often was reduced to a single flower arrangement. Unlike the typical modern European painting, which usually remains on the wall all year around, the hanging scroll was frequently rotated, with a new scroll hung for each new occasion. The current season was thus reflected in the innermost part of the residence.

Another major architectural feature of the *shoin*-style residence was the enclosed garden, which was small in comparison with the vast garden grounds of the *shinden*-style residence. The back of the garden was walled off, so the garden resembled a landscape painting when viewed from the parlor, particularly if viewed through a window or an open sliding door. Unlike the large *shinden* garden, the *shoin* garden was to be looked at, not walked in. This was particularly true of the rock-and-sand garden (*kare-sansui*), which was often small, with the sand representing water, rivers, and sea, and the rocks evoking mountains and waterfalls. The *kare-sansui*, like many other related forms such as flower arrangement, depends on the technique of *mitate*, in which an image or a shape is used to suggest a larger and distant image. The *mitate*, which means something like "to see X as Y," does not refer to the replication of a distant object or landscape so much as its evocation through one or more physical features, such as a figuration of rocks and sand. The *kare-sansui* could thus suggest a specific or general distant

landscape while appearing natural in its configuration. Many rock-and-sand gardens include few or no flowers. Instead, the flowers moved indoors to the alcove in the form of the standing-flower arrangement, which, together with the enclosed scenic garden and the hanging scrolls, became a symbolic, interior representation of nature.

The earliest formal use of flowers in this manner in Japan was as an offering (*kuge*), either to the Buddha or to the spirit of the dead. By the twelfth century, Buddhism had spread to the point where Buddhist rites were carried out in private residences, and flowers were used as offerings in the home, placed before a Buddhist painting that substituted for the statue found in a Buddhist temple. This practice eventually resulted in the formal arrangement of flowers (ikebana), which evolved into two major types: *rikka* (立花; literally, "standing flower"), also called *tatebana*, a formal style that was established in the mid-fifteenth century and can be traced back to flower offerings placed before an image of the Buddha; and *nageire* (投入, thrown-in flowers), a more casual style that was established in the seventeenth century and can be traced back to the Heian period, when aristocrats attached flowers to letters, placed flowers in vases, and held flower contests, at which flowers presented by the participants were compared and judged. Thus ikebana has both religious and secular origins, evident in attendant socioreligious practices: offerings or implicit prayers, seasonal greetings, elegant social communication, and aesthetic appreciation.

Linked verse was also composed in front of the decorated alcove, which both indicated the season or occasion and served as an altar to Kakinomoto no Hitomaro (d. ca. 707), who had been designated one of the Thirty-six Poetic Immortals and had become the god of poetry. The *Sendenshō* (*Transmission of the Immortal*, written in the Muromachi period and printed in 1643), the oldest and most highly valued of secret treatises on *rikka*, notes that once the opening verse (*hokku*) of a linked-verse sequence has been composed, a flower arrangement should be made in accordance with the season of the *hokku*.[9] That is to say, the flower arrangement marks the seasonal moment, just as the seasonal word (*kigo*) does in the *hokku*. The *hokku*, much like the flower arrangement itself, was generally considered to be a greeting to the host or the main guest of the gathering.

Due primarily to the accomplishments of Ikenobō Senkō (1536?–1621) and Ikenobō Senkō II (1575–1658), two key pioneers of *rikka*, the fundamental

rules for standing-flower arrangement were established by the Kan'ei era (1624–1645). The central element was the center (*shin*) branch, the main axis, usually a tree branch that reached straight upward, to which was added the augmentation (*soe*), made up of branches, grasses, or flowers. At the bottom was the base (*tai*), which anchored the flower arrangement to the vase. This tripartite structure gradually expanded into "seven tools" (*nanatsu no dōgu*), or branch positions, and then into "nine tools" (*kokonotsu no dōgu*) or branch positions, which became the basic elements of the art of flower arrangement. Generally speaking, the tree branches (*ki-mono*) were thought to give a sense of strength; the grasses (*kusa-mono*), by contrast, appeared gentle; and the "two-way things" (*tsūyō-mono*)—such as wisteria, peony, bamboo, yellow kerria, and hydrangea—which could be treated as either trees or grasses, connected the worlds of tree and grass.

The *Ikenobō Sen'ō kuden* (*Ikenobō Sen'ō's Secret Transmission*, 1542), the first treatise to explain *rikka* systematically, provides a list of plants that can function as the *shin* for each of the twelve months:

SPRING

| First Month | Pine, plum tree |
| Second Month | Willow, camellia (*tsubaki*) |
| Third Month | Peach tree, iris (*kakitsubata*) |

SUMMER

| Fourth Month | Deuztia flower (*unohana*), Chinese peony (*shakuyaku*) |
| Fifth Month | Bamboo, sweet flag (*shōbu*) |
| Sixth Month | Lily, lotus |

AUTUMN

| Seventh Month | Bellflower (*kikyō*), lychnis (*senō*; literally, "immortal elder") |
| Eighth Month | Hinoki (Japanese) cypress, white hinoki |
| Ninth Month | Chrysanthemum, cockscomb (*keitō*) |

| Tenth Month | Chinese dogwood (*kara-mizuki*), nandina or heavenly bamboo (*nanten*) |
| Eleventh Month | Narcissus (*suisen*), Chinese aster (*kangiku*) |
| Twelfth Month | Loquat (*biwa*), early plum[10] |

The *shin* is frequently taken from strong plants, such as pine, bamboo, plum, weeping willow, hinoki cypress, and Chinese juniper (*ibuki*). The three most valued trees (*sanboku* [the three trees]) in *rikka* are, indeed, pine, hinoki cypress, and Chinese juniper, with pine occupying a particularly high position. The *shin* thus has a double function: to represent the season or month of the year and to serve as the structural pillar for the entire arrangement. In contrast to the role of seasonal plants in *waka*, which draw their associations from a wide range of textual sources, *rikka* depends on the physical shape and strength of the *shin*. Wisteria (*fuji*), for example, is a major late-spring–early-summer flower in classical poetry, but it is avoided as a *shin* since its branches droop and twist. As the *Sendenshō* indicates, however, wisteria can be used as a *soe* in a summer arrangement.[11]

*Rikka* is usually intended to encapsulate nature at large and bring it close, so it can be enjoyed. In this sense, it is similar to the rock-and-sand garden, which also represents high mountains, rivers, or distant seas in miniature or in a small space close to the inhabitant of the residence. Like *kare-sansui*, it makes use of the *mitate* technique of bringing distant landscapes within easy reach. The *Sendenshō* in fact makes a comparison between "setting up flowers" (*hana o tateru*) in a flower arrangement and constructing a rock garden: "When setting up a branch in a grass-flower vase, one should do it as if one were planting a tree in a garden; first, one should set up the center [*shin*] and then add the appropriate grasses at the base."[12] The "Enpekiken-ki" (Record of Enpekiken, 1675), a personal essay by Enpekiken (Kurokawa Dōyū [d. 1691], a doctor and historian), notes:

Originally *rikka*, standing-flower arrangement, came from the art of gardening [*sakutei*]. Sōami and Monami of the Sōrin-ji Temple in Higashi-yama also constructed gardens. The garden in the Jōdo-ji [Pure Land Temple] is Sōami's. It is from there that he began to work on the

idea of *rikka*. The horizontal sand vase [*sunamono*] is an abbreviated representation of an island. The *rikka* reflects the mountains and rivers.[13]

Both Mon'ami (d. 1517), a Jishū (Time Sect) priest and cultural assistant (*dōbōshū*) to the Muromachi shogun Ashikaga Yoshitane, and Sōami (d. 1525), a *dōbōshū* and noted ink painter, were *rikka* artists.[14] A subgenre of *rikka*, the *sunamono* (*suna-no-mono*) is designed to look like a small island, a common feature of Japanese rock-and-sand gardens, and to create the perspective of a garden up close, as opposed to the standard *rikka*, which represents a distant view of mountains and rivers.

The term "art of the flower" (*kadō*) is misleading, since the overall function of *rikka* is not to focus on the flower, as in a bouquet of roses, but to re-create the basic elements of nature (tree, grass, flower, river, mountain, waterfall, sky). An arrangement can evoke a wilderness or natural landscape. The preface to the *Ikenobō Sen'ō kuden*, for example, notes that the foremost function of the flower arrangement "is to express within a room the wild fields and mountains and the water's edge as they exist outdoors." The preface maintains that "with a little water and a short branch, one can represent a spectacular scene with many rivers and mountains, a beautiful scene of eternal changes amid the ephemeral."[15] In a typical *rikka*, the branch of the tree (shaped and held in place by pins) represents a mountain, the vase suggests a river, and the grasses at the bottom indicate wild fields, allowing the vastness of nature to be represented in a single vase. An arrangement can also suggest a more intimate scene. The *Sendenshō*, for example, includes instructions for such landscapes as "a fresh spring amid a wild field," "flowers in the shadow of a giant rock," and "flowers in a wild field blown by wind."[16]

As noted in the *Rikka imayō sugata* (*Modern Shape of Standing Flowers*, 1688), an arrangement can also be highly symbolic and abstract. It can represent Mount Sumeru (Jp. Shumisen)—in Buddhist lore, a high mountain that symbolizes the center of the universe—a buddha (Skt. Tathagata), a bodhisattva, or the Buddhist cosmos.[17] A *rikka* even can be flowerless, as in a display by Fushunken Senkei, a noted *rikka* professional active in the Genroku era (1688–1704), in which pine branches were the center, the augmentation, and the base. In a surprising reversal, the branches suggested blossoming flowers.

# Gift Wrapping and Ritual Efficacy

As a one-time act or performance, *rikka*, like *waka*, was a means of everyday communication (of offering greetings, congratulations, condolences, and so forth) and had to be polite and subtle. In Japan, gifts are almost invariably wrapped, making them indirect and thus polite. Representations of nature both in poetry and in arts such as flower arrangement similarly became a way to make a message suggestive, cultured, and elegant. For example, one of the primary functions of the *hokku*, the opening verse in a *renga* sequence, was to greet the host of a poetry gathering. The seasonal word (*kigo*) marked the occasion (season) and the place. Typically, in *waka* or *hokku*, a natural image (such as a flower or a bird) served as a symbol for the host or the person being honored. Such poems used representations of nature to initiate or reaffirm social and political relations and to offer praise, prayer, and consolation to the addressee, sometimes including the spirits of the dead. The tea ceremony (*chanoyu*) and standing-flower arrangement were similarly used to establish and cement social relations. As such, they had to show respect and properly address the other party (whether a guest, a host, a military leader, or a member of the aristocracy). A poem offered or exchanged on such an occasion was part of a performative process in which the calligraphy and the paper (color, texture, and design) played a key role. All three elements (calligraphy, paper, and text) had to be appropriate to the season, the place, and the social position of the participants. Today, it is considered proper etiquette in Japan to begin all personal letters with an observation about the present phase of the season. This custom, which is taught in school and begins very early in Japan, creates an elegant greeting, with the seasonal reference becoming the epistolary version of the seasonal word in haiku.

Many of the screen paintings (*byōbu-e*) of the Heian and medieval periods were prepared as gifts to mark auspicious occasions, such as birthdays, weddings, and housewarmings (for example, the entrance of a daughter of a powerful minister from the northern Fujiwara clan into the imperial harem), and were given by one aristocrat to another or, in the medieval period, by one provincial warlord to another on important political or social occasions. Through their natural and seasonal iconography, these paintings indicated the pedigree, social status, and power of the giver and the importance of the recipient. For example, screen paintings and furniture designs alluding

to the "Hatsune" (The First Song of the Warbler) chapter in *The Tale of Genji*, which marks the beginning of spring, were a favorite wedding gift or dowry in the Muromachi and Edo periods because of the chapter's auspicious topoi (New Year and early spring) and association with courtly refinement.

A flower arrangement could be an offering (for example, to a god portrayed in a hanging scroll), a greeting from a host to a guest, a salute to the seasonal moment, and/or part of a social occasion or religious ritual. As the *rikka* treatises point out, pine covered with wisteria symbolized harmony between man and woman; pine, bamboo, and plum branch expressed congratulations; and the sacred lily (*omoto* 万年青; literally, "ten-thousand-year green") represented continuity over generations—all associations that continue to be maintained. Chōbunsai Eishi's (1756–1829) print *Shinnen no iwai (Celebration of the New Year)* shows women preparing auspicious flowers, such as narcissus (*suisen*), a winter and New Year flower; pheasant's eye (*fukujusō*; literally, "wealth and felicity flower"); and sacred lily.[18] The important role of *rikka* in annual observances is indicated in the list of appropriate *shin* for the Five Sacred Festivals (Gosekku) in the *Ikenobō Sen'ō kuden*:

| | |
|---|---|
| Third day of the First Month (New Year) | Plum, narcissus, marigold (*kinsenka*) |
| Third day of the Third Month (Jōshi) | Peach, willow, yellow kerria (*yamabuki*) |
| Fifth day of the Fifth Month (Tango) | Bamboo, sweet flag (*shōbu*) |
| Seventh day of the Seventh Month (Tanabata) | Bellflower (*kikyō*), lychnis (*sennō*) |
| Ninth day of the Ninth Month (Chōyō) | Chrysanthemum, cockscomb (*keitō*)[19] |

Each of these plants had a ritual function—such as dispelling evil elements (sweet flag) at the Tango Festival and promising long life (chrysanthemum) at Chōyō—appropriate to the observance.

The social function of *rikka* is also made evident in a long list of special occasions for flower arrangement in the *Sendenshō*:

Flowers for coming of age (*genpuku no hana*)

Flowers for when a person becomes a priest (*hōshi nari no hana*)

Flowers for when a child begins to speak (*shōnin nado mōsu toki no hana*)

Flowers for going off to battle (*shutsujin no hana*)

Flowers for a new dwelling (*watamashi no hana*)

Flowers for praying to gods and buddhas (*kitō no hana*)[20]

The *Sendenshō* goes on to note that "flowers for when a child begins to speak" should not have thorns that could catch on the long sleeves or hem of the clothes and should have especially bright colors (implicitly to match the beauty of the child). When preparing "flowers for going off to battle," one should not use camellia, maple, azalea (*tsutsuji*), or other plants whose flowers or leaves wither or scatter easily. "Flowers for a new dwelling" should not include anything that is red, which suggests fire. When it comes to "flowers for praying to gods and buddhas" to cure illness, one should not use carnation or pink (*tokonatsu*), a perennial whose name (literally, "everlasting summer") would be inauspicious under such a circumstance. In similar fashion, the *Ikenobō Sen'ō kuden* lists plants that should be used on auspicious occasions (such as pine, bamboo, camellia, and willow) and those that should not be used on auspicious occasions, such as plants with four colors or four leaves, which evoke the word "four" (*shi*), a homonym with the word "death" (*shi*).[21]

Ikebana—like *waka*, *renga*, *haikai* (popular linked verse), and *chanoyu*—is best defined as a performance art; once the occasion is over, the flower arrangement has fulfilled its primary function. The Kan'ei era witnessed a sudden boom in the publication of secret treatises and illustrated texts on *rikka* that served as records of one-time performances, much like the records of tea ceremonies that appeared in the Tenbun era (1532–1555) and the *haikai* diaries of the Edo period. The original contexts of these performances, which were often social, religious, or political, could never be fully re-created. But they served as guides and lessons for future performances and transmitted knowledge and expertise from teachers to disciples.[22]

# The Thrown-in Flower and the Tea Ceremony

Under the impact of Sen no Rikyū (1522–1591), the tea ceremony (*chanoyu*) evolved from a highly formal Chinese-style ritual, with complex rules, to "rustic tea" (*wabicha*), which reduced the size of the tearoom from the parlor (*shoin*) to a very small space. The *wabicha* teahouse took the form of a miniature grass hut (*sōan*), thereby re-creating the mountain village (*yamazato*), which was a major topos in medieval *waka* and *renga*, in the middle of the city. Following a similar historical arc, the palace-style (*shinden-zukuri*) garden evolved into the enclosed *shoin* garden and then further shrank into the rock-and-sand garden (*kare-sansui*) and the sand-and-stone landscape on a tray (*bonseki*).[23] The small form was not necessarily easier to approach, often becoming increasingly complex, but it was clearly more compact.

A different kind of "slimming down" occurred in the transition from *renga* to *haikai*, which relaxed the complex rules of *renga* and became significantly shorter—from hundred- or thousand-verse to fifty- or thirty-six-verse sequences—eventually focusing on the seventeen-syllable *hokku*. There was also a movement in flower arrangement from the formal and highly regulated standing-flower (*rikka*) form to the relaxed thrown-in-flower (*nageire* or *nageirebana*) form, which maintained many of the social and cultural functions of *rikka*, but presented them in a much smaller, simplified, casual, and accessible manner.

This movement from formal to informal and from heavy to light versions of performance was often articulated by their practitioners by using the calligraphic terms *shin* (formal style), *gyō* (cursive style), and *sō* (abbreviated style; literally, "grass style"). The *Sashibana keiko hyakushu* (*Hundred Poems on Practicing Ikebana*, 1768), for example, compares *rikka* to *shin*, *sunamono* (sand vase arrangement) to *gyō*, and *nageire* to *sō*.[24] In contrast to *rikka*, which was highly regulated and involved great effort to shape and bend the tree and flower branches (using pins and wire), *nageire* was formed with only one or two flowers. In the latter half of the sixteenth century, when Sen no Rikyū established the understated tea ceremony (*wabicha*), he also adapted the thrown-in-flower style, calling it the tea flower (*chabana*). Typically, the host removes the hanging scroll from the alcove (*tokonoma*) and replaces it with a simple flower arrangement as an offering to his guest or guests (figure 14). The objective is to display a taste for nature appropriate to a miniature retreat and to articulate the seasonal moment.

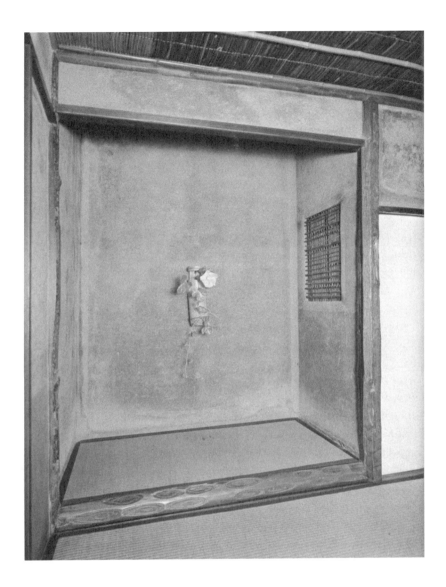

FIGURE 14

TEAROOM AND A FLOWER IN THE ALCOVE

The understated-tea-style (*wabicha*) tearoom was much smaller than the parlor in a *shoin*-style residence, and the alcove was similarly reduced in size. The alcove usually displayed a standing-flower arrangement and/or a hanging scroll with a painting or calligraphy. Following the *wabicha* style, this alcove, in the Shinju-an (Pearl Hut) in the Daitoku-ji temple complex in Kyoto, is decorated with a simple thrown-in-flower arrangement in a plain vase hung from the wall. The bud of the morning glory faces the guest (seated on the right), who watches it bloom in the course of the tea ceremony. (From Tamagami Takuya, Hayashiya Tatsusaburō, and Yamane Yūzō, eds., *Ikebana no bunkashi*, vol. 3 of *Zusetsu ikebana taikei* [Tokyo: Kadokawa shoten, 1970], fig. 29. Courtesy of Kadokawa shoten)

By the Genroku era, the popularity of *nageire* had grown to the point where it became independent of the tea ceremony and inspired its first treatise, *Nageirebana denshō* (*Secret Transmission of the Thrown-in-Flower Arrangement*, 1684). *Nageire* eliminated the triad display (incense burner, flower vase, and crane-and-turtle candle lamp) before a Buddhist image, with its religious and ceremonial implications. It also reduced the complex system of seven or nine branch positions in *rikka* to the basic three of center (*shin*), augmentation (*soe*), and base (*tai*). But the thrown-in-flower style did retain certain fundamental elements of *rikka*: the tree branches (*ki-mono*); the grasses (*kusa-mono*); and the "two-way things" (*tsūyō-mono*), which could be regarded as either trees or grasses. The smaller, lighter, and simpler thrown-in-flower style, which was more appropriate to the small alcoves in the houses of urban commoners and farmers, eventually spread throughout Edo society and appeared in a variety of formats, including the "nailed flower" (*kakehana*), a small vase hung from a wall or pillar by a nail; the "suspended flower" (*tsurihana*), a small vase (in the shape of the moon, a boat, a basket, and the like) suspended from the ceiling; and the flower arrangement placed on the staggered shelves (*chigaidana*) of a parlor.

When a flower arrangement was combined with a hanging scroll in the alcove in either *rikka* or *nageire*, the two had to harmonize. The *Sendenshō* notes that in flower arrangement and painting, "a willow should be matched with a Kannon bodhisattva painting; cherry (or plum) with a Tenjin [Sugawara no Michizane (845–903)] god portrait; bamboo with a tiger; pine with a dragon; an old tree with an ancient person. . . . Waterside flowers and plants or trees in fields and mountains should be matched with a landscape painting."[25] The plum blossom was a symbol of Michizane, a major poet of the Heian period; the strength of bamboo matched that of the tiger; and pine reflected the longevity and good fortune of the dragon. A similar connection existed between the flower arrangement and the enclosed garden outside the parlor, viewed through an open door or a window. The *Nageirebana denshō* observes that the flower arrangement should not duplicate the garden; instead, the flower arrangement, the room, and the garden should complement one another.

The tea ceremony (*chanoyu*) connected these various forms through a semi-ritualized presentation of tea, sweets (*wagashi*), and sometimes food. It displayed different media in an alcove (flower arrangement, painting,

Chinese and Japanese poetry, and calligraphic fragments of literary and religious texts) and made use of ceramics, lacquerware, metalware, and hanging scrolls—not to mention the garden outside the teahouse. All these elements were arranged in order to harmonize with the seasonal moment. For example, a tea ceremony often was held after an excursion to view the cherry blossoms. According to the *Rikyū hyakushu* (*Rikyū's One Hundred Poems*, 1642), one of the hundred-poem sequences on tea ceremony principles attributed to Sen no Rikyū, a painting of flowers should not be displayed or a flower arrangement should not be made with cherry blossoms.[26] Instead, the season should be suggested, for example, by a poem or a calligraphic text on a hanging scroll that implies spring. The moment could also be reflected in the arrangement of the small vegetable and fish dishes (*kaiseki*) or the ceramic plates for side dishes (*mukōzuke*; literally, "far-side dishes"). For example, Ogata Kenzan (1663–1743), a noted Rimpa ceramics master, made *mukōzuke* dishes such as the *Colored Painting of the Tatsuta River* (Miho Museum, Kyoto), which represents the poetic essence of autumn. As we will see, the tea ceremony also involved the presentation, naming, and consumption of Japanese sweets that embodied the season. In short, *chanoyu*, which was intended to develop cultural sensitivity as well as provide the opportunity for social bonding and private entertainment, raised the presentation of tea and food to the level of art, fusing textual and material culture to create a tactile symphony of the seasonal moment. In this sense, the tea ceremony, which developed in the middle of the metropolis as a formalized and temporary mini-retreat from urban life, epitomizes the development of secondary nature in Japan, bringing the interiorization and representation of nature and the seasons to one of its historical heights.

## Women and Ikebana

In the Edo period, *waka* and ikebana were considered indispensable for the education of a daughter from a high-ranking samurai or wealthy merchant family. Standing-flower arrangement (*rikka*) as a woman's accomplishment was first practiced—along with the arts of calligraphy, koto (zither-like instrument), poetry, and dance—by high-ranking courtesans in the pleasure quarters.[27] For them, flower arrangement was essential to entertaining

customers, and their skill in this art is illustrated in *Yoshiwara no tei* (*A Scene from Yoshiwara*, ca. 1688), a black-and-white woodblock print by Hishikawa Moronobu (1618–1694), and a scene from *Seirō bijin awase sugata kagami* (*A Mirror of Beautiful Women in the Pleasure Quarters*, 1776), a four-season guide to the best courtesan houses in Yoshiwara by Kitao Shigemasa (1739–1820) and Katsukawa Shunshō (1727–1792) (figure 15). The art of ikebana then spread to the wives and daughters of urban commoners, for whom it became an essential means to acquire culture.

The *Onna chōhōki* (*Treasures for Women*, 1692, revised 1847), a widely used etiquette manual and guide for women, notes that a woman should be accomplished in *rikka*, incense contest, the tea ceremony, and linked verse (*renga-haikai*). As *Onna chōhōki* and *Nan chōhōki* (*Treasures for Men*, 1693), a popular etiquette guide for men, indicate, both men and women were supposed to learn *chanoyu* and *rikka* as part of their cultural, social, and moral training, but the tea ceremony became primarily a male occupation, while women gravitated to flower arrangement, particularly in the form of *seika* (*shōka*; literally, "live flower"), a style that began in the mid-Edo period and simplified *rikka* for popular use. *Seika* came to be regarded as an indispensable part of a girl's education, a view that continued into the Meiji period (1868–1912) when, in 1887, the government officially made *kadō* (way of the flower) part of women's public education.

The ukiyo-e developed into the multicolor print (*nishiki-e*) in the latter half of the eighteenth century, from around 1765, which coincides with the time that ikebana became extremely popular among urban commoners in Edo. These woodblock prints portray a range of women (from daughters of urban commoners to famous courtesans of the pleasure quarters) with a wide variety of flower vases in different places (sitting in an alcove, on a veranda, or on a tatami floor; hanging from a ceiling or wall). The styles of ikebana differ widely, from *rikka* (standing flower) to *nageire* (thrown-in flower) to the various competing styles of *seika*. The women are sometimes shown practicing ikebana—taking a vase out of a box, working with an ikebana teacher, or cutting and arranging the flowers—as in Kitao Shigemasa's *Bijin hana-ike* (*Beautiful Women Arranging Flowers*, eighteenth century).[28] Late-eighteenth-century ukiyo-e such as Chōbunsai Eishi's series "Fūryū gosekku" (Elegant Five Sacred Festivals, ca. 1794–1795) and hanging scrolls such as Katsukawa Shunshō's *Fujo fūzoku jūnikagetsu zu* (*Women's Customs in the Twelve Months*, ca. 1781–1790) show women with

FIGURE 15

HIGH-RANKING COURTESANS WITH A FLOWER ARRANGEMENT

Kitao Shigemasa and Katsukawa Shunshō's *A Mirror of Beautiful Women in the Pleasure Quarters* (*Seirō bijin awase sugata kagami*, 1776) depicts high-ranking courtesans engaged in cultural activities during the four seasons. This scene shows four courtesans—Tamanoi, Katsuyama, Sugatano, and Sayoginu—with an elaborate, autumn standing-flower (*rikka*) arrangement: a pine branch for the main axis and smaller branches, autumn grasses, and flowers for the triangular base. The *rikka* mirrors the beauty of the courtesans. (Courtesy of the New York Public Library, Spencer Collection, Sorimachi 439, digital ID 1504263)

the flowers associated with two of the Five Sacred Festivals (see figures 21 and 23).

Many of the ukiyo-e are serial prints (one for each month or one for each season), in which the seasons are contrasted with one another, as in Heian-period four-season screen paintings (*shiki-e*) and Kamakura-period

twelve-month paintings (*tsukinami-e*). But unlike the four-season and twelve-month paintings, which depict landscapes, these ukiyo-e are *bijinga* (portraits of beautiful people) that portray women indoors, concentrating on their clothing, particularly the colorful *kosode* (kimono) designs that complement the flower displays. As Kobayashi Tadashi has argued, the prominent presence of arranged flowers in these *bijinga* enabled ukiyo-e artists to interiorize the earlier tradition of twelve-month screen paintings, which represented nature and flowers from the garden or the hills, bringing "nature" into a commoner residence.[29]

## The Return of the Flower Garden

For most of Japanese history, the cultivation of flowers was part of elite culture. But from the early Edo period, flower gardening (growing flowers and plants for recreation and aesthetic purposes) also became very popular among both samurai and urban commoners. Three early Tokugawa shoguns—Ieyasu (1542–1616), Hidetada (1579–1632), and Iemitsu (1604–1651)—were great lovers of planted trees, and the provincial warlords (daimyo) and bannermen imitated them. The camellia rage of the Kan'ei era reflected the interests of Hidetada, Iemitsu, and Retired Emperor GoMizunoo (1596–1680; r. 1611–1629). After the Meireki fire in 1657, which destroyed much of Edo, powerful samurai, temples, and shrines hired gardeners to reconstruct or develop new gardens, which became very popular. The rise of botany and the study of nature for medicinal purposes (*honzōgaku*) at this time also spurred the boom in flower gardening.

In the Heian and medieval periods, the most highly valued flowers, such as plum and cherry, were those of trees that bloomed in the mountains or on the grounds of shrines or temples and that had religious significance. There was a gradual shift in the Edo period from these tree flowers—such as plum, cherry, mandarin orange, and camellia—toward such grass flowers as Japanese woodland primrose (*sakurasō*), sweet flag (*shōbu*), and chrysanthemum. The azalea (*tsutsuji*), a low-bush flower ideal for gardens, became popular in the Genroku era, and a craze for chrysanthemums developed in the Meiwa era (1764–1772). The gradual shift to grass flowers, which could be easily grown in private gardens, is perhaps best exemplified by the

increasing popularity of the chrysanthemum, which appears in many women-and-ikebana ukiyo-e from the late eighteenth century onward. Somei in Edo (present-day Komagome, Tokyo) became famous for its many garden shops that produced various types of azalea, rhododendron, and chrysanthemum, as well as the Somei-Yoshino cherry tree, which became the representative cherry tree in modern Japan (figure 16). This new gardening culture, which led to the proliferation of garden clubs, emerged at

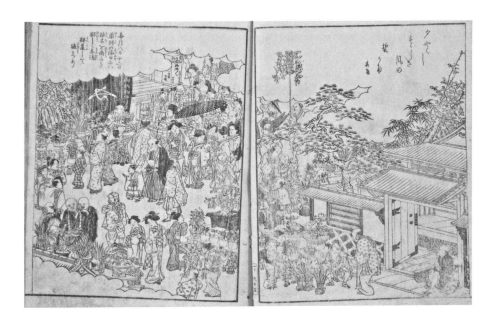

FIGURE 16

GARDEN SHOP IN EDO

The popularity of ikebana in Edo was paralleled by the growth of gardening as a pastime pursued by both powerful warlords and urban commoners. This illustration by Hasegawa Settan (1778–1843) in *Illustrated Guide to Famous Places in Edo* (*Edo meisho zue*, 1834–1836), edited by Saitō Gesshin (1804–1878) and others, depicts the open market for vendors of plants and gardening implements, held on the eighth and twelfth days of each month, at the Hall of the Healing Buddha (Yakushidō) in Kayabachō. A wide range of cultivated plants, including bonsai, is being admired by men and women of all ages and social positions. (Courtesy of Waseda University Library, Special Collection, Tokyo)

the same time that urban commoners were participating in more public "nature" activities or forms of entertainment, such as cherry-blossom viewing (*hana-mi*) and making chrysanthemum dolls (*kiku ningyō*).[30] The spread of gardening had a profound impact on the representation of nature, particularly flowers and trees. Together with flower arrangement and the tea ceremony, which emerged as forms of "natural" retreat in the city, it brought "nature" into the large metropolis (such as Edo and Osaka) and made it an integral part of domestic, everyday commoner life.

The emergence of a complex secondary nature in the city occurred in at least three fundamental ways in the long span from the eighth through the sixteenth century. First, it appeared most concretely in the form of poetry (especially *waka* and renga), which developed a highly codified set of seasonal associations that became the basis for daily and ritualistic communication and that functioned as an elegant, indirect, and polite means of address, with various levels of overtones. Second, the codification of the seasons and of nature spread to a wide variety of visual and material forms: dress, screen painting, scroll painting, and decorative arts such as ceramics and furniture. Some of the genres, such as the bird-and-flower paintings (*kachōga*) that would become very popular from the medieval period, had their precedents in China and developed their own native variations. Third, Japanese architecture, with its removable or movable walls and doors, developed a strong sense of spatial continuity between the interior and the exterior, especially between the living quarters and the garden, first in the palace-style (*shinden-zukuri*) residence of the Heian period and later in the parlor-style (*shoin-zukuri*) residence, which became the archetype for the Japanese house. The Muromachi-period arts of the alcove (*tokonoma*) in the parlor further reinforced this sense of continuity between the human and natural spheres. Furthermore, in the Edo period, new forms emerged that were more accessible to urban commoners—such as *haikai*, ikebana (especially *seika*), and landscape woodblock prints—and maintained many of the social and ritualistic functions that *waka* and screen paintings had held for the aristocracy.

These capital-centered representations and reconstructions of nature would intersect with and be enriched by provincial, commoner-based views of nature and landscape that appeared in mythic, folk, and popular literature.

# Rural Landscape, Social Difference, and Conflict

By the early thirteenth century, Fujiwara no Shunzei and his son Fujiwara no Teika had helped to canonize what are now known as the Heian classics—*The Tale of Genji* (*Genji monogatari*, early eleventh century), *The Tales of Ise* (*Ise monogatari*, ca. 947), the first three imperial *waka* (classical poetry) anthologies (*Kokinshū* [*Collection of Japanese Poems Old and New*, ca. 905], *Gosenshū* [*Later Collection*, 951], and *Shūishū* [*Collection of Gleanings*, 1005–1007]), and *Bo Juyi's Collected Works* (Ch. *Boshi wenji*, Jp. *Hakushi bunshū*)—which formed the textual foundation for the seasonal associations in the aristocratic literary tradition. While the power of the aristocracy declined politically and economically from the end of the Heian period (794–1185), *waka* culture continued to flourish and was carried on by aristocrats, Buddhist priests, and some well-educated samurai. Indeed, it could be said that the precipitous political and economic decline of the aristocracy (and then the irreversible military defeat of the imperial court itself in the Jōkyū Disturbance [1221]) led to a strengthening of the *waka* tradition, which the nobility developed and exploited as valuable cultural property. One result is that *waka* and *The Tale of Genji* continued to have cultural authority long after

the political demise of the court and the nobility. Even after the destruction of the capital in the Ōnin War (1467–1477) and the dispersal of the nobles to the provinces, court culture centered on *waka* continued to represent high culture, as is evident in the numerous reconstructions of Heian court culture in genres ranging from Muromachi popular tales (*otogi-zōshi*) to *renga* (classical linked verse) to noh. In fact, one result of the dispersal of educated aristocrats and priest-scholars to the provinces was that the culture of the four seasons, with its representations of an elegant and highly encoded nature, spread to upper-rank samurai and to wealthy urban commoners (*machishū*), as well as to various regions of the country.

Meanwhile, another view of nature, which I have referred to as the farm-village (*satoyama*) landscape and which appears in the writings of low-ranking aristocrats and Buddhist priests, emerged from the estates (*shōen*) in the provinces. This landscape arose as early as the ancient period (before 784), but came to the fore around the twelfth century. The medieval cosmology of the *satoyama* has been summarized by Miyake Hitoshi:[1]

| | |
|---|---|
| High mountain peak | Wizard (*sennin*), goblin (*tengu*), heavenly maiden (*tennyo*), divine white bird (*shiratori*) |
| Deep in the mountain | Mountain people (*yamabito*), mountain ogre (*yamanba*), demons (*oni*) |
| Mountain base | Fox, badger, monkey, rabbit, wild boar, snake |
| Farm village | Dog, cat, chicken, cow, horse |
| Rice field | Snake, frog, insect |

The typical farm village was located between the rice fields—which, in turn, were near a river that provided the irrigation—and the forest at the foot of the surrounding hills, which were home to foxes, badgers, monkeys, rabbits, and wild boars that wreaked havoc on both the rice fields and the domesticated animals (figure 17). The *satoyama*, which included both the *sato* (human settlement) and the *yama* (surrounding hills), can be considered a form of secondary nature in that the plants (those of both the rice fields and the immediate surrounding forest) were constantly harvested. The animals at the foot of the mountain populate the folk literature of Japan and frequently appear as local gods (*kami*). At a much higher elevation stood the

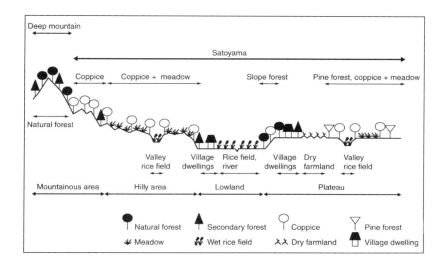

FIGURE 17

TOPOGRAPHY OF A *SATOYAMA*

This modern reconstruction of a traditional *satoyama* shows the virgin and secondary forests on the mountain peak; the coppice woodlands, which were a major agricultural resource and the key field of interaction between humans and nature, at the mountain base; and the village and rice paddies in the valley. (From K. Takeuchi et al., *Satoyama: The Traditional Rural Landscape of Japan* [Tokyo: Springer, 2003], 3. Courtesy of the National Institute of Agro-Environmental Sciences and the University of Tokyo)

inner recesses of the mountains (*okuyama*), which were basically uninhabited (except for scattered mountain people) and represented, in the cosmology of popular literature and folklore, a borderland between this and the next world. The peak of a high mountain (such as that of Mount Fuji) was considered to be the gateway to the other world. Most of the animals and supernatural creatures that appear in either the *satoyama* or the deep mountains never appear in *waka* or court tales of the Heian or Kamakura (1185–1333) periods. Except for falconry, aristocrats were not interested in hunting or in rice agriculture. This cultural and natural topography, which is strikingly different from that which emerged in aristocratic court culture in the capital, is worth examining for the impact that it would eventually have on Japanese cultural and religious views of nature.

In contrast to the capital-centered landscape of the late Heian and medieval (1185–1599) periods, the *satoyama* landscape, much like that of the ancient

period (as found in the early chronicles), is saturated with deities (*kami*) of different types, many of them related to farming, hunting, and fishing. The mountains (and sometimes large trees and rocks) surrounding the *satoyama* were believed to be the home of gods, as was the sea near coastal farm villages.[2] The gods of the mountains (*yama no kami*) were often believed by rice farmers to come down in the early spring to become the gods of the rice fields (*ta no kami*) and then return to the mountains in the autumn. Shrines were built at the foot of the mountains, or shrines or *torii* (divine gates) were erected on the shore facing the sea.[3] The mountains and the sea thus represented two "other worlds" inhabited by gods, the source of great powers or treasures. In the early chronicles and the popular literature of the medieval period, birds, other animals, and plants often represented a bridge between the human world and the divine world; the birds that flew back and forth over the mountains, for example, were depicted as messengers of the gods.

## Classical Birds and Commoner Birds

The contrast between the capital-centered and the provincially based representations of nature is evident in the representations of birds, which can be divided into "classical birds" and "commoner birds." Due to extreme seasonal changes in temperature and the elongated north–south shape of the Japanese archipelago, many birds in Japan are migratory or semi-migratory. By one count, there are roughly 350 species of wild birds in Japan, which can be divided into non-migratory birds, such as the sparrow, crow, pigeon, and pheasant; semi-migratory birds, such as the bush warbler, which move within a single region with the change of season; and migratory birds, such as the small cuckoo, wild goose (*kari*), wild duck or mallard, and swan. The non-migratory birds—such as the sparrow, crow, and pigeon (which was eaten for food from the ancient period)—were closely associated with farming life and appear frequently in the early chronicles and anecdotal literature. Many of the semi-migratory and migratory birds—such as the bush warbler, small cuckoo, and wild goose—were seasonal and became prominent figures in *waka*, Yamato-e (Japanese-style painting), and aristocratic culture.

As we have seen, the capital-based poeticization of birds began in the Nara period (710–784), in the middle to late poems of the *Man'yōshū* (*Collection of Ten Thousand Leaves*, ca. 759), and became a widely instituted

practice in the Heian period, when certain birds, along with selected plants and atmospheric conditions, came to be representative of the seasons, each with a circle of well-known associations. The most important bird for spring was the bush warbler (*uguisu*); for summer, the small cuckoo (*hototogisu*); and for autumn, the wild goose (*kari*). The *Man'yōshū* contains as many as 150 poems on the small cuckoo, 67 on the wild goose, and 51 on the bush warbler.[4] All three birds continued to be major seasonal topics in the Heian and medieval periods. In classical poetry, the birds of winter are mainly waterfowl: the plover (*chidori*), wild duck (*kamo*), mandarin duck (*oshidori*), and dabchick (*nio* or *kaitsuburi*). The overwhelming focus in *waka* on these birds is on their songs or voices. The "first cry" of the bush warbler, the "first cry" of the small cuckoo, and the "first cry" of the wild goose became important poetic markers of spring, summer, and autumn, respectively. To "hear" a certain bird was to confirm the identity of a season. Like a number of insects (such as the pine cricket [*matsumushi*] or bell cricket [*suzumushi*]), these birds also appear prominently in love poems, functioning as metaphors for irrepressible desire, longing, and loneliness.

The classical birds stand in stark contrast to what we might call the commoner or popular birds—such as the sparrow, pigeon, falcon, crow, swallow, and chicken—which appear in abundance in the early chronicles, anecdotal literature, military tales, and Muromachi tales and played a role in the everyday lives of farmers and provincial samurai. The sparrow (*suzume*), for example, is a major character in medieval popular tales, but is absent from the first eight imperial *waka* anthologies.[5] Some birds—such as the small cuckoo, pheasant, wild goose, and crane—appear both in classical poetry and in popular narratives, but serve very different functions in each. For example, the first cry of the *hototogisu*, which was eagerly awaited by Heian-period poets as the first sign of summer, signaled to farmers the beginning of the rice-planting season and became the subject of rice-planting songs, which Sei Shōnagon observed in the *Makura no sōshi* (*The Pillow Book*, ca. 1000) on her way to the Kamo Shrine.

The difference between the treatment of the wild goose in classical poetry and in the farm village is the humorous subject of a *kyōgen* play, a comic genre of the Muromachi period (1392–1573) with commoner roots that often represents the cross-currents of capital- and provincial-based representations of nature. The call of the wild goose sounds like a horn (*gaan, gaan*), resulting, it is said, in the Sino-Japanese reading of the graph for "wild

goose" as *gan*, which became the vernacular word for "wild goose." But it sounded like *kari, kari* to the ancients, and hence the classical poetic word for "wild goose" is *kari*. In the *kyōgen* play *Gan-karigane* (*Wild Geese / Wild Geese*), a farmer from Tsu Province (the *shite* [protagonist]) pays the annual tax in the form of an offering of a wild goose to the landlord in the capital, citing a classical poem and using the poetic word *karigane*. A farmer from Izumi Province (the *waki* [side character]), who makes the same payment of a wild goose to the same landlord, counters by saying *hatsu-gan desu* (These are the first wild geese), using vernacular Japanese. Each is rewarded equally. The humor comes from the dissonance between the two cultural perspectives on nature: that of the farmer and that of capital-based culture.[6]

Perhaps the most striking function of commoner birds in medieval popular narratives is as a symbol of parental love, familial order, or marital fidelity. In classical poetry, the pheasant (*kiji* or *kigisu*) is a spring bird that, while seeking food in the wild fields, cries out for its mate,[7] but in anecdotal literature, military narratives, and Muromachi popular tales, the pheasant is a symbol of a mother's devotion to her child. The *Hosshinshū* (*Tales of Awakening*, 1216?), a collection of early medieval anecdotes, notes that when the pheasant encounters a fire in a wild field, it stands up in shock, but unable to leave behind its young, it enters the smoke to retrieve its chick and often burns to death in the process—a scene referred to as "pheasant in a burning field" (*yakeno no kigisu*). This association became the basis for the modern proverb *yakeno no kigisu, yoru no tsuru* (pheasant in a burning field—the night crane),[8] translated roughly as "Parents risk life and limb for their children."

Another commoner bird associated with familial love is the swallow (*tsubame* or *tsubakurame*), which came from the south in late spring and returned in autumn. Making its nest on house eaves and roof ridges, the swallow was a familiar bird from the ancient period, but it rarely appears in *waka*. The swallow was known for its ability to reproduce rapidly (it mates twice and sometimes three times in the summer). In the noted *Taketori monogatari* (*Tale of the Bamboo Cutter*, ca. 909), one of the suitors of the Shining Princess is given the difficult task of finding the legendary "easy-birth shell" of a swallow. The swallow was also thought to be faithful to its mate (spending each year with the same partner) and to take care of its young, and thus it became a symbol of marital and familial harmony. In "Karukaya," a sermon tale (*sekkyōbushi*) written in the Muromachi period, the son, upon

seeing a family of swallows (father, mother, and young), realizes that he has no father.[9]

Commoner birds frequently functioned as messengers from the other world, much more so than classical birds. In one of the most famous stories about a sparrow, "How a Sparrow Repaid Its Debt of Gratitude" (48), in *Uji shūi monogatari* (*A Collection of Tales from Uji*, early thirteenth century), a sparrow whose back is broken by a child repays an old woman who nurses it back to health. With the seed of a gourd brought by the sparrow, the old woman is rewarded with many gourds filled with rice. A neighbor attempts to duplicate the old woman's luck by first injuring a sparrow and then trying to nurse it back to health, but is punished instead. In this story, which became the basis for such popular folk tales as "Koshiore suzume" (Broken-hip Sparrow) and "Shita-kiri suzume" (Tongue-cut Sparrow), the sparrow, as a representative of heaven or a higher world, brings just rewards to the human world.[10]

## Animals as Prey and as Victims

Birds also appear as prey and as food in popular narratives. *Ryōri monogatari* (*Tales of Cooking*, 1643), an influential cookbook that reflects the new values of the Edo period (1600–1867), lists eighteen different birds in order of culinary merit, beginning with the crane; followed by the swan, wild goose, wild duck, pheasant, and mountain pheasant; and ending with the chicken. In addition to its association with good fortune and felicity, the crane (*tsuru*) was considered the number-one prey in falconry, being prized by warriors as the tastiest of birds. In the Edo period, the crane was given as a precious gift from the provincial warlords (daimyo) to the shogun and from the shogun to the court and to selected daimyo. The value of cranes as game was such that commoners were forbidden to hunt them[11] and the military government (*bakufu*) took special measures to protect them, causing a conflict with farmers, who considered cranes to be harmful since they ate the grains of rice.[12] A pheasant captured by a falcon was also regarded as a great delicacy.[13] In section 118 of *Tsurezuregusa* (*Essays in Idleness*, 1310–1331?), Priest Kenkō (ca. 1283?–1352?) notes that the meat of the pheasant was considered to be equal to that of the carp, the king of fish; and in the

famous story "How Ōe no Sadamoto, Governor of Mikawa, Became a Buddhist Monk" (19:2) in *Konjaku monogatari shū* (*Tales of Times Now Past*, ca. 1120), Ōe no Sadamoto (Jakushō) witnesses a pheasant being feathered, skinned, and cooked alive, a traumatic experience that causes him to take holy vows. By the end of the medieval period, the pheasant had become one of the "three birds" (best for hunting) in samurai society, along with the crane and the wild goose.

Farmers had to kill insects and other animals that harmed their rice fields, which led to the widespread ritual of praying for the spirits of slaughtered animals and insects. In order to get rid of harmful insects that damaged the harvest, farm villagers lit pine torches (*taimatsu*) and rang bells. This was followed by *mushi-kuyō* (offerings to the spirits of deceased insects). Similar offerings were carried out for whales, fish, boar, deer, and other hunted animals.[14] Numerous medieval anecdotal tales (*setsuwa*), Muromachi popular tales (*otogi-zōshi*), and noh plays reveal this fundamental conflict between the need to control nature—particularly the pressure to hunt, kill harmful animals, and clear the forests—and the desire to appease and worship nature, which was believed to be a realm filled with gods. This tension was made even more complex by the gradual infiltration into Japan of Buddhist thought, particularly the prohibition against killing certain animals and the notion that all sentient beings can achieve enlightenment. The sin of killing could be compensated for, at least in part, by praying for the spirits of dead animals (*kuyō*) or by releasing captured animals (*hōjō*), frequent motifs in early and medieval anecdotal literature.

An awareness of the Buddhist sin of hunting and killing, which emerged as early as the *Nihon ryōiki* (*Record of Miraculous Events in Japan*, ca. 822), came to the fore in the medieval period and created a sense of sympathy for the hunted animal, an attitude evident in *setsuwa* such as "How a Man Called Umanojō Shot a Male Mandarin Duck in Akanuma in Michinoku Province and Then Received the Tonsure" (30:713), in the collection *Kokon chomonjū* (*A Collection of Things Written and Heard in the Past and Present*, 1254):

In Michinoku Province, the village of Tamura, there lived a man named Umanojō So-and-so who raised hawks. One day, when his hawks had failed to catch any birds and he was coming home empty-handed, at a place called Akanuma he saw a pair of mandarin ducks flying about. Fit-

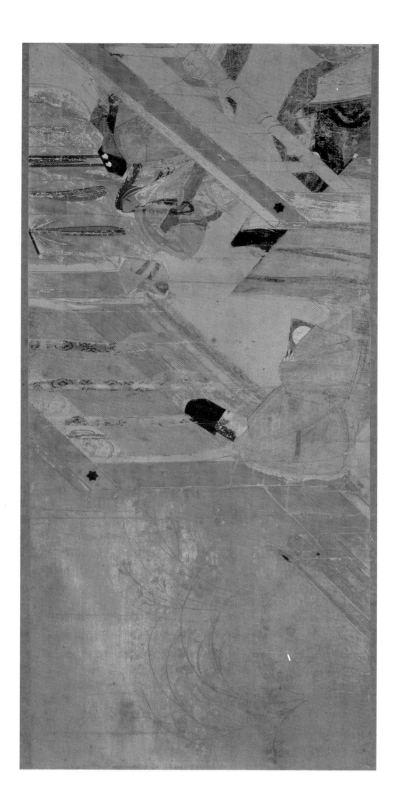

FIGURE I

INTERIOR AND GARDEN IN A HEIAN-PERIOD RESIDENCE

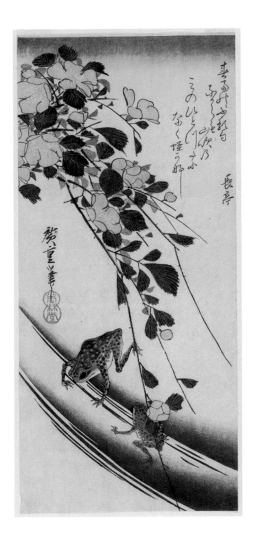

FIGURE 5

*YELLOW KERRIA AND FROGS*

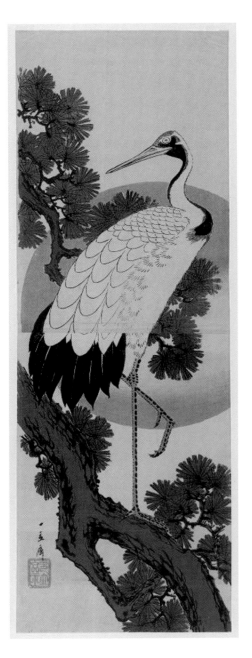

FIGURE 18

*CRANE, PINE, AND RISING SUN*

FIGURE 6
MULTILAYERED HEIAN-PERIOD KIMONO

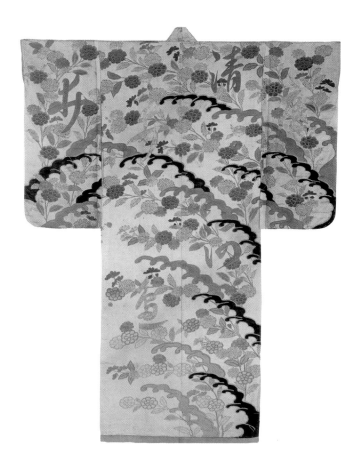

FIGURE 7
YOUNG WOMAN'S KIMONO WITH YELLOW KERRIA

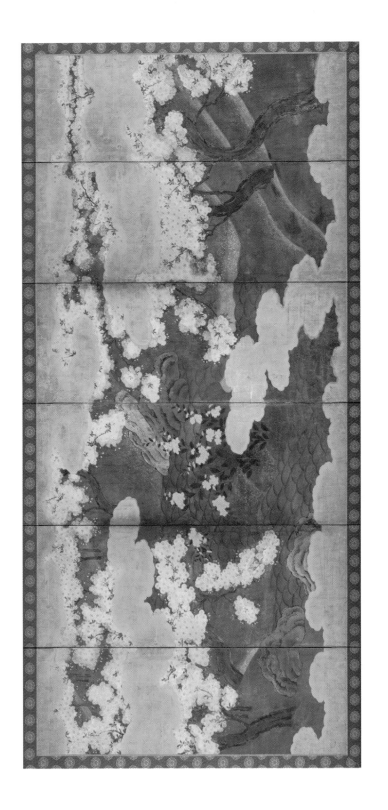

FIGURE 9

BLOSSOMING CHERRY TREES IN YOSHINO

FIGURE 10

NABESHIMA WARE DISH WITH TATSUTA RIVER

FIGURE 20

MOUNT HŌRAI WITH COVES, CRANES, AND PINES

FIGURE 15

HIGH-RANKING COURTESANS WITH A FLOWER ARRANGEMENT

FIGURE 21

DOLL'S FESTIVAL AND IKEBANA

FIGURE 26

*AUTUMN MOON IN THE MIRROR STAND*

ting an arrow with a special type of point to his bow, he shot and killed the male of the pair. He fed the body to his hawks and put the remainder in his bag and took it home.

That night in a dream, a beautiful little woman came to his pillow, crying piteously. Wondering at this, he asked, "Who are you, and why are you crying?"

She replied, "Yesterday at Akanuma, a terrible thing happened. You killed my husband, my companion of many years, and therefore I weep in unbearable sorrow. I have come to tell you of this. Because of this sorrow, I do not know how I can go on living." Weeping uncontrollably, she recited this poem in Japanese and then went away, still weeping:

| *Hi kurureba* | As evening comes, |
| *sasoi shi mono wo* | how sad that I, |
| *Akanuma no* | who had slept with my mate, |
| *makomo-gakure no* | must sleep alone in the shade |
| *hitorine zo uki* | of the marsh grass of Akanuma. |

Shocked and saddened by these words, on the following day the man opened his bag to find the bill of the female bird paired with that of her mate. Because of what had happened, he abandoned his regular occupation and took the tonsure. He was a samurai in the service of Lord Nakayoshi, former commissioner of the Ministry of Justice.[15]

This story embodies the fundamental tension between the provincial dependence on hunting and the Buddhist sin of killing birds and other animals. The tale is poignant because the bird that is killed is (for humans) a highly sympathetic animal, the mandarin duck (*kamo*), which forms long-term pairs and had become a poetic and cultural symbol of marital fidelity and deep love. Following the pattern of Buddhist tales, the killing results in religious awakening and conversion (*hosshin*).

In these stories of hunting, the prey animal is often personified. In "Kari no sōshi" (Story of a Wild Goose), a Muromachi popular tale that survives in a picture scroll (*emaki*) from 1602, a lonely lady-in-waiting sets off on a pilgrimage to Ishiyama Temple to pray to the bodhisattva Kannon, sees a flock of wild geese flying in front of a bright autumn moon, and wishes that someone would marry her, even a wild goose. A young man in court dress

soon appears, and they become intimate. One night, in the middle of the Third Month, the man regretfully informs her that he must return home and promises to come back in the autumn. The next morning, the woman sees a wild goose fly off from the eaves and realizes the young man's true identity. The woman continues to long for her former lover and has a dream in which the wild goose reveals that he was killed on the way home by a hunter. The woman retreats to a hermitage, takes holy vows, and is reborn in the Pure Land.[16] This late Muromachi tale, which belongs to the "marriage to another species" (*iruikon*) type, is remarkable for the way in which it employs the classical poetic associations of the wild goose—loneliness, arrival in autumn, return in spring, and evening moon—and personifies the bird. The story, which also shows the Buddhistic concern with the sin of hunting, treats the wild goose as a victim whose death leads to the woman's disillusion with this world.

In Muromachi popular tales that belong to the "marriage to another species" subgenre, an animal or a plant enters the world in human form and has a relationship with a human. Sometimes the animal appears only temporarily in human form, as in "Kari no sōshi." In one version of "Nezumi no sōshi" (Story of a Mouse), a similar tale, a girl who desires to be married is suddenly blessed with visits from a male lover, to whom she plans to be formally married. When her mother comes to meet her future son-in-law, she is accompanied by a cat that pounces on the man, whereupon he returns to his original form as a mouse. In these *iruikon* tales, which became very popular in the late medieval period, the animals not only are sympathetic characters, but make their world more familiar to the human audience, as the tales in such collections as *Aesop's Fables* often do.[17]

This kind of sensitive, anthropomorphic representation of animals extends to *kyōgen*, which features animal and even plant protagonists in such plays as *Kani-yamabushi* (*Crab Mountain Priest*), *Ka-sumō* (*Mosquito Sumo*), *Semi* (*Cicada*), *Tako* (*Octopus*), and *Tokoro* (*Mountain Potato*).

## Plants as Protagonists

Perhaps the most striking example of the personification of animals, plants, and even atmospheric conditions in the Muromachi period is the large

group of noh plays in which they appear as spirits and gods (*kami*). The most prominent examples are *Kochō* (*Butterflies*), *Ume* (*Plum Tree*), *Saigyō-zakura* (*Saigyō and the Cherry Blossoms*), *Sumizome-zakura* (*Ink-Dyed Cherry Blossoms*), *Yugyō yanagi* (*The Wanderer and the Willow*), *Fuji* (*Wisteria*), *Kakitsubata* (*Iris*), *Bashō* (*Plantain Tree*), *Hajitomi* (*The Lattice Shutter*), *Susuki* (*Miscanthus Grass*), *Kaede* (*Maple Tree*), and *Yuki* (*Snow*).[18] While nature is often personified in *waka* of the Heian and medieval periods, the plants and animals do not appear as spirits of the dead or as gods. In this respect, these noh plays hark back to the early chronicles and reflect local beliefs in the existence of *kami* in plants, animals, and rocks. The numerous spirits of nature in these plays, though, do represent the continuation of a long tradition of *waka*, in which nature is personified or treated as a companion. As Ki no Tsurayuki (872–945) notes in the kana preface to the *Kokinshū*: "Hearing the cries of the warbler among the blossoms or the calls of the frog that lives in the waters, how can we doubt that every living creature gives voice to song?" This statement became the object of extensive medieval *waka* commentary, which both drew on and gave rise to anecdotal literature (*setsuwa*) on poetic topics.

Typically, a tree or flower found in classical poetry or in a classical text such as *The Tales of Ise* or *The Tale of Genji* appears as a beautiful woman and performs a dance. Following the double structure of the dream-noh (*mugen-nō*) play, in the first half (*maeba*), the *waki* (usually a traveling Buddhist priest) meets the protagonist, who normally appears as a local woman; she reveals that she is in fact the spirit of a tree or another plant, and then reappears in the second half (*nochiba*) of the play as that spirit. These plant-spirit plays tend to follow one of two fundamental patterns. One type dramatizes a legend about a plant from *waka*. The other type uses the plant spirit to preach the Buddhist notion that all plants have the capacity to achieve salvation or enlightenment. Often, both types are combined.

A good example of the *waka*-centered play is *Fuji*, in which a traveler visits Tago-no-ura (Etchū Province), a place made famous for wisteria by Ōtomo no Yakamochi (718–785?) and others in a series of poems in the *Man'yōshū* (19:4199–4202). When the traveler recites a poem on the wisteria, a local woman is critical of the poem and recites two other poems about the famous wisteria that she deems to be superior. In the second half of the play, the woman appears as the spirit of the wisteria and praises both the Lotus

Sutra and the wisteria. Thus *Fuji* pays homage to the rich cultural history of wisteria, drawing on its classical associations, such as its relation to the pine and the significance of the color lavender.

The *renga*-esque use of the poetic and lexical associations of a flower, a tree, or another plant is also a salient characteristic of these *waka*-based plays. Such associations, which can be found in handbooks such as *Renga yoriai* (*Linked-Verse Lexical Links*, 1494), were woven together, particularly in the song and dance sections of noh plays, to create a rich intertextual fabric. For example, the second half of *Saigyō-zakura* includes an "exhaustive listing of famous places" (*meisho-zukushi*) known for cherry blossoms. Similarly, *Yugyō yanagi* has an "exhaustive listing" of legends about the willow in China and Japan, including the scene in the "Wakana jō" (New Herbs, Part 1) chapter in *The Tale of Genji* in which Kashiwagi, who is standing near a willow tree, catches a glimpse of the Third Princess.

Probably the most prominent example of a plant-spirit play that foregrounds the belief that "trees, grasses, and earth all become buddhas" (*sōmoku kokudo shikkai jōbutsu*) is *Bashō*, which was written by Konparu Zenchiku (1405–1468) and is set in China. A woman (the *shite*) appears in front of a hermit who is reciting the Lotus Sutra. As she listens to the sutra, she asks if it will bring salvation to women and to non-sentient beings, such as plants. According to the hermit, the "Yakusōyu hon" (Parable of the Medicinal Plants) in the Lotus Sutra teaches that trees and other plants can achieve Buddhahood and that women can escape from the "Burning House"—this illusory world. In the second half of the play, the woman reappears as the spirit of the plantain (*bashō*) praises the Lotus Sutra, gives a lyric description of the four seasons, and explains the impermanence of all things. In the end, the leaves and flowers break and scatter: "The mountain wind, the wind through the pines, sweeps through, sweeps through; the flowers and plants scatter and scatter; the plantain leaves are torn and left broken."[19] In this play, the *bashō* not only becomes a symbol of the impermanence of all things, but represents those beings (such as women) who are thought to have difficulty being saved.

The "Yakusōyu hon" gave rise to the doctrine that plants could attain Buddhahood. Chan-jan (711–782), the ninth patriarch of the Tiantai (Jp. Tendai) school, argued that since all matter contains the fundamental, unchanging nature of all things, even non-sentient beings can become Buddha.[20] In China, there was considerable debate about this issue,[21] but in

Japan, this Tendai position was accepted by all the major new Buddhist sects (Shingon, Zen, Jōdo, and Nichiren), leading to the popular phrase "trees, grasses, and earth all become buddhas," which appears repeatedly in plant-spirit plays. By representing both the ever-changing seasonal nature of plants and the notion that these non-sentient beings can achieve Buddhahood, *Bashō* suggests that humans may be spiritually awakened by grasses and trees, which, like all phenomena, undergo continuous change even as they retain their unchanging Buddha nature.[22]

Plant-spirit plays also defend the value of *waka*. A good example is *Kakitsubata*, which is based on the famous story of a single poem in *The Tales of Ise*. As a priest (the *waki*), who has traveled to the Eight Bridges in Mikawa Province, gazes at the blooming iris, a young woman tells him about Ariwara no Narihira's (825–880) famous *kakitsubata* poem in which Narihira expresses his longing for a lover back in the capital. The woman later reappears in the Chinese robe (*karakoromo*) described in Narihira's poem, revealing that she is the spirit of the *kakitsubata*, that Narihira was the manifestation of a bodhisattva, and that she hopes to attain enlightenment through Narihira's poem, which has the power of a sutra. The play ends with the words of the chorus: "The flower of the iris, whose heart of enlightenment opens up, truly, in this moment, trees, grasses, and earth, truly, in this moment, trees, grasses, and earth all become buddhas, and with this she vanishes."[23]

The idea that the noted poet Ariwara no Narihira is a manifestation of a bodhissatva reflects *honji-suijaku* belief, which casts local deities as "traces" or incarnations (*suijaku*) of originary Buddhist gods (*honji*). In the Muromachi period, the logic of *honji-suijaku* was often reversed to give higher value to the local deity (here Narihira), making him or her the origin rather than the trace. In a similar manner, *Kakitsubata* uses Buddhist thought to give priority to *waka* and to make it the source and embodiment of the divine.[24] Thus the play is not only a manifesto of the Buddhist notion that "trees, grasses, and earth all become buddhas," but also a defense of *waka*, particularly against the Buddhist criticism of classical poetry as *kyōgen kigo* (wild words and ornate phrases), which condemned poetry for deceiving readers and arousing frivolous thoughts. *Kakitsubata* implies that *waka*, which was associated with love and passion, could function as an expedient means (*hōben*) to lead audiences to a higher level of truth or enlightenment.

Noh began as a form of entertainment for commoners involving mime and dance and then gained such elite appeal that it was performed regularly

for shoguns; this status was due primarily to the efforts of Kan'ami (1333–1384) and Zeami (1363–1443), who incorporated the classical poetic tradition into noh. In refashioning noh, dramatists drew on every possible source, from ancient myths to anecdotal literature to Buddhist texts. In doing so, they relied heavily on two intermediaries: *renga* manuals, which provided the lexical and cultural associations of particular poetic topics and words, and medieval commentaries on *waka* and the *Kokinshū*, which explored the "historical origins" of places, flowers, and plants in Japanese poetry and sought out the "historical personages" behind personifications in poetry. The secret commentaries, for example, explained how the "twin pines of Takasago and Suminoe grew old together," an anecdote that, when combined with poems on these trees, provided the basis for the noh play *Takasago*.[25] Noh dramatists combined this kind of *setsuwa*-based commentary with *honji-suijaku* belief, stressing the importance of *waka* as a means to enlighten the audience, particularly in the face of the Buddhist condemnation of literature as "wild words and ornate phrases."

In a number of noh plays, the spirit of a plant, particularly a tree, is a god (*kami*). According to Kageyama Haruki, *kami* were originally thought to be formless beings that resided in certain rocks and trees.[26] Trees—or branches or leaves—also functioned as intermediaries between humans and the gods, as in the example of the sacred branch of the *sakaki*, which appears as early as the *Nihon shoki* (*Chronicles of Japan*, 720), in which Ame-no-uzume-no-mikoto puts *sakaki* branches on her head in preparation to draw the sun goddess, Amaterasu, out of a grotto. *Sakaki* was used in Shinto rites as an offering to the *kami* or as an implement to drive away pollution or evil spirits. Shrines were originally thought to be sacred groves inhabited by the gods.[27] *Yorishiro*, objects that the *kami* could descend to, were often sacred trees called *shinboku* (sacred tree) or *himorogi* (marked dwelling place of a god).[28]

These animistic beliefs form the backdrop for noh plays such as *Oimatsu* (*Old Pine*), *Takasago*, and *Miwa*. In *Oimatsu*, a god-noh (*waki-nō*) and dream-noh (*mugen-nō*) play attributed to Zeami, a worshipper at the Kitano Tenman Shrine (dedicated to the poet Sugawara no Michizane [845–903]) has a dream telling him to visit the Anraku-ji temple in Tsukushi (present-day Kyūshū). When he arrives at the temple, he is met by an old man (the *mae-jite* [protagonist of the first half of the play]) and a guardian of the flowers. They tell the visitor about the Old Pine and the Crimson Plum (Kōbaidono), both divine trees, and then disappear. In the second half of the play, the god

of the Old Pine (the *nochi-jite* [protagonist of the second half]) appears, blesses the spring of the great reign, and dances. The story tells and dramatizes the legend of Sugawara no Michizane in which the plum tree, in response to a poem by its exiled master, Michizane, flies overnight to Tsukushi to follow him and then is followed by the pine (the name Oimatsu can be read as either "Old Pine" or "Following Pine"). In *Takasago*, another god play, the spirit of the god of Sumiyoshi resides in a pine at Sumiyoshi and the spirit of the god of Takasago resides in a pine at Takasago. In *Miwa*, a dream-noh play, a priest (the *waki*) gives a woman (the *mae-jite*) a robe that appears the next day hanging from a cypress tree. When the priest prays beneath the cypress, the god of Miwa appears in the form of the woman, tells the ancient myth about Mount Miwa, dances a god dance (*kagura*), and disappears. In this play, the spirit of a god (Myōjin of Miwa) resides in a cypress tree.

Nature in noh, in short, derives from both the Heian court poetry tradition and the animistic medieval farm-village landscape, often incorporating both into one play.

## Resistance and Legitimation

The medieval period, beginning around the early thirteenth century, was a time of extensive deforestation in Japan, as farmers cleared trees to lay out new rice fields.[29] As medieval anecdotal tales (*setsuwa*) reveal, there was constant conflict between farmers who wanted to fell trees and long-held beliefs in the spirits of large trees. Two kinds of forests appear in medieval anecdotal literature. The first is the coppice (mixed-tree) woodland (*zōkibayashi*), represented by the red pine (*akamatsu*), which surrounded the farm villages (*satoyama*) and covered the foothills of the mountains. This forest was considered communal property and was constantly harvested by villagers, who used it for fertilizer, building materials, firewood, and other basic necessities. The second kind of forest, which was found deeper in the mountains, consisted of oak (*kashi*), chinquapin (*shii*), and other broad-leaved evergreen trees that grew to great heights and were thought to be divine or inhabited by gods.[30] Stories about cutting down "giant trees" usually involved these trees, which often grew on or around the grounds of a shrine and temple.

Farmers, who had to hew large trees that were blocking sunlight, fre-
quently turned to higher authorities, including the emperor, for aid, as in
"Giant Oak at Kurimoto District in Ōmi Province" (31:37) in *Konjaku mo-
nogatari shū*. In this story, the shadow of a giant beech tree in Ōmi Province
prevents villagers in three districts from tilling the land. The farmers receive
imperial permission to fell the tree, which they do without hesitation. The
elimination of the tree results in a bountiful harvest. The story reinforces the
authority of the emperor, who brings prosperity, but also shows that the
farmers were afraid to cut down large trees and felt the need to placate their
angry spirits. As Hōjō Katsutaka has shown, the long history of myths, leg-
ends, and folktales about this conflict tends to break down into two catego-
ries: narratives that legitimize the felling of large trees, and narratives that
reveal the resistance of the trees.[31]

Japanese folktales about the resistance of trees include these narrative
variations:

1. When part of a tree is cut, it immediately grows back.
2. Blood flows from the gash in the tree.
3. The tree refuses to be cut.
4. The tree screams or groans when cut.
5. The spirit of a tree appears in human form and marries a human
   being.
6. The woodcutter becomes ill or dies.
7. The felling of the tree brings natural disaster.
8. The tree is cut down but refuses to be moved.[32]

In these narratives, the tree is shown to have the emotions, flesh, blood, and
suffering of human beings. If the spirit of a giant tree marries a human, the
union results in a child, but when the tree is cut down, the tree spirit and its
family are forced to part. Sometimes, when the tree refuses to be felled or to
move, the family offers prayers to pacify its spirit and the tree is finally
turned into lumber.

Probably the best-known tree-spirit narrative of this type is the play
*Sanjū sangendō munagi no yurai* (*Origins of the Ridgepole of the Thirty-Three-
Pillar Buddhist Hall*), which first appeared as a puppet play (*jōruri*) in the
Hōreki era (1751–1764) and later became popular as a kabuki play.[33] The
protagonist is a giant, old willow in the mountains of Kumano (Kii Province)

that is about to be cut down, but whose life is saved by a samurai called Yokosone Heitarō. (In the *Kojiki* [*Record of Ancient Matters*, 712] and *Nihon shoki*, legends about tree deities are almost exclusively located in Kii Province, perhaps because that vast forest region was close to the center of imperial power.)[34] In the play, the tree spirit appears as a beautiful woman called Oryū (Willow), who marries the samurai and bears him a child named Midorimaru. At the request of Retired Emperor GoShirakawa (1127–1192, r. 1155–1158), an order is given to cut down the giant willow in Kumano to build the ridgepole for the Thirty-Three-Pillar Buddhist Hall in Kyoto. When Oryū learns that she is about to die, she bids farewell to Heitarō and Midorimaru and disappears. The huge willow is brought down and hauled to the capital, but it suddenly stops in front of Heitarō's house; only when Midorimaru straddles the tree and sings does it slowly begin to move again, allowing for the completion of the temple hall. In Japanese myths, the marriage between a human and an animal usually ends (as in the myth "Luck of the Sea and Luck of the Mountain" in the *Kojiki* and *Nihon shoki*) when a taboo on viewing is broken and the animal is seen by a human. But in the marriage between a human and a plant, the plant usually withers away or is tragically cut down, as in the Muromachi popular tale "Kiku no sei monogatari" (Chrysanthemum Spirit; also known as "Kazashi no hime" [The Story of Princess Kazashi], sixteenth century).[35] The *jōruri*–kabuki version of *Sanjū sangendō munagi no yurai*, which stresses the close bonds between husband and wife, mother and child, also reflects the tension between the power of the imperial state and the sympathy of commoners toward the sacrificed tree. As with many noh plays, this drama has a *chinkon* (pacification of a restless or angry spirit) function, intended to offer prayers to a god or spirit who died an unnatural or unfair death.

The literature of the Muromachi period, both popular and dramatic, is marked by a major reemergence of animism, which appears extensively in ancient chronicles and remains in popular narratives of the Heian period, but is almost completely absent from Heian court tales and classical poetry. Medieval popular narratives also incorporated local folklore, particularly about foxes, badgers, and other semi-imaginary animals that interacted with the inhabitants of the farm village (*satoyama*).[36] The emergence of spirits of plants and animals in Muromachi popular literature can also be traced, at least in part, to the increasingly widespread Buddhist belief in the

notion that "trees, grasses, and earth all become buddhas." Instead of regarding animals as a lower tier of existence—as part of the Six Worlds (Rokudō), or six levels of samsaric migration—as in early Heian–period *setsuwa* anthologies such as the *Nihon ryōiki*, animals and plants were thought in this new Buddhist view to have the potential to be enlightened and achieve salvation. This idea overlapped with long-held indigenous beliefs in the spirits of trees, plants, and animals, many of which were locally worshipped or feared as gods (*kami*) and often served as a link to the other world. The capital-centered, *waka*-based, highly codified elegant view of nature and the four seasons also had a profound impact on popular narratives and drama, which became a rich mixture of both classical and provincial representations of nature.

The Muromachi and early Edo periods were a time of great destruction of the natural environment caused by extensive urbanization, expansion of new rice fields, excessive harvesting of the forest, and poor conservation. In the rural villages, this resulted in bald mountains (*hageyama*), forcing animals from their natural habitats and causing some of them, such as wolves, to attack humans. The many animal and plant spirits in Muromachi tales may also be interpreted as surrogates for a natural environment that was being heavily damaged. As the ecological balance between humans and animals/plants deteriorated, the spirits of animals and plants in farm villages became more prominent in the social and literary unconscious. Like many of the ghosts in noh, the spirits of plants and animals in popular narratives may be considered the voices of the vanquished. A number of plays end with a prayer for the salvation of the suffering or dead plant or animal, suggesting a need to pacify the spirit of the dead (*chinkon*) and the damaged part of nature, particularly animals driven from their habitats and forests cleared of their trees.

This kind of conflict is particularly prominent with regard to large trees. Japan has historically made extensive use of wood in traditional architecture: palace-style (*shinden-zukuri*) and parlor-style (*shoin-zukuri*) residences, temples and shrines, and imperial and shogunal castles. Indeed, wood is an integral part of the "natural" appearance of Japanese architecture and design, and it contributes significantly to the sense of harmony between the human and the natural. The construction in 758 of the Tōdaiji daibutsuden (Tōdaiji Temple Hall of the Great Buddha) in Heijō (Nara), the capital, caused the first widespread deforestation in this region. The high volume of

subsequent wood consumption resulted in a constant tension between the need to cut down the forest and the anxiety and fear caused by such destruction. The various folk narratives that center on the felling of large trees reveal both the resistance to and the legitimization and rationalization of such devastation.

Set against such despoliation, nature was also used as a means of protection against disaster and danger. Throughout the history of both court culture and farm-village life, nature was both feared and worshipped, but first in court culture and later in commoner culture, systematic representations of nature—in the form of poetry, visual art, and drama—were used to aid against unpredictable threats, to bring a sense of harmony to an otherwise tumultuous world.

*Chapter Five*

# Trans-Seasonality, Talismans, and Landscape

Japanese poetry displays extreme sensitivity to the transience of nature and the passing of the seasons. This might be attributed to the rainy climate and the quick growth of vegetation; for example, the reed (*ashi*), which became a symbol of Japan in the ancient period, is one of the fastest-growing plants in the world. A more convincing explanation, however, is that natural change came to be a metaphor for the transience of life and the uncertainties of this world, a view that was reinforced by the Buddhist belief in the evanescence of all things. This perspective became particularly prominent from the Heian period (794–1185) and permeates poetic representations of both nature and human life, as exemplified by such a seasonal topic as cherry blossoms, which scatter as soon as they bloom.

The notion of nature as constant transformation was also accompanied by either talismanic or trans-seasonal representations of nature, which sought to counter ephemerality. The *Oxford English Dictionary* defines "talisman" as "a stone, ring, or other object engraven with figures or characters, to which are attributed occult powers of the planetary influences and celestial configurations under which it was made; usually worn as an amulet to

avert evil from or bring fortune to the wearer; also medicinally used to impart healing virtue; hence, any object held to be endowed with magic virtue; a charm."[1] These talismanic functions, whose power in Japan is generally drawn from different aspects of the natural world, are a recurrent feature of textual, visual, and dramatic representations of nature. A close examination of the history of culturally prominent plants reveals three fundamental types:

- Those such as the cherry blossom, bush clover, and yellow valerian, which embody impermanence, fragility, and vulnerability
- Those such as the plum, mandarin orange, wisteria, and chrysanthemum, which are associated with a specific season but sometimes also have auspicious and talismanic functions
- Those such as the pine and bamboo, which transcend the seasons and have very strong talismanic functions

The talismanic powers of natural motifs emerged in the ancient period, played an important role in the court culture of the Heian period, and continued to be of major importance in the medieval period (1185–1599). In noh plays of the Muromachi period (1392–1573), this function was carried out by the deity- or god-noh (*waki-nō*) plays, which came at the beginning of a day of performances. The most famous of these dramas are *Takasago*, *Kiku jidō* (*Chrysanthemum Child*), and *Tsurukame* (*Crane and Turtle*), which use icons of nature as a means to pray for long life and happiness. This talismanic function also appears in a wide range of Muromachi popular tales (*otogi-zōshi*), including "Urashima Tarō" (Urashima's Eldest Son), "Sazareishi" (Small Stones), and "Suehiro monogatari" (Tale of the Open Fan).[2] In the early Edo period (1600–1867), such stories were read by young women at the beginning of the New Year to bring good luck and were given as bridal gifts (*yomeiri-bon*). These auspicious narratives (*shūgi-mono*) represent prayers for happiness in marriage, birth of children, achievement of wealth, promotion in rank, and other forms of worldly success, but the most frequent prayer is for longevity and rejuvenation. In all these texts, trans-seasonal or talismanic icons of nature play a major role, as do such utopian spaces as the Buddhist Pure Land (Jōdo), Mount Hōrai (Jp. Hōrai-san, Ch. Penglai), and the Dragon Palace (Ryūgū), where old age and death are suspended. These idealized other worlds, which are represented not only in Muromachi tales

but in Japanese gardens, were derived from Indian, Chinese, and Japanese myths and often fused various mythic elements. Perhaps the most frequently used natural symbols are pine and bamboo, crane and turtle, and the seven herbs (*nanakusa*), which are also the main ingredients of New Year annual observances. "Nanakusa sōshi" (The Tale of Seven Herbs), a Muromachi tale set in China, tells how the seven herbs acquired felicitous value. A number of talismanic stories, like their noh counterparts, are set in the ancient period, describing emperors who lived for an extremely long time—an image that was also thought to be felicitous. Reading a tale, such as "Bunshō sōshi" (The Tale of Bunshō) or "Issun bōshi" (Little One-Inch), about a commoner of low birth rising to great social heights, a miraculous happening that would have been attractive to commoner audiences, was also thought to bring good luck. As Ichiko Teiji has noted, the popularity of these kinds of tales in the Muromachi period may be attributed to a general sense of impermanence caused by the chaos of war, the instability of society, and the uncertainty of everyday life.[3] The desire for talismanic protection extended from the lowest levels to the highest reaches of Heian court and medieval elite samurai society, where it was represented in the most lavish attention to screen paintings, design, and dress.

## The Power of Green

In the ancient period, the green leaves and colorful flowers that appear in spring were believed to be full of a life force. Songs describing the thickening of the tree leaves and the blooming of the flowers were a means to praise and tap into that life force. Flowers, leaves, and branches of trees were broken off and placed in the hair (an action called *kazasu*) so that the life force could be transferred to the body. This early belief eventually led, in the eighth century, to the custom at banquets of decorating hair with a branch or flower—usually that of willow, plum, bush clover, or pink.

The leaves of evergreen trees such as mistletoe (*hoyo* or *yadorigi*), mandarin orange (*tachibana*), Japanese cedar (*sugi*), and pine (*matsu*) were thought to have particular vitality. In a poem in the *Man'yōshū* (*Collection of Ten Thousand Leaves*, ca. 759) composed by Ōtomo no Yakamochi (717?–785) at a banquet in the spring, on the second day of the First Month of 750, the poet decorates his hair with mistletoe, which remains green throughout the

winter: "Taking the mistletoe from the top of the mountain and placing it in my hair, wanting to celebrate a thousand years" (*Ashihiki no yama no konure no hoyo torite kazashitsuraku wa chitose hoku to so* [18:4136]). A similar belief lies behind the use of branches of the *sakaki* (a kind of camellia) in Shinto ceremonies and the *shikimi* (Japanese anise tree) in Buddhist rituals. The arrival of spring was marked by a series of rites such as flower viewing (*hana-mi*), originally thought to transfer the life force of the flowers to the participants. In *no-asobi* (prayers in the moor), one of the most important spring observances, grasses were gathered, boiled, and eaten so that their fresh life force could be absorbed into the body.

The belief in the magico-religious power of flowers and plants is also evident in the flower-grass designs that were brought to Japan from Tang China (618–907), became popular among Japanese aristocrats in the seventh and eighth centuries, and are preserved in the Shōsōin, in the Tōdaiji temple, in Nara. The most popular of these symmetrical designs were of the lotus (*hasu*); palmette (*parumetto*), which looks like an open fan and resembles a palm leaf; *hōsōge* (literally, "treasury flower"); and *karakusa* (literally, "Chinese grass"), a pattern of vines—plants or flowers that were thought never to fade. The *hōsōge* figure combines the peony, lotus, pomegranate, and other flowers to create a single beautiful flower in an arabesque pattern; in China, it was thought to bloom in Buddhist Heaven and the land of the immortals and is represented on Japanese sutra containers.

The most important and by far the most popular of the trans-seasonal trees is the pine (*matsu*), an evergreen with needle-shaped leaves. Of the many types of pine native to Japan, the red pine (*akamatsu*) and the black pine (*kuromatsu*) are the best known. The red pine grows in mountains and fields, where it was cultivated, and the black pine flourishes on the seacoast. From the ancient period, pine was used for lumber and for pine torches (*taimatsu*), but culturally it was known for its long life and unchanging green color and consequently became a sacred tree associated with longevity, as in this poem by Ki no Asomi Kahito: "The pine, the tree that waits for a thousand reigns, that flourishes and stands godly at Shigeoka, knows no year" (*Shigeoka ni kamusabitachite sakaetaru chiyo matsu no ki no toshi no shiranaku* [*Man'yōshū*, 6:990]).

In another poem, Ōtomo no Yakamochi contrasts flowers, which fade and wither, with the pine, which remains unchanged: "As the eight thousand flowers fade, let us tie the branch of the unchanging pine" (*Yachikusa*

*no hana wa utsurou tokiwa naru matsu no saeda wo ware wa musubana* [*Man'yōshū*, 20:4501]). In the ancient period, tying a ribbon to a branch of the pine was an act of prayer for safety and long life. The root of the pine was thought to have no end (*tayuru koto naku*), as in a poem written by a woman who was confident that her lover would remain true to her: "Like the root of the pine that grows god-like on the crags, your heart will not forget me" (*Kamusabite iwao ni ouru matsu ga ne no kimi ga kokoro wa wasurekane-tsumo* [*Man'yōshū*, 12:3047]). The pine also functioned as a *yorishiro*, a place for a god to rest or descend to the Earth. The gate pine (*kadomatsu*) set out for the New Year, the three pines placed on the bridge (*hashigakari*) of the noh stage, and the old pine (*oimatsu*) depicted on the backs of mirrors—all derive from the belief in the pine as a talisman. In the Heian period, the rite of "pulling up the small pine" (*komatsu-hiki*), performed on the first Day of the Rat (Nenohi) in the First Month, was similarly a prayer for long life. The pine was the main tree in the palace-style (*shinden-zukuri*) garden of the Heian period, and the reflection of the pine in the lake was taken as an image of the prosperity of the owner of the residence. The pine also became an indispensable element in Heian-period screen paintings (*byōbu-e*) commissioned for celebratory occasions.

In *waka* (classical poetry), the pine has specific homophonic associations, especially with the verb *matsu* (to wait) and with the emotions of waiting for a lover: "If the flower of the plum tree blooms and scatters, I will be the pine that waits, wondering if my beloved will come or not come" (*Ume no hana sakite chirinaba wagimoko wo komu ka koji ka to aga matsu no ki so* [*Man'yōshū*, 10:1922]).[4] Indeed, the association of the pine with waiting grew so strong that by the mid-tenth century, more than half the poems that feature the image of the pine appear in the love books of the *Gosenshū* (*Later Collection*, 951). Like many other natural images, the pine had multiple purposes, depending on the topic, context, and genre.

Another major talismanic plant is bamboo (*take*), a perennial grass that multiplies through its underground stems.[5] Like China, Japan depended heavily on bamboo for everyday life; it was used for food, building material, brush handles, flutes, bows, arrows, umbrellas, fans, brooms, and lamp shades. The young buds or shoots (*takenoko*; literally, "children of bamboo"), which emerge underground, were also valued as food. In all probability, the fast growth of bamboo was considered auspicious, and the bamboo epithet implied long life and prosperity. Bamboo also became associated with

immortality as a result of its evergreen leaves, and it appears frequently in the celebration (*ga*) books of the imperial *waka* anthologies from the *Go-senshū* onward, as in this poem from the *Shūishū* (*Collection of Gleanings*, 1005–1007), composed for a screen painting made in 934 to celebrate the fiftieth birthday of an empress: "Only you will see which lasts longer—the bamboo or the pine, both of unchanging color" (*Iro kaenu matsu to take to no sue no yo wo izure hisashi to kimi nomi zo mimu* [Celebration, no. 275]). Bamboo also came to be identified with long life because of the numerous "joints" (*fushi*) in the stem, as in this poem from the *Senzaishū* (*Collection of a Thousand Years*, 1183): "Above all, you compare to the thousand years packed in the many joints of the bamboo that I planted and view in the brushwood fence" (*Uete miru magaki no take no fushigoto ni komoreru chiyo wa kimi zo yosoen* [Celebration, no. 607]). In China, bamboo forests were associated with the Seven Sages of the Bamboo Grove (Ch. Zhu lin qi xian, Jp. Chikurin no shichiken), who turned their backs on the world and enjoyed themselves in a bamboo forest—a painting topic that became very popular in Japan in the Edo period. Since bamboo is an evergreen and grows straight, it also became a symbol of fidelity and chastity.

## Talismanic Birds and Fish

The foremost example of a celebratory, trans-seasonal bird in Japanese culture is the crane (*tsuru*). The word *tsuru* usually refers to the modern *tanchō tsuru*, a large bird with a long neck and beak, big wings, long legs, and a relatively short tail. These cranes congregate near rivers, swamps, and the ocean, where they eat fish. The crane appears in forty-six poems in the *Man'yōshū*, coming in fourth in frequency among birds after the small cuckoo, wild goose, and bush warbler. Almost all the early crane poems were composed by aristocrats while traveling along the coast, where the crying crane (*tazu*) became an implicit metaphor for the loneliness of the traveler.[6] Since the crane was thought to be happily mated and to care for its young, the crying of the crane was believed to express longing for its mate or its chicks.[7] These associations—longing for home and for the family—continued into the Heian period, as in this poem from the *Shikashū* (*Collection of Poetic Flowers*, 1151–1154): "Separated from its young in the capital, the evening crane

longs for its children, crying until dawn" (*Yoru no tsuru miyako no uchi ni hanatarete ko wo koitsutsu mo nakiakasu kana* [Miscellaneous 1, no. 340]). In the succeeding Kamakura period (1185–1333), the nun and poet Abutsu (d. 1283) wrote *Yoru no tsuru* (*Evening Crane*, ca. 1276), a poetry treatise, out of concern for the future of her son Reizei Tamesuke.

In the Heian period, the crane was also transformed into a symbol of long life. This shift of the crane from a flying bird to an auspicious bird, like the emergence of the auspicious chrysanthemum, probably reflects Chinese influence during the reign of Emperor Saga (786–842, r. 809–823). It is referred to as *tsuru* and often is combined with the turtle or the pine in celebratory poems (figure 18). In a poem by Kiyohara no Motosuke—"When winter comes to the crane that lives in the pine at Takasago, the frost on the hilltop no doubt becomes whiter than ever" (*Takasago no matsu ni sumu tsuru fuyu kureba onoe no shimo ya okimasaruran* [*Shūishū*, Winter, no. 237])—since the white crane roosts in the pine, the frost at the top of the hill becomes even whiter, enhancing the eternal life of the pine. (Like red, white was considered a talismanic color.) In his twelve-month bird-and-flower *waka*, which became popular among almost all Edo-period painting schools, Fujiwara no Teika (1162–1241) placed the crane in the Tenth Month. As a consequence, the crane is depicted in the Tenth Month in twelve-month bird-and-flower screen paintings (*jūnikagetsu kachōzu*), including those by Ogata Kenzan (1663–1743)[8] and Kanō Eikei (1662–1702).[9] In short, the crane came to function as both a seasonal and a talismanic image.

In the Tenpyō era (729–749), decorative objects—many of which had originated in ancient Assyria and Egypt and in Persia—were brought to Japan from the continent by emissaries to Tang China and by visitors from Shiragi (in present-day Korea). A number of these objects were decorated with images of auspicious and magical birds, including the phoenix (*hōō*), kalavinka (*karyōbinka*), parrot (*ōmu*), mandarin duck (*oshidori*), peacock (*kujaku*), and flying bird with a flower in its beak (*hana kui dori*).[10]

In China, the phoenix was one of the four sacred animals, along with the kylin (*kirin*), dragon, and turtle. The *Engishiki* (*Ceremonial Procedures of the Engi Era*, 927) describes the phoenix as resembling a crane, having the head of a chicken (or rooster), the beak of a swallow, the neck of a snake, and the body of a dragon. In the section "Ko no hana wa" (As for Tree Flowers) in *Makura no sōshi* (*The Pillow Book*, ca. 1000), Sei Shōnagon notes that the

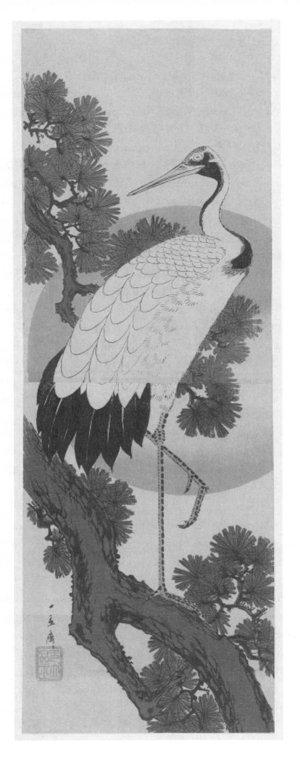

lavender flowers of the paulownia are very attractive, that the leaves are broad and distinctive, and that in China the legendary phoenix selects the paulownia tree to roost in. In both China and Japan, the phoenix became a sign of peace and sage rule, and the emperor's outer robe (*hou*) featured a paulownia, bamboo, and phoenix design. In Japan, the phoenix first appeared in handiwork and crafts of the Asuka period (late sixth–mid-seventh century) and became a major topic and motif in painting, architecture (such as the Byōdō-in at Uji, where the Amida Hall became known as the Phoenix Hall), and design of the Heian period.[11] In the Momoyama period (1568–1615), the phoenix was very popular among warlords, who had it portrayed in screen paintings, a practice that continued into the Edo period, as exemplified by *Phoenixes and Paulownia*, a screen painting attributed to Tosa Mitsuyoshi (1539–1613).[12] In the Edo period, bed covers were decorated with images of the paulownia and phoenix to ward off evil spirits at night.[13]

The kalavinka, an imaginary Buddhist bird with a bodhisattva for its upper body and a bird for its lower body, was believed to live in snowy mountains or a Buddhist heaven and to have a voice like that of the Buddha. The parrot, which also became an auspicious motif in Japanese painting and design, usually is depicted in pairs, with the two parrots facing each other. The mandarin duck, the male and female always swimming or sleeping together, similarly figures on Japanese ceramics, paintings, mirrors, noh robes, wedding furniture, and clothing as an auspicious symbol of fidelity and marital harmony. A flying bird with a flower or branch in its beak was believed to bring good fortune from the heavens. This image, which was very popular in the Tenpyō era, evolved into a flying crane with a pine branch in its beak, thus combining three symbols of longevity: the crane, the pine, and the bird with a flower in its beak. This triad appears widely on mirrors, lacquerware, and dyed cloth produced in the Heian and medieval periods.[14]

FIGURE 18

*CRANE, PINE, AND RISING SUN*

The rising sun (*hinode*), now used on the national flag, was considered an auspicious sight, particularly at the beginning of the year, and the crane and pine were associated with long life. This woodblock print (ca. 1852–1853) by Utagawa Hiroshige (1797–1858) is typical of a broader tradition of using such talismanic natural motifs. (Color woodblock print [signed Ichiryūsai]; vertical *ōban*, 28.4 × 9.8 inches. Courtesy of the Museum of Fine Arts, Boston, William and John Spaulding Collection, 1921, no. 21.68888)

Almost all these exotic or magical birds were popular subjects for bird-and-flower paintings (*kachōga*), which emerged in the Northern and Southern Courts period (1336–1392) and flourished in the Edo period.[15] These paintings, particularly those by the Kanō and Tosa schools—which were patronized by the military government (*bakufu*) and the imperial court, respectively—often were given as gifts on important occasions to high-ranking or powerful individuals. They had the ritualistic function of conferring good fortune on or acknowledging the virtue or authority of the recipient. If given as a wedding present, the painting was a good-luck charm, meant to ensure a harmonious and long-lasting relationship. These talismanic birds were frequently combined with auspicious trees and other plants (such as pines and bamboo) in designs to decorate clothing, furniture, and other objects.

As did certain plants and birds, some fish—notably the carp (*koi*) and the sea bream (*tai*)—became auspicious signs. In China, the word for "fish" (*yu* 魚) was homophonous with the words for "extra" (*yu* 余) and "jewel" (*yu* 玉) and, as a consequence, came to mean "good fortune" and "the flourishing of descendents." Since they produce many eggs, fish became a symbol of fertility and were a popular design motif in Japan from the ancient period. Shrimp (*ebi*), written with the characters 海老 (Ch. *hailao*; literally, "elder of the sea"), came to connote long life. *Katsuo* (bonito) was regarded as auspicious among samurai because of the word's homophony with *katsu* (to win), much as *kuromame* (black beans) were eaten at the New Year because they implied *mame* (good health or a strong body).

In the medieval period, the carp was considered the king of freshwater fish, and in section 118 of *Tsurezuregusa* (*Essays in Idleness*, 1310–1331?), Priest Kenkō (ca. 1283?–1352?) refers to carp as the fish of all fish (figure 19). In China, the carp was thought to climb the rapids called Dragon Gate (Ryūmon) and become a dragon, and as a consequence it was valued as a symbol of social ascent or success; in Japan, it was served at a samurai's coming-of-age ceremony (*genpuku*). The raising of carp streamers (*koinobori*) on poles at the Tango Festival (now Boy's Day) is a continuation of this tradition.

In the Edo period, with the shift of political and economic power to major port cities, the sea bream, considered the best of the sea fish (being tasty, attractive in form, and auspicious), replaced the carp as the king of fish. In the famous opening line of "Hyakugyo no fu" (Ode to a Hundred Fish), the *haikai* poet Yokoi Yayū (1702–1783) writes: "Among humans, [the best] is

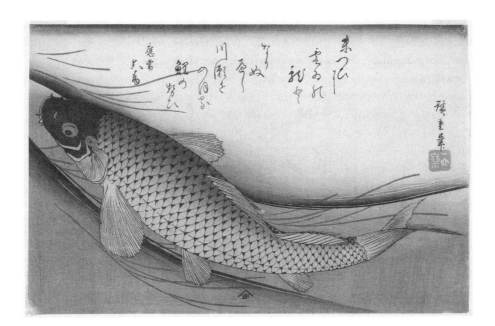

FIGURE 19

CARP WITH *KYŌKA* POETRY

This woodblock print (ca. 1840–1842) in Utagawa Hiroshige's (1797–1858) "Fish Series" (Sakana-zukushi) has three major features: the talismanic function of the carp climbing the rapids; the realistic depiction of the fish; and the inscribed *kyōka*, which reinforces the talismanic theme of the dragon in the clouds: "In the end, it no doubt becomes a dragon in the clouds of the palace—the force of the carp climbing the river rapids" (*Sue tsui ni kumoi no ryū to narinubeshi kawase wo noboru koi no ikioi*). (Color woodblock print, 9.8 × 14.4 inches. Courtesy of the Museum of Fine Arts, Boston, William and John Spaulding Collection, 1921, no. 21.9616)

the samurai; among pillars, the best is cypress; and among fish, it's the sea bream" (*Hito wa bushi, hashira wa hinoki, sakana wa tai to yomikeru*).[16] When the sea bream comes to the Inland Sea to spawn, its red color becomes even brighter than usual, due to hormones, and as a result it is called *sakuradai* (literally, "cherry-blossom sea bream") or *hanami-dai* (cherry-blossom-viewing sea bream), both of which are seasonal words for spring. Before its spawning run, the sea bream eats a large quantity of shrimp, which was thought to intensify the fish's red color. Because of its auspicious

color and its phonic associations with the adjective *medetai* (auspicious), the *tai* came to be associated with Ebisu, one of the Seven Gods of Good Fortune (Shichifukujin), who is depicted carrying a sea bream and who became a god of business for merchants. Merchant houses celebrated Ebisukō (Ebisu Festival) on the twentieth day of the Tenth Month with unlimited eating and drinking for employees, relatives, friends, and guests. Samurai, who sought to avoid being "cut" in battle, served the fish whole on celebratory occasions.

## Auspicious Topography

Both Heijō (Nara) and Heian (Kyoto), the capitals during the Nara (710–784) and Heian periods, sit in basins with mountains to the north, east, and west. In the seasonal poems of the *Man'yōshū*, spring first appears as mist over the mountains; the small cuckoo (*hototogisu*), the harbinger of summer, arrives from the other side of the mountains; the autumn deer live in the mountains; and the wild geese fly over the mountains. In other words, the mountains became the dominant landscape on which the four seasons unfold, as is evident in such poetic words as "autumn mountain" (*aki-yama*), which refers to bright foliage, and "summer mountain" (*natsu-yama*), which implies the deep green and dense vegetation caused by the long summer rains (*samidare*). At the same time, from as early as the Nara period, in the *Kaifūsō* (*Nostalgic Recollections of Literature*, 751), the first major anthology of *kanshi* (Chinese-style poetry), mountains were treated as a place of the immortals. In the sphere of Buddhist and folk religion, large mountains, particularly those with high and sharp peaks, were regarded as sacred and became the sites of annual pilgrimages.[17]

There were also talismanic landscapes, which were thought to bring good fortune and protection to their owners or creators. The most prominent example is the lake island (*nakajima*), a major feature of the palace-style (*shinden-zukuri*) garden of the Heian period (see figure 13). The lake with an island, which also appears in the gardens of temples and shrines, can be traced back to ancient beliefs about the Eternal Land (Tokoyo or Tokoyo no kuni), thought to be an island or a string of islands inhabited by gods.[18] By building "isles of eternity" in their garden lakes, Japanese aristocrats in the Nara and subsequent periods sought to bring the power of

those gods within their reach. The southern side of the palace-style residence is centered on a small lake with one or two of these islands. The edge of the island was often constructed to look like a rough seashore (*araiso*), a windswept beach lined with irregular boulders.[19] The sea could also be evoked by a cove beach (*suhama*) or a series of deeply indented coves, which were created by laying out pebbles to look like a shoreline after the tide recedes.

Both the lake island and the cove beach became auspicious talismanic images in a wide range of Japanese traditional arts, from poetry to kimono, lacquerware (figure 20), mirrors, and furniture.[20] For Heian-period poetry contests (*uta-awase*) and on celebratory occasions such as the New Year and weddings, a portable island stand (*shima-dai*), also referred to as a cove beach stand (*suhama-dai*), was placed in the central hall (*shinden*) of a palace-style residence. Figurines representing a small mountain; pines, bamboo, and plum; a crane and turtle; and/or an old man and old woman were placed on a miniature cove beach to create the felicitous image of Mount Hōrai (Jp. Hōrai-san, Ch. Penglai),[21] a tradition that has continued to the present day.

From the late sixth century, Chinese beliefs about the three islands of immortals—Hōrai, Hōjō (Ch. Fangzhang), and Eishū (Ch. Yingzhou)—entered Japan and were fused with the indigenous belief in the Eternal Land.[22] It was thought that when mortals approached Mount Hōrai, the wind would blow them away, not allowing them to step on the island. In the Heian period, the three mythic islands were combined with or transformed into Crane Island and Turtle Island, which had been familiar symbols of immortality and good fortune. Crane and Turtle islands made of rock became particularly popular in the Muromachi period and appeared in symbolic form in rock-and-sand gardens (*kare-sansui*).[23] In the large gardens built by provincial warlords (daimyo) in the Momoyama and Edo periods, visitors were able to cross bridges and walk to the felicitous islands in the lakes.

## Four Seasons in Four Directions

Another type of talismanic landscape was the four-seasons–four-directions garden, which appeared as early as the Heian period and is extremely prominent in Muromachi tales (*otogi-zōshi*). The notion of four seasons in four directions can be traced in part to *fūsui* (Ch. *feng shui*) geomancy,

FIGURE 20

MOUNT HŌRAI WITH COVES, CRANES, AND PINES

The design on this black lacquer incense container (thirteenth or fourteenth century) depicts Mount Hōrai—the legendary island in the sea where immortals live—surrounded by a winding cove beach, covered with pines, and populated by cranes. Similar talismanic configurations appear in Heian-period island stands, in medieval rock-and-sand gardens, and in medieval and Edo-period screen paintings. (Black lacquer, with mother-of-pearl inlay and gold flakes; 3.1 × 2.4 × 1.2 inches. Courtesy of the Suntory Museum of Art, Tokyo)

which was imported from China and Korea and which lay behind Nara- and Heian-period urban planning. *Fūsui* (literally, "wind and water") was based on the belief that the land contained vital forces that had to be secured for the prosperity of the residents. The ideal terrain had a mountain to the north, hills to the east and west, and a plain facing the sea or a river to the south. The imperial capitals of Fujiwara (694–710), Heijō (Nara [710–784]),

and Heian (Kyoto [794–1868]) and the first shogunate capital of Kamakura (1192–1333) were constructed to meet these requirements.[24]

The practice of *fūsui* revolved around four guardian gods (*shijin sōō*), who stood in the four directions and corresponded to the four seasons:[25]

Black Tortoise / North / Winter

White Tiger / West / Autumn ————— Blue Dragon / East / Spring

Scarlet Bird / South / Summer

According to the *Sakuteiki* (*Record of Garden Construction*, 1040), attributed to Tachibana Toshitsuna (1028–1094), the water that comes from the house and flows east is called the Blue Dragon (Seiryū).[26] The road that goes west is called the White Tiger (Byakko). The lake to the south is called the Scarlet Bird (Shujaku). The hill to the north is called the Black Tortoise (Genbu). In the Heian capital, the water to the east was the Kamo River, the large road to the west was San'indō, the lake to the south was Lake Ogura, and the mountain to the north was Kitayama (Northern Hills).

In the ancient period, autumn was believed to arrive from the west. Significantly, the Tatsuta River, at the foot of a canyon pass in the northwestern corner of Heijō, was the most notable autumnal poetic place (*utamakura*). Tatsuta's association with autumn probably derives from the Tatsuta Shrine, whose god ruled over the wind and was thought to foster or destroy the harvest. In similar fashion Mount Sao (Saho), in the northeastern corner of Heijō, was the home of the goddess of spring, Saohime (Princess Sao), who was worshipped at Sao Shrine at the foot of Mount Sao. In short, the gods of autumn and spring stood at the western and eastern sides of the capital, which eventually became the poetic places for these seasons.

The *fūsui*-based garden design of spring in the east, summer in the south, autumn in the west, and winter in the north became a cultural ideal, as suggested by court tales such as *Utsuho monogatari* (*The Tale of the Hollow Tree*, 980), *The Tale of Genji* (*Genji monogatari*, early eleventh century), and *Eiga monogatari* (*Tales of Splendor and Glory*, ca. 1028–1092?). The "Koma kurabe" (Comparing Horses) chapter of *Eiga monogatari*, a historical narrative of the life of the regent Fujiwara no Michinaga, describes the garden of

the Kaya-no-in Palace, which was reconstructed in 1019 by Fujiwara no Yorimichi. The garden is laid out "so that one can see the four seasons in four directions."[27] The "Fukiage" chapter of *Utsuho monogatari* similarly describes a mansion constructed by Tanematsu of Kaminabi-in with gardens in four quarters: the spring garden (east) has hillocks, the summer garden (south) has shade, the autumn garden (west) has thickets of trees, and the winter garden (north) has a pine forest.[28] The most famous variation on the *fūsui* model is the Rokujō-in in *The Tale of Genji*, the grand residence built by the Shining Genji at his political apex to house his most important women: Lady Murasaki (Lavender), who was discovered by Genji in the spring, is placed in the spring quarters (to the southeast); Akikonomu (One Who Loves Autumn) lives in the autumn quarters (to the southwest); Hanachirusato (Village of Scattered Flowers) resides in the summer quarters (to the northeast); and the Akashi lady inhabits the winter quarters (to the northwest). Genji's most treasured woman (Murasaki) occupies the spring quarters, and the most publicly important woman (Akikonomu) occupies the autumn quarters. The Rokujō-in does not strictly follow the seasonal-directional correspondences found in the *Sakuteiki* and other *fūsui*-based models, but it is close: the summer garden is shifted one and a half quarters and the three other seasons deviate by only half a quarter.

When the protagonist of a Muromachi tale visits a utopian world, he or she usually comes to a place where the four seasons exist simultaneously in the four directions, as in the widely disseminated "Urashima Tarō." In one of the popular versions of this tale, a turtle that Urashima Tarō caught and freed appears to him as a beautiful woman, takes him to the Dragon Palace (Ryūgūjō), and persuades him to become her husband. The Dragon Palace, which is the equivalent of the Eternal Land or Mount Hōrai,[29] appears under the sea:

> When one opened the door to the east, spring appeared. The plum and cherry trees were blooming in profusion, the branches of the willow tree bent in the spring wind, and from the midst of the spring mist, one could hear the voice of the bush warbler near the eaves. Flowers were blooming everywhere in the trees.
>
> When one looked to the south, summer appeared. In a hedge separated from spring, the deutzia flowers were no doubt blooming. The lotus in the lake was covered with dew, and numerous waterfowl played amid

the cool ripples. As the tips of the various trees grew thick, the voice of the cicada cried in the sky, and amid the clouds that followed an evening shower, the small cuckoo sang, announcing summer.

In the west, autumn appeared. Everywhere the leaves of the trees were turning bright colors, and there were white chrysanthemums in the bamboo fence. The bush clover at the edge of the mist-filled meadow parted the dew, and the lonesome voice of the deer told us that this was autumn.

When one gazed to the north, winter appeared. The treetops in all directions had withered in the cold, and there was the first dew on the dried leaves. At the entrance to the valley where the mountains were buried in white snow, the smoke was rising in lonely fashion over the charcoal ovens, clearly revealing the lowly work of the men making charcoal and telling us that this was winter.[30]

Moving from spring to summer to autumn to winter, each paragraph weaves together the representative poetic topoi for the season in 5/7 syllabic *waka*-esque rhythm. Spring appears in the east, summer in the south, autumn in the west, and winter in the north, with a lake in the south and mountains in the north, as they would at a Heian-period palace-style residence.

Similar scenes appear in other Muromachi tales, such as "Kochō monogatari" (Tale of the Butterfly), "Shuten dōji" (Drunken Child), "Shaka no honji" (Story of Buddha), "Jōruri jūnidan sōshi" (Tale of Lady Jōruri), "Suehiro monogatari" (Tale of the Open Fan), "Tanabata" (Star Festival), "Tamura no sōshi" (Tale of Tamura), and "Suwa engi goto" (Divine Origins of the Suwa Shrine).[31] In contrast to Heian court tales, such as *Utsuho monogatari* and *The Tale of Genji*, which describe a kind of ideal on Earth, Muromachi tales offer other worlds (*ikyō*) in which the four-seasons–four-directions garden or residence signals the cessation or perpetual renewal of time. The garden becomes a utopian world, a poetic variation on the Eternal Land (Tokoyo no kuni), Mount Hōrai (Hōrai-san), Land of the Immortals (Senkyō), Dragon Palace (Ryūgūjō), Pure Land (Jōdo), and/or Tao Yuanming's Peach Blossom Spring (Ch. Tao hua yuan, Jp. Tōgenkyō).

Tokuda Kazuo has argued that in the Muromachi period, the four-seasons–four-directions theme had a celebratory, supplicatory function. For example, folk dances and songs on the four seasons in the four directions prayed for the prosperity of a residence or family.[32] In the sixteenth-century

genre of screen painting called *rakuchū rakugaizu* (scenes in and around Kyoto), the capital is portrayed in a similar, celebratory order: the eastern part in spring, the southern part in summer, the western part in autumn, and the northern part in winter—with annual observances represented to match each season and each place. The Gion Festival, for example, appears in summer in Shimogyō, southern Kyoto. These screen paintings, which fuse the traditions of four-season painting (*shiki-e*) and famous-place painting (*meisho-e*), implicitly commemorate the capital as an ideal space.

Similar seasonal-directional paintings appear on the sliding doors in the Daisen'in and Jukōin of the Daitoku-ji monastery. For example, in the "Eight Views of the Xiao and Xiang" (Shōshō hakkei) panels by Kano Shōei (1519–1591) in the Jukōin, the wintry scene "Evening Snow" is found at the northern end of the room, while "Autumn Moon over Lake Dongting" is set on the western side.[33] The prominent Muromachi popular tale "Jōruri jūni-dan sōshi" contains a passage describing a four-seasons–four-directions other world represented on a screen painting that is viewed from right to left—from spring to summer to autumn to winter.[34] This convention of depicting the otherworld with four simultaneous seasons continued through the Edo period and into the present. For example, Asanoshin, the protagonist of Hiraga Gennai's novel *Furyū shidōken* (*Modern Life of Shidōken*, 1763), goes to a peach-blossom grove and then to a place where the four seasons coexist. In the twenty-first century, a four-season–four-directions garden appears in the Japanese anime film *Spirited Away* (*Sen to chihiro no kamikakushi*, 2001) by the director Miyazaki Hayao.

Many of the talismanic and auspicious motifs in early Japanese aristocratic culture came from China. For example, the plum tree, which originated in China, was long admired for its elegant flower and its ability to bloom early, in the cold of winter, showing strength and endurance. In the Song period (960–1279), it was grouped with the pine, which remains green throughout the year, and bamboo, which puts forth leaves even in winter, to form a painting topic dubbed the "Friends of the Cold" (*saikan sanyū*), which implied fidelity and fortitude. Together with the chrysanthemum, orchid, and bamboo (all of which can survive wind, frost, snow, and ice), the plum was also considered one of the "Four Gentlemen" (Jp. *shikunshi*, Ch. *si junzi*), which, from the Song period, were used to represent the purity and nobility of the virtuous (Confucian) scholar-gentleman. In Japan from as early as the

time of the *Man'yōshū*, the plum also took on a more characteristically Japanese role as a seasonal marker.[35] In this capacity, which came to the fore in Heian-period imperial *waka* anthologies and scroll paintings, the main function of the plum blossom was as a representative of the late-winter and early-spring landscape, where it was combined with snow and the bush warbler. A broad shift from a Sino-centric view of horticulture to one that was more native in orientation is often seen in the transition from the plum blossom, which was the most popular poetic flower in Japan in the eighth century, to the cherry blossom, which overtook the plum blossom in popularity in the ninth and tenth centuries. But while the cherry blossom surpassed the plum blossom in popularity in Japan, both continued to be regarded as the premier flowers of spring—the former for mid- to late spring and the latter for early spring. In *waka* and Yamato-e (Japanese-style painting), the plum functions primarily as a seasonal motif, one that often has soft, if not erotic, overtones. But in Chinese-inflected genres such as *kanshi*, Muromachi-period Chinese-style (*kanga*) screen painting, and Edo-period literati (*bunjin*) painting, in which the focus is often on its fortitude or its strong trunk and branches, the plum took on a moral dimension—of strength, resilience, purity, and fidelity—as well as a talismanic role.

Other plants, such as the chrysanthemum (*kiku*) and mandarin orange (*tachibana*), also developed multiple dimensions. The chrysanthemum became a major icon of autumn in the Heian period, but it was also closely identified with immortality, purity, and the imperial house. Even the cherry blossom, often used to symbolize ephemerality, could also function as an image of eternal splendor and glory. The ability of flowers and trees to acquire both seasonal and talismanic dimensions was often a key to their role in a wide variety of cultural activities, particularly celebratory and ritual observances. Furthermore, these two qualities were often combined in poetry and traditional arts, such as flower arrangement (ikebana), the tea ceremony (*chanoyu*), and noh. Standing-flower (*rikka*) arrangements, for example, typically combined an evergreen, which functioned as the vertical center (*shin*), with a seasonal flower as the support (*tai*) or horizontal augmentation (*soe*). In *waka*, the image of the wisteria (spring) wrapped around a pine symbolizes the relationship of the Fujiwara (literally, "wisteria fields") family to the imperial throne (eternal pine).

Buddhist iconography also made use of seasonal, trans-seasonal, and talismanic natural images. The most important of these was the lotus flower,

iconographically the seat for the meditating Buddha, which symbolizes enlightenment or purity amid the mud of the surrounding pond or swamp. The peony (*botan*) was thought appropriate as a flower offering to the Buddha, and the peacock (*kujaku*) was believed to play in the garden of the Pure Land—two associations probably imported from China. A native set of beliefs emerged in association with cherry blossoms and autumn grasses. Cherry blossoms in full bloom were considered to be intoxicating and to draw the adherent's spirit into the world of the gods and buddhas. When the cherry blossoms bloomed at Mount Fudaraku (variously thought to exist in southern India; in China; and in Japan, to the south of Mount Nachi, in present-day Wakayama Prefecture), the distance to the Pure Land was believed to disappear, and this world became that world. If the believer also saw autumn grasses, a vivid reminder of the evanescence of this world, his or her spirit could achieve peace and move toward enlightenment and transcendence.[36]

A key to understanding the talismanic function of nature can be found in the historical roots of ikebana. In Buddhist sutras of the Pure Land, the heavenly sphere is often depicted as a place filled with flowers. The interiors of Buddhist temples were decorated with flowers to replicate the heavenly sphere in this world, and flowers were offered, together with candles and incense, to the image of the Buddha—one practice from which the art of ikebana may have derived.[37] At the same time, flowers were believed, from the ancient period in Japan, to embody or transmit the power of the gods (*kami*), who were thought to reside in nature. In annual observances and festivals, flowers, pines, and their representations were used to celebrate or placate the spirits of local gods.[38] The gate pine (*kadomatsu*), set up at the entrance of a house on New Year's Day, was originally believed to be the place where a god descended to Earth; it served as a greeting to the god, who was also welcomed in the alcove of the parlor-style (*shoin-zukuri*) residence. In short, in both Buddhist rituals and the worship of gods, icons of nature, particularly flowers, served not only as a reminder of the ephemerality of the world, but as a medium for the manifestation of the buddhas and gods, who could ward off disease and impermanence. These beliefs coexisted with various Chinese and Japanese talismanic traditions that made the ritualistic representation of nature a widespread and long-lasting cultural phenomenon and that played a major role in annual observances.

*Chapter Six*

# Annual Observances, Famous Places, and Entertainment

Annual observances, which became an integral part of the culture of the four seasons, differ greatly according to place, profession, community, and period. They cover a broad spectrum of activities, from religious rituals, such as Hatsumōde (first pilgrimage of the year to a shrine) and the Festival of the Dead (Obon), to agricultural rites such as *taue* (planting rice seedlings) and *inekari* (harvesting rice). Some are held in appreciation of seasonal nature, such as cherry-blossom viewing (*hana-mi*), moon viewing (*tsuki-mi*), and bright-foliage viewing (*momiji-gari*). Others evolved into recreational activities, such as the Doll's Festival (Hinamatsuri), which is celebrated on the third day of the Third Month. Most annual observances combine two or more of these functions, with one dimension dominating or evolving into another. Many, such as the Five Sacred Festivals (Gosekku), were initially court or public ceremonies, while others, such as changing to summer clothes (*koromogae*), were observed at home.[1] In either case, these annual observances were marked off from everyday time by distinctive decorations, clothing, offerings, or foods—all of which were closely linked to the cycle of the four seasons.

Annual observances celebrated at the imperial court beginning in the Heian period (794–1185) differed radically from those held in farm villages. Whereas court ceremonies derived in large part from Chinese customs, village rituals tended to be indigenous and related to rice agriculture. A good example is *ta-asobi* (prayers for rich rice harvest), in which, before the gods, farmers imitated the beginning of hoeing (*kuwa-ire*), the planting of rice seedlings, the driving away of birds, and the harvesting and storing of rice—thereby praying for a rich harvest and prosperity for the family and its descendants. This practice, which began in the Kamakura period (1185–1333) and faded in the Edo period (1600–1867), was performed in the First Month, particularly on Minor New Year (Koshōgatsu), the fourteenth and fifteenth days of the First Month. In contrast to aristocrats, who stressed Major New Year (Ōshōgatsu), the first to seventh days of the First Month, medieval farmers focused on Minor New Year.[2] Another annual observance for medieval farmers was rice-seedling planting songs (*taue-uta*), in the Fifth Month, a ritual accompanied by music, songs, and dances that functioned as a prayer for a rich harvest and that made its way into Edo popular culture.

The military government (*bakufu*) in the Kamakura period generally imitated the annual observances of the Heian-period imperial court, but the *bakufu* in the Muromachi period (1392–1573) significantly altered them and incorporated new ones into the ceremonial calendar, probably because the weakened nobility could no longer maintain the older ceremonies. By the Edo period, the major court observances, particularly the Five Sacred Festivals, had become an integral part of the new urban commoner society. At the same time, new observances originating in the farm villages—such as Hassaku, when gifts were exchanged with neighbors on the first day of the Eighth Month—or in the metropolis were added to the dense calendars of annual celebrations for city dwellers. Since Tokugawa Ieyasu first entered Edo Castle on the first day of the Eighth Month of 1590, Hassaku also became an annual observance for provincial warlords (daimyo) and bannermen (*hatamoto*), who paid homage to the shogun on this day. Thus annual ceremonies had different meanings for different classes, communities, and regions, but they all served to mark social and seasonal time.

# The Five Sacred Festivals

In the Nara period (710–784), the imperial court adapted Chinese annual observances, such as White Horses (Aouma), seventh day of the First Month;[3] Stamping Song (Tōka), fourteenth to sixteenth days of the First Month;[4] Archery Day (Jarai), seventeenth day of the First Month; first Day of the Snake (Minohi or Jōshi), often third day of the Third Month; Tango Festival (Tango no sekku), fifth day of the Fifth Month; Star Festival (Tanabata), seventh day of the Seventh Month; and Festival of the Dead (Obon), thirteenth to fifteenth days of the Seventh Month. In the early Heian period, more Chinese annual observances were adapted by the imperial court, such as Seven Grasses (Nanakusa), seventh day of the First Month; Fire Festival (Sagichō), fifteenth to eighteenth days of the First Month;[5] Rabbit Stick (Uzue), first Day of the Rabbit of the First Month;[6] Buddha's Birthday (Kanbutsu), eighth day of the Tenth Month; Chrysanthemum Festival (Chōyō), ninth day of the Ninth Month; Wild Boar Day (Gencho), first Day of the Boar (Inoko) of the Tenth Month;[7] and Repulsing Demons (Tsuina), New Year's Eve.[8]

Most of these annual court ceremonies were sponsored or initiated by Emperor Kanmu (737–806, r. 781–806) after the move of the capital from Heijō (Nara) to Heian (Kyoto) and were intended to reinforce the power of the court. By the time of Emperor Ichijō (980–1011, r. 986–1011), when the regency system (with the northern branch of the Fujiwara family controlling the throne) was at its peak, these court observances were also being held at the private residences of aristocrats. As texts like Sei Shōnagon's *Makura no sōshi* (*The Pillow Book*, ca. 1000) reveal, the most important annual ceremonies for mid-Heian aristocrats were the Five Sacred Festivals (Gosekku), the major banquet days based on auspicious double (odd) numbers—first day of the First Month, third day of the Third Month, fifth day of the Fifth Month, seventh day of the Seventh Month, and ninth day of the Ninth Month—which were very important in constructing a sense of the seasons.

Under the luni-solar calendar, the New Year coincided with the beginning of spring, making it the most important observance of the year for the aristocracy. In the Heian period, New Year ceremonies extended from New Year's Day (Ganjitsu) to the Day of the Rat (Nenohi), which usually fell on the seventh day of the First Month, when courtiers went out to the fields

(*no*), pulled up small pines,[9] and gathered new herbs (*wakana*) as a prayer for long life. This ritual gradually spread to the provinces and to commoners, eventually resulting in the New Year practice of the gate pine (*kadomatsu*), in which a pair of small pines was placed at the gate of a house.[10] A popular Heian-period painting topic representing the First Month was "prayers on the Day of the Rat" (*Nenohi no asobi*), which depicted the auspicious scene of pulling up small pines in a spring field.[11] Both young herbs and gathering young herbs, particularly at Kasuga Field, became major poetic topics for the First Month, appearing in both the spring and celebration (*ga*) books of the *Kokinshū* (*Collection of Japanese Poems Old and New*, ca. 905).[12] By the Kamakura period, the observance of the Day of the Rat had been abandoned at the imperial court, but the custom of gathering and eating young greens continued as the annual ceremony known as the Seven Grasses (Nanakusa).[13]

In ancient China, the first Day of the Snake in the Third Month was a ritual carried out at the edge of water to drive away evil influences. This ceremony became the Meandering Stream Banquet (Kyokusui no en), at which wine was served. Eventually, it was celebrated on the third day of the Third Month, also referred to as Peach Day (Momonohi), and became one of the Five Sacred Festivals in Japan.[14] In the Heian period, this observance evolved into the Day of the Snake Exorcism (Minohi no harai), a ritual in which pollution (*kegare*) was transferred from a person's body to a surrogate doll (*hitogata* or *katashiro*), which was thrown into a river or the sea.[15] The custom of playing with elaborately dressed dolls emerged from this ritual, and in the Muromachi period the third day of the Third Month evolved into the Doll's Festival (Hinamatsuri),[16] which spread to commoners in the Edo period and became a topic for *haikai* (popular linked verse). Today, dolls are dressed as royalty and placed on doll stands with doll furniture. A noted *hokku* (opening verse of a *renga* sequence) by Matsuo Bashō's (1644–1694) disciple Mukai Kyorai, in the spring section of *Sarumino* (*The Monkey's Raincoat*, 1691), reads: "Celebration—last year's doll reduced to the lower seat" (*Furumai ya shimoza ni naoru kozo no hina*).[17] In an ironic twist, the dolls grow old from year to year and are demoted or abandoned in favor of new ones. The cultural connection between the Doll's Festival and nature is evident in an ukiyo-e by Chōbunsai Eishi (1756–1829), one of a series of five prints called "Fūryū gosekku" (Elegant Five Sacred Festivals, ca. 1794–1795), produced in the Kansei era (1789–1801) (figure 21). A woman from an

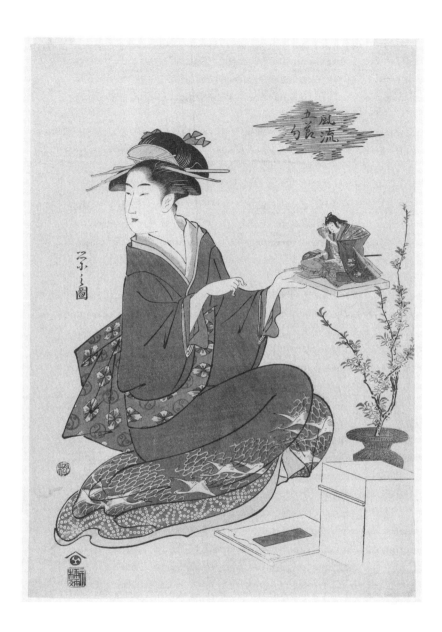

FIGURE 21

DOLL'S FESTIVAL AND IKEBANA

This "portrait of a beautiful person" (*bijinga*) in Chōbunsai Eishi's series "Elegant Five
Sacred Festivals" (Fūryū gosekku, ca. 1794–1795) exemplifies the ways in which an annual
observance (Peach Day, also known as the Doll's Festival [third day of the Third Month])
combines nature (white peach flowers, a prayer for immortality, in ikebana form) with the
rituals of the observance (doll making). (Color woodblock print [signed *Eishi zu*]; vertical
*ōban*, 14.8 × 9.9 inches. Courtesy of the Museum of Fine Arts, Boston, William S. and John
T. Spaulding Collection, 1921, no. 21.4905)

upper-rank samurai house, at the bannerman (*hatamoto*) level, is taking a doll from a box. The branches and flowers from a peach tree in the flower arrangement in front of her match the "natural" associations of the Day of the Snake (Peach Day), which by this time had become a major observance of late spring.

The most prominent summer observance in the Heian period was the fifth day of the Fifth Month, better known today as the Tango Festival,[18] which was originally a ritual for dispelling evil influences. From the early eighth century, plants with strong scents, such as sweet flag (*shōbu*) and mugwort (*yomogi*), were placed close to the body, in the hair, and in the eaves and on the roofs of houses to ward off evil. With the addition of the custom of drinking sweet-flag wine and bathing in sweet-flag water, this practice continued into the Edo period. As an expression of thanks to his host who gave him sandals (*waraji*) as a farewell present, Bashō wrote this *hokku* in *Oku no hosomichi* ( *Journey to the Deep North*, ca. 1694): "Grass of the sweet flag—I shall use them to tie my straw sandals" (*Ayamegusa ashi no musuban waraji no o*). Unlike city dwellers, who put sweet flag in the eaves of their homes, the traveler, in a *haikai* twist, places them on his sandals, making travel his dwelling. In the Heian period, the Tango Festival was celebrated at the imperial court with sweet flag (which closely resembles the iris) and medicine balls (*kusudama*) made of incense and decorated threads.[19] Horseback archery and horse racing took place at the court on the fifth and sixth days of the Fifth Month, followed by a banquet.[20] The word *shōbu* (sweet flag) was a homonym for *shōbu* (尚武; literally, "honoring the warrior"), and in the medieval period (1185–1599), the Tango Festival became a day for boys to display their martial talents.[21]

The Star Festival, a major topic in *kanshi* (Chinese-style poetry) and *waka* (classical poetry), was held on the seventh day of the Seventh Month, at the beginning of autumn. Tanabata was derived from Kikōden, a Chinese annual observance imported to Japan and first celebrated at the imperial court in 755. According to the Chinese legend, two stars—the Herdsman (Kengyū [Altair]) and the Weaver Woman (Shokujo [Vega])—were lovers, but were punished for a transgression and separated by the Milky Way (Ama-no-gawa). On the seventh day of the Seventh Month, the two stars were allowed to meet for one night only, and on this day women prayed to improve their skills in weaving and sewing. In ancient China, the Herdsman was associated with agriculture, and the Weaver Woman with sericulture, thread,

and needle. By the Six Dynasties period (220–589) in China, the custom had developed of writing poems on the night of the seventh day of the Seventh Month, and the same tradition began in the Nara period (710–784) in Japan.[22] In contrast to Chinese and Japanese *kanshi* on Tanabata, in which the Weaver Woman crosses a bridge that spans the River of Heaven, in *waka* the Herdsman crosses the river to meet his lover, following Japanese marital customs. From the Heian period, it was customary to write a poem on the leaf of a *kaji* (kind of mulberry tree) and offer it up to the two stars. The word *kaji* was a homonym for the *kaji* (rudder or oar) of the boat that crosses the River of Heaven. A tub of water was set out so that the heavenly meeting could be reflected, as a prayer to the two stars, as in this poem in the *Shinkokinshū* (*New Anthology of Poetry Old and New*, 1205): "In the surface of the water, where I dip my hand and soak my sleeve, I see two heavenly stars meeting in the sky" (*Sode hichite waga te ni musubu mizu no omo ni ama tsu hoshiai no sora wo miru kana* [Autumn 1, no. 316]).[23]

Tanabata did not spread to commoner society until the Edo period, when it became an official holiday. A colored poetry strip, sometimes tied with a five-colored string, was substituted for the mulberry leaf and became an offering and a prayer for excellence in sewing and other arts. The importance of the Star Festival for women is apparent in an early ukiyo-e by Okumura Masanobu (1686–1764), *Tanabata-matsuri zu* (*Tanabata Festival* [MOA Museum of Art, Atami]). In the top half is the heavens, above the clouds, in which the Herdsman, with his cow, and the Weaver Woman are separated by the River of Heaven, over which some magpies are flying (another part of the Tanabata myth). Below is a young woman playing the koto (zither), as she imagines the romance of the two stars. Behind her, on the branches of bamboo, are poetry strips and hanging robes. Surrounding the young woman are other musical instruments—drum and *biwa* (lute)—indicating that this is a prayer for a daughter to improve her musical skills. As Imahashi Riko has argued, this kind of print probably taught Edo-period urban commoners how to observe the various annual observances.[24]

The last Gosekku of the year was the Chrysanthemum Festival, held on the ninth day of the Ninth Month, at the end of autumn. Chōyō, which was originally celebrated by climbing a hill and drinking chrysanthemum wine, derives from the legend that the dew on chrysanthemums that grew on a large mountain in China became the water of a river and that those who lived near the river never grew old. *Kanshi* on chrysanthemum wine at the Chōyō

banquet appear in the *Kaifūsō* (*Nostalgic Recollections of Literature*, 751), but there are no poems on chrysanthemums in the *Man'yōshū* (*Collection of Ten Thousand Leaves*, ca. 759). It was only after the revival of the Chrysanthemum Festival banquet in 814, during the reign of Emperor Saga (786–842, r. 809–823), that the chrysanthemum became popular in both *waka* and *kanshi*. A number of poems in the autumn books of the *Kokinshū* are related to Chōyō, such as this one by Ki no Tomonori: "Let me break it off, still wet with dew, and place it in my hair, the flower of the chrysanthemum, so that the autumn will never grew old" (*Tsuyu nagara orite kazasamu kiku no hana oisenu aki no hisashikarubeku* [Autumn 2, no. 270]). Heian-period aristocrats, particularly women, wiped their faces with cloth that had been soaked in the dew of a chrysanthemum the night before, thereby praying for long life and immortality, as described in Sei Shōnagon's *Makura no sōshi*.

In short, the symbolic focus of the Five Sacred Festivals, as with a number of other annual court observances, was on particular trees, grasses, flowers, and animals—such as pine, new herbs, peach, sweet flag, mugwort, chrysanthemum, wild boar, and white horse—that were thought to have magical powers, representing new life (new herbs), immortality (pine, peach, and chrysanthemum), fertility (wild boar), or the ability to ward off or exorcise evil (sweet flag and mugwort). The talismanic function of plants is evident in the peach bow for Repulsing Demons on New Year's Eve,[25] peach tree for Rabbit Stick, peach wine for the Day of the Snake, and sweet flag for the Tango Festival.[26] Parallels appear in the European tradition (such as evergreens and mistletoe for Christmas and rabbits for Easter), but in contrast to Christian annual observances, which tend to be anthropomorphic (Christ and saints) and rely on symbolism of the human body, these annual ceremonies are heavily based on natural or agricultural imagery, thereby connecting them directly to the landscape of the four seasons.[27]

## Sweets and Cakes

Sweets and cakes were an important component of annual observances celebrated at the imperial court in the Heian period and of subsequent ceremonies and festivals of all kinds. The original function of the sweet was as an offering, a prayer for a good harvest, or a means to avoid misfortune. Traditional Japanese confectionary or cakes (*wagashi*) are usually made of

*mochi* (sticky cake made from pounded rice) filled with sweet red beans (*azuki*). The rice was originally a symbol of the rice harvest or the spirits of the dead, and the red beans—or the red color of the beans—were thought to dispel calamity or misfortune.[28] In the Edo period, rice cakes were served on such annual observances as Buddhist Memorial Day (Higan), Summer Fatigue Day (Doyō), and the Festival of the Dead (Obon).

A good example of a spring sweet is the grass rice cake (*kusamochi*), which is made of pounded rice mixed with the leaves of mugwort (*yomogi*) or a similar grass. Originally, the grass (*kusa*) used was *hahakogusa* (literally, "mother–child grass") or cudweed (*gogyō*), one of the seven grasses of spring. In China, the scent of this grass was thought to ward off evil, and it was customary, from the early Heian period, to eat *hahakogusa* rice cakes on the Day of the Snake (Jōshi), the third day of the Third Month, when sins and pollution were exorcised through ablution. When the Day of the Snake evolved into the Doll's Festival (Hinamatsuri) in the Edo period, the *kusa-mochi* continued to be eaten in the belief that they got rid of pollution and prevented calamity.

On the Tango Festival, the fifth day of the Fifth Month, Heian-period aristocrats customarily ate *chimaki*, pounded rice wrapped in cogon grass (*kaya*) or rush (*makomo*) and steamed—a custom also derived from China. Today, the pounded rice is molded into a triangle or cone, wrapped in young bamboo grass (*sasa*), and tied with a common rush (*igusa*). The *chimaki* was replaced in the mid-Edo period by the oak-leaf rice cake (*kashiwa-mochi*), a circular, flat sticky rice cake that is folded over sweet bean paste and then wrapped in an oak leaf (*kashiwa*) (figure 22). Since old oak leaves do not drop off a tree until the new buds have grown, the *kashiwa* became popular among samurai and commoners as an object of prayer for the success of one's family and descendants. The historical origins of these sweets reveal the importance of the talismanic functions of food in annual observances of all kinds.

## Paintings

Annual observances, particularly those held at the imperial court, eventually became the subject of annual-observance paintings (*nenjū-gyōji-emaki*), of which the most famous is the *Nenjū gyōji emaki* (*Annual Observance Scroll*), executed in the late Heian period. Retired Emperor GoShirakawa

FIGURE 22
OAK-LEAF RICE CAKE

Like many other Japanese sweets, this confection, the oak-leaf rice cake (*kashiwa-mochi*), combines nature, season (summer, Tango Festival [fifth day of the Fifth Month]), and talismanic qualities (prayer for success of offspring), here derived from the notion that the oak leaf does not drop off the tree until new leaves appear. (Photograph by the author)

(1127–1192, r. 1155–1158) commissioned the monumental picture scroll in an attempt to restore a long tradition of court observances that had gone into severe decline by his time.[29] GoShirakawa's picture scroll was followed by similar efforts to preserve or recover knowledge of these traditions, such as *Kenmu nenjū gyōji* (*Kenmu Annual Observances*), a record of court observances edited by Emperor GoDaigo (1288–1339, r. 1318–1339) in the Kenmu era (1334–1336).

The role of annual observances in the visual representation of the four seasons is also evident in four-season paintings (*shiki-e*) and twelve-month screen paintings (*tsukinami-byōbu*), which became very popular in the

medieval period.[30] They were followed in the late Muromachi and early Edo periods by a wide range of what are now called *fūzoku-e* (paintings of scenes from everyday life, or genre paintings), many of which depict annual observances and related social activities in a four-season or twelve-month format. A good example is the *Tohi zukan* (*Capital-Country Painting*, 1691–1705 [Kobun-in, Nara]), a fifty-foot scroll by the Yamato-e–style painter Sumiyoshi Gukei (1631–1705).[31] The scroll begins with spring celebrations in the houses of aristocrats (coming-of age-ceremony, *waka* composition, and kick ball [*kemari*] under cherry blossoms); moves to the homes of upper-rank samurai, who are changing to summer clothes (*koromogae*); shifts to scenes of urban commoners on the city outskirts, who are observing the Festival of the Dead (Obon) in the middle of the Seventh Month; and ends with farm villages in the fields outside the capital, with withered trees and accumulated snow. The *Tohi zukan* portrays annual observances of every major social class—aristocrat, warrior, urban commoner, and farmer—in the context of the four seasons.[32] In contrast to earlier annual-observance paintings, which focus exclusively on court or aristocratic events, this scroll, much like the popular literature and poetry of the time, depicts activities in diverse social contexts in both the city and the provinces.

The role of annual observances in Edo-period painting is revealed in Katsukawa Shunshō's (1726–1792) *Fujo fūzoku jūnikagetsu zu* (*Women's Customs in the Twelve Months*, ca. 1781–1790), long and narrow hanging scrolls painted on silk that depict the lives of young urban commoner women. The original twelve scrolls (those for the First Month and Second Month have been lost) combine *waka*-based seasonal bird-and-flower motifs and portrayals of annual activities. In the Third Month, women are playing *kemari* under the cherry blossoms; the Fourth Month shows a woman, with a lute, peony, and small cuckoo in the background; the Fifth Month depicts women reading to the light of fireflies, with sweet flag in a vase; in the Sixth Month, a woman is cooling off and bathing in a tub of water (*gyōsui*); the Seventh Month focuses on women sewing and celebrating Tanabata, with poetry strips attached to young bamboo and a tub of water reflecting the stars; in the Eighth Month, a woman in a boat is watching wild geese fly past the harvest moon while two other women converse; and the Ninth Month reveals courtesans and their attendants in Yoshiwara celebrating the Chrysanthemum Festival with a large flower arrangement (figure 23).[33]

FIGURE 23
WOMEN AND THE CHRYSANTHEMUM FESTIVAL

Katsukawa Shunshō's *Women's Customs in the Twelve Months* (*Fujo fūzoku jūnikagetsu zu*, ca. 1781–1790), with one hanging scroll for each month, reflects the close relationship between the alcove and the seasons and shows the importance of flower arrangement as part of women's culture. In this scroll for the Ninth Month (late autumn), high-ranking courtesans in the pleasure quarters (*above*) watch their young assistants (*below*) carry a large chrysanthemum arrangement during the Chrysanthemum Festival (ninth day of the Ninth Month). (Color on silk; 4.5 × 10.1 inches. Courtesy of the MOA Museum of Art, Atami)

In the alcoves in the houses of wealthy urban commoners and upper-class samurai in the Edo period, it was customary to display a vertical hanging scroll whose subject was appropriate for the month, thus changing the scrolls in a twelve-month series like that of Katsukawa Shunshō as the year progressed.[34] For the First Month, for example, a felicitous theme typically was an old man and an old woman at Takasago; a crane and a turtle on Mount Hōrai; the triad of pine, bamboo, and plum tree; or the morning sun (*asahi*) rising over the waves. In short, by the early Edo period, annual observances and their visual representations became an integral part of the interiorization of the four seasons in the residences of well-to-do families.

## Kabuki

Each of the traditional arts, from tea ceremony to noh, had its own set of annual observances. To give one prominent example, the kabuki season in Edo began on the first day of the Eleventh Month with the *kaomise* (face-showing performance), at which the new line-up of actors was introduced to the theatergoers. This was followed by the early-spring plays (*hatsuharu kyōgen*), performed from the New Year. Then came the spring plays (*yayoi kyōgen*), staged in the Third Month, and the Fifth Month plays (*Satsuki kyōgen*), from the fifth day of the Fifth Month, to coincide with the Tango Festival. The theaters were originally closed in the Sixth and Seventh Months, when the lead actors went on vacation, but eventually secondary actors took advantage of the opportunity to play roles they normally were denied. The result was summer plays (*natsu kyōgen*), also called plays for the Festival of the Dead (*Bon shibai*) because they were presented in the month of Obon. The last part of the season was reserved for Chrysanthemum Month plays (*Kikuzuki kyōgen*) because they were performed from the ninth day of the Ninth Month.[35]

From the Kyōho era (1716–1736), the three kabuki theaters in Edo (Tokyo) customarily staged a new First Soga Play (*Hatsu Soga*)—the most notable examples being *Yanone* (*Tip of the Arrow*) and *Kotobuki Soga no taimen* (*Felicitous Soga Meeting*)—as the early-spring play. In the revenge tale *Soga monogatari* (*Tale of the Soga*), the Soga brothers (Jūrō and Gorō), after eighteen years of suffering, exact their revenge on the twenty-eighth day of the Fifth Month, killing their bitter enemy Kudō Suketsune at the foothills of

Mount Fuji. The First Soga Play, which was performed at the beginning of the New Year, did not focus on the revenge scene itself but on the beginning, with a meeting among the main figures, thereby functioning as a ritualistic prayer for good luck or good fortune implied in the Soga brothers' ultimate success.[36] In the initial meeting (*taimen*) between the Soga brothers and Kudō, an auspicious *mitate* (visual transposition) usually is created in which Gorō stands in the middle, representing Mount Fuji, with Jūrō and Kobayashi Asahina (the brothers' protector) forming the base of the mountain. Kudō, with a fan in his right hand and a sword in his left, adds a visual allusion to a crane. Both Mount Fuji and the crane were auspicious New Year images. The early-spring plays thus had the same kind of function as pulling up small pines, harvesting young herbs, and performing other New Year rituals.[37]

## Famous Places and Urban Excursions

Annual observances such as cherry-blossom viewing, moon viewing, and snow viewing often involved visiting "famous places" (*meisho*), a term that became popular in the Edo period and that refers to four types of sites:

- Poetic places (*utamakura*), on which noted poems had been written
- Historic sites, such as a former barrier or battleground
- Famous temples or shrines
- Locales noted for their seasonal landscapes

*Utamakura* were places that had acquired established clusters of poetic associations as a result of their inclusion in one or more famous *waka*. The *Waka shogakushō* (*First Steps in Learning Waka*, ca. 1169), a *waka* primer by Fujiwara no Kiyosuke (1104–1177), lists noted *utamakura* and their associations, including

| | |
|---|---|
| Mount Tatsuta | Brocade, waves, robe, mist |
| Mount Kasuga | Pine, wisteria |
| Mount Ausaka | To meet, barrier, spring |
| Uji River | Fishing weir, bridge, Bridge Maiden (Hashihime) |

The *Waka shogakushō* also gives twenty-two seasonal motifs and the poetic places associated with them, including

| | |
|---|---|
| Spring mist | Beautiful Yoshino (Mi-yoshino), Ashita Field (Ashita-no-hara) |
| Moon | Old Crone Mountain (Obasute-yama) in Sarashina, Hirosawa Lake (Hirosawa-no-ike), Akashi Bay |
| Snow | Mount Yoshino, Mount Fuji, Shirayama of Koshi, Shirane of Kahi |
| Cherry blossoms | Mount Yoshino, Mountain Crossing at Shiga (Shiga no yamagoe)[38] |

As the list suggests, many poetic places, like famous places in general, were identified with a specific seasonal motif. So close was the connection that if a painter combined a river and a fishing weir (*ajiro*), a seasonal word for winter, the scene immediately signified the Uji River.[39]

The association of season with place continued into the Edo period, when visiting famous places became a major form of recreation for urban commoners. Seasonal topics and the famous places connected with them appear in Oka Sanchō's (d. 1828) guidebook *Edo meisho hanagoyomi* (*Flower Calendar of Famous Places in Edo*, 1827). A sampling includes

SPRING

| | |
|---|---|
| Bush warbler | Negishi Village (Negishi-no-sato) |
| Plum blossoms | Umeyashiki |
| Camellia | Mukōjima |
| Cherry blossoms | Tōeizan at Ueno, Sumida River, New Yoshiwara (Shin-Yoshiwara) |

SUMMER

| | |
|---|---|
| Wisteria | Tenmangu Shrine at Kameido, Sannō Shrine at Ueno |

| Small cuckoo (*hototogisu*) | First Song Village (Hatsune no sato) at Takada, Surugadai |
| Lotus | Shinobazu Lake |
| Cooling off (*nōryō*) | Ryōgoku Bridge |

AUTUMN

| Moon | Mitsumata, Asakusa River (mouth of the Sumida River) |
| Fields | Musashino |
| Insects | Dōkan Hills (Dōkanyama), on the road from Hikurashi to Ōji |
| Bright foliage | Mama (Guhōji Temple at Mama Hill) |

WINTER

| Winter chrysanthemum (*kangiku*) | Hōon-ji Temple at Heikan-san Hills |
| Withered fields (*kareno*) | Road from Zōshigaya to Horiuchi |
| Plovers (*chidori*) | Susaki[40] |
| Snow | Atagoyama,[41] Takanawa |

*Edo meisho hanagoyomi* describes 43 seasonal motifs and 154 famous places. Another noted guide to *meisho* in Edo, Saitō Gesshin's (1804–1878) *Tōto saijiki* (*Seasonal Almanac of the Eastern Capital*, 1838), lists 37 seasonal motifs and 253 famous places. Of the 312 famous places found in these books, the largest numbers fall under entries on cherry blossoms (61), snow (23), plum blossoms (19), autumn foliage (18), and the moon (16). The familiar triad of cherry-blossom viewing, moon viewing, and snow viewing dominate. Flowers (cherry, plum, camellia, and peach) are the focus of close to 70 percent of the famous places. The remaining 30 percent center on birds (bush warbler, small cuckoo, plovers, and marsh hen [*kuina*]), insects, moon, and snow. Forty-four percent of the famous places are temples or shrines. Only 12 percent are flower gardens such as Somei, in which grew special flowers like the peony (*botan*), Chinese peony (*shakuyaku*), morning glory (*asagao*), and chrysanthemum (*kiku*).[42]

The percentages roughly reflect the seasonal pyramid of topics in classical Japanese poetry—with spring cherry blossom, autumn moon, and winter snow at the top—indicating that many of the aristocratic pursuits associated with the four seasons that emerged in the Nara and Heian periods were followed by a large number of urban commoners in the Edo period. Equally important, many famous places were built for or converted to the use of seasonal entertainment by transplanting cherry trees, releasing bush warblers, or otherwise creating seasonal motifs. The mountain cherry (*yamazakura*), which had been the focus of cherry-blossom viewing in the Heian and medieval periods, was mainly a tree planted or found in coppice woodlands (*zōkibayashi*) that had replaced virgin forest. Just before the Meiji period (1868–1912), the *yamazakura*, which Motoori Norinaga (1730–1801) praised in a noted poem—"If one asks people about the heart of Yamato, it is the mountain cherry blossoms that glow in the morning sun" (*Shikishima no yamatogokoro o hito towaba asahi ni niou yamazakurabana*)—were replaced by Somei–Yoshino cherry trees, which came from a gardener in Ueki in Edo.[43] In short, the cherry trees viewed in Edo and in Tokyo today are almost entirely the product of Japanese horticulture.

Throughout the Heian and Kamakura periods, cherry-blossom viewing (*hana-mi*) was largely an activity of the aristocracy and military elite.[44] It was not until the Warring States period (1477–1573) that it also became a pastime for commoners. Screen paintings such as *Kaka yūraku zu byōbu* (*Screen Painting of Amusement Under the Flowers*) by Kanō Naganobu (1577–1654) and *Hanami takagari zu byōbu* (*Screen Painting of Flower Viewing and Falcon Hunting*) by Unkoku Tōgan (1547–1618), both painted in the Momoyama period (1568–1615), show commoners in a variety of dress, some playing flutes and drums, while others hold branches of cherry blossoms and fans as they dance wildly.[45] In the *kyōgen* (comic drama) play *Kenbutsuzaemon* (*Zaemon the Sightseer*; also known as *Hanami* [*Flower Viewing*]), the protagonist, an urban commoner, goes from one famous cherry-blossom site to another in Kyoto, reflecting the cherry-blossom craze among commoners.[46] Thus by the Edo period, flower viewing had reached all levels of society, and the concomitant socializing, drinking, eating, and dancing—activities permitted by the military government (*bakufu*) during *hana-mi* time—became a major outlet for commoners' energy (figure 24).

Another popular social practice in the Edo period was moon viewing (*tsuki-mi*), enjoyed especially on the evenings of the thirteenth, fifteenth,

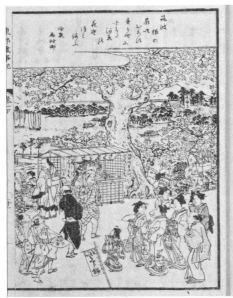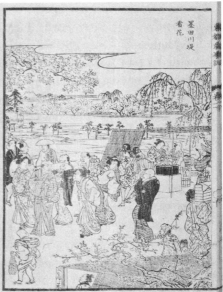

FIGURE 24

CHERRY-BLOSSOM VIEWING AT THE SUMIDA RIVER

This illustration in Saitō Gesshin's *Seasonal Almanac of the Eastern Capital* (*Tōto saijiki*, 1838), a popular guide to annual commoner and warrior observances in Edo, shows one of the most popular spots for cherry-blossom viewing: the embankment of the Sumida River. The walkway is lined with food stands, including one for cherry-blossom rice cakes (*sakura-mochi*). (Courtesy of Waseda University Library, Special Collection, Tokyo)

and twenty-sixth days of the Eighth Month. The evening of the fifteenth day of the Eighth Month (*Hazuki-jūgoya*), alternatively called the night of the fifteenth (*jūgoya*), was considered to be the clearest of all evenings in the year, and the harvest moon was thought to be bright from the afternoon onward. In the Heian period, a banquet had been held at the imperial court, with music and poetry composition.[47] From the Muromachi period, when the term *meigetsu* (bright moon) came into use, offerings were made to the moon on the evening of the fifteenth. Kitagawa Morisada's *Morisada mankō* (1853), a guide to Edo customs, describes offerings of sweet potatoes (*imo*), dango cakes, green soybeans (*edamame*), and miscanthus grass in ear (*susuki*)—no doubt derived from earlier agricultural observances. Moon viewing even-

tually became, among commoners, a major social event almost as important as cherry-blossom viewing.[48] On the evening of the twenty-sixth day of the Eighth Month, people gathered at a place with a good view and waited for the moon to rise, eating and drinking; composing *kanshi*, *waka*, *renga* (classical linked verse), or *haikai*; and being regaled by storytellers, dancers, and other street entertainers.[49] In Yoshiwara, which hosted elaborate moon-viewing parties, the female entertainers (*yūjo*) made every effort to empty their customers' pockets, resulting in *hokku* such as "Viewing the moon until the family mansion collapses" (*Ie yashiki katabuku made no tsuki o miru*).[50]

Various locales throughout the country became famous places for moon viewing, among the most notable being Obasute-yama (Old Crone Mountain) in Sarashina (present-day Nagano Prefecture), Sayo no nakayama (Shizuoka Prefecture), Ishiyama Temple in Ōmi (Shiga Prefecture), and Akashi Bay in Harima (Hyōgo Prefecture). A medieval legend has it that Murasaki Shikibu began to write *The Tale of Genji* (*Genji monogatari*, early eleventh century) as she watched the harvest moon over Lake Biwa from Ishiyama Temple. "Ryōya bokusui no tsukimi" (Moon Viewing on the Sumida River on a Good Night), an illustration by Hasegawa Settan (1778–1843) in Saitō Gesshin's *Tōto saijiki*, shows boats on the Sumida River stocked with food and saké. In all likelihood, the men in the boat will take their time and proceed to nearby Yoshiwara, the pleasure quarters.

Thus urban commoners and samurai enjoyed nature and the four seasons not only in their alcoves and gardens, but also at famous places in Edo or the immediate vicinity. The number of *meisho* vastly increased in the Edo period, particularly from around the Kyōho era (1716–1736), reflecting the growing interest in visiting such sites. Another indication of the popularity of this pastime is the publication of a series of guidebooks, such as *Murasaki hitomoto* (*Stem of the Lavender*, 1683), *Edo kanoko* (*Edo Fawn*, 1687), *Zoku Edo sunako* (*Sequel to Edo Sand*, 1735), and Oka Sanchō's *Edo meisho hanagoyomi*, which, like *Tōto saijiki*, was illustrated by Hasegawa Settan. The first two books list the famous places by topographical type, while the third and fourth categorize the *meisho* by major seasonal motifs, such as the entry for "cherry blossoms" in the spring section of *Edo meisho hanagoyomi*:

New Yoshiwara, in Sanya. Each year, from the first [day] of the Third Month, inside the Great Gate, on Naka-no-chō Avenue, they plant a thousand cherry trees. People are coming and going here all the time.

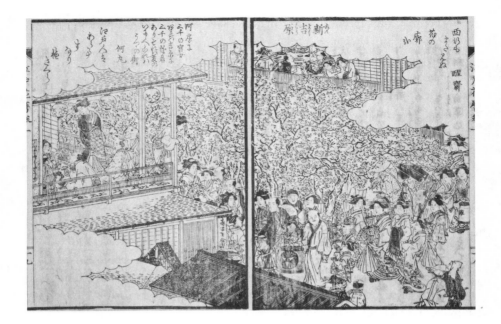

FIGURE 25
CHERRY-BLOSSOM VIEWING IN THE PLEASURE QUARTERS

This illustration by Hasegawa Settan, in Oka Sanchō's *Flower Calendar of Famous Places in Edo* (*Edo meisho hanagoyomi*, 1827), a noted guide to seasonal activities in Edo, shows cherry-blossom viewing at New Yoshiwara, the pleasure quarters in Edo. The inscribed *hokku* is: "Pleasure quarters of flowers that even Saigyō did not see" (*Saigyō mo mata minu hana no kuruwa kana*). (Courtesy of Waseda University Library, Special Collection, Tokyo)

The cherry trees at New Yoshiwara (Shin-Yoshiwara), the official pleasure quarters in Edo (figure 25), were brought in on the first day of the Third Month and taken away after the blossoms had scattered. At night, they were illuminated, making for an incredible spectacle.

Annual observances, like festivals to the gods (*matsuri*) in general, derived from at least three fundamental functions tied to the seasons: to welcome or pray to a god, with the welcome generally occurring at the beginning of the year or in the spring; to drive out evil, which tended to occur in the summer (the time of plague and harmful insects); and to celebrate or show

gratitude for a rich harvest, which usually took place in the autumn.[51] From as early as the Heian period, annual observances often included natural motifs (such as chrysanthemum and peach flowers) that became seasonal topics in *waka* and painting. By the Edo period, a large portion of the seasonal words in *haikai* were related to annual ceremonies. If architectural structures such as the garden of the palace-style (*shinden-zukuri*) residence and the alcove of the parlor-style (*shoin-zukuri*) residence, in which seasonal paintings and flower arrangements were displayed, served to interiorize secondary nature in the city, then annual observances in the form of cherry-blossom viewing and similar outdoor activities served to exteriorize secondary nature, placing it within easy reach, especially in the form of famous places that were constructed with increasing frequency in the major cities of the Edo period, particularly in the eighteenth century.[52] Significantly, this exteriorized nature centered on *waka*-esque motifs (such as cherry blossoms, bright foliage, and harvest moon), thus integrating a former court tradition into urban commoner life. Indeed, as the requirements of *renga* and the discourse of *haikai* treatises suggest, the cherry blossoms and moon, representing the two major cultural seasons, became synonymous with the beauty of nature, now enjoyed in a variety of urban forms.

In the Heian and medieval *waka* tradition, the poetic places functioned, as Kamo no Chōmei notes in *Mumyōshō* (*Nameless Treatise*, 1211–1216), as a kind of textual garden, a means to bring nature into immediate reach and express a poet's emotions and needs through its poetic landscape.[53] By contrast, the Edo-period *meisho* became a kind of public garden for urban commoners, many of whom could not afford their own gardens. In carefully cultivated scenic places, they could enjoy nature with little care and almost no cost. In contrast to the rock-and-sand gardens (*kare-sansui*) of medieval Zen temples, which were intended to be sites for quiet viewing and contemplation, the famous places of the Edo period became spaces for unrestrained behavior and inebriation. For urban commoners, cherry-blossom viewing was more akin to a festival, a time out of ordinary time, when the social rules and boundaries were temporally lifted. Probably forgotten was one of the ancient roots of cherry-blossom viewing: the belief that green leaves and sprays of flowers, when rubbed against the body or placed in the hair or clothing, brought new life to an individual.

Four other key aspects of the cultural representation of nature emerged in the Edo period: the impact of *haikai*, the rise of literary and visual parody, the role of food, and the influence of medical botany—all of which built on and dramatically altered the seasonal representations of nature as they had existed for almost a thousand years.

# Seasonal Pyramid, Parody, and Botany

The widespread influence of *haikai*, a new interest in food, a booming culture of parody, and the rise of medical botany left a deep imprint on the culture of the four seasons in the Edo period (1600–1867). *Haikai* (popular linked verse), which emerged in the Muromachi period (1392–1573) and came to the fore in the seventeenth century, transmitted the seasonal associations and images that had been developed in *waka* (classical poetry), even as it added a vast new sphere of poetic topics—from kabuki to unpleasant insects. With the shift of the capital to Edo (Tokyo), two major port cities (Edo and Osaka) became the cultural and economic centers, moving the general urban perspective from inland basins (Nara and Kyoto) to the coast and the sea, which became an important source of food. One result was that fish and food became major components of visual and literary culture, playing an influential role in such arts as the tea ceremony and *haikai*. Popular culture, while still depending on a knowledge of the literary classics (both Japanese and Chinese), now had the temporal distance and social difference to parody them extensively in the literary and visual arts and to make them the object of *mitate* (visual transposition), creating double images of past and

present, elite and popular. Added to these popular influences was that of medical botany (*honzōgaku*), which provided a detailed, visual, and scientific view of plants and which had a deep impact on the development of horticulture, the cultivation of cherry trees, and the spread of private flower gardens in the major cities. These new representations of nature, which are very apparent in the emerging print culture, did not supplant earlier literary and cultural representations so much as supplement them, creating a wide array of representations of nature and the seasons.

## The Seasonal Pyramid

The popularization of *waka*-based seasonal associations in the Edo period owed much to the rapid rise and spread of *haikai*, which became the most widely pursued literary and cultural genre in the seventeenth century, spreading from the major cities to every corner of Japan.

*Haikai*, which was practiced either as linked verse or as an autonomous opening verse (*hokku*, now called haiku) of a linked-verse sequence, required the use of seasonal words (*kigo*) and, by implication, the knowledge of seasonal topics (*kidai*). By the end of the seventeenth century, the seasonal words in *haikai* formed a vast pyramid, capped by the most familiar seasonal topics of classical poetry—cherry blossoms (*hana*), small cuckoo (*hototogisu*), moon (*tsuki*), bright leaves (*momiji*), and snow (*yuki*)—representing spring, summer, autumn, and winter, respectively. Spreading out from this narrow peak were other topics from *waka*—for example, spring rain (*harusame*), warbler (spring), willow (spring), orange blossoms (summer), and returning geese (autumn)— and those that had been added by *renga* (classical linked verse), such as paulownia flower (*kiri no hana*), a seasonal word for summer. Occupying the base of the pyramid were the new *haikai* words (*haigon*), which numbered in the thousands by the mid-seventeenth century. In contrast to the elegant, refined images at the top of the pyramid, the seasonal words at the bottom— such as dandelion (*tanpopo*), garlic (*ninniku*), horseradish (*wasabi*), and cat's love (*neko no koi*), all spring words—were taken from everyday commoner life and reflected popular culture in both the cities and the countryside. The pyramid of seasonal words embodies the hybrid character of *haikai*, with its roots in *waka* and *renga* and its unbounded contemporary sociocultural horizons, and is emblematic of Edo culture as a whole.

With the dramatic growth of *haikai* in the seventeenth century, the number of new seasonal words grew rapidly. Matsue Shigeyori's (1602–1680) *Hanahigusa* (*Sneeze Grass*, 1636), one of the earliest *haikai* handbooks, contains over 590 seasonal words divided by month, and his *Kefukigusa* (*Blown-fur Grass*, 1645) includes 950 seasonal words for *haikai* and 550 for *renga*, listed separately. Saitō Tokugen's (1559–1647) *Haikai shogaku shō* (*Instructions for Haikai Beginners*, 1641) lists more than 770 seasonal words, and Kitamura Kigin's (1624–1705) *Yama-no-i* (*The Mountain Well*, 1648), the earliest handbook devoted entirely to *kigo*, has over 1300 seasonal words. Finally, Takase Baisei's (d. ca. 1702) *Binsen shū* (*Available Boat Collection*, 1669) includes as many as 2000 seasonal words. But while the number of seasonal words grew at an astounding pace, the number of seasonal topics remained relatively limited.

*Haikai* poets, like *renga* poets before them, made a distinction between seasonal words (*kigo*), which indicate simply a particular season, and seasonal topics (*kidai*), which have an established cluster of poetic associations, usually centered on a poetic essence (*hon'i*), such as the loneliness identified with the cries and flight of wild geese in autumn. Most new seasonal words, such as "garlic," indicate a particular season (spring) but lack such poetic associations. The spring section of Matsue Shigeyori's *Enoko-shū* (*Puppy Collection*, 1633), a *haikai* collection of the Teimon school (led by Kitamura Kigin), consists almost entirely of familiar, established classical topics such as plum blossom (*ume*), lingering snow (*zansetsu*), spring grass (*shunsō*), and spring moon (*haru no tsuki*).

Over time, some new seasonal words evolved into seasonal topics. A good example is "cat's love for its mate" (*neko no tsumagoi*)—later simply called cat's love (*neko no koi*)—a *haikai* seasonal topic for spring that became popular in the Edo period. Matsuo Bashō (1644–1694) composed the following *hokku* in 1691 and included it in *Sarumino* (*The Monkey's Raincoat*): "(At a farmhouse) A cat's wife—grown thin from love and barley?" (*Mugimeshi ni yatsururu koi ka neko no tsuma*).[1] Bashō humorously depicts a female cat that has grown emaciated not only from being fed barley instead of rice—an economy that reflects a poor farmhouse—but from intense love-making. Another *hokku*, composed by Bashō in 1692, juxtaposes the loud caterwauling with the subsequent quiet of the misty moonlight (*oborozuki*), a classical seasonal word for spring, causing the two erotic moods to interfuse: "Cats making love—when it's over, misty moonlight in the bedroom"

(*Neko no koi yamu toki neya no oborozuki*). If the stag's longing for his mate—expressed by his mournful cries—is the archetypal seasonal topic on love in *waka*, then cat's love—with the baby-like crying of the male as it chases the female—embodies the down-to-earth, humorous character of the seasonal topic in *haikai*.

In the *haikai* treatise *Uda no hōshi* (*The Uda Priest*, 1702), Morikawa Kyoriku (1656–1715), one of Bashō's samurai disciples from Ōmi Province, divides poetic topics into "vertical topics" (*tate no dai*), the "province of classical poets," and "horizontal topics" (*yoko no dai*), the "province of *haikai* poets."[2] The difference lay in the approach, particularly to the poetic essence, which was generally fixed for *waka* poets but unrestricted for *haikai* poets. Unlike classical poets, who could not leave their own province, *haikai* poets were free to enter and explore either province. Of the two regions, they ultimately spent more time in what Kyoriku calls the "province of *waka*," tending to gravitate toward classical seasonal topics and established poetic places (*utamakura*)—such as Yoshino, Tatsuta River, Suma, Akashi, and Matsushima—which had a rich cluster of associations (Tatsuta with bright foliage, Suma with the autumn moon, and so on). *Haikai* poets were drawn to the classical topics at the top of the seasonal pyramid—such as cherry blossoms, small cuckoo, moon, and snow—which offered a poetic matrix around which a poet could build an entire *hokku* and which were no doubt easier to parody and make humorous variations on than the *haikai* topics at the bottom of the pyramid. Developed through hundreds of years of *waka* history, classical seasonal topics implied a rich world shared by poet and audience, one that could not be easily duplicated by new seasonal words or topics.

Thus Bashō and other *haikai* poets favored the top of the seasonal pyramid, but they approached these topics, as they did *utamakura*, from a *haikai* angle, often using *haikai* or vernacular words. In a *hokku* by Bashō, *zansho* (lingering summer heat) is the seasonal word for early autumn: "In a cowshed, mosquitoes buzzing darkly—lingering summer heat" (*Ushibeya ni ka no koe kuraki zansho kana*). The classical poetic essence of lingering summer heat is the contrast between the desire for the coolness that normally accompanies the arrival of autumn and the unbearable reality of the lingering heat. In a *haikai*-esque twist, using non-classical vocabulary (such as "cowshed"), Bashō approaches the classical topic and its poetic associations from a farmer's point of view.

One way in which *haikai* poets sought new approaches to classical topics was to observe the topic in its actual physical state. The classical poetic essence

of the small cuckoo (*hototogisu*) is its voice, which was the object of yearning but which was heard only sporadically: "The small cuckoo—where it disappears, a single island" (*Hototogisu kieyuku kata ya shima hitotsu*). In this poem, which Bashō wrote in 1688, during his *Oi no kobumi* (*Backpack Notes*) journey, the speaker implicitly hears the *hototogisu*, but by the time he looks up in its "direction" (*kata*), it has disappeared, replaced by an island—presumably Awajishima, the small island across the Inland Sea from Suma and Akashi, where the speaker stands. This *hokku* departs from classical *waka* in focusing on the cuckoo's physical motion: the arrowlike flight of the bird, the sharp cry being heard only once before it disappears from view. "Where it disappears" (*kieyuku kata*), which may refer to either the voice or the body of the *hototogisu*, is replaced on the horizon by "a single island" (*shima hitotsu*). In *haikai* fashion, the *hokku* is also parodic, twisting a well-known classical poem in the *Senzaishū* (*Collection of a Thousand Years*, 1183): "When I gaze in the direction of the crying cuckoo, only the moon lingers in the dawn" (*Hototogisu nakitsuru kata wo nagamureba tada ariake no tsuki zo nokoreru* [Summer, no. 161]). The flight or sound of the *hototogisu* leads the eye of the reader not just to one island but, in a *haikai* twist, to the classical past.[3]

The manner in which *haikai* expanded the perspective on nature and the four seasons is evident in its treatment of insects, which is a key topic in *waka* but exploded in popularity in Edo-period *haikai*. The most frequently encountered insects (*mushi*) in the first eight imperial *waka* anthologies are the frog (*kawazu*), butterfly (*kochō*), pine cricket (*matsumushi*), katydid (*kirigirisu*), bell cricket (*suzumushi*), and cicada (*higurashi*). The frog, along with the snake, was considered an insect before the Edo period. Except for the frog (spring) and the butterfly (summer), all these insects are autumn topics. Furthermore, except for the butterfly, the focus of all these insects is on their voices and singing, which became their poetic essence. (Most of these insects do not actually sing or cry, but rub their wings together to produce sound.) Poems on singing or crying insects appear for the first time in large numbers in the first autumn book of the *Kokinshū* (*Collection of Japanese Poems Old and New*, ca. 905): "Though autumn does not come for me alone, when I hear the sound of the insects it makes me sadder than anything else" (*Waga tame ni kuru aki ni shi mo aranaku ni mushi no ne kikeba mazu zo kanashiki* [Autumn 1, no. 186]). As the end of autumn approaches, the sound of the insects weakens, deepening the pathos.

In *waka*, small birds sing in high voices in the spring or summer, and their voices are generally considered bright and full of life. By contrast, the sounds made by insects were thought to be thin and lonely, and they came to symbolize the passing of the season. Many insects begin to sing with the arrival of evening, a time associated with decline or endings. The Buddhist notion of impermanence also had an impact, making some insects (such as the *utsusemi* [shell of the cicada]) a symbol of transience.[4] In the Heian period (794–1185), *waka* poets were also interested in homophonic associations. For example, the primary interest of the *matsumushi* (pine cricket) was the word *matsu* (to wait), which associated the cricket with love (longing), while the main interest of the *suzumushi* (bell cricket) was the word *suzu* (bell) and the notion of ringing (*furu*).

*Renga* manuals list insects under either early autumn (Seventh Month) or autumn, a practice that was continued in Edo-period *haikai* anthologies. This association is a key to understanding most poems on insects, such as a *hokku* by Raizan (d. 1716), an Osaka *haikai* poet of the Sōin school (led by Nishiyama Sōin [1605–1682]): "Even bathing outdoors occurs on alternate days—sound of insects" (*Gyōzui mo himaze ni narinu mushi no koe*). From late spring through summer, commoners bathed outdoors, using a bucket (*gyōzui*), but with the arrival of autumn, this daily practice decreased to alternate days. In the poem, the sound of insects echoes the increasing coolness of autumn.

By the first half of the seventeenth century, *haikai* was poeticizing small, everyday insects, which came to represent aspects of commoner society. For example, *Kefukigusa*, a *haikai* handbook and anthology edited by Matsue Shigeyori, includes such everyday insects as the ant, louse, mole cricket (*kera*), snail, slug (*namekuji*), flea, and fly. In the lists of *tsukeai* (associated words used to link verses), louse (*shirami*) is linked to beggar (*kojiki*), sick person, boat, thicket (*yabu*), old wadded cotton clothes (*furui nunoko*), and flower-viewing time (*hanami-koro*).[5] These became the new *haikai* poetic associations of the louse.

In contrast to classical insects, which are primarily autumn topics, the overwhelming number of new insects—such as the ant, lizard, hairy caterpillar, fly, earthworm, and centipede—are primarily seasonal words for summer. In *Makura no sōshi* (*The Pillow Book*, ca. 1000), Sei Shōnagon lists mosquitoes among "unpleasant things" (*nikuki mono*). But in the Edo period, the mosquito, fly, and flea became popular seasonal words for summer. The summer

section of Matsue Shigeyori's *haikai* collection *Enoko-shū* contains a subsection on "mosquitoes and summer insects," with eight *hokku*, including one that parodies the classical notion of singing insects: "In the summer evening, noh chanting to the accompaniment of mosquitoes" (*Natsu no yo wa ka no tsukegoe no utai kana*).[6]

From the Heian period, the fly had been associated with unpleasant noise and was not considered a poetic topic. In the Edo period, however, *haikai* poets focused on its weakness and helplessness, making it a victim to be pitied, the object of empathy, as in Kobayashi Issa's (1763–1827) *hokku* written in 1819: "The fly on the veranda, swatted as it rubs its hands!" (*En no hae te o suru tokoro wo utarekeri*). Another famous *hokku* is in Issa's *Hachiban nikki* (*Eighth Diary*, 1821): "Don't swat it! The fly rubs its hands, rubs its feet" (*Yare utsu na hae ga te o suri ashi o suru*).[7] These poems reflect a larger cultural fascination with and sympathy for small creatures, particularly insects, which function as metaphors for the condition of low-level commoners and farmers.

## Food and Fish

In the Edo period, various foods—particularly fish and vegetables, which were seasonally identified—became seasonal words, playing a key role in *haikai* and popular culture. In the seventeenth century, the tea ceremony (*chanoyu*), particularly in the forms of light cuisine (*kaiseki*) and confectionary or cakes (*wagashi*), helped to elevate food to the level of art, where it became part of the culture of the four seasons. The impact of *haikai*, which transformed the names of foods and fish into seasonal words, was equally large. Generally speaking, *waka* and *renga* avoided the treatment of food, which was regarded as low or vulgar. However, in Muromachi-period *haikai*, which deliberately broke with this tradition, the humor frequently comes from linking a vulgar subject (food, sex, the body, bodily excretions) with an elegant topic (flowers, birds, nature, love), as in the opening *hokku* to *Chikuba kyōgin shū* (*Hobby Horse Comic-Verse Collection*, 1499): "Something that Kitano, the Lady of the House, likes: the plum blossom" (*Kitano-dono no on-suki no mono ya ume no hana*). *Kitano-dono* (literally, "Lord of the Northern Field") refers to Sugawara no Michizane (845–903), who was associated with plum blossoms and with memory due to a famous poem he

had written while in exile, and to the lady of the house (who occupied the northern quarters) who likes (*suki*) sour things (*suki-mono*), such as pickled plum (*ume-zuke*), because she is pregnant. The web of elegant associations (Michizane, plum blossom, poetry, and devotion to the arts) is humorously mixed with the web of "low" associations (pregnancy and food) lurking within the poem. The cultural history of the plum begins with the flower, which came to the fore in the Nara period (710–784); moves to the scent, which dominated poetics in the Heian period; and culminates with the fruit and taste in the Muromachi and Edo periods.

Fish also emerged as a topic in Edo-period *haikai*. The sea plays a significant role in the early chronicles and in the *Man'yōshū* (*Collection of Ten Thousand Leaves*, ca. 759), but in the Heian period, when the capital was inland, the sea was a distant place. When it does appear, it is often hostile and dangerous, as in the search for the jewel in the dragon's neck in the South Seas in *Taketori monogatari* (*Tale of the Bamboo Cutter*, ca. 909) or in *The Tale of Genji* (*Genji monogatari*, early eleventh century) when Genji is exiled to Suma and Akashi, on the Inland Sea, where he encounters high tides and storms. This situation was to change dramatically in the Edo period, with the development of two major waterfront cities, Osaka and Edo; the growth of the fishing industry; and the spread of new transportation methods, which made sea fish a key part of the food chain.

A symbol of the new Edo cuisine was *Ryōri monogatari* (*Tales of Cooking*, 1643), which reflects the new commoner values and attitudes toward food. The first half of the book begins with "fishes of the sea," giving seventy-one species, starting with the sea bream (*tai*), and followed by "grasses of the sea," featuring twenty-five kinds of seaweed. Next are river fish (nineteen types), birds (eighteen), animals (seven), mushrooms (twelve), and vegetables (seventy-six). In short, *Ryōri monogatari* begins with the "treasures of the sea" (*umi no sachi*) and ends with the "treasures of the mountains" (*yama no sachi*). In the medieval period, the fishing industry rapidly grew, while the hunting of land animals diminished but never died. In *Ryōri monogatari*, the category "animals" (*kedamono*) lists four-legged animals—deer, badger, wild boar, rabbit, otter, bear, and dog—that were eaten more widely in the pre-Edo period than is usually imagined. From 675, when Emperor Tenmu (ca. 631–686, r. 673–686) issued his prohibition on the consumption of meat (which reflected the extensive hunting practices of the time), the custom of avoiding meat gradually spread, together with the Buddhist proscription on

killing and the Shinto notion of pollution (*kegare*). But Tenmu's prohibition was restricted to five animals: cattle, horses, dogs, monkeys, and chickens. It did not include deer and boar, which continued to be important sources of food. Many aristocrats did not eat meat, but most commoners continued to do so. In the Edo period, however, the aristocratic avoidance of meat began to penetrate society as a whole, and a prejudice developed against those who handled meat.[8] Vegetarian cuisine (*shōjin ryōri*), which had emerged from Zen temples in the Kamakura period (1185–1333), slowly spread and was followed in the early Edo period by *kaiseki ryōri*, a light cuisine that sometimes included fish and fowl, but was fundamentally vegetarian. Whereas Kyoto aristocratic cuisine was based essentially on vegetables, Edo commoner cuisine was based on fish, particularly small fish (*kozakana*) and shellfish. The dishes that are today considered representative of Japanese cuisine—sushi, tempura, *kabayaki* (eel grilled and basted in sweet sauce), *hamo* (pike conger), *dojō* (loach), *kai-nabe* (shellfish stew), *tsukudani* (food boiled down in soy sauce)—were created as a result of the availability of fresh fish and shellfish from Edo Bay, referred to as the Edo waterfront (Edo-mae).

In the classical poetic tradition, sight, sound, and smell were considered to be elegant sensations, while taste was regarded as vulgar. But in the Edo period, the preparation and presentation of food became a major cultural activity, and a wide variety of foods were "seasonalized" in *haikai*. By the mid-Edo period, cultural awareness of the seasons stemmed in significant part from the growth of gastronomic culture, which was reflected in the enormous surge in the number of seasonal words derived from food. Rantei Seiran's *Haikai saijiki shiorigusa* (*Guiding Grass Haikai Seasonal Almanac*, 1851) was the most influential seasonal almanac (*saijiki*) for poets in the late Edo period,[9] and the scholar Morikawa Akira calculates that it includes as many as 480 food words out of around 3400 seasonal words—that is, some 14 percent of the total:[10]

SPRING

Celebratory rice-vegetable soup (*zōni*), herring roe (*kazu no ko*), black soybean (*kuromame*), seven-spring-herbs soup (*nanakusa*), whitebait (*shirauo*), corbicula clam (*shijimi*), baby-neck clam (*asari*), cherry bass (*sakuradai*), white rice wine (*shirozake*), bracken (*warabi*), butterbur (*fuki no tō*)

Oak-leaf rice cake (*kashiwa-mochi*), first bonito (*hatsu-gatsuo*), eggplant (*nasubi*), selling cold water (*hiyamizu-uri*), agar weed (*tokoroten*), young bamboo shoots (*takenoko*), quick vinegared fish (*haya-zushi*)

AUTUMN

New rice wine (*shinshu*), potato (*imo*), sweet potato (*satsumaimo*), shiitake mushroom, matsutake mushroom, chestnut (*kuri*), chrysanthemum-flower banquet (*kikka no en*), grape plant (*budō*), persimmon (*kaki*), watermelon plant (*suika*)

WINTER

Medicinal eating (*kusuri-gui*), blowfish (*fugu*), scallion (*negi*), pulling up Japanese radishes (*daikon-hiki*), clay-pot stew (*nabeyaki*)

This list, which represents only a fraction of the existing seasonal words related to food, reflects the range of foods (particularly fish and shellfish) that took on seasonal connotations in *haikai*. A notable exception to the practice of not eating meat is *kusuri-gui*, which involves cooking and eating deer meat as a cure for illness.

In contrast to meat (beef, pork, chicken, and lamb or mutton), which does not change fundamentally during the year, fish, like vegetables, are eaten in season. Two words that were key to Japanese cuisine were *shun* (peak season or tastiest time)—when a particular fish, vegetable, or fruit is at its best—and *hashiri* (first of the season)—when a particular fish, vegetable, or fruit first appears, also known as *hatsu-mono* (first things), which implies the anticipation of something new and tasty. The bonito (*katsuo*), a fish that lives in warm and tropical waters, rides on the Kuroshio Current in the Pacific Ocean, going from Kyushu to Shikoku at the beginning of spring and then up the Honshu coast to the Chiba area (near Tokyo) by early summer. The first bonito (*hatsu-gatsuo*) was the first bonito of the year, harvested around the Fourth Month at the beginning of summer. The word *hashiri* (literally, "running") is said to come from the running that was required to bring a fish to market. In the Edo period, bonito were caught at Kamakura or Odawara

(present-day Kanagawa Prefecture) and rapidly couriered to Edo, where they arrived by night (thus the name night bonito [*yo-gatsuo*]).[11] A *hokku* by Bashō captures this practice: "Were they alive when they left Kamakura? The first bonito" (*Kamakura wo ikete idekemu hatsu-gatsuo*).[12] The classical *waka* equivalent of *hashiri* would be the first song of the bush warbler or of the small cuckoo. A *hokku* by Yamaguchi Sodō (1642–1716), a contemporary and colleague of Bashō, brings these elements together: "Before my eyes the green leafed hills, the small cuckoo, and the first bonito" (*Me ni wa aoba yama hototogisu hatsu-gatsuo*). This famous *hokku* grasps early summer through three senses: sight (new green leaves in the hills), sound (the voice of the small cuckoo), and taste (the first bonito).

## Parody and *Mitate*

The reception of the "Eight Views of the Xiao and Xiang" (Shōshō hakkei), a major Chinese painting and poetry (*kanshi*) topic (see figure 12), is a good example of the impact of "*haikai* culture" on both visual and poetic genres. Except for Lake Dongting and the Xiao and Xiang rivers, the "Eight Views" are not specific place-names. The flexibility of locale in the "Eight Views" allowed the Japanese artist, poet, and audience to graft their own favorite domestic and local places onto them. This led to the "Eight Views of Ōmi" (Ōmi hakkei), "Eight Views of Edo," "Eight Views of Kanazawa," and so forth. The "Eight Views" became so popular in the Edo period that they sprang up in various provinces. The earliest and most famous of these groupings is the "Eight Views of Ōmi," a province on the southern shore of Lake Biwa, northeast of Kyoto, which gave rise to the following eight views:

Clearing Storm at Awazu (Awazu seiran)
Sunset over Seta (Seta sekishō)
Sails Returning at Yabase (Yabase kihan)
Night Rain at Karasaki (Karasaki yau)
Vesper Bell at Mii Temple (Mii banshō)
Autumn Moon at Ishiyama (Ishiyama shūgetsu)
Descending Geese at Katata (Katata rakugan)
Evening Snow on Mount Hira (Hira bosetsu)

In this series, the atmospheric, celestial, and seasonal motifs are the same as those in the "Eight Views of the Xiao and Xiang," but the locations are now bridges, temples, and famous local sights in the Ōmi area. As Haga Tōru has pointed out, many of the "Eight Views of Ōmi" had already appeared as *utamakura* in famous-place paintings from as early as the Heian period.[13]

Konoe no Nobutada (1565–1614), a high-ranking noble in the service of Emperor GoYōzei (1571–1617, r. 1586–1611), created the first illustrated album with eight *waka* on the "Eight views of Ōmi." The *waka* on "Autumn Moon at Ishiyama" is "Ishiyama—the moon that shines over Lake Biwa, like that of Akashi and of Suma, how extraordinary!" (*Ishiyama ya nio no umi teru tsuki kage wa Akashi mo Suma mo hokanaranu kana*). The harvest moon at Akashi and Suma, on the Inland Sea, had become famous in the Heian period because of *The Tale of Genji*, in which the Shining Genji gazes at the autumn moon from Suma. Even more important was the medieval legend that Murasaki Shikibu, gazing at the reflection of the moon on Lake Biwa from Ishiyama Temple, had been inspired to write *The Tale of Genji*, beginning with the "Suma" chapter. Suzuki Harunobu (1725?–1770), a noted ukiyo-e master, used Nobutada's poem in his print *Autumn Moon at Ishiyama* (*Ishiyama shūgetsu* [Museum of Fine Arts, Boston]), from the "Eight Views of Ōmi" series he did in the early 1760s.

The topic of "Eight Views of Ōmi" was so popular that by the 1760s it had become the object of visual and textual parody. A classic example is Harunobu's series "Eight Parlor Views" (Zashiki hakkei, 1766):

*Clearing Breeze from the Fans (Ōgi no seiran)*
*Evening Glow of the Lantern (Andō no sekishō)*
*Returning Sails of the Towel Rack (Tenuguikake kihan)*
*Night Rain on the Heater Stand (Daisu no yau)*
*Vesper Bell of the Clock (Tokei no banshō)*
*Autumn Moon in the Mirror Stand (Kyōdai no shūgetsu)*
*Descending Geese of the Koto Bridges (Kotoji no rakugan)*
*Evening Snow on the Floss Shaper (Nurioke no bosetsu)*

In Harunobu's domestic variation, the scene "Autumn Moon at Ishiyama" becomes *Autumn Moon in the Mirror Stand*, with a woman looking into a mirror that has the shape of a round moon (figure 26). The miscanthus grass (*susuki*) bending in the breeze outside the window is a seasonal sign,

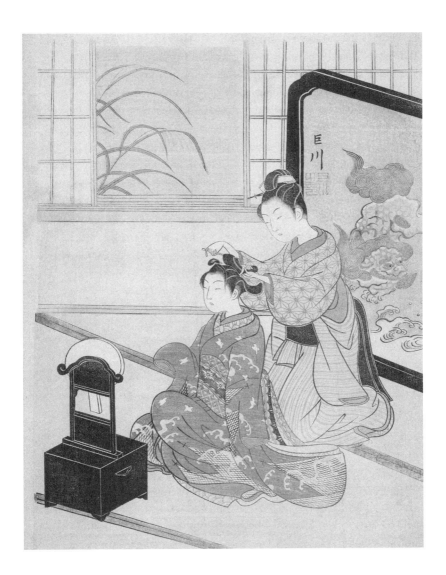

FIGURE 26

*AUTUMN MOON IN THE MIRROR STAND*

In *Autumn Moon in the Mirror Stand* (*Kyōdai no shūgetsu*), a print in Suzuki Harunobu's series "Eight Parlor Views" (Zashiki hakkei, 1766), the mirror becomes a visual pun on the autumn moon, creating a parody of "Autumn Moon at Ishiyama" (Ishiyama shūgetsu), one of the "Eight Views of Ōmi." (Color woodblock print; *chūban*, 11.3 × 8.1 inches, Clarence Buckingham Collection, 1928.898, The Art Institute of Chicago. Photography @ The Art Institute of Chicago)

turning the mirror into the harvest moon and, by implication, the moon at Ishiyama Temple. Using the familiar ukiyo-e technique of *mitate*, of seeing *X* as *Y*, Harunobu creates a double vision, superimposing the exterior landscape of the "Eight Views," with its specific atmospheric and seasonal associations, onto the interior world of urban commoners in contemporary Edo; the two are held together by the visual pun of the mirror reflecting the lovely young woman, much as serene Lake Biwa reflects the harvest moon in the *waka* tradition.[14]

This kind of parodic *mitate*, apparent in a wide range of genres from kabuki to *kibyōshi* (yellow books), grew directly out of *haikai* and *kyōka* (comic poetry; literally "wild poetry"), which became a major parodic genre in the second half of the eighteenth century. *Kyōka* uses the same form (thirty-one syllables) as *waka*, but unlike *waka*, it is unrestricted in content and diction. A "visual transposition" link (*mitate-zuke*) in *haikai* can be seen in the following sequence from *Kōbai senku* (*Crimson Plum Thousand Verses*, 1653):

| | |
|---|---|
| *Koganebana* | The golden flowers |
| *mo sakeru ya hon no* | have also bloomed! |
| | |
| *Hana no haru* | The true flowers of spring. |
| *shinchū to miru* | The *yamabuki* look like brass, |
| *yamabuki no iro* | the color of the gold coins.[15] |

The first verse presents the beauty of the golden flowers, and the second, or added, verse compares them to brass coins. The two are linked by a pun on *yamabuki* (yellow kerria), a seasonal word for spring that in the Edo period also became the name for a gold coin. The *mitate* link transforms the yellow of an elegant and poetic flower of *waka* culture into the yellow money of plebian culture. The *haikai* link, in other words, creates a double image of court culture (hovering in the background) and popular culture (pushed to the foreground).

An even further parodic twist appears in *Autumn Moon in the Mirror Stand* from Harunobu's "Fashionable Eight Parlor Views" (Fūryū zashiki hakkei, ca. 1769), an erotic (*shunga*) series produced for private consumption (figure 27). Harunobu depicts a man grasping a half-naked woman from

FIGURE 27

*AUTUMN MOON IN THE MIRROR STAND*

This version of *Autumn Moon in the Mirror Stand* (*Kyōdai no shūgetsu*), a print in Suzuki Harunobu's series "Fashionable Eight Parlor Views" (Fūryū zashiki hakkei, ca. 1769), parodies his own print of the same name in "Eight Parlor Views," which in turn plays off the scene "Autumn Moon at Ishiyama." This multilayered parody is typical of the way in which late-eighteenth-century genres such as *haikai*, *kyōka*, and ukiyo-e treated classical topics. (Color woodblock print; 7.9 × 11.2 inches. Private collection)

behind and fondling her genitals as she dresses in front of a mirror. Outside, on the veranda, is a pot of flowering pinks (*nadeshiko*; literally "petting a child"), one of the seven grass flowers of autumn, which alludes to the erotic action indoors. The *kyōka* inscribed at the top of the print reads: "Moon of an autumn evening, climbing the pedestal until it can be seen through the clouds—moon of an autumn evening" (*Aki no yo no kumo ma no tsuki to miru made ni utena ni noboru aki no yo no tsuki*). The moon in Harunobu's *kyōka* refers to the half-naked woman, who is emerging from the robes (clouds) that are being pulled off by the man embracing her, and the round

(moon-like) mirror. The moon can also represent the man, who is "climbing" the woman, symbolized by the *utena* (pedestal), on which the mirror rests, which also means "calyx," a metaphor for female genitals.[16] In short, Harunobu uses text and image to create a complex, intertwining parody that can be read and viewed on multiple levels.[17]

Straddling both popular and elite culture (*ga-zoku*), *haikai* moved in two fundamental directions: either it could seek the high in the low, or it could seek the low in the high. In the seventeenth century, the poems of Matsuo Bashō exemplified a kind of *haikai* that sought spiritual and aesthetic value in everyday, commoner topics. This occurs in the "Eight Views of Ōmi," which were elevated by being associated with the "Eight Views of the Xiao and Xiang." In *mitate* ukiyo-e, noted courtesans are similarly elevated by visual and textual allusions to Murasaki Shikibu, the female poet Ono no Komachi, famous female characters from *The Tale of Genji* (such as the Third Princess), and bodhisattvas and other Buddhist figures or goddesses.

Like *kyōka*, though, *haikai* often reduced the elegant to the popular, sometimes using scatological or vulgar imagery. Essentially, this occurred in two ways. The first method was elegant. Harunobu's series "Eight Parlor Views" exemplifies witty and refined "dressing down." In place of the high culture represented by the "Eight Views of the Xiao and Xiang," Harunobu depicts the everyday culture of urban commoner women. The second way was erotic or sometimes pornographic, as in Harunobu's series "Fashionable Eight Parlor Views." Whether the artist or poet was seeking the high in the low, finding the low in the high, or doing both, the classical representations of nature and the four seasons were radically recast, often becoming the object of humor and parody.[18]

## Medical Botany

In the late Edo period, the cultural and visual representation of nature was heavily influenced by medical botany (*honzōgaku*), a pharmaceutical science centering on plants but also including animals and minerals. In 1803, Kyokutei Bakin (1767–1848) published *Haikai saijiki* (*Haikai Seasonal Almanac*), which contains more than 2600 seasonal topics (*kidai*) arranged by the four seasons and the twelve months of the year with *haikai* examples. *Haikai*

*saijiki*, which is detailed in its description and citation of sources, is the first seasonal almanac centered on Edo, the new cultural center of Japan.[19] In 1851, Rantei Seiran published a revised and expanded edition called *Haikai saijiki shiorigusa*, better known as *Shiorigusa* (*Guiding Grass*), which was widely used in the modern period. By the end of the Edo period, there were two basic types of seasonal almanacs: collections of seasonal words and topics for *haikai* practice and encyclopedic almanacs, which provided information about almost every phase of everyday life. *Shiorigusa*, which represents the culmination of the latter trend, drew on a variety of sources: the *haikai* collections of seasonal words (*kiyose*); the topically arranged poetry collections (*ruidaishū*); dictionaries such as Minamoto no Shitagō's *Wamyō-ruiju-shō* (*Collection of Japanese Words*, 931–938), Japan's first Chinese–Japanese dictionary; and encyclopedias. The last source included Li Shizhen's *Honzō kōmoku* (Ch. *Bencao gangmu*; *Compendium of Materia Medica*, 1578), a great compendium of *bencaoxue* (Jp. *honzōgaku*) imported to Japan in 1607; *Kinmōzui* (1666), Japan's first illustrated encyclopedia; and *Wakan sansai zue* (*Sino-Japanese Three Worlds Illustrated Encyclopedia*, 1712), edited by Terajima Ryōan. Particularly important was *Honzō kōmoku*, which had an impact on East Asia as a whole.

By the mid-Edo period, the classical associations of nature and the four seasons in *haikai* began to overlap with new scientifically based views of nature, particularly as the result of medical botany, which had evolved to the point that it approached what is now regarded as natural history (*hakubutsugaku*). In the medieval period, there had been a widespread belief (evident, for example, in the military narratives) in the four birth types (*shishō*), which divide sentient beings by the way in which they are born: womb birth (*taishō*), egg birth (*ranshō*), humidity birth (*shisshō*), and spontaneous or supernatural birth from an unknown source (*keshō*). In contrast to mammals, which were born from wombs, and birds, which were born from eggs, insects were thought to be born from humidity or spontaneously, which placed them at a lower level than and at a farther distance from humans, weakening the implicit prohibition against killing them.

*Honzō kōmoku* divides insects into three birth types. Insects in the egg-birth category include the bee, silkworm, butterfly, dragonfly, spider, ant, fly, mite, and louse. The humidity-birth category contains such insects as the frog, centipede (*mukade*), earthworm (*mimizu*), snail, slug, and whirligig

beetle (*mizusumashi*). In the spontaneous-birth category are earth insects (*jimushi*), tree-eating insects (*ki-kui-mushi*), cicada, goldbug (*koganemushi*), praying mantis, mole cricket (*kera*), firefly, silverfish, wood louse (*waraji-mushi*), locust (*inago*), and wasp. A major change in this view of insects, however, occurred in the mid-Edo period with the introduction of the microscope, which revealed that insects mate and do not arise from humidity or by spontaneous generation. Hiraga Gennai (1728–1779) asserted that all insects mate and that there is no difference between insects and human beings in this respect. Gennai's contemporary Shiba Kōkan (1747–1818), a painter and printmaker, used a microscope to enlarge his view of small insects, which allowed him to accurately draw them. The impact of the microscope is evident in an illustration by Utagawa Kunisada (1786–1864) in Santō Kyōden's (1761–1816) *gōkan* (bound book) *Matsu to ume to take tori monogatari* (*Tale of Gathering Pine, Plum, and Bamboo*, 1789), in which a man dreams of being attacked by monsters that are depicted like insects enlarged under a microscope (figure 28).

The effect of *honzōgaku* on classical views of nature is also apparent in late-eighteenth-century ukiyo-e. These woodblock prints were originally designed to depict the "floating world," primarily the licensed quarters and the theater, illustrating beautiful courtesans (*bijinga*) and kabuki actors (*yakusha-e* [actor prints]). But under the influence of Edo-period Tosa and Kanō school bird-and-flower (*kachōga*) screen paintings, which were produced primarily for powerful warlords, the imperial family, and wealthy merchants, ukiyo-e artists began to make bird-and-flower woodblock prints that had wider social circulation. With the emergence in 1765 of the fully polychromatic ukiyo-e (*nishiki-e*; literally, "brocade painting"), the bird-and-flower prints began to have some of the full-color appeal of the Kanō and Tosa school paintings.

Around 1790, the ukiyo-e master Kitagawa Utamaro I (1753–1806) produced realistic bird-and-flower pictures for illustrated *kyōka* books (*kyōka ehon*), which opened up a new and vibrant field of visual culture. Wealthy samurai and urban commoners, who worked in groups, commissioned ukiyo-e artists such as Utamaro to illustrate their *kyōka* collections. Utamaro's most noted work in this vein is a three-part *kyōka* picture book series: *Ehon mushi erami* (*Illustrated Book of Selected Insects*, 1788), which depicts insects and flowers; *Shiohi no tsuto* (*Gifts of the Ebb Tide*, probably 1789),[20] which illustrates shellfish; and *Momo chidori kyōka uta-awase* (*The*

FIGURE 28
INSECTS AS MONSTERS

These monsters (flea, louse, mosquito, and red mosquito larva), appearing in a man's dream in
Santō Kyōden's *Tale of Gathering Pine, Plum, and Bamboo* (*Matsu to ume take tori monogatari*,
1789), were inspired by illustrations in *Stories from Holland* (*Kōmō zatsuwa*, 1787), edited by
Morishima Nakara, which show mosquitoes, cockroaches, fleas, and other insects under a
microscope. (From *Santō Kyōden zenshū*, ed. Mizuno Minoru [Tokyo: Perikansha, 1999], 7:363.
Courtesy of Perikansha)

*Myriad Birds Comic-Poetry Contest*, 1790), which portrays birds. *Momo chi-
dori kyōka uta-awase*, which pairs thirty kinds of birds (such as skylark and
quail, green pheasant and barn swallow, and egret and cormorant), goes
beyond the classical circle of birds to include those (such as chicken, pigeon,
tree sparrow, and barn swallow) found in everyday, commoner life. Illus-
trated in a highly naturalistic manner, each bird is accompanied by a *kyōka*
in a poetry-contest format (figure 29). The *kyōka* on the skylark in "Skylark
and Quails"—"Conceited skylark, flying high in the sky, even you must come
down to Earth when night falls" (*Oozora ni omoiagareru hibari sae yūbe wa
otsuru narai koso are*)—puns on the verb *omoiagaru* (to be proud or con-

ceited), which contains another verb, *agaru* (to rise high), for which the sky-
lark is known.[21] As Imahashi Riko has shown, the *kyōka* picture books,
which eventually led to a new type of bird-and-flower ukiyo-e, grew out of
two important predecessors: illustrated *haikai* books (*haisho*) and illustrated
*honzōgaku* books, which copied birds, insects, and plants as accurately as
possible for scientific and medical purposes.[22]

The visual impact of medical botany on the world of poetry is also evident
in *Haikai na no shiori* (*Haikai Guide to Names*, 1780), a *haikai* seasonal alma-
nac edited by Tani Sogai (1733–1823) that identifies the characteristics of each

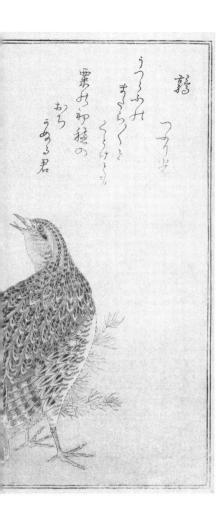

FIGURE 29

BIRDS WITH *KYŌKA* POETRY

The illustration for "Skylark and Quails" in Kitagawa Utamaro's *Myriad Birds Comic-Poetry Contest* (*Momo chidori kyōka uta-awase*, 1790) combines naturalistic images of birds with corresponding *kyōka* by Zeniya Kinrachi (for the skylark) and Tsuburi Hikaru (for the quail). (Color woodblock print; horizontal *ōban*, 10 × 15 inches. Courtesy of the Museum of Fine Arts, Boston, William S. and John T. Spaulding Collection, 1921, no. 21.6589)

bird and that was illustrated with scientific and naturalistic precision by the noted ukiyo-e artist Kitao Shigemasa (1739–1820) (figure 30).[23] The almanac was designed so that *haikai* poets could identify plants and animals that they knew about but had never seen. A similar degree of visual accuracy is apparent in illustrations of fish, which also became the subject of bird-and-flower–style color woodblock prints in the latter half of the Edo period. Most noteworthy is the so-called Fish Series (Sakana-zukushi) of twenty-one color prints that Utagawa Hiroshige (1797–1858) did in his last years.[24] Hiroshige had turned his attention to bird-and-flower ukiyo-e in the Tenpō era (1830–1844),[25] at

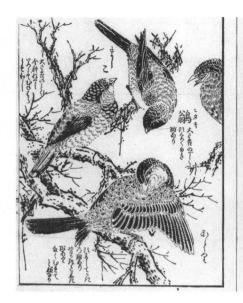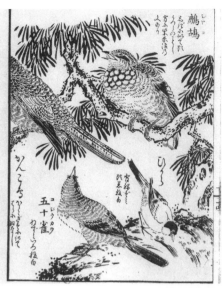

FIGURE 30

BIRD GUIDE AND SEASONAL WORDS

Tani Sogai's seasonal almanac *Haikai Guide to Names* (*Haikai na no shiori*, 1780), with illustrations by Kitao Shigemasa, categorizes plants, birds, fish, and insects by season (beginning with spring) and depicts them in scientifically accurate fashion, allowing poets to identify and use them as seasonal words in verse. Each bird is identified by name and accompanied by a seventeen-syllable *hokku*. On the upper left are the crested flycatcher (*hitaki*) and rosy finch (*mashiko*), seasonal words for autumn, and in the middle and lower right are the nuthatch (*gojūkara*) and cuckoo (*kankodori*), seasonal words for summer. (Courtesy of the Kaga Collection, Tokyo Metropolitan Central Library)

about the same time that he began to create his noted famous-place (*meisho*) landscape prints. In the "Fish Series," Hiroshige, drawing under the obvious influence of *honzōgaku*, substituted different fish for the usual birds found in earlier bird-and-flower paintings and prints. One of the *kyōka* in the print *Abalone, Peach Blossoms, and Halfbeak* reads: "Matching the menu, the half-beak changes to summer clothes, stripping off its skin, taking out its guts, and preparing itself for a meal" (*Kondate no awase sayori mo koromogae wata wo nukite zo koshiraenikeru*) (figure 31). In Hiroshige's print, the fish is personified in much the same way that flowers and birds are personified in *waka*, but with a humorous twist that links it to food culture.

Medical botany (*honzōgaku*), which expanded to what is now regarded as natural history (*hakubutsugaku*), had an impact on a wide variety of fields—horticulture, gardening, agriculture, pet culture, and animal exhibitions (*misemono*), or mini-traveling zoos, to mention only the most obvious—and led to a profusion of illustrations and color woodblock prints of plants, insects, reptiles, fish, and other animals, all of which were replicated with uncanny accuracy. As cities grew larger in the Edo period, and as urban dwellers became separated from the natural environment, the practical medical function of *honzōgaku* faded and medical botany and related fields expanded to encompass knowledge of nature. Thus at the point at which urban dwellers were separated from the natural environment, "nature" was partially recovered or reproduced both through a virtual nature, in illustrated books and ukiyo-e, and through a recultivated nature, in such forms as flower gardens, ikebana, and famous places.

One of the most striking aspects of the culture of the four seasons in Japan is the deep impact of classical poetry and its seasonal associations, which spread to commoner society in both the cities and the provinces in the Muromachi and Edo periods. The influence was so significant that by the mid-seventeenth century—when commercially based, urban culture came to the fore—the classical associations had become both a requirement for the education of urban commoners and, increasingly, in the hands of poets and artists, the object of parody and humorous variation. Parody occurs only when the form and content have become distanced (desacralized) and yet remain familiar enough to the audience that the slightest variation strikes a humorous or witty chord. This dual aspect—as both basis for education and object of humor—is best embodied in the phenomenon of *haikai*, which, while making available to commoners the canon of seasonal associations, produced its own earthy, popular variations on these familiar topics and motifs, thereby expanding and revivifying the culture of the four seasons. The multiple roles of *haikai* are also visible in the seasonal pyramid, which was capped by the classical associations but had a broad and extensive base of popular, contemporary words and images. The *haikai* poet could travel through either the "province of *waka*" or the "province of *haikai*" or explore both at the same time.

Emblematic of these large changes are the new perspectives on insects and fish. In the hands of *haikai* poets, insects—known for their song in the

FIGURE 31
BIRD-AND-FLOWER GENRE UNDERWATER

In *Abalone, Peach Blossoms, and Halfbeak* (ca. 1840–
1842), a print in his "Fish Series" (Sakana-zukushi),
Utagawa Hiroshige combines the realistic depiction of
nature underwater with the humor of *kyōka* and the
brilliance of color ukiyo-e, giving new life to the
bird-and-flower genre. (Color woodblock print,
horizontal *ōban*, 9.8 × 14.4 inches, Courtesy of Forest
Where the Sea Appears Art Museum [Umi no mieru
mori bijutsukan], Hiroshima)

*waka* tradition—became the embodiment and metaphor of everyday, gritty
commoner existence (including the unpleasant heat and humidity of sum-
mer) both in the farm villages and in the cities. *Haikai* also focused on fish
and seafood, which had never been part of the classical literary tradition but
emerged as important elements in visual and literary culture as a result of
changes in the environment, the rise of medical botany, and the impact of
new popular genres.

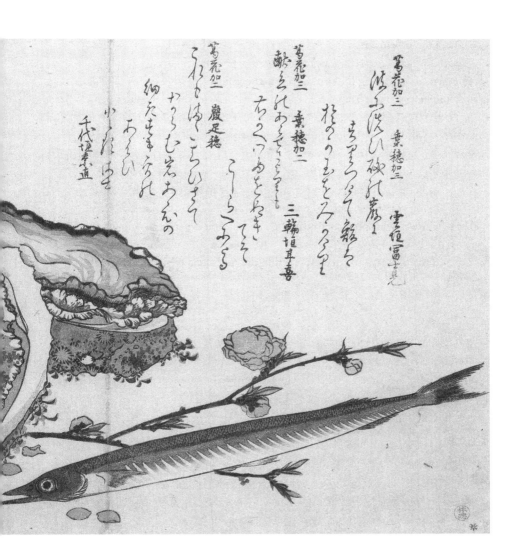

The *haikai* spirit of parody and comic inversion also informed new visual genres, such as the woodblock print, which, as in Suzuki Harunobu's variations on the "Eight Views of Ōmi," combined Japanese poetry with fresh visual images that alluded to and parodied the Japanese and Chinese models on both the pictorial and textual levels. As a result of the coexistence of multiple poetic genres—*waka*, *haikai*, *kanshi* (Chinese-style poetry), *senryū* (satiric haiku), and *kyōka*—representations of nature and the seasons in vi-

sual and literary culture were many-layered, drawing on classical associations and interweaving references to contemporary life and events.

Further complicating the situation was the increasing impact of medical botany (*honzōgaku*) and the natural sciences, which, by the eighteenth century, both observed natural phenomena scientifically, including under a microscope, and had a huge impact on artists and designers. *Honzōgaku* changed the Japanese understanding of nature, particularly the classification of species, and profoundly influenced the visual representations of plants, animals, and other natural phenomena, particularly in the new print culture. The surprising combination of scientifically observed birds, flowers, insects, and sea creatures with poetic parody, wit, and allusion is evident in the illustrated *kyōka* books (*kyōka ehon*), which encapsulate the new representations of nature and the four seasons that emerged in the mid- to late Edo period.

*Conclusion*

# History, Genre, and Social Community

This book approaches the idea of secondary nature, particularly in urban environments, from various angles—textual and visual arts, architecture, socio-religious rituals, and annual observances—and explores the evolution of some of the major components of secondary nature through a number of closely interlinked art forms: *waka* (classical poetry), *renga* (classical linked verse), *haikai* (popular linked verse), standing-flower (*rikka*) arrangement, gardens, the tea ceremony (*chanoyu*), screen painting (*byōbu-e*), and ukiyo-e. What emerges is not a unified "Japanese" view of nature and the seasons, but a highly diverse perspective, with functions and representations of nature differing greatly, depending on the historical period, genre, social community, and environment. As we have seen, depictions of nature over the thousand years from the Nara (710–784) to the Edo (1600–1867) period reflect the social hierarchies and values of producers and consumers, particularly those—such as the aristocracy in the Heian period (794–1185)—in positions of dominance and influence. Earlier constructions were not totally replaced so much as modified and woven into newer ones, in an increasingly variegated fabric of intersecting representations. Thus beliefs about the talismanic

powers of animals, plants, and natural objects, which first appeared in the ancient and Nara periods, continued to coexist with the elegant depictions of nature—based on color, scent, and sound—that developed in aristocratic and court society in the Heian period, and these in turn coexisted with Chinese-influenced monochromatic landscapes painted in the medieval period (1185–1599). In the Edo period, the earlier views continued alongside new perspectives on nature that resulted from the emergence of medical botany (*honzōgaku*), which was closely tied to the highly scientific, realistic depictions of plants and animals, including insects and fish, that began to appear in paintings and prints.

Both the intensive focus on the seasons and the notion of harmony with nature in Japanese culture have been attributed by modern Japanese scholars and critics to the climate of Japan and the agricultural basis of Japanese society. But in the early chronicles—the *Kojiki* (*Record of Ancient Matters*, 712) and *Nihon shoki* (*Chronicles of Japan*, 720)—and the provincial gazetteers (*fudoki*), there is little evidence of the "love of nature" that is now thought to be such a major characteristic of Japanese culture.[1] On the contrary, uncultivated nature is generally depicted as a threat to human existence. The chronicles and the gazetteers are filled with gods of nature, who were often feared. By the mid- to late Heian period, when farmers had gained more control over the land in the estates (*shōen*) in the provinces, many of the nature deities had evolved into guardian gods (*chinju no kami*) or agricultural gods. As Buddhism became more and more influential, indigenous nature gods were often displaced by or fused with Buddhist deities. Folk stories and myths of agricultural origin were likewise given Buddhist interpretations.

The sense of harmony with nature and the focus on the seasons that is associated with Japanese culture arose in the so-called middle and late poetry of the *Man'yōshū* (*Collection of Ten Thousand Leaves*, ca. 759), in the late seventh and early eighth centuries, particularly after the move of the capital to Heijō (Nara) in 710. Furthermore, this seasonal poetry emerged under the very heavy cultural influence of China, in which there had been a long-standing tradition of poetry that used landscape (*kei*) and nature to express human emotions (*jō*) and thought. There was also a venerable continental tradition of using figures of nature for symbolic purposes—for example, the carp climbing a river or waterfall as a sign of success or an auspicious future, the plum blossom in early spring as a sign of resilience, or the wild goose in

the sky as a sign of loneliness or exile. Many of the seasonal and natural associations that are found in Japanese poetry, painting, and urban culture in fact derived from Chinese models and entered Japan through Chinese poetry and related genres, both in the Nara and early Heian periods (from Six Dynasties [220–589] and Tang [618–907] China) and in the Muromachi period (1392–1573) (from Song China [960–1279]). Many of the natural motifs that appear in eighth-century *waka* (such as the plum, peach, and mandarin orange) do not reference plants found in the wild, but trees that had been imported from China and were cultivated in the gardens of aristocrats.

Above all, it was the Heian court-based culture, in the capital of Heian (Kyoto), particularly in the tenth and eleventh centuries, that developed and established an extremely complex and highly codified view of the four seasons that would become the model of elegance and the primarily literary representation of nature for the next thousand years. The overwhelming influence of this "flower and bird, wind and moon" (*kachō fūgetsu*) model can be attributed to the literary and cultural impact of the imperial court. In particular, the imperial *waka* anthologies and such court narratives as *The Tale of Genji* formed a court tradition that was absorbed by subsequent classes and social communities (such as the provincial warlords [daimyo] in the Muromachi period) who desired to acquire the cultural pedigree of the Heian nobility.

A close connection also developed between *waka* and women's culture. *Waka*-esque associations permeated the design of clothing displayed on the female body, first in the twelve-layered robes (*jūni hitoe*) of the Heian period and later in the haute couture of the *kosode* (kimono) in the Edo period. They also informed the names used to designate the imperial consorts and their female attendants in the Heian period; the occupants of the *ōoku* (shogunal harem quarters) of large castles in the Muromachi and Edo periods; and the high-ranking professional women in the pleasure quarters of the major cities in the Edo period, where well-educated courtesans took on elegant classical names such as Fuji (Wisteria) and Yūgiri (Evening Mist). As a result, certain poetic associations, particularly those established in both *waka* and *The Tale of Genji* (written by a woman largely for women), became culturally gendered.

In the twelfth and thirteenth centuries, even as the aristocracy lost political power, Heian court culture took on renewed authority, leading to a classical renaissance. The neoclassical impulse is encapsulated in allusive

variation (*honka-dori*), a major feature of the *waka* in the *Shinkokinshū* (*New Anthology of Poetry Old and New*, 1205), in which poetry is created out of noted mid-Heian *waka* or passages from the *Ise monogatari* (*The Tales of Ise*, ca. 947) and *The Tale of Genji*. Saigyō's (1118–1190) famous poem in the *Shinkokinshū*—"Was the beautiful spring at Naniwa in the province of Tsu just a dream? The wind blows through the withered reeds" (*Tsu no kuni no Naniwa no haru wa yume nare ya ashi no kareha ni kaze wataru nari* [Winter, no. 625])—is an allusive variation on a noted mid-Heian poem, collected in the *Goshūishū* (*Later Collection of Gleanings*, 1086), by Nōin (b. 988): "How I would like to show it to someone of sensibility! The spring scene at the Naniwa Crossing in the province of Tsu" (*Kokoro aru hito ni misebaya Tsu no kuni no Naniwa watari no haru no keshiki wo* [Spring 1, no. 43]). Saigyō praises winter (wind blowing through the reeds) by noting the absence of spring as it was conceived in this Heian-period *waka*.

The far-ranging impact of *waka* stemmed from its creation of a cultural vocabulary, a communal language, that became associated with education, pedigree, and elegance. From at least the tenth century, education for both men and women implied the ability to compose *waka*. A major turning point was the Ōnin War (1467–1477), which destroyed Kyoto and its cultural monuments. After the war, the culture of the capital survived in *waka*, painting, and other genres that attempted to preserve or re-create the customs of the lost imperial court. The traditions of Heian court culture also spread to the provinces, transmitted and taught by scholars and clerics who had fled the capital. *Renga* masters such as Sōgi (1421–1502) and aristocratic scholars such as Ichijō Kanera (1421–1520) became the new purveyors of classical culture to provincial daimyo who were eager to acquire a culture to which they were not entitled by birth. Knowledge of the Heian court classics, particularly with regard to *waka*, became a form of cultural capital for the surviving aristocrats, who transmitted or created secret teachings (*hiden*). Meanwhile, the broader cultural meanings of the Heian classics and their seasonal associations were loosely disseminated through such popular genres as Muromachi tales (*otogi-zōshi*) as well as through more elite genres such as noh, flower arrangement (*ikebana*), and other arts of the Muromachi period.

One result of the medieval neoclassical impulse is that much of the literature of the period—from war tales to linked verse to noh plays—uses *waka* and its seasonal associations as set pieces. The descriptions of nature in the

Kakuichi variant of the *Heike monogatari* (*The Tales of the Heike*, mid-thirteenth century)—such as the "Viewing the Moon" episode in book 5, in which Shikkei of the Daitoku-ji Temple returns to the abandoned capital; the moonlit evening at Saga in the "Kogō" section in book 6; and GoShirakawa's visit to Kenreimon'in's retreat (Jakkō-in) in the section "The Retired Emperor Visits Ōhara" at the end—weave together citations of famous Heian-period *waka*, evoking the cultural past. In creating a cosmology of Heaven and Earth, *renga* similarly codifies the associations of classical poetry, and noh plays by Kan'ami (1333–1384) and Zeami (1363–1443) string together lines from classical *waka* to create stage settings.[2]

From the twelfth century, at least two major literary representations of nature emerged and coexisted in writings by aristocrats and Buddhist priests: the *satoyama* view, focused on farm villages in the provinces, usually at the feet of small mountains; and the elegant view, derived from *waka* and capital culture. In the ancient period, untamed nature was often regarded as a bitter adversary, as a land filled with wild and dangerous gods. But at least from the mid- to late Heian period, the *satoyama* emerged in literary texts as a place in which humans appear to have been in an intimate (though not necessarily mutually beneficial) relationship with nature. There was a close interaction between the villagers and the animals and plants in the surrounding forests and wild fields, which were harvested for food, brushwood, and other necessities. The animals in the *satoyama*—such as rabbits, wolves, and raccoons—almost never appear in *waka* or court tales (*monogatari*) of the Heian and Kamakura (1185–1333) periods, but they are important protagonists of folk stories, anecdotal narratives (*setsuwa*), war tales (*gunki-mono*), and other popular genres, particularly those that came to the fore in the medieval period. By the Muromachi period, the plants and animals of the *satoyama* appeared regularly not only in *renga* but even in *waka*.

As early as the eleventh century, an idealized view of the *satoyama* appeared in urban, aristocratic representations of nature, particularly in the literary and poetic "pastoralization" of the mountain village (*yamazato*), which was regarded by Heian-period *waka* poets as a retreat from the danger and bustle of society. In the Muromachi period, with the influx from China of Zen-inspired ink paintings that depicted recluses in the mountains, the *yamazato* became even more idealized. The most obvious manifestation of this idea of nature occurred in the Muromachi and early Edo periods with the emergence of the "rustic" tea ceremony (*wabicha*), conducted in small

teahouses in the middle of the city, representing a kind of "pastoral" retreat.

The capital-based landscape and the village-based landscape (as represented in writings by cultural elites) began to intersect in a wide range of popular genres—anecdotal literature, war tales, Muromachi popular tales, noh, comic drama (*kyōgen*), and *haikai*—particularly from the Muromachi period. For the most part, Nara- and Heian-period *setsuwa* collections rarely contain *waka*. The *Konjaku monogatari shū* (*Tales of Times Now Past*, ca. 1120) devotes only one of its thirty-one volumes to *waka*. But the *waka* tradition became increasingly prominent in popular genres to the degree that Muromachi popular tales (*otogi-zōshi*) include a whole subgenre of aristocratic tales (*kuge-mono*). Even the Kakuichi version of the *Heike monogatari*—which was edited around 1371 and drew heavily on anecdotal literature—interweaves *waka*-esque and court tale–type sections, some of which feature female characters, into its narrative of war. Takarai Kikaku's (1661–1707) famous *hokku* (opening verse of a *renga* sequence)—"Unlike *The Tales of the Heike*, not even a moon appears in the *Taiheiki*" (*Heike nari Taiheiki ni wa tsuki mo mizu*)—astutely points to the portrayals of natural beauty and courtly elegance (symbolized by the moon) in the *Heike monogatari* but not in the *Taiheiki* (*Record of Great Peace*, 1368?–1379?), a narrative about the bloody battles of the Northern and Southern Courts period (1336–1392).[3] Noh, which came to the fore in the Muromachi period, also represents a major intersection of court-based culture and provincial views of nature. Of particular interest is the appearance of *waka*-esque figures (such as the willow, cherry tree, and chrysanthemum) as the protagonists of both medieval tales and noh plays. The animal and plant protagonists express a new kind of interiority, revealing the "suffering" of nature as a result of the actions of humans or the destruction of the environment. The Edo period was marked by the growth of urban popular literature, but the *satoyama* landscape—with its cosmology of plants, animals, and supernatural beings—continues to appear in folk tales and in such genres as *kusa-zōshi*, illustrated red-, black-, and yellow-covered books originally written mainly for children and then later for adults.

The variety of representations and reconstructions of nature is as great as the number of social and religious communities, but two features stand out amid the diversity of views: the deep and pervasive impact of *waka* and its seasonal and natural associations on a range of media, particularly among

the socially and politically dominant classes; and the extensive and tightly controlled re-creation of nature in the city and in what became the "traditional arts" of Japan. As we have seen, the thirty-one-syllable *waka* had an overwhelming influence on Japanese views of nature from the Nara period through the Edo period and permeated all the other major vernacular genres in aristocratic culture—court tales (*monogatari*), poem tales (*uta-monogatari*), literary diaries (*nikki*), and travel diaries (*kikōbun*)—as well as such visual media as screen paintings (*byōbu-e*), door or partition paintings (*fusuma-e*), and picture scrolls (*emaki*). Thus the *waka*-based view of the world—with its stress on seasonal associations, harmony, and elegance— came to be regarded in the modern period as the Japanese view of nature, overshadowing a multiplicity of other reconstructions of the natural environment.

*Waka* had two potential functions: as a one-time social, political, or religious act, in which the poem and its media (calligraphy and paper) functioned as a form of elevated dialogue that inevitably lost much of its significance after the occasion; and as a text, in handwritten or printed form, that continued to survive outside its initial context. The desire to re-create the original social, political, or religious context of a poem gave rise to a number of literary genres, such as the poem tale, literary diary, travel diary, and headnotes or interlinear commentary supplied in poetry collections. When later generations had difficulty reconstructing the original social context of a poem, they read it in relation to earlier poems and established topics, particularly seasonal topics. So while its force as performance would eventually be lost, the poem as text continued to exist in larger, trans-historical contexts, with its seasonal topics anchoring it in a communal memory that was accessible through anthologies, treatises and handbooks, and seasonal almanacs.

*Waka* also played a major role in what I have called the ideology of the four seasons—that is, the use of the culture of the four seasons to reinforce hierarchical power relations. The imperial *waka* anthologies, beginning with the *Kokinshū* (*Collection of Japanese Poems Old and New*, ca. 905), created an idealized world that centered on the emperor and the upper echelons of the imperial court. The anthologies, which had immense prestige throughout the Heian and medieval periods, long after the aristocracy lost its economic and political power, attempted to create the illusion that both time and space—that is, "all under Heaven," nature and humans, the Heavens and the Earth—were brought to order around the sovereign and the

imperial court and were held in harmony through poetry. This stance derived, at least in part, from a long-standing Chinese tradition that regarded the orderly cycle of the seasons to be a direct reflection of the state of imperial rule. In this cosmology, natural disruptions or disasters (earthquakes, floods, plagues) became a sign of misrule or governmental mismanagement. This belief is reflected in such narratives as *The Tale of Genji*—for example, when the protagonist is exiled to Suma and Akashi. As we have seen, the co-existence of the four seasons in four directions also was a symbol from as early as the Heian period of a utopian state or an eternally harmonious world.

The ideology of the four seasons was also represented in poetic places (*utamakura*), locales made famous by *waka*, which represented a cultural mapping of Japan as viewed from the capital. These sites were initially concentrated in the Nara and Kyoto areas, but they gradually extended to the east (Kanto area), to Kyushu, and to the north (Tōhoku area). They included famous places (*meisho*) around the capital, such as Arashiyama and Yoshino, frequently visited by the nobility and famous for their cherry blossoms, autumn foliage, snow, or other classical seasonal landscapes. In the Heian and Kamakura periods, the more remote *utamakura* functioned as cultural nodes in the imagination of poets and educated courtiers, as a means for urban nobles to travel without traveling; to compose on distant *utamakura* was to bring a provincial landscape into one's own textual and poetic garden. In the Heian period, poetic places were reproduced in quantity in screen paintings, in the gardens of palace-style (*shinden-zukuri*) residences, and even on miniature landscape stands (*suhama-dai*) that represented the Japanese archipelago and on which pins were placed to identify specific *utamakura*. Gradually, beginning in the late Heian period and extending through the Edo period, *waka*, *renga*, and *haikai* poets such as Nōin, Saigyō, Sōgi, and Matsuo Bashō (1644–1694) visited and wrote poems on these distant poetic places, making them increasingly popular not only as locales to reference poetically, but also as sites to visit. From the Edo period, poets who lived in provinces without established *utamakura* (essentially, spaces without authoritative cultural recognition), particularly in the Ōshū region (northwestern Honshū), began to construct their own poetic places, using *waka*-esque names and thereby connecting themselves with capital culture. At the same time, *haikai* poets, seeking to go beyond such classical associations and to break out of the yoke of capital-centric discourse, used non-classical diction and

rural landscapes to create new poetic places called *haimakura* (*haikai* poetic places).

The Edo period brought about radical change in the poetic topography with the emergence of a commercial, capital-based society centered on three major cities—Osaka, Kyoto, and Edo (Tokyo)—in which the main focus of interest was human relations as determined by money and social status, a situation reflected in the fiction and drama of Ihara Saikaku (1642–1693) and Chikamatsu Monzaemon (1653–1725), respectively. However, the commercial economy centered not so much on manufactured goods as on agricultural products, which were distributed around the country and encouraged a high level of awareness of the seasons, climate, and food. Furthermore, the mercantile economy resulted in a vastly expanded transportation network, leading in turn to dramatic growth in the number of travelers and pilgrims, such as the *haikai* poet Bashō, who could now seek out and experience nature firsthand, outside the cities. The commerce-based society also created the leisure and education that allowed for engagement in poetry—*haikai*, *senryū* (satiric haiku), *kyōka* (comic poetry), *kanshi* (Chinese-style poetry), and *kyōshi* (comic Chinese-style poetry)—and the traditional arts, which flourished on an unprecedented scale among samurai, urban commoners, and wealthy farmers. One result was the extensive production of books on farming, travel, and poetry of all varieties.

The rise of print culture and the publication of *haikai* books in the seventeenth century also had a major impact on the spread of poetic knowledge. Mid-seventeenth-century Teimon school *haikai* poets and scholars such as Kitamura Kigin (1624–1705) encouraged the dissemination of classical literary knowledge (which had hitherto been restricted to aristocrats, priests, and powerful warriors) among urban commoners. The *haikai* genre proved to be a highly effective carrier of classical culture, since it relies heavily on traditional verbal associations, particularly seasonal associations, for its foundation. Leading *haikai* poets and teachers such as Kigin compiled and published modern editions of and commentaries on the Heian classics—a notable example being Kigin's *Genji monogatari kogetsushō* (*The Tale of Genji Moon on the Lake Commentary*, 1673)—and created poetic seasonal almanacs such as *Yama-no-i* (*The Mountain Well*, 1648), also by Kigin, that gave commoner poets and readers easy access to traditional seasonal associations. Thus by the early Edo period, Heian court culture, particularly *waka*

culture, managed to thoroughly infiltrate commoner culture and spread to the far corners of Japan.

At the everyday, amateur level, Japanese poetry might better be regarded as a craft than as an art. Significantly, *renga* masters (*rengashi*) were identified as craftsmen (*shokunin*) in the Muromachi period. Poems (*waka*, *renga*, *haikai*) were intended to be composed by anyone, not only those with superior talent. Japanese traditional arts are generally based on the acquisition of fixed patterns (*kata*), which enable the form to be practiced by a wide populace, including amateurs, under the supervision of a teacher or school. The average seasonal word (*kigo*), such as *hototogisu* (small cuckoo), consists of five sound units (*onji*). Thus the seventeen-syllable *hokku* or haiku is almost one-third finished when the *kigo* is chosen. More complex operations are involved in the composition of *waka* and *renga*, but the practice of using fixed patterns and imitating standard models remains unchanged. As a kind of craft that can be widely practiced, shared, and imitated, poetry became a key vehicle for the transmission of cultural memory.

All the major poetic genres—from the banquet poetry of the Nara period in the *Man'yōshū* to the poetry contest (*uta-awase*) in the Heian period to *haikai* in the Edo period—were composed in group settings, usually under the supervision of a professional or teacher, such as a judge (*hanji*) in the *uta-awase* or a *renga* or *haikai* master. These poetry masters were also heads or subheads of poetry houses (*ie*) or schools (*mon*). Noted poets existed within the context of house lineages or schools, which continued over many generations, sometimes over many centuries, and served as the repositories of specialized knowledge and texts. The house system was characteristic of traditional Japanese arts in general, not just poetry. Familiar examples are the Reizei family in *waka*,[4] the five schools of noh (Kanze, Hōshō, Konparu, Kongō, and Kita), the Ikenobō school in ikebana, and the Urasenke family in the tea ceremony. Family schools first appeared in the mid-Heian period, but a new type of school, based on the household (*iemoto*) system, emerged in the Edo period and sometimes recruited a large body of followers for financial gain.

The tradition of such houses or schools led, on the one hand, to the increasing specialization of knowledge. This is evident in the composition of *renga*, whose rules became so complex that a master had to preside over the *za* (gathering of poets for group composition) to ensure that they were being followed. On the other hand, particularly from the Edo period, when the

household system emerged, the practitioners of poetry included many amateurs, including wealthy samurai and urban commoners. These literary and performance genres are simple enough to be accessible to non-specialists, but at the highest level they can be mastered only by specialists. The system of open schools has continued to the present day. One result has been continual growth in the population of practicing poets and followers of the arts, all of whom depend to some degree on a knowledge of the culture of the four seasons.

*Kanshi*, which held a position equal to, if not higher than, that of *waka* through the Edo period, encompasses a much wider range of topics and subject matter than does *waka*, ranging from poverty to education to war. *Kanshi* (by both Chinese and Japanese poets) served as a continual source of inspiration for a range of seasonal topics, as the topos of the "Eight Views" suggests, but it did not give rise, as did *waka*, to a well-cataloged, systematic set of seasonal associations, a communal language, that supplied a rich vocabulary for social and aesthetic usages. Various forms of song lyrics—from the *imayō* (popular songs) of the Heian and medieval periods to the *dodoitsu* (ditties sung to the samisen [banjo-like instrument]) and *hauta* (music and songs performed in the popular theater and the pleasure quarters) of the Edo period—dealt frankly with such "inelegant" topics as sexuality and the body. But even these popular lyric forms drew heavily on classical traditions of *waka* diction and imagery, appropriating elements of classical poetry for the purposes of popular culture.

*Haikai* also played a key role in combining classical associations with new topics from popular culture and in developing the technique of *mitate* (visual transposition). As we saw with Suzuki Harunobu's multiple takes on the "Eight Views of Ōmi," motifs and topoi derived from the *waka* culture of the four seasons often became the object of parodic and ironic treatment in the Edo period, particularly in such genres as *haikai*, *senryū*, and *kyōka*, which parodied classical poetry and frequently turned elegant topics into crude or pornographic images. This vulgarization of *waka*-based topics and associations began as early as the Muromachi period with early *haikai*, which playfully inverted canonical images into their opposites. By the latter half of the eighteenth century, highly educated samurai and wealthy townspeople who were well versed in the Heian and Chinese classics were composing *kyōka*, which took the parodic inversion of classical motifs to an even higher level. Much of the humor of late Edo popular literature and ukiyo-e

depends on *mitate* that ironically transposes classical images into topics of contemporary commoner life. Both *kyōka* and *haikai* have the potential to lower their textual targets by debasing them or undercutting their authority, but they can also elevate their subjects by drawing attention to their traditional cultural associations.

The system of seasonal words (*kigo*), the seasonal encoding of almost all aspects of nature and society, was first extensively developed in *waka* and *renga*, then widened in *haikai*, and finally inherited and further disseminated by haiku, the most popular poetic form in the twentieth century. One constant throughout these changes was an emphasis on representations of nature and the seasons as a way of giving value not only to the months and years, but to everyday life and the physical world. One can argue that the seasons are important in all cultures, but what makes the Japanese culture of the four seasons particularly striking is the various and prominent ways in which cultural seasonalization—particularly the breaking down of nature into seasonal categories and phases with specific associations—occurs across a wide variety of media and genres over a millennium. The evolution of this poetic and artistic tradition paralleled the development of secondary nature in the metropolis, where nature took on multiple social, cultural, religious, and recreational functions.

As we have seen, secondary nature in Japanese poetry and visual arts tends to fall into the two broad categories of seasonal and trans-seasonal motifs. Seasonal motifs (such as the bush warbler, cherry blossom, and butterfly) mark a specific season or phase of a season. Trans-seasonal motifs (such as the pine, bamboo, crane, turtle, and carp), by contrast, appear all year round and usually have auspicious or talismanic significance. Sometimes a particular motif, such as the plum or chrysanthemum, straddles both categories. Motoori Norinaga (1730–1801), who was firmly rooted in the *waka* tradition, identified the cherry blossom as the ultimate symbol of Japan in a noted *waka*: "If one asks people about the heart of Yamato, it is the mountain cherry blossoms that glow in the morning sun" (*Shikishima no yamatogokoro wo hito towaba asahi ni niou yamazakurabana*).[5] By contrast, in *Nihon fūkei-ron* (*Discussion of Japan's Landscape*, 1894), perhaps the most famous description of nature in Japan in the Meiji period (1868–1912), Shiga Shigetaka (1863–1927) considers the pine, with its rugged strength, as the ultimate embodiment of Japanese "character." Both the cherry blossom, the most noted seasonal motif, and the pine, the most prominent trans-seasonal and talismanic motif,

have coexisted over the centuries, playing different but complementary roles.

The cultural functions of nature appear on at least three fundamental semi-ritualistic levels in urban society. First, it emerged in the form of annual observances that frequently had talismanic objectives (to protect against evil, prolong life, bring good fortune, and so forth). These ceremonies generally connected participants with cosmic sources of life energy or with the gods (*kami*), who often were believed to be embodied in natural objects (plants, animals, rocks). This role can be seen in almost all the major court observances—from the setting up of the gate pine (*kadomatsu*) on New Year's Day to the gathering of new herbs (*wakana*) in the spring—derived from Chinese precedents, as well as in the provincial culture of the *satoyama*, where many such rituals were of indigenous origin, local in character, and related to agriculture.

Second, the cultural use of nature functioned on an interpersonal level as a form of greeting (*aisatsu*) to a guest, friend, or social superior. One of the historical origins of ikebana (flower arrangement) was the Heian-period aristocratic custom of attaching seasonal flowers or plants to a letter—with the requisite poem, the paper, and the flower all matching the seasonal occasion. In this context, nature served as an elegant means of communication in an elite society that prized politeness and refinement. These two cultural uses of nature, one ritualistic (talismanic) and the other interpersonal (social), are combined in the Muromachi- and Edo-period arts of standing-flower (*rikka*) arrangement and the tea ceremony (*chanoyu*).

Third, nature functioned as an object of communal, socially sanctioned entertainment, exemplified in the practices of viewing cherry blossoms, the harvest moon, autumn foliage, and fallen snow. These forms of seasonal entertainment had religious roots, but they evolved into opportunites for communal release. Cherry-blossom viewing began as early as the Nara period in aristocratic circles, gradually spread to commoner society in the Muromachi period, and became an integral part of urban commoner life in the Edo period. Significantly, such communal entertainment—which focused on eating, drinking, and dancing—concentrated on the aforementioned "big four," the most popular topics in *waka*. They were staged in the pleasure quarters as major seasonal events and were closely associated with travel to famous places (*meisho*), an activity that became popular among commoners in the Edo period.

The role of nature as the object of communal entertainment was fueled especially by the rapid and widespread construction in the Edo period of new centers for seasonal observances within and around the major cities—on temple and shrine grounds and in parks such as Ueno in Edo. In ancient times, the cherry tree was regarded as part of the coppice (mixed-tree) woodland (*zōkibayashi*); grew on the tops of hills and mountains; and was used for firewood. But as the Yasurai Festival at the Imamiya Shrine in Kyoto—which can be traced to the Heian period and is now held on the second Sunday in April—indicates, the cherry blossom (whose scattering was thought to cause illness) began to be worshipped and its spirit placated as a means to prevent the spread of disease in the spring. From the second half of the ninth century, cherry trees, like willows, were planted in the capital and the gardens of nobility for aesthetic purposes, eventually leading to the construction of famous places for cherry blossoms.

When the capital moved to the present-day city of Kyoto, at the beginning of the Heian period, the practice of seeking out bright foliage (*momiji*) probably began sporadically in mountain valleys around the capital, but eventually it shifted to sites in the city itself, thanks to horticultural efforts to create gardens and groves notable for colorful autumn leaves. Today, such sites in Kyoto—among them Takao, Toganoo, Makinoo, Ōhara sanzen-in, Jakkō-in, Shūgaku Detached Palace, Kiyomizu Temple, Arashiyama, Katsura Detached Palace, and Tōfuku-ji temple—feature special trees such as the Japanese maples *Acer palmatum* (*iroha-momiji*), with its bright crimson leaves, and *Acer amoenum* (*oomomiji*), whose leaves change from bright yellow to red. These trees are planted to be seen; they are carefully pruned to look attractive and are cleared of underbrush, and their grounds are regularly swept.[6] In other words, this aspect of the seasonal "nature" for which Kyoto is known is a carefully manicured production intended to attract sightseers and tourists.

All three types of cultural seasonalization continued into the modern period. With the shift to the solar calendar in the early Meiji period, the government officially abandoned the Five Sacred Festivals (Gosekku), which had been the core annual observances of the luni-solar calendar through the Edo period. Today, in Tokyo, the Star Festival (Tanabata), which is an autumn topic in *waka* and was celebrated on the seventh day of the Seventh Month, is observed on July 7, thus maintaining the double number (7/7) but moving from autumn to summer. In most modern seasonal almanacs (*saijiki*),

however, Tanabata remains an autumn topic and seasonal word, thus creating a significant disjunction between the actual observance and its traditional cultural associations. With the shift to the solar calendar, the New Year, which had marked the advent of spring, was split off from that season, now considered to begin in early February. Despite these severe disruptions, the system of seasonal words remains so vital to haiku that traditional seasonal words and their associations continue to be used.

The main difference between Edo-period *haikai* (and its opening verse [*hokku*]) and its modern descendant haiku is that linked verse disappeared totally in the twentieth century, leaving only the seventeen-syllable haiku, which requires a seasonal word. One consequence was that haiku, at least in its early stages, was seasonal poetry first and social poetry second. Masaoka Shiki (1867–1902), the pioneer of modern haiku, wrote almost no love poems. It was not until the Taishō period (1912–1926), with the appearance of haiku poets such as Sugita Hisajo (1890–1946), one of the first women haiku poets, that we find notable love poetry in haiku: "Taking off the cherry blossom robe—left tangled in strings of all sorts" (*Hanagoromo nugu ya matsuwaru himo iroiro*). The seasonal word in this haiku is *hanagoromo* (cherry-patterned robe), which is a spring word. *Hanagoromo* were worn by court women in the Heian period and by modern women when they went cherry-blossom viewing. The haiku suggests that the speaker has just come back from viewing cherry blossoms and, perhaps intoxicated by the flowers and by wine, attempts to fling off the bright kimono that remains attached to her body by multicolored strings.

Although modern haiku depended on the classical seasonal associations for its survival, they are not necessary for the composition of the thirty-one-syllable *tanka* (short poem), the contemporary form that replaced the traditional *waka*. A good example is a *tanka* by Yosano Akiko (1878–1942), one of the pioneers of love poetry in the Meiji period: "Won't you be lonely, not touching the hot blood under my soft skin? You who philosophize" (*Yawahada no atsuki chishio ni fure mo mide sabishikarazu ya michi wo toku kimi*). This poem, in *Midaregami* (*Tangled Hair*, 1901), shows a very iconoclastic approach to love, with the woman taking on the position of the aggressor. A more recent example is by Tawara Machi (b. 1962), whose *tanka* collection *Sarada kinenbi* (*Salad Anniversary*, 1987) became a pop phenomenon and sold over a million copies: "Looking up at the rain that falls down, suddenly, in this position, I want your lips" (*Ochite kita ame wo miagete sono mama no*

*katachi de fui ni kuchibiru ga hoshi*). In *tanka*, the topic of love does not have to be mediated by a season, as in haiku. Thus *tanka* may draw on seasonal associations, but does not depend on them for its survival. This is a far cry from the symbiotic relationship between love and the four seasons in the *Kokinshū*.

The tendency to move toward non-seasonal poetry is evident in the emergence in the mid-eighteenth century of *senryū*, a seventeen-syllable, satiric, and socially centered verse that split off from *haikai*, that does not require a seasonal word, and that remains popular. In contrast to Heian *waka*, which had been highly restrictive in limiting its vocabulary to refined topics, Muromachi- and Edo-period *haikai* allowed for any kind of language and any kind of topic, including the vulgar and the erotic. In the Meiji period, *tanka* became the successor to *waka*, and haiku became the successor to *haikai*. But there was a dramatic reversal of roles. It is *tanka* that has no restrictions on diction and content, while haiku requires a seasonal word, anchoring the form in the poetic tradition. In other words, the new form of *waka*, which had been the classical genre for more than a thousand years, became the vehicle for the avant-garde, while the descendant of *haikai*, which had begun as an anti-establishment genre, became the guardian of the culture of the four seasons.

In a series of important essays published in the newspaper *Nihon* ( *Japan*), beginning on July 24, 1894,[7] Masaoka Shiki analyzed the relationships among nature, human affairs, and genre. One of the major characteristics of Japanese literature, Shiki argues, is the primacy of poetry and of nature, with poetry (specifically haiku and *tanka*) providing the main vehicle for representations of nature. By contrast, in Shiki's view, modern European literature—centered on drama, epic, and the novel—tends to focus on prose and human affairs. In the Meiji period, Shiki points out, under the impact of European culture and literature, Japanese writers shifted their attention from poetry—the central literary genre, along with chronicles—to the novel and drama, to the extent that some now considered them to be the only literary forms. Shiki's stance on poetry and nature can be interpreted as defensive with regard to the short or lyric poem, which had descended in the modern genre hierarchy, which places the novel and drama at the top, but it also throws light on the complex relationship between genre and nature in Japanese literary history. Takahama Kyoshi (1874–1959), Shiki's chief disciple, stressed in a famous lecture in 1928 that "haiku is literature that should describe

flowers, birds, wind, and the moon [*kachō fūgetsu*]."[8] This view, referred to as *kachō fūei* (composing on flowers and birds), spurred an opposition movement in 1931 called the Shinkō haiku undō (New Haiku Movement), led by Kyoshi's disciple Mizuhara Shūōshi (1892–1981) and others, who believed that human affairs and social engagement, including antiwar activism, should be the central subjects of haiku. The two directions—one toward nature and the other toward society—represent different sides of haiku. But whichever direction they take, the vast majority of haiku (as opposed to *senryū*) continue to use seasonal words, which provide a base of shared associations between the poet and the reader and which remain the cultural foundation of Japanese poetry. Those associations and poetic examples are gathered in seasonal almanacs, which have served as handbooks and references for modern haiku poets and have come to represent a shared cultural memory.

A typical modern haiku seasonal almanac (for example, the *Nihon daisaijiki* [*Great Japanese Seasonal Almanac*, 1983], edited by Mizuhara Shūōshi, Katō Shūson, and Yamamoto Kenkichi) contains as many as five thousand seasonal words divided into five categories: New Year, spring, summer, autumn, and winter. The pyramid of seasonal topics that emerged in the Edo period remains, with the narrow top derived from the classical tradition and the broad base occupied by seasonal words from contemporary life. Due to urbanization and environmental change, some of the icons at the top, such as the small cuckoo, have faded, while the cherry blossom and autumn foliage remain cultural heavyweights. Examples of new seasonal words for summer are beer, swimming (*oyogi*), camping (*kyampu*), baseball night game (*naitaa*), yachting (*yotto*), sunburn (*hiyake*), sunglasses (*sangurasu*), and short-sleeved shirt (*natsu shattsu*). Beer may be drunk throughout the year, but in Japan, cold beer and beer halls have a close association with hot summer nights, linking summer to the poetic or cultural essence of beer. As these examples show, the topics subsumed under the four seasonal categories are not restricted to plants, animals, hills, and rivers. It would be hard to call beer or a short-sleeved shirt a form of secondary nature. Instead, modern seasonal words extend to a wide range of social activities, from food to baseball, covering the human and social landscape in the broadest possible sense. In other words, the system of *kigo* not only reflects an awareness of nature, but also serves as a means to organize individual and social life throughout the year, providing seasonally coded markers. In that sense,

seasonal vocabulary goes hand in hand with seasonal clothing, for example, and the ways in which fashion still equates certain seasons and their phases with specific colors, words, and images.

In a country in which little original wilderness survives, reconstructed nature—in the form of replanted forests, cultivated gardens, famous places (*meisho*), and shrine and temple grounds—has contributed to the greening of both the countryside and the urban environment. For city dwellers, who make up the vast majority of the population, representations of nature in poetry, paintings, ikebana, kimono patterns, foods, and annual observances raise awareness of the seasons. In an urban environment in which the average company employee probably encounters little nature or even natural sunlight in the course of the day, the tea ceremony, like many of the traditional artistic and literary forms, brings the worker back in touch with nature and the seasons, if only through secondary forms: the flower in the alcove, the calligraphic text on the hanging scroll, and the poetic name (*uta-mei*) of the tea jar or tea scoop.[9] Although nature may be far away, it is relived or recaptured in the cultural imagination.

The population of practitioners of ikebana or of the tea ceremony has dramatically diminished in the post–World War II era, though, with few young people joining the ranks; and the alcove (*tokonoma*), which was once the cultural center of the traditional residence, has almost entirely disappeared from modern apartments and homes, together with the tatami room. It is also increasingly difficult to find examples of the farm village (*satoyama*) landscape even in the remote countryside. The sense of nature and the seasons instead derives from such activities as hiking in the mountains, domestic tourism, visiting food markets, eating high-end traditional Japanese cuisine, and watching television, on which the weather reports show the arrival and departure of the seasons, particularly the cherry blossoms and the autumn foliage.

The diminished representation of nature and the seasons in contemporary Japan, however, does not lessen their enormous impact across more than a thousand years of Japanese cultural history, not only in poetry, painting, and the traditional arts but also in a wide range of media, from architecture to fashion. As we have seen, natural imagery in poetry provided a key means of social communication from as early as the seventh century, and representations of nature and the seasons became an important channel

of aesthetic, religious, and political expression in the subsequent centuries. The highly encoded system of seasonal representation created by poetry provided an enduring foundation for an increasingly complex and multilayered view of the four seasons.

At the same time, the extensive cultural seasonalization and the pervasive presence of secondary nature may have dulled the sense of urgency with regard to conservation and the need to save the environment, where Japan's record has not been good in the postwar period. The destruction of poetic places (*utamakura*), for example, has aroused environmental awareness of particular traditionally famous places, as has the destruction of shrines that protect large trees, but modern haiku and traditional-arts groups have not been in the forefront in raising concerns about broader environmental issues. In this sense, the pervasiveness of secondary nature in Japanese culture has often been mistaken for a closeness to or a belief in Japanese harmony with primary nature.

# Seasonal Topics in Key Texts

## Seasonal Poems in the First Eight Imperial *Waka* Anthologies

|  | SPRING | SUMMER | AUTUMN | WINTER | TOTAL |
|---|---|---|---|---|---|
| *Kokinshū* (ca. 905) | 134 | 34 | 145 | 29 | 342 |
| *Gosenshū* (951) | 146 | 70 | 226 | 65 | 507 |
| *Shūishū* (1005–1007) | 78 | 58 | 78 | 48 | 262 |
| *Goshūishū* (1086) | 164 | 70 | 142 | 48 | 424 |
| *Kinyōshū* (ca. 1127) | 98 | 66 | 109 | 52 | 325 |

| | SPRING | SUMMER | AUTUMN | WINTER | TOTAL |
|---|---|---|---|---|---|
| *Shikashū* (1151–1154) | 50 | 31 | 58 | 21 | 160 |
| *Senzaishū* (1183) | 135 | 89 | 161 | 90 | 475 |
| *Shinkokinshū* (1205) | 174 | 110 | 266 | 156 | 706 |

## *Horikawa hyakushu*

The hundred topics in *Horikawa hyakushu* (*Horikawa Poems on a Hundred Fixed Topics*, 1105) are divided into spring (20 poems), summer (15), autumn (20), winter (15), love (10), and miscellaneous (10).

### SPRING

Beginning of spring, pine pulling on the Day of the Rat (Nenohi), mist (*kasumi*), bush warbler, new herbs, remaining snow, plum, willow, young bracken (*sawarabi*), cherry blossoms, spring rain, spring horses, returning wild geese, cuckoo (*yobukodori*), rice-seedling bed (*nawashiro*), violet (*sumire*), iris (*kakitsubata*), wisteria, yellow kerria (*yamabuki*), last day of the Third Month (*sangatsujin*)

### SUMMER

Changing clothes (*koromogae*), deutzia flowers (*unohana*), hollyhock (*aoi*), sweet flag (*ayame*), young rice seedlings (*sanae*), night firelight (*tomoshi*), mandarin-orange blossoms (*hanatachibana*), insect-repelling flares (*kayaribi*), lotus, ice room (*himuro*), wellspring (*izumi*), Sixth Month exorcism (*aranigo no harae*)

### AUTUMN

Beginning of autumn, Star Festival (Tanabata), reeds (*ogi*), yellow valerian (*ominaeshi*), miscanthus grass (*susuki*), kangaroo grass (*karukaya*), boneset (*fujibakama*), bush clover, wild geese, deer, dew, fog (*kiri*), morning glory, Greeting Horses (Komamukae), moon, fulling cloth (*tōi*), insects, chrysanthemum, bright foliage, last day of the Ninth Month (*kugatsujin*).

Early winter, scattered showers (*shigure*), frost, hail, snow, cold hut (*kanro*), plovers, ice, waterfowl (*mizutori*), wickerwork fish trap (*ajiro*), god dances (*kagura*), hawk hunting (*takagari*), charcoal-making oven (*sumigama*), charcoal fire in ash (*uzumibi*), New Year's Eve (*joya*)

## Roppyakuban uta-awase

The topics in the *Roppyakuban uta-awase* (*Poetry Contest in Six Hundred Rounds*, 1193) are divided into spring (15 poems), summer (10), autumn (15), and winter (10).

### SPRING

New Year banquet (Gannichi no en), lingering cold (*yokan*), spring ice (*haru no kōri*), young grass (*wakakusa*), Court Archery Festival (Noriyumi), playing in the wild fields (*yayū*), pheasants (*kiji*), skylark (*hibari*), heat shimmer (*itoyū*), spring dawn (*haru no akebono*), long spring day (*chijitsu*), mountain crossing at Shiga (*Shiga no yamagoe*), third day of the Third Month (*Yayoi mika*), frog, remaining snow (*zanshun*)

### SUMMER

Green-leafed tree (*shinju*), summer grass (*natsukusa*), Kamo Festival, cormorant fishing (*ukawa*), summer night (*natsu no yo*), summer robe (*natsugoromo*), fan (*ōgi*), evening faces (*yūgao*), evening shower (*yūdachi*), cicada (*semi*)

### AUTUMN

Lingering heat (*zansho*), Star Festival (Tanabata), lightning, quail, tempest (*nowaki*), autumn rain (*akisame*), autumn evening (*aki no yūbe*), autumn rice field (*aki no ta*), snipe (*shigi*), distant view of Hirosawa Lake (*Hirosawa no ike no chōbō*), ivy (*tsuta*), konara oak (*hahaso*), ninth day of the Ninth Month (*Nagatsuki kokonoka*), autumn frost, end of autumn (*boshū*)

Fallen leaves (*ochiba*), remaining chrysanthemums (*nokori no kiku*), withered fields (*kareno*), sleet (*mizore*), imperial procession to wild fields (*no no miyuki*), winter morning (*fuyu no ashita*), winter pine (*kanshō*), chinquapin brushwood (*shii-shiba*), bedclothes (*fusuma*), Buddha's Name (*butsumyō*)*

*Buddha's Name is a ritual that was held on the fifteenth day of the Twelfth Month, calling on the names of the various buddhas of the Three Worlds, to confess and extinguish the sins of the past year.

# Notes

## Abbreviations for Multivolume Primary Sources

NKBT    Nihon koten bungaku taikei, 106 vols. (Tokyo: Iwanami shoten, 1957–1968)

NKBZ    Nihon koten bungaku zenshū, 51 vols. (Tokyo: Shōgakukan, 1970–1976)

SNKBS   Shinchō Nihon koten shūsei, 95 vols. (Tokyo: Shinchōsha, 1997–2005)

SNKBT   Shin Nihon koten bungaku taikei, 100 vols. (Tokyo: Iwanami shoten, 1990–2005)

SNKBZ   Shinpen Nihon koten bungaku zenshū, 88 vols. (Tokyo: Shōgakukan, 1994–2002)

## Preface

1. Augustin Berque, *Japan: Nature, Artifice, and Japanese Culture*, trans. Ros Schwartz (Yelvetoft Manor: Pilkington Press, 1997), 79–80.

2. Ursula K. Heise, in "Forum on Literatures of the Environment," *PMLA* 114, no. 5 (1999): 1097–1098.

3. Kate Soper, *What Is Nature? Culture, Politics, and the Non-Human* (Oxford: Blackwell, 1995), 155–156.

## Introduction: Secondary Nature, Climate, and Landscape

1. "Nihon bungaku no tokuchō," in *Shinsōgō zusetsu kokugo*, rev. ed., ed. Nishihara Kazuo, Tsukakoshi Kazuo, Katō Minoru, Watanabe Yasuaki, and Ikeda Takumi (Tokyo: Tōkyō shoseki, 2000), 2.

2. Haga Yaichi, "Kokuminsei jūron," in *Ochiai Naobumi, Ueda Kazutoshi, Haga Yaichi, Fujioka Sakutarō shū*, ed. Hisamatsu Sen'ichi, Meiji bungaku zenshū 44 (Tokyo: Chikuma shobō, 1968), 235–281.

3. See, for example, Masaharu Anesaki, *Art, Life, and Nature in Japan* (Tokyo: Tuttle, 1973), cited in Arne Kalland, "Culture in Japanese Literature," in *Japanese Images of Nature: Cultural Perspectives*, ed. Pamela J. Asquith and Arne Kalland (Richmond, Eng.: Curzon Press, 1997), 244.

4. Ki no Tsurayuki, kana preface, in *Kokin wakashū*, ed. Kojima Noriyuki and Arai Eizō, SNKBT 5 (Tokyo: Iwanami shoten, 1989), 4.

5. Fujiwara no Shunzei, *Koraifūteishō*, in *Karonshū*, ed. Hashimoto Fumio, Ariyoshi Tamotsu, and Fujihira Haruo, NKBZ 50 (Tokyo: Shōgakukan, 1975), 273, 371.

6. Fujiwara no Teika, *Maigetsushō*, in ibid., 515.

7. A similar stance is taken by Retired Emperor Juntoku (1197–1242; r. 1210–1221) in book 6 of his *Yakumo mishō* (*Layered Clouds Honorable Notes*, early thirteenth century). See Sasaki Nobutsuna, ed., *Nihon kagaku taikei* (Tokyo: Kazama shobō, 1956–1965), 3:73–94.

8. Nishioka Hideo, *Kandan no rekishi: Nihon kikō shichihyakunen shūkisetsu* (Tokyo: Kōgakusha, 1949), cited in Takahashi Kazuo, *Nihon bungaku to kishō*, Chūkō shinsho 512 (Tokyo: Chūō kōronsha, 1978), 12–13.

9. In this book, dates in the premodern luni-solar calendar are referred to by capitalized, numbered months, such as "fifteenth day of the First Month," while dates in the modern solar calendar are referred to, for example, as "January 5."

10. The average peak for the ninth century was April 10; for the fifteenth century, April 10; and for the sixteenth century, April 16. See Yamato Takeo, "Nihon sakurabana shiryō to Ōa no kikō sōkan," *Kigaku* 22, no. 1 (1952), cited in Takahashi, *Nihon bungaku to kishō*, 234.

11. The highest temperature for 1881 was in August, when it reached 89.6 degrees Fahrenheit. The lowest temperature in the same year was in January, when it averaged 27.32 degrees Fahrenheit. See Takahashi, *Nihon bungaku to kishō*, 15.

12. Kira Tatsuo, "Nihon bunka no shizen kankyō," in *Seitaigaku kara shizen* (Tokyo: Kawade shobō shinsha, 1983), 140–148.

13. Takahashi, *Nihon bungaku to kishō*, 58.

14. The typhoons begin in the South Pacific, in tropical, low-pressure areas; reach wind speeds of up to thirty-eight miles per hour at the center; and cause extensive damage and large rainfall. In classical Japanese, a typhoon is referred to as *nowaki*.

15. Yasuda Yoshinori, "Rettō no shinzen kankyō," in *Nihon rettō to jinrui shakai*, Iwanami kōza tsūshi 1 (Tokyo: Iwanami shoten, 1993), 41–81.

16. Sen no Rikyū, "Records of the Words of Rikyū," in *Wind in the Pines: Classic Writings of the Way of Tea as a Buddhist Path*, ed. Dennis Hirota (Fremont, Calif.: Asian Humanities Press, 1995), 223.

17. English-language scholarship on Japanese views of nature, like much of Japanese scholarship, fails to distinguish between these two fundamental perspectives and tends to be ahistorical or ignore a long history of premodern evolving views.

18. *Hizen no kuni fudoki*, in *Fudoki*, NKBT 2 (Tokyo: Iwanami shoten, 1958), 393. Hizen Province, in western Kyūshū, is now occupied by Saga and Nagasaki prefectures.

19. Iinuma Kenji, "Kankyō rekishigaku josetsu: shōen no kaihatsu to shizen kankyō," *Minshūshi kenkyū*, May 2001, 11.

20. For the history and characteristics of the *satoyama*, see K. Takeuchi, R. D. Brown, I. Washitani, A. Tsunekawa, and M. Yokohari, eds., *Satoyama: The Traditional Rural Landscapes of Japan* (Tokyo: Springer, 2003).

21. *Uji shūi monogatari*, NKBZ 28 (Tokyo: Shōgakukan, 1973), 74–75; "How a Young Lad from the Country Wept on Seeing the Cherry-Blossom Falling," in *A Collection of Tales from Uji*, trans. D. E. Mills (Cambridge: Cambridge University Press, 1970), 150.

## 1. Poetic Topics and the Making of the Four Seasons

1. For example, the Festival to Pray for a Rich Harvest (Toshigoi no matsuri) was held on the fourth day of the Second Month (mid-spring) to pray for a bountiful harvest of the five grains, peace for the country, and the good health of the emperor.

2. *Satsuki no tama* is thought to have been a medicine ball (*kusudama*) to ward off evil on the fifth day of the Fifth Month, but it is best interpreted in this poem as the fruit of the mandarin orange (*tachibana*).

3. Ōtomo no Yakamochi (d. 785), perhaps with the help of Ōtomo no Sakanoue no Iratsume (Lady Sakanoue [700–750]), may have selected outstanding seasonal poems from the past and placed them in prominent positions in book 8 as models for the present. The opening poems in each section of the book are from the second *Man'yōshū* period (672–710), while the overwhelming majority of the poems are from the third *Man'yōshū* period (710–733). The "old" poems are at the beginning

of each major section, followed by "new" poems from the present or recent past. Itō Haku points out that this "old–new" structure informs the first sixteen of the twenty books of the *Man'yōshū*, in "*Man'yōshū* ni okeru 'inishie' to 'ima': maki kyū no kōzōron o tōshite," *Kokugo to kokubungaku*, December 1, 1971, 1–15.

4. The early *zōka* were defined by context (public occasions related to the imperial family), while *sōmon* and *banka* were defined by content (love and death, respectively). These miscellaneous poems appear as early as the Genmei era (661–721), are prominent in book 1 of the *Man'yōshū*, and continue to be a central genre in subsequent books. Banquet poetry, by contrast, emerges in books 5 and 6, which collect poetry from the Jinki (724–729) and Tenpyō (729–749) eras, and then comes to the fore in books 8 and 10, when seasonal poems emerge.

5. Aso Mizue has argued that the plum-blossom poetry banquet was a major impetus for banquet poetry on seasonal topics, in "*Man'yōshū* no shiki bunrui," in *Ronshū jōdai bungaku*, ed. Man'yō shichiyōkai (Tokyo: Kasama shoin, 1973), 10–11. A number of important seasonal banquets were held in the early Tenpyō era, from around 730 to 738.

6. This poem, probably by Ōtomo no Tabito, is from a group of four (*Man'yōshū*, 5:849–852) that were added to the original thirty-two plum poems (5:815–846) at Tabito's banquet.

7. The *Kokinshū* topics are not as clearly defined as the list suggests; for example, in summer, the small cuckoo and orange blossoms often are in the same poem. Also, a topic may appear once and then reappear with another topic. A number of poetic places (*utamakura*), which are not indicated here, are also interwoven into the seasonal motifs. For example, Mount Yoshino appears repeatedly in the snow sequence (nos. 317, 321, 325, 327, 332) in the winter book of the *Kokinshū*.

8. In this poem, Kaguyama (Mount Kagu) is the gateway for spring, since, as the "Heavenly Hills," it is closest to the heavens. Kaguyama is in the Nara basin, but even after the capital moved to present-day Kyoto, the aristocrats continued to write about the hills of Nara, which were rich in cultural connotations.

9. A salient example is the second poem in the *Shinkokinshū* (*New Anthology of Poetry Old and New*, 1205), by Emperor GoToba: "Faintly, it seems, spring has arrived in the sky—mist trailing over Heavenly Kagu Mountain" (*Honobono to haru koso sora ni kinikerashi Ama no Kaguyama kasumi tanabiku* [Spring 1, no. 2]).

10. Kawamura Teruo, *Sekkanki wakashi no kenkyū* (Tokyo: Miyai shoten, 1991), 368, 405–420.

11. The *ume*, which was imported from China, is actually a kind of apricot, but it is traditionally translated as "plum."

12. The *Man'yōshū* has eight poems (nos. 1846–1853) on the willow in the "Spring Miscellaneous" section of book 10.

13. There is only one poem in the *Man'yōshū* (20:4500) on the scent of the plum.

14. There are a few instances in the *Kokinshū* in which the word "flower" (*hana*) refers to the plum blossom, such as in Ki no Tsurayuki's poem (Spring 1, no. 42),

but generally *hana* in the spring books refers to the cherry blossom from mid- to late spring.

15. Opinions were divided on whether yellow kerria was a grass flower or just a grass. Sei Shōnagon's *Makura no sōshi* (*The Pillow Book*, ca. 1000) includes the eight-layered *yamabuki* among the grass flowers (*kusa no hana*), while in *Tsurezuregusa* (*Essays in Idleness*, 1310–1331?), Priest Kenkō lists both yellow kerria and wisteria (*fuji*) as grasses (*kusa*).

16. The poem plays on the verbs *utsurou*, which can mean both "to move" and "to reflect," and *fuku* (to blow), which is also embedded in the word *yamabuki* (literally, "mountain blows"). The flowers reflected on the surface of the water appear to be scattering at the bottom of the river.

17. The summer book of the *Kokinshū* has only 34 poems compared with 134 poems in the two spring books.

18. The *Man'yōshū* includes as many as seventy poems on the mandarin orange (with about half on the flower [*hanatachibana*]), making it the equal of the plum blossom and the bush clover as a seasonal topic.

19. The "person of long ago" is probably a lover whom the poet has lost. The poem also appears in section 60 of *The Tales of Ise* (*Ise monogatari*, ca. 947).

20. One etymological theory is that the *sa-* in *samidare* refers to *satsuki* (Fifth Month) and that *-midare* refers to the dripping of water (*mizu tareru*). From the late Heian period, three Chinese graphs, 五月雨 (literally, "Fifth Month Rain"), were used for the word. In the medieval period, the Chinese compound *bai-u* (plum rain, when the fruit of the plum ripens) and its Japanese reading (*ume no ame*) were used to denote the time of the long rains. In the Edo period, this compound was read as *tsuyu*, and *samidare* referred to the rain itself, the season of the long rains, or both.

21. The Tanabata poems in the "Autumn Miscellaneous" section of book 10 of the *Man'yōshū* include a large group of thirty-eight (nos. 1996–2033), probably written around 680, that are labeled "From Hitomaro's Poetry Collection." Most of the Tanabata poems, however, come from a later period.

22. In Satomura Jōha's treatise *Renga shihōshō* (*Shihōshō; Collection of Treasures*, 1586), *ominaeshi* is categorized as a seasonal word for the Seventh Month, the first month of autumn, a tradition carried on by early Edo *haikai* handbooks such as Matsue Shigeyori's *Hanahikusa* (*Sneeze Grass*, 1636) and *Kefukigusa* (*Blown-fur Grass*, 1645), and Kitamura Kigin's *Zōyamanoi* (*Additional Mountain Well*, 1667).

23. Of the *momichi* poems in books 8 and 10 of the *Man'yōshū*, three refer to red leaves and seventeen to yellow leaves.

24. The chrysanthemum became an autumn topic, while the *zangiku* (lingering chrysanthemum) became an early-winter topic. *Renga* and *haikai* handbooks categorize the chrysanthemum as a seasonal word for the Ninth Month, the last phase of autumn, following the association of the chrysanthemum with the ninth day of the Ninth Month.

25. For more detail, see Arai Eizō, "*Kokin wakashū* shiki no bu no kōzō ni tsuite no ichi kōsatsu: tairitsuteki kikōron no tachiba kara," in *Kokinwakashū*, ed. Nihon bungaku kenkyū shiryō kankōkai, Nihon bungaku kenkyū shiryō sōsho 15 (Tokyo: Yūseido, 1976), 92–117.

26. The notion of love as it appears in the *Kokinshū* differs significantly from the modern Western idea of "love," which implies passionate involvement with someone. In classical poetry, love (*koi*) means yearning to be with someone of the opposite sex who is absent or beyond reach. A graph often used in the *Man'yōshū* for "love" is 孤悲 (*ko-hi*; literally, "lonely sorrow"). *Koi* is about the pain of being apart or separated from the object of desire; it is rarely about the joy of being together.

27. The importance of waterfowl (*mizutori*) in Heian-period *waka* is evident in the fact that the *Horikawa hyakushu* (*Horikawa Poems on One Hundred Fixed Topics*, 1105) chooses it as one of the fifteen winter topics.

28. *Tentoku yonen sangatsu sanjūnichi dairi uta-awase*, in *Uta-awase*, ed. Hagitani Boku and Taniyama Shigeru, NKBT 74 (Tokyo: Iwanami shoten, 1965), 82.

29. Ibid., 83.

30. The *Roppyakuban uta-awase* immediately follows the *Senzaishū*, the seventh imperial *waka* anthology, which was also edited by Shunzei.

31. The return to the *Makura no sōshi*, together with the extensive use of *The Tale of Genji* topics, such as evening faces (*yūgao*) and autumn tempest (*nowaki*), may have been part of the effort of the organizers, particularly the Kujō family (northern branch of the Fujiwara clan), founded by Kujō Kanezane (1149–1207), to relive the time when the Fujiwara Regency (*sekkanke*) was at its height, in the mid-Heian period. See Shinozaki Yukie, "Roppyakuban uta-awase kadai-kō: Shiki no bu o megutte," *Kokubungaku kenkyū*, May 1990, 62.

32. According to the *Waka genzai shomokuroku* (*Contemporary Catalogue of Japanese Poetry*, ca. 1166), a late Heian catalogue, the first *hyakushu-uta* was composed by Minamoto no Shigeyuki (d. 1000), who offered his hundred poems to the crown prince (later Emperor Reizei) in 967.

33. Hashimoto Fumio and Takizawa Sadao, *Kōhon Eikyū yonen hyakushu waka to sono kenkyū* (Tokyo: Kasama shoin, 1978), 162. In contrast to the *Horikawa hyakushu*, 87 percent of whose topics overlap with those in earlier collections, only 33 percent of the topics in the *Eikyū yonen hyakushu* (*Poems on One Hundred Fixed Topics in the Fourth Year of Eikyū*, 1116) correspond to those found in earlier collections. If the *Horikawa hyakushu* draws heavily on the *Wakan rōeishū* (*Japanese and Chinese-Style Poems to Sing*, ca. 1013), the *Eikyū yonen hyakushu* draws on the *Senzai kaku* (*Superior Verses of a Thousand Years*, ca. 947–957), a topically arranged anthology based on two-line excerpts from *kanshi*.

34. The seasonal words for the pastoral landscape include, for spring, young bracken (*sawarabi*), spring rain (*harusame*), spring horses (*harukoma*), rice-seedling bed (*nawashiro*), violet (*sumiregusa*), iris (*kakitsubata*); for summer, hollyhock (*aoi*), young rice seedlings (*sanae*), firelight (*tomoshi*), insect-repelling fires (*kayaribi*), lotus,

ice room, spring (*izumi*); for autumn, reeds (*ogi*), kangaroo grass (*karukaya*), boneset (*fujibakama*), morning glory (*asagao*), fulling cloth (*tōi*); and for winter, early winter, cold house, wicker fish trap (*ajiro*), god dance (*kagura*), falconry (*takagari*), charcoal oven (*sumigama*), and charcoal fire in ash (*uzumibi*).

35. *Nawashiro* first appears as a fixed topic in the *Kokiden nyōgo uta-awase* (*Kokiden Consort Poetry Contest*, 1041).

36. *Sanae* first appears as a topic in the *Gon Dainagon no ie no uta-awase* (*Poetry Contest at the House of the Provisional Major Counselor*, 1096).

37. Another example of seasonal ambiguity is the willow, which became associated primarily with the beginning of spring, but also appears in summer and winter topics.

38. Kazamaki Keijirō, "Hachidaishū shikibu no dai ni okeru ichi jiitsu," in *Shinkokin jidai*, vol. 6 of *Kazamaki Keijirō zenshū* (Tokyo: Ōfūsha, 1970), 63–83.

39. Ariyoshi Tamotsu, *Shinkokinshū no kenkyū, zoku hen* (Tokyo: Kasama shoin, 1996), 136.

## 2. Visual Culture, Classical Poetry, and Linked Verse

1. The descriptions of the most prominent color combinations of the *kasane* are based on the historical reconstructions in Ihara Aki, *Heian chō no bungaku to shikisai*, Chūkō shinsho 673 (Tokyo: Chūō kōronsha, 1982), frontispiece. Since the robes from the Heian period do not survive, these colors are based on non-visual evidence found in documents, resulting in a range of interpretations.

2. Ibid., 27–28.

3. Takeda Tsuneo, *Nihon no kaiga to saiji: Keibutsuga shiron* (Tokyo: Perikansha, 1990), 20–21.

4. Ōnakatomi no Yoshinobu, *Yoshinobu shū*, in *Chūkō*, vol. 1 of *Shikashū taisei*, ed. Wakashi kenkyūkai (Tokyo: Meiji shoin, 1973), 571–572.

5. The paintings do not survive, but the twenty-four *waka* are preserved in the *Shūi gusō* (*My Gathered Writings*, 1216), a private collection of poetry by Fujiwara no Teika. See Ishikawa Tsunehiko, ed., *Shūi gusō kochū*, Chūsei no bungaku (Tokyo: Miyai shoten, 1989).

6. Ogata Kenzan's *Teika-ei jūnikagetsu waka kachōzu kakuzara* (1702), a set of twelve square dishes with seasonal motifs, each with a poem on the reverse side, is in the MOA Museum of Art, Atami. Photographs of the set are in Suntory bijutsukan, ed., *Uta o egaku, e o yomu: waka to Nihon bijutsu* (Tokyo: Suntory bijutsukan, 2004), 124–125.

7. Depending on the design of the tree or flower, the points were different. The designs with the highest value (twenty points) were pine with crane; cherry blossoms with tent curtain (*maku*); miscanthus grass with moon; willow with Ono no Tōfū (894–966), a noted Heian calligrapher; and paulownia with phoenix. Combination

designs—such as plum blossoms and warbler, wisteria and cuckoo, sweet flag and Eight Bridges, peony and butterfly, bush clover and wild boar, miscanthus grass and wild geese, chrysanthemum and saké cup, bright foliage and deer, and willow and swallow—earned the next highest marks (ten points).

8. For more details on flower cards, see Sakai Yasushi, *Nihon yūgishi* (Tokyo: Kensetsusha, 1933).

9. On the relationship of Heian-period painting to poetic places, see Yoshiaki Shimizu, "Seasons and Places in Yamato Landscape and Poetry," *Ars Orientalis* 12 (1981): 1–14.

10. Fujiwara no Tameaki, *Chikuenshō*, in *Nihon kagaku taikei*, ed. Sasaki Nobutsuna (Tokyo: Kazama shobō, 1956), 3:426.

11. *Shōtetsu monogatari*, in *Karonshū, nōgakuronshū*, ed. Hisamatsu Sen'ichi and Nishio Minoru, NKBT 65 (Tokyo: Iwanami shoten, 1961), 176. For a translation, see *Conversations with Shōtetsu*, trans. Robert H. Brower, with introduction and notes by Steven D. Carter, Michigan Monographs in Japanese Studies, no. 7 (Ann Arbor: Center for Japanese Studies, University of Michigan, 1992), 77–78.

12. Tamamushi Satoko, "Waka o hakobu katachi: byōbu-e kara kosode made," in *Uta o egaku, e o yomu*, ed. Suntory bijitsukan, 134–135.

13. Mito Nobue, "Unkin," in *Uta o egaku, e o yomu*, ed. Suntory bijitsukan, 106–107.

14. Ida Tarō, "Kigō no bonsai," in *Mitate yatsushi no sōgō kenkyū: purojekkuto hōkokusho dai yongō* (Tokyo: Ningen bunka kikō kokubungaku shiryōkan, 2009), 37–43.

15. Mito Nobue, "Mitate to nazuke: waka to no arata na deai," in *Uta o egaku, e o yomu*, ed. Suntory bijitsukan, 115–116.

16. Nijō Yoshimoto, *Hekirenshō*, in *Renga ronshū, nōgakushū, haironshū*, ed. Ijichi Tetsuo, Omote Akira, and Kuriyama Riichi, NKBZ 51 (Tokyo: Shōgakukan, 1973), 44. Nijō Yoshimoto's *Renri hishō* (*Secret Notes on the Principles of Linking*, ca. 1349), which is said to be a revised version of *Hekirenshō*, has an identical list of seasonal topics for the twelve months. See Ijichi Tetsuo, ed., *Renga ronshū*, Iwanami bunko (Tokyo: Iwanami shoten, 1953), 1:38.

17. The *yobukodori* (cuckoo [*Cuculus canorus*]) differs from the *hototogisu* (little cuckoo [*Cuculus poiocephalus*]), translated here as "small cuckoo."

18. Nijō Yoshimoto, *Hekirenshō*, 58.

19. Satomura Jōha, *Shihōshō*, in *Renga ronshū*, ed. Ijichi Tetsuo, Iwanami bunko (Tokyo: Iwanami shoten, 1956), 2:233.

20. Ibid., 234.

21. The *Senzai kaku*, a collection of selected lines from Chinese-style poetry (*kanshi*), is arranged in the following order: four seasons (*shiji*), annual observances (*jisetsu*), astronomical and atmospheric phenomena (*tenshō*), terrestrial phenomena (*chiri*), human affairs (*jinji*), imperial palace, dwellings (*kyosho*), grass and trees (*sōmoku*), animals, enjoying banquets, excursions (*yūhō*), parting (*ribetsu*), hermits

(*in'itsu*), Buddhism, and the Way of the immortals (*sendō*). For the text, see Kaneko Hikojirō, *Heian jidai bungaku to Hakushi monjū: Kudai waka Senzai kaku kenkyū hen* (Tokyo: Baifūkan, 1955), 641–766.

22. Akabane Shuku, "Fujiwara Teika no jūdai hyakushu," *Bungei kenkyū*, September 1964; Kubota Jun, *Shinkokin kajin no kenkyū* (Tokyo: Tōkyō daigaku shuppankai, 1973). The *Waka iroha* (*ABC's or Primer of Classical Poetry*), a poetry treatise written by Jōkaku in the twelfth century, contains a similar list.

23. Mitsuta Kazunobu, "Renga shinshiki no sekai: renga shikimoku moderu teiritsu no kokoromi," *Kokugo kokubun*, May 25, 1996, 346–347.

24. For example, a descending object such as snow could be followed by an ascending object such as spring mist, but a descending object had to be separated from another descending object by at least three verses.

25. Among mountain places (*sanrui*), hill and peak were classified as static, while waterfall represented movement. Stasis or movement could occur only once or twice in a row, as in stasis/stasis/movement or movement/movement/stasis. See Okuda Isao, *Rengashi, sono kōdō to bungaku* (Tokyo: Hyōronsha, 1976), 31–36.

26. The flower verse was called the *hana no ku*; the moon verse, *tsuki no ku*; and the love verse, *koi no ku*.

27. Sōgi, Shōhaku, and Sōchō, *Minase sangin hyakuin*, in *Rengashū*, ed. Ijichi Tetsuo, NKBT 39 (Tokyo: Iwanami shoten, 1960), 345–347.

28. Evening (time of day), mist (ascending).

29. Tree (plant).

30. Wind, tree (plant).

31. Night (time of day), boat (water). "Miscellaneous" (*zō*) indicates non-seasonal, and thus was commonly used when moving from one season to another in a sequence.

32. Night (time of day), mist (ascending), moon (luminous object).

33. Frost (descending).

34. Insect (animal), grass (plant).

35. For a commentary on *Minase sangin hyakuin* and a chart on the rules for the distribution of topics as they are observed in this sequence, see Kaneko Kinjirō, *Sōgi meisaku hyakuin chūshaku*, Kaneko Kinjirō renga kōsō 4 (Tokyo: Ōfūsha, 1985), 89–98.

36. Nijō Yoshimoto, *Tsukuba mondō*, in *Renga ronshū, haironshū*, ed. Kidō Saizō and Imoto Nōichi, NKBT 66 (Tokyo: Iwanami shoten, 1961), 82.

37. Mitsuta, "Renga shinshiki no sekai."

38. Tomiyasu Fūsei, ed., *Haiku saijiki: Shin'nen no bu* (Tokyo: Heibonsha, 1959).

39. Takahama Kyoshi, *Shinsaijiki* (1934; rpt., Tokyo: Sanseidō, 1951).

40. Mizuhara Shūōshi, Katō Shūson, and Yamamoto Kenkichi, eds., *Nihon daisaijiki: karā zusetsu* (Tokyo: Kōdansha, 1983).

41. Kazamaki Keijirō, "Fūgashū to Mokkei," in *Genji monogatari no seiritsu*, vol. 4 of *Kazamaki Keijirō zenshū* (Tokyo: Ōfūsha, 1966), 444–447.

42. *Fūgashū*, in *Chūsei wakashū*, ed. Inoue Muneo, SNKBZ 49 (Tokyo: Shōgakukan, 2000), 286.

43. Okuda Isao, "Renga ni okeru fūkei," *Seishin joshi daigaku ronshū*, December 1989, 23–36.

44. Tsurusaki Hiroo, "Rengashi no egokoro: renga to suiboku sansuiga, toku ni Shōshō hakkei-zu ni tsuite," *Geinōshi kenkyū*, no. 43 (1973): 38-49.

# 3. Interiorization, Flowers, and Social Ritual

1. Kawamoto Shigeo, "Sumai no keifu to kazari no keifu," in *"Kazari" to "tsu-kuri" no ryōbun*, ed. Tamamushi Satoko, Kōza Nihon bijutsushi 5 (Tokyo: Tōkyō daigaku shuppankai, 2005), 35. See also Kawamoto Shigeo, *Shinden-zukuri no kū-kan to gishiki* (Tokyo: Chūō kōron bijutsu shuppan, 2005).

2. An early example of the pillar-space type of architecture is the Daigokuden (main building) in the Heijō (Nara) and Heian (Kyoto) imperial palaces, where the emperor carried out public rituals.

3. Itō Teiji, "Nihon no dezain," in *Nihonjin no kachikan*, ed. Itō Shuntarō, Kōza hikaku bunka 7 (Tokyo: Kenkyūsha, 1976), 335–339.

4. Princess Kishi (951–986), also called Noriko, was the daughter of Emperor Murakami (926–967; r. 946–967).

5. Tachibana Narisue, *Kokon chomonjū ge*, ed. Nishio Kōichi and Kobayashi Yasuharu, SNKBS 76 (Tokyo: Shinchōsha, 1986), 337–338.

6. On the relationship of *waka* to the *sumahama* (island beach) and the garden, see Nishiki Jin, "Waka ni okeru suhama to teien," *Bungaku*, June 2006, 79–94.

7. The sequence of the plays is based on a seasonal performance chart of the Kanze school received from Yamanaka Reiko of the Nogami Memorial Noh Theater Research Institute at Hōsei University. See also Horigami Ken and Baba Akiko, *Nō no shiki* (Tokyo: Tachibana shuppan, 2001).

8. Furuido Hideo, *Buyō techō* (Tokyo: Shinshokan, 2000).

9. However, as *rikka* became more important and more formal, particularly as offerings to the gods, the *renga* flower arrangements (*renga no hana*) were made in advance of the session. See *Sendenshō* (1643) and Ōi Minobu, "Ikebana to renga," both in *Ikebana jiten*, ed. Ōi Minobu (Tokyo: Tōkyōdō shuppan, 1976), 372, 33–34.

10. Ikenobō Senkō, *Ikenobō Sen'ō kuden* (Zoku Gunsho ruijū 553), in *Ikebana jiten*, ed. Ōi, 393–394.

11. A tree branch could function as a *shin* (center) in a particular month and then as a *soe* (augmentation) in other months. According to the *Sendenshō*, maple branches could be both the *shin* in the Seventh and Eighth Months (autumn) and the *soe* in other months. See *Sendenshō*, in Kudō Masanobu, *Ikebana no seiritsu to hatten*, Nihon ikebana bunkashi 1 (Kyoto: Dōhōsha shuppan, 1992), 79, 186.

12. Ibid., 189.

13. Kurokawa Dōyū, "Enpekiken-ki," in *Ikebana jiten*, ed. ōi, 60.

14. Mon'ami was noted as a *rikka* artist and wrote a number of treatises, including *Mon'ami densho* (*Transmissions on the Flower by Mon'ami*, early sixteenth century). Sōami, who established the Sōami school of painting, also was noted for his work on and talent in parlor-style architecture, *renga*, the tea ceremony, incense competition, and standing-flower arrangement.

15. Ikenobō, *Ikenobō Sen'ō kuden*, 389, 391.

16. *Sendenshō*, in Kudō, *Ikebana no seiritsu to hatten*, 82–83, 182.

17. *Rikka imayō sugata*, in *Ikebana jiten*, ed. Ōi, 335.

18. Chōbunsai Eishi's print *Shinnen no iwai* (Asian Art Museum, Berlin) is reproduced in Kobayashi Tadashi, ed., *Ikebana no fūzoku*, Ikebana bijutsu zenshū 9 (Tokyo: Shūeisha, 1983), 16, fig. 8.

19. Ikenobō, *Ikenobō Sen'ō kuden*, 394.

20. *Sendenshō*, in Kudō, *Ikebana no seiritsu to hatten*, 77–79, 179–180.

21. Ikenobō, *Ikenobō Sen'ō kuden*, 385, 396. The *Rikka byōbu zu* (*Screen Painting of Rikka*, ca. 1630 [Fumihide Nomura Collection, Kyoto]), attributed to Iwasa Matabei, shows various *rikka* arrangements by Ikenobō Senkō II that are appropriate to the occasion. The painting is reproduced in Donald Richie and Meredith Weatherby, eds., *The Masters' Book of Ikebana: Background and Principles of Japanese Flower Arrangement* (Tokyo: Bijutsu shuppansha, 1966), figs. 61, 62.

22. Hayashiya Tatsusaburō, "Ikebana no nagare," in *Ikebana no bunkashi*, ed. Hayashiya Tatsusaburō, vol. 3 of *Zusetsu ikebana taikei*, ed. Tamagami Takuya, Hayashiya Tatsusaburō, and Yamane Yūzō (Tokyo: Kadokawa shoten, 1970), 1:13–14.

23. *Bonseki* emerged in the Kamakura period and became popular at the same time as the *kare-sansui*.

24. Katō Sadahiko, "Yatsushi to teien bunka," in *Zusetsu mitate to yatsushi: Nihon bunka no hyōgen gihō*, ed. Ningen bunka kenkyū kikō kokubungaku kenkyū shiryōkan (Tokyo: Yagi shoten, 2008), 163.

25. *Sendenshō*, in Kudō, *Ikebana no seiritsu to hatten*, 190.

26. According to one of the poems in the *Rikyū hyakushu*, "If you give tea to those returning from flower viewing, don't hang a picture of birds and flowers or put out any flowers" (*Hanami yori kaeri no hito ni chanoyu seba kachō no e wo mo hana mo okumaji*). Another poem in the series notes: "If you hang a scroll of poetry in the alcove, know to avoid using poetry elsewhere in the room" (*Toko ni mata waka no tagui woba kakeru nara hoka ni utagaki woba kazaranu to shire*). Translated at www.teahyakka.com; for the full text, see "Chadō kyōyu hyakushu ei," in *Chadō koten zenshū*, ed. Sen Sōshitsu (Kyoto: Tankō shinsha, 1962), 10:133–150.

27. Hayashiya, "Ikebana no nagare."

28. Kitao Shigemasa's print *Bijin hana-ike* is reproduced in Kobayashi, ed., *Ikebana no fūzoku*, 22, fig. 13.

29. Kobayashi Tadashi, "Ikebana to ukiyoe," in *Ikebana no fūzoku*, ed. Kobayashi, 101.

30. Nakao Sasuke, "Nihon no hana no rekishi," in *Hana to ki no bunkashi*, Iwanami shinsho 357 (Tokyo: Iwanami shoten, 1986), 105–178.

## 4. Rural Landscape, Social Difference, and Conflict

1. Miyake Hiroshi, "Sōron: kyōdōtai no denshō to kosumolojii," in *Minzoku to girei: sonraku kyōdōtai no seikatsu to shinkō*, ed. Miyake Hiroshi, Taikei Bukkyō to Nihonjin 9 (Tokyo: Shunjūsha, 1986), 21.

2. According to Augustin Berque, "Although the mountains in Japan are not very high—apart from Mount Fuji, the highest peaks are not more than 3000 metres [9843 feet]—they are however omnipresent, covering nearly three-fifths of the country. Only on the Kantō plain (in the Tokyo region) and, to a lesser extent, that of Tokachi (on Hokkaido), do mountains not form the immediate backdrop to inhabited areas" (*Japan: Nature, Artifice, and Japanese Culture,* trans. Ros Schwartz [Yelvetoft Manor: Pilkington Press, 1993], 47).

3. The most prominent shrines of this type are Sumiyoshi Shrine (in present-day Osaka) and Itsukushima Shrine, which is built in the water.

4. Takahashi Chihaya, "Tori no Nihonshi," in *Kachō fūgetsu no Nihonshi* (Tokyo: Moku shuppan, 2000), 157–213.

5. Ten poems on sparrows, as a bird that picks up fallen rice seeds in a field or nests in bamboo or in the eaves of a house, appear in volume 17 of the *Fubokuwakashō* (*Japanese Collection*, ca. 1310), compiled by Fujiwara no Nagakiyo. The *Fubokuwakashō* includes 17,350 *waka* from *kashū* (private poetry collections), *utaawase* (poetry contests), *hyakushu* (poems on a hundred fixed topics), and other types of collections. It is arranged by topical categories, by the seasons, and by miscellaneous topics, and it includes a much wider range of topics than that found in the imperial *waka* anthologies. See Fujiwara Nagakiyo, comp., *Fuboku wakashō*, ed. Kokusho kankōkai, Daiikki kankō 15 (Tokyo: Kokusho kankōkai, 1906).

6. *Gan-karigane*, in *Kyōgen shūsei*, ed. Nonomura Kaizō and Andō Tsunejirō (Tokyo: Shun'yōdō, 1931), 112–113.

7. See, for example, Ōtomo no Yakamochi's poem in the *Shūishū* (*Collection of Gleanings*, 1005–1007), Spring 1, no. 21.

8. The crane (*tsuru*) is thought to cover its chicks with its wings on cold nights.

9. "Karukaya," in *Kojōruri, sekkyōshū*, ed. Shinoda Jun'ichi and Sakaguchi Hiroyuki, SNKBT 90 (Tokyo: Iwanami shoten, 1999), 272. The same occurs in "Sanshō dayū" (Sanshō the Wealthy), another *sekkyōbushi*.

10. Kurata Minoru, "Suzume," in "Kotenbungaku dōbutsushi," ed. Kokubungaku: kaishaku to kyōzai no kenkyū, special issue, *Kokubungaku: kaishaku to kyōzai no kenkyū* 39, no.12 (1994): 53.

11. Kaneko Hiromasa, Konishi Masayasu, and Sasaki Kiyomitsu, *Nihonshi no naka no dōbutsu jiten* (Tokyo: Tōkyōdō shuppan, 1992), 106–107.

12. In the Edo period, parts of rice fields were marked off, preventing farmers from chasing away wild geese—a situation described in "Gan kamo no ine wo kurau nangi no koto" (The Difficulty Caused by Wild Geese and Wild Ducks Eating Rice Plants [3:7]), in Asai Ryōi's *Ukiyo monogatari* (*Tales of the Floating World*, 1665–1666), in *Kana-zōshi shū*, ed. Taniwaki Masachika, Oka Masahiko, and Inoue Kazuhito, SNKBZ 64 (Tokyo: Shogakukan, 1999), 164–167.

13. In *Utsuho monogatari* (*The Tale of the Hollow Tree*, tenth century), Ariwara Tadayasu, while poor, cooks pheasant to honor his dear son-in-law, Minamoto no Nakayori.

14. Both the noh play *Ukai* (*Cormorant Fishing*) and the *kyōgen* (comic) play *Tako* (*Octopus*) involve *kuyō*. For a translation of *Ukai*, see Arthur Waley, *The Nō Plays of Japan* (Rutland, Vt.: Tuttle, 1976), 127–133. For a translation of *Tako*, see Carolyn Haynes, "Parody in *Kyōgen*: *Makura Monogurui* and *Tako*," *Monumenta Nipponica* 39 (1984): 261–279.

15. "How a Man Called Umanojō Shot a Male Mandarin Duck in Akanuma in Michinoku Province and Then Received the Tonsure," trans. Burton Watson, in *The Demon at Agi Bridge and Other Japanese Tales*, ed. Haruo Shirane (New York: Columbia University Press, 2011), 132–133.

16. "Kari no sōshi," in *Muromachi monogatari shū*, ed. Ichiko Teiji, Akiya Osamu, Sawai Taizō, Tajima Kazuo, and Tokuda Kazuo, SNKBT 54 (Tokyo: Iwanami shoten 1989), 1:312–324. For an analysis, see Tokuda Kazuo, "Kari," in "Kotenbungaku dōbutsushi," 68–69.

17. Tokugawa bijutsukan, ed., *E de tanoshimu Nihon mukashibanashi: otogi-zōshi to ehon no sekai* (Tokyo: Tokugawa bijutsukan, 2006), 40.

18. In *Hajitomi*, a priest is making an offering of a standing-flower (*rikka*) arrangement at the Unrin-in in Kitayama, north of the capital, when a woman appears and confesses that she is the spirit of Yūgao (Evening Faces); she asks the priest to visit the area of the Fifth Ward (Gojō), and then disappears. When the priest goes to the Fifth Ward, she appears in the trellis of evening-faces blossoms and tells the story of the Shining Genji and his lover Yūgao. She then disappears as if in a dream. For a translation, see Janet Goff, *Noh Drama and The Tale of Genji: The Art of Allusion in Fifteen Classical Plays* (Princeton, N.J.: Princeton University Press, 1991), 111–114.

19. *Bashō*, in *Yōkyokushū*, ed. Itō Masayoshi, SNKBS 3 (Tokyo: Shinchōsha, 1988), 99. For a translation, see Japanese Classics Translation Committee, ed., *The Noh Drama: Ten Plays from the Japanese* (Rutland, Vt.: Tuttle, 1955), 127–141.

20. Donald Shively, "Buddhahood for the Nonsentient," *Harvard Journal of Asiatic Studies* 20, nos. 1–2 (1957): 139.

21. The idea that plants have a Buddha nature appears as early as Huiyuan (532–592), who wrote that although plants and non-sentient beings lack a mind, the Buddha

nature inheres in them. See Fabio Rambelli, *Vegetal Buddhas: Ideological Effects of Japanese Buddhist Doctrines on the Salvation of Inanimate Beings*, Occasional Papers 9 (Kyoto: Scuola Italiana di Studi sull' Asia Orientale, 2001), 9; and Yoshiaki Shimizu, "The Vegetable *Nehan* of Itō Jakuchū," in *Flowing Traces: Buddhism in the Literary and Visual Arts of Japan*, ed. James H. Sanford, William R. LaFleur, and Masatoshi Nagatomi (Princeton, N.J.: Princeton University Press, 1992), 201–233.

22. Shively, "Buddhahood for the Nonsentient," 144.

23. For a translation, see *Kakitsubata*, trans. Susan Blakeley Klein, in *Twelve Plays of the Noh and Kyōgen Theaters*, ed. Karen Brazell, Cornell University East Asia Papers, no. 50, rev. ed. (Ithaca, N.Y.: East Asia Program, Cornell University, 1990), 63–80.

24. Mochida Kimiko, "Shizenkan hihyō," in *Kibō no rinrigaku: Nihon bunka to bōryoku o megutte* (Tokyo: Heibonsha, 1998), 68.

25. Susan Blakeley Klein, "Turning Damsel Flowers to Lotus Blossoms," in *The Noh Ominameshi: A Flower Viewed from Many Directions*, ed. Mae Smethurst and Christina Laffin, Cornell East Asia Series, no. 118 (Ithaca, N.Y.: East Asia Program, Cornell University, 2003), 47–87.

26. Kageyama Haruki, *Shinzō: kamigami no kokoro to katachi* (Tokyo: Hōsei daigaku shuppankyoku, 1978), 17.

27. Sonoda Minoru, "Shinto and the Natural Environment," in *Shinto in History: Ways of the Kami*, ed. John Breen and Mark Teeuwen (Richmond, Eng.: Curzon Press, 2000), 32–46.

28. Matsuoka Seigō, *Kachō fūgetsu no kagaku* (Kyoto: Enkōsha, 1994), 76–83.

29. Seta Katsuya, "Kirareru kyoju to sanrin: kaihatsu no jidai," in *Ki no kataru chūsei*, Asahi sensho 664 (Tokyo: Asahi shinbunsha, 2000), 5–33.

30. Seta Katsuya, "Senkyoshi ga mita sanrin no keikan," in *Ki no kataru chūsei*, 34–36.

31. Hōjō Katsutaka, "Juboku bassai to zōsen, zōtaku: bassai teikō denshō, bassai girei, kamigoroshi," in *Kankyō to shinsei no bunkashi: Kankyō to shinsei no kattō*, ed. Masuo Shinichirō, Kudō Ken'ichi, and Hōjō Katsutaka (Tokyo: Bensei shuppan, 2003), 2:61.

32. Ibid., 57–59.

33. *Sanjū sangendō munagi no yurai*, which is the third and most famous part of a puppet play called *Gion nyōgo kokonoe nishiki* (*Gion Consort and the Nine-Layered Brocade*), first performed in 1760, became popular and is now staged as an independent play. For the *jōruri* version, see *Sanjūgendō munagi no yurai*, in *Gidayū shū*, ed. Kaiga Hentetsu (Tokyo: Hakubunkan, 1917), 2:159–169. The kabuki version is in Toita Yasuji, ed., *Kabuki meisakusen* (Tokyo: Tōkyō sōgensha, 1957), 11:103–146.

34. Fabio Rambelli, *Buddhist Materiality: A Cultural History of Objects in Japanese Buddhism* (Stanford, Calif.: Stanford University Press, 2007), 146, citing Murayama Shūichi, *Henbō suru kami to hotoketachi* (Kyoto: Jinbun shoin, 1990), 190–191.

35. Ichiko Teiji, *Chūsei shōsetsu no kenkyū* (Tokyo: Tōkyō daigaku shuppankai, 1955), 348.

36. It was not until the Muromachi period, in the picture scrolls that accompany the popular tales, that highly realistic depictions of animals became widespread. As Tokuda Kazuo has pointed out, the importation of *Aesop's Fables* (with its extensive use of animals) to Japan in the late sixteenth century, its printing in the early seventeenth century (as *Isoho monogatari*), and its immediate popularity were probably the result of an existing widespread interest in animals as characters in narratives. See Tokuda Kazuo and Yashiro Seiichi, *Otogi-zōshi, Isoho monogatari*, Shinchō koten bungaku arubamu 16 (Tokyo: Shinchōsha, 1991).

## 5. Trans-Seasonality, Talismans, and Landscape

1. *Oxford English Dictionary Online*, s.v. "talisman," http://www.oed.com.

2. The image of an open fan, which suggested unending space, was considered felicitous.

3. Ichiko Teiji, *Chūsei shōsetsu no kenkyū* (Tokyo: Tōkyō daigaku shuppankai, 1955), 310.

4. In the Heian period, this pun became the foundation for a famous parting (*ribetsu*) poem by Ariwara no Yukihira in the *Kokinshū* (*Collection of Japanese Poems Old and New*, ca. 905): "If, after I leave, I hear you say 'wait/pine,' which grows at the peak of Inaba Mountain, I will return right away" (*Tachiwakare Inaba no yama no mine ni ouru matsu to shi kikaba ima kaerikomu* [Partings, no. 365]). Inaba (in present-day Tottori Prefecture) consequently became a poetic place (*utamakura*) associated with the pine.

5. People in the ancient and Heian periods had difficulty determining if the bamboo was a tree or a grass, as indicated by this poem in the *Kokinshū*: "It appears that my life will be neither here nor there, like the bamboo, which is neither tree nor grass" (*Ki ni mo arazu kusa ni mo aranu take no yo no hashi ni waga mi wa narinuberanari* [Miscellaneous 2, no. 959]).

6. In early usage, the word *tsuru* referred to the crane in everyday situations, while the word *tazu* was poetic diction. Loneliness is expressed in this poem by Yamabe no Akahito: "As the tide rises at Wakanoura, the flats disappear, and the cranes head for the shore of reeds, crying" (*Waka no ura ni shio michikureba kata wo nami ashibe wo sashite tazu nakiwataru* [Man'yōshū, 6:919]).

7. Yearning for family is expressed in this poem by Ōtomo no Tabito: "Is it because it yearns for its wife, as I do, that the crane in the reeds at Yunohara cries constantly?" (*Yunohara ni naku ashitazu wa aga gotoku imo ni koure ya toki wakazu naku* [Man'yōshū, 6:961]).

8. Kobayashi Tadashi and Murashige Yasushi, eds., *Shōsha na sōshokubi: Edo shoki no kachō*, Kachōga no sekai 5 (Tokyo: Gakushū kenkyūsha, 1981), fig. 158.

9. Ibid., figs. 56, 57.

10. The peacock, for example, does not appear in the *Man'yōshū*, *Kokinshū*, or *Shinkokinshū* (*New Anthology of Poetry Old and New*, 1205).

11. Kaneko Hiromasa, Konishi Masayasu, and Sasaki Kiyomitsu, *Nihonshi no naka no dōbutsu jiten* (Tokyo: Tōkyōdō shuppan, 1992), 120–121.

12. Tosa Mitsuyoshi's screen painting *Phoenixes and Paulownia* (Cleveland Museum of Art) is reproduced in Miyeko Murase, *Masterpieces of Japanese Screen Painting: The American Collections* (New York: Braziller, 1990), 35–38.

13. In the Edo period, paulownia was also used to make chests of drawers (*tansu*).

14. Kaneko, Konishi, and Sasaki, *Nihonshi no naka no dōbutsu jiten*, 98–99.

15. Shimada Shūjirō, Takeda Tsuneo, et al., "Nihon no kachōga, seiritsu to tenkai," in *Kachōga shiryō shūsei*, ed. Takeda Tsuneo and Tsuji Nobuo, Kachōga no sekai 11 (Tokyo: Gakushū kenkyūsha, 1983), 90–123.

16. Yokoi Yayū, "Hyakugyo no fu," in *Chūkō hairon haibunshū*, ed. Shimizu Takayuki and Matsuo Yasuaki, vol. 14 of *Koten haibungaku taikei* (Tokyo: Shūeisha, 1971), 460.

17. For example, Mount Miwa, which plays a key role in the *Man'yōshu* and the *Nihon shoki* (*Chronicles of Japan*, 720), was thought to be a dwelling place of a god (*himorogi*). See Gorai Shigeru, "Nihon no shūkyo to shizen," in "Shizen," special issue, *Nihon no bigaku* 3, no. 10 (1987): 38–41.

18. The design of a lake island has been connected to Shinto shrines built on islands in lakes. See Hasegawa Masami, *Nihon teien yōsetsu* (Tokyo: Shirakawa shoin, 1978), 76–77.

19. An example of a surviving rough seashore is the shore of the lake at Mōtsū-ji temple in Hiraizumi.

20. The design of a cove beach appears, for example, on the cover of the *Heike nōkyō* (*Heike Sutra Container*, 1164) at the Itsukushima Shrine. See Iwasaki Haruko, *Nihon no ishō jiten* (Tokyo: Iwasaki bijitsusha, 1984), 143.

21. In the Nara period, Mount Hōrai was depicted as being populated with imaginary animals and plants, but from the Heian period, they were replaced by the more realistic but equally auspicious images of the pine, bamboo, and plum and the turtle and crane.

22. Hōrai, Hōjō, and Eishū are mentioned together as three sacred mountains (*sanshenshan*) in the biography of Qin Shihuang, First Emperor of the Qin, in Sima Qian's *Shiji* (Jp. *Shiki*; *Records of the Grand Historian*, 109–91 B.C.E.).

23. Hasegawa, *Nihon teien yōsetsu*, 184–185.

24. Higuchi Takahiko, *Keikan no kōzō: Randosukēpu to shite no Nihon no kūkan* (Tokyo: Gihōdō, 1971), 118; *The Visual and Spatial Structure of Landscapes*, trans. Charles S. Terry (Cambridge, Mass.: MIT Press, 1983).

25. *Fūsui* actually posits five guardian gods, five directions, and five seasons, but for Japanese architects and gardeners, the fifth was not important compared with the other four.

26. Jiro Takei and Marc P. Keane, *Sakutei: Visions of the Japanese Garden: A Modern Translation of Japan's Gardening Classic* (Boston: Tuttle, 2008), 9–10, 83–86, 196.

27. For an analysis of this passage, see Mori Osamu, *Heian jidai teien no kenkyū* (Kyoto: Kuwana bunseidō, 1945), 173–174.

28. "Fukiage jō," in *Utsuho monogatari*, ed. Kōno Tama, NKBT 10 (Tokyo: Iwanami shoten, 1959), 1:308.

29. The name Tokoyo (Eternal Land) appears in a pair of poems on Urashima in the *Man'yōshū* (9:1740 and 1741).

30. "Urashima Tarō," in *Otogi-zōshi*, ed. Ichiko Teiji, NKBT 38 (Tokyo: Iwanami shoten, 1958), 340–341.

31. Tokuda Kazuo, "Shihō shiki no fūryū," in *Otogi-zōshi kenkyū* (1988; rpt., Tokyo: Miyai shoten, 1990), 47–79.

32. Ibid., 54.

33. Matthew P. McKelway, *Capitalscapes: Folding Screens and Political Imagination in Late Medieval Kyoto* (Honolulu: University of Hawai'i Press, 2006), 15.

34. Tokuda, "Shihō shiki no fūryū," 74–75.

35. Takeda Tsuneo, *Nihon kaiga to saiji: keibutsuga shiron* (Tokyo: Perikansha, 1990), 5–6.

36. Shinbō Tōru, "Shōgonsuru hana to tori: Shūkyōga ni kakareta kachō," in *Yamatoe no shiki: Kamakura no kachō*, ed. Shinbō Tōru, Kachōga no sekai 1 (Tokyo: Gakushū kenkyūsha, 1982), 59.

37. "Ikebana, futatsu no genryū," in *Tokubetsuten ikebana: Rekishi o irodoru Nihon no bi*, ed. Kyotofu Kyoto bunka hakubutsukan, Edo Tokyo hakubutsukan, and Yomiuri shinbunsha (Tokyo: Yomiuri shinbun, 2009), 30.

38. Another plant to which talismanic power has been attributed is the hollyhock (*aoi*), which was originally found in the hills and mountains of the Kyoto basin. At the Kamo Festival—otherwise known as the Aoi Festival—in Kyoto, the *aoi* becomes the resting place for a god. As an early-summer drought-resistant plant credited with a strong life force, the hollyhock was also highly regarded by farmers as a sign of a rich harvest. These various associations, including one with the imperial family, resulted in the *aoi* becoming a major cultural symbol.

## 6. Annual Observances, Famous Places, and Entertainment

1. On the distinction between public and private observances, see Kanzaki Noritake, *Matsuri no shokubunka*, Kadokawa sensho 382 (Tokyo: Kadokawa shoten, 2005), 12.

2. The celebration of the first day of the First Month was not taken up by farmers until the beginning of the eleventh century. See Kimura Shigemitsu, "Chijūsha

no seiritsu to nōkō girei," in *Kankyō to shinsei no bunkashi: Kankyō to shinsei no kattō*, ed. Masuo Shinichirō, Kudō Ken'ichi, and Hōjō Katsutaka (Tokyo: Bensei shuppan, 2003), 1:249.

3. At the White Horses (Aouma) observance, a white horse was presented to the emperor for viewing, followed by a banquet. It was thought that if one looked at a white horse on the seventh day of the First Month, the evil forces for that year would be exorcised—a custom that came from China. A blue-gray horse (*aouma*) was used at first, but since white horses were considered divine in Japan, white horses came to be presented at the ceremony.

4. In the ancient period, Stamping Song (Tōka), a group dance to singing and stamping, was held at the imperial court, where male and female dancers were invited to celebrate the beginning of the New Year. The Tōka for men was held on the fourteenth and fifteenth days of the First Month, while that for women took place on the sixteenth day.

5. At Sagichō, a fire festival held on Minor New Year (Koshōgatsu), the first document of the year (*kissho*) was burned in the belief that this ritual would prevent illness for the coming year.

6. The rabbit stick (*uzue*)—which was made from a branch of peach, plum, camellia, or false holly (*hiiragi*)—was used to dispel demons and other evil forces, and then was offered to the emperor and empress at court.

7. Gencho, held on the first Day of the Boar in the Tenth Month, was an observance in which cakes called *inoko-mochi* (literally, "piglet cakes") were eaten at the Hour of the Boar (9:00–11:00 P.M.) to prevent illness. Because boars procreate quickly, Gencho was also a prayer for the well-being of children and descendants.

8. For more on the calendar of annual observances, see Torigoe Kenzaburō, *Saijiki no keifu* (Tokyo: Mainichi shinbunsha, 1977); and Yamanaka Yutaka and Endō Motoo, eds., *Nenjū gyōji no rekishigaku* (Tokyo: Kōbundō, 1981).

9. The Heian-period ritual of pulling up the roots of small pines (*komatsu*) on the first Day of the Rat derives from the homonyms *ne* (rat) and *ne* (root). Pulling up roots was auspicious, since it implied lengthening the year.

10. In the Kamakura period, bamboo was added to the pines at the gate.

11. Kanai Shiun, *Tōyō gadai sōran* (Kyoto: Unsōdō, 1943; rpt., Tokyo: Kokusho kankōkai, 1997), 737; Inoue Kenichirō, "Chūsei no shiki keibutsu," in *Keibutsuga: shiki keibutsu*, ed. Takeda Tsuneo, vol. 9 of *Nihon byōbue shūsei*, ed. Takeda Tsuneo, Yamane Yūzō, and Yoshizawa Chū (Tokyo: Kōdansha, 1977), 154.

12. A good example of a poem about gathering young herbs is one by Sosei, composed on a spring screen painting on the occasion of the fortieth birthday of a Fujiwara courtier: "No doubt the god watches me gather new herbs at Kasuga Field and celebrate ten thousand years of your life" (*Kasugano ni wakana tsumitsu-tsu yorozu yo wo iwau kokoro wa kami zo shiruramu* [*Kokinshū*, Celebration, no. 357]). Kasuga Field was at the foothills of Mount Kasuga in Nara, near the Kasuga Shrine, home of the ancestral god of the Fujiwara clan.

13. From the Muromachi period, the *wakana* were chopped up, a practice that became widespread among commoners in the Edo period. Today, this traditional meal takes the form of seven-grasses gruel (*nanakusagayu*).

14. The Meandering Stream Banquet entered Japan as early as the Nara period and was celebrated at the imperial court until the early ninth century. As part of a purification ritual, a cup of saké was floated down a stream on the grounds of the imperial palace. Poets sat alongside the stream, composed *kanshi* (Chinese-style poems) before the cup reached them, and then drank from the cup when it arrived.

15. In the "Suma" chapter of *The Tale of Genji*, the exiled Genji places a surrogate doll on the water, lets it float away, and pleads his innocence in a poem.

16. The third day of the Third Month is also related to the peach, which in China was thought to have the power to ward off evil and bring about long life, and to the Meandering Stream Banquet. "The third [day] of the Third Month (Peach)" appears in the *Wakan rōeishū* (*Japanese and Chinese-Style Poems to Sing*, ca. 1012) as a poetic topic, with a *kanshi* on Meandering Stream. From the time of the *Roppyakuban uta-awase* (*Poetry Contest in Six Hundred Rounds*, 1193), in which Meandering Stream appears as a *waka* (classical poetry) topic for spring, poems on Meandering Stream were often juxtaposed with poems on peach blossoms.

17. Matsuo Bashō, *Sarumino*, in *Bashō shichibushū*, ed. Shiraishi Teizō and Ueno Yōzō, SNKBT 70 (Tokyo: Iwanami shoten, 1990), 313.

18. Tango literally means "first Day of the Horse." The reading of the graph for "horse" (*go*) was homophonous with that for "five" (*go*), for the fifth day of the Fifth Month.

19. Today, the Tango Festival (Tango no sekku) is also referred to as the Sweet Flag Festival (Ayame no sekku), since the annual observance is so closely associated with the sweet flag, which blooms at this time of the year and is used in the ceremony. The graph for the word *ayame* or *ayamegusa* (sweet flag) is often confused with or used synonymously with that for *kakitsubata* (iris), which it closely resembles.

20. This tradition survives in the annual Kamo Shrine Equestrian Contest (Kamo no kurabe-uma).

21. Boys dressed as soldiers and engaged in various mock-martial events. In the Edo period, dolls were placed in front of a sweet-flag helmet (*ayame-kabuto*) to make warrior dolls.

22. There are six *kanshi* on the night of the seventh day of the Seventh Month in the *Kaifūsō* (*Nostalgic Recollections of Literature*, 751), the earliest Japanese collection of poetry in Chinese.

23. The customs of writing a poem and viewing the Herdsman and the Weaver Woman reflected in water are illustrated in the painting for the Seventh Month in Katsukawa Shūnshō's (1716–1792) *Fujo fūzoku jūnikagetsu zu* (*Women's Customs in the Twelve Months*, ca. 1781–1790 [MOA Museum of Art, Atami]). At the top, poetry sheets are tied to bamboo leaves. On the left side, a young woman intently

passes a thread through a needle. At the bottom is a decorated tub filled with water, in which are reflected the stars, depicted as four round spots. For a digital reproduction, see http://www.moaart.or.jp.

24. Imahashi Riko, *Edo no kachōga: Hakubutsugaku o meguru bunka to sono hyōshō* (Tokyo: Sukaidoa, 1995).

25. In commoner society, by the Edo period, Repulsing Demons (Tsuina) had become or was replaced by Driving Out Demons (Setsubun), also celebrated on the day before the beginning of spring. Setsubun was originally an agricultural observance in which demons were driven away at the beginning of the New Year. See Yuasa Hiroshi, *Shokubutsu to gyōji: sono yurai o suirisuru*, Asahi sensho 478 (Tokyo: Asahi shinbunsha, 1993), 48–51.

26. Nakamura Yoshio, "Shinkō, shūzoku, to nenjū gyōji," in *Nenjū gyōji no bungeigaku*, ed. Yamanaka Yutaka and Imai Gen'ei (Tokyo: Kōbundō, 1981), 441–456.

27. Except for some observances such as Kanbutsu and Nehan-e, which are related to the Shakyamuni Buddha, few of these annual observances are about historical or religious figures. By contrast, the most prominent festivals in the European calendar are centered on Jesus or the Christian saints, including Saint Nicholas, a major saint in Germany and the Low Countries.

28. In ancient China, red beans were thought to have special powers, particularly in preventing disease and misfortune. Ki no Tsurayuki's *Tosa nikki* (*Tosa Diary*, ca. 935) indicates that it was normal to make *azuki* gruel on Minor New Year in the capital in the early tenth century. See Yuasa, *Shokubutsu to gyōji*, 22.

29. At GoShirakawa's request, Tokiwa Mitsunaga and other artists depicted annual observances both at court and among commoners in the *Nenjū gyōji emaki*, which was originally more than sixty scrolls long. The picture scroll was destroyed, and only nineteen scrolls are extant, sixteen of which are copies of the originals by the painter Sumiyoshi Jokei (1599–1670).

30. Inoue, "Chūsei no shiki keibutsu," 150–155.

31. A similar painting by Sumiyoshi Gukei is *Rakuchū rakugai zukan* (*In and out of the City Painting* [Tokyo National Museum]).

32. Takeda Tsuneo, *Nihon kaiga to saiji: keibutsuga shiron* (Tokyo: Perikansha, 1990), 77. See also Takeda Tsuneo, "Nenjū gyōji-e ni tsuite," in *Nenjū gyōji*, vol. 1 of *Kinsei fūzoku zufu* (Tokyo: Shōgakukan, 1983), 74–75.

33. For a digital reproduction of the series, see http://www.moaart.or.jp.

34. Takeda, "Nenjū gyōji-e ni tsuite," 80.

35. Hattori Yukio, *Kabuki saijiki*, Shincho sensho (Tokyo: Shinchōsha, 1999), 11–13.

36. Ibid., 21–24.

37. *Hatsu Soga* (First Soga Play) and *hatsuharu kyōgen* (early-spring play) became seasonal words for the New Year in *haikai* and popular culture.

38. Fujiwara no Kiyosuke, *Waka shogakushō*, in *Nihon kagaku taikei*, ed. Sasaki Nobutsuna (Tokyo: Kazama shobō, 1956), 2:172–248. The entries for "Mount Tatsuta" and "Mount Kasuga" are on 221; "Mount Ausaka," 222; "Uji River," 226; and "spring mist," "moon," "snow," and "cherry blossoms," 238.

39. Okumura Tsuneya, *Utamakura*, Heibonsha sensho 52 (Tokyo: Heibonsha, 1977), 23–25.

40. Susaki is the area around Kiba in present-day Kōtō Ward, Tokyo.

41. Atagoyama is a hill north of Shiba Park in present-day Minato Ward, Tokyo.

42. Higuchi Tadahiko, *Kōgai no fūkei: Edo kara Tokyo e* (Tokyo: Kyōiku shuppan, 2000), 21–23.

43. Another view is that from as early as the Heian period, farmers and commoners observed the custom of climbing the hills, with food and drink, to enjoy the blooming of the cherry trees in spring—a practice referred to as "entering the spring mountains" (*haruyama iri*). The aristocratic banquet tradition eventually fused with this commoner custom, resulting, by the end of the medieval period, in the practice of eating, drinking, and merrymaking under the cherry trees. See Kira Tatsuo, "Sakura to Nihonjin: nanjūnendai no shizen hogo no tame ni," in *Seitaigaku no mado kara* (Tokyo: Kawade shobō shinsha, 1973).

44. Nishiyama Matsunosuke, *Hana: bi e no kōdō to Nihon bunka*, NHK bukkusu 328 (Tokyo: Nippon hōsō shuppan kyōkai, 1978), 12–32.

45. Kanō Naganobu's *Kaka yūraku zu byōbu* (Tokyo National Museum), labeled a National Treasure, is a six-panel screen painting that shows characteristics of the bird-and-flower paintings by his grandfather Motonobu (1476–1559). Unkoku Tōgan's *Hanami takagari zu byōbu* (MOA Museum of Art, Atami), designated a Valuable Cultural Treasure, consists of two folding screens (the right one of commoners enjoying cherry blossoms, and the left one of falcon hunting at a warrior's residence), each with six panels. Unkoku was the founder of the Unkoku school.

46. *Kenbutsu-zaemon*, in *Kyōgenshū*, ed. Furukawa Hisashi, Nihon koten zensho 81 (Tokyo: Asahi shinbunsha, 1956), 1:190–192.

47. Sugawara no Michizane wrote a number of *kanshi* on the "night of the fifteenth." It appears as a topic in the *Wakan rōeishū*, which includes poems such as Bo Juyi's "Thinking of a friend two thousand leagues away on the night of the fifteenth of the Eighth Month."

48. In the Meiji period, with the change to the solar calendar, the fifteenth day of the Eighth Month moved to summer, so that a key annual observance was lost.

49. Since this final moon viewing occurred in the latter half of the Eighth Month, it was also a cooling-off (*nōryō*) time.

50. Hōjō Akinao, "Edo no fūzoku to ikebana," in *Ikebana no fūzoku*, ed. Kobayashi Tadashi, Ikebana bijutsu zenshū 9 (Tokyo: Shūeisha, 1982), 91.

51. A good example of welcoming a beneficial god is the *kaomise* (face-showing performance) in kabuki, which occurred at the end of the year, on the first day of the Eleventh Month in the luni-solar calendar (coinciding with the winter solstice)

in Edo. The *kaomise* is thought to have derived from the myth of Amaterasu (Sun Goddess) in the cave; when Amaterasu hid herself away, the world was thrown into darkness, but she was then drawn out of the cave by dancing, singing, and music, which foreshadow kabuki. An example of driving out the destructive gods is the Gion Festival, which is observed in the summer and is intended to rid a city of the plague and other evil elements. See Takashina Shūji, Ōhashi Ryōsuke, and Tanaka Yūko, "Zadankai," in "Nenjū gyōji," special issue, *Nihon no bigaku* 31 (2000): 6.

52. Cherry trees originally grew on the top of hills and mountains, where there was good drainage, but aristocrats wanted to have them close by and transplanted them in the gardens of their city residences. See Takahashi Kazuo, *Nihon bungaku to kishō*, Chūkō shinsho 512 (Tokyo: Chūō kōronsha, 1978), 83–84.

53. Edward Kamens, *Utamakura, Allusion, and Intertextuality in Traditional Japanese Poetry* (New Haven, Conn.: Yale University Press, 1997), 3; Kamo no Chomei, *Mumyōshō*, in *Mumyōshō zenkai*, ed. Takahashi Kazuhiko (Tokyo: Sōbunsha, 1987), 236.

# 7. Seasonal Pyramid, Parody, and Botany

1. *Yatsururu* (to become emaciated) modifies both *mugimeshi* (barley) and *koi* (love), meaning "emaciating barley and love."

2. Morikawa Kyoriku, *Uda no hōshi*, in Matsuo Bashō, *Kōhon Bashō zenshū*, ed. Komiya Toyotaka (Tokyo: Fujimi shobō, 1991), 7:274.

3. This section is based on Haruo Shirane, "Seasonal Associations and Cultural Landscape," in *Traces of Dreams: Landscape, Cultural Memory, and the Poetry of Bashō* (Stanford, Calif.: Stanford University Press, 1998), 185–211.

4. In *Mushi to Nihon bunka* (Tokyo: Taikōsha, 1997), Sakai Masaaki has argued that in the Nara period (710–784), the aristocracy lived in fairly direct contact with nature, while in the Heian period the nobility became urbanized, with nature at a greater distance, making it an object of aesthetic appreciation.

5. Matsue Shigeyori, *Kefukigusa*, ed. Takenouchi Waka and Shinmura Izuru, Iwanami bunko 3304–3308 (Tokyo: Iwanami shoten, 1943), 144, 150.

6. Matsue Shigeyori, *Enoko-shū*, in *Teimon haikaishū*, ed. Nakamura Shunjō and Morikawa Akira, vol. 1 of *Koten haibungaku taikei* (Tokyo: Shūeisha, 1970), 83.

7. Kobayashi Issa, *Hachiban nikki*, in *Issa-shū*, ed. Maruyama Kazuhiko and Kobayashi Keiichirō, vol. 15 of *Koten haibungaku taikei* (Tokyo: Shūeisha, 1970), 182.

8. Harada Nobuo, *Edo no ryōrishi*, Chūō shinsho 929 (Tokyo: Chūō kōron shinsha, 1989).

9. Kyokutei Bakin, comp., and Rantei Seiran, ed., *Zōho haikai saijiki shiorigusa*, ed. Horikiri Minoru, Iwanami bunko (Edo: Hanabusaya daisuke, 1851; Tokyo: Iwanami shoten, 2000). In 1803, Kyokutei Bakin edited and published *Haikai saijiki* (*Haikai*

# *Chanoyu* (Tea Ceremony)

Anderson, Jennifer L. *An Introduction to Japanese Tea Ritual*. Albany: State University of New York Press, 1991.

Hayashiya, Seizō. *Chanoyu: Japanese Tea Ceremony*. Translated by Emily J. Sano. Essays by H. Paul Varley et al. New York: Japan Society, 1979.

Hayashiya, Tatsusaburō, Masao Nakamura, and Seizō Hayashiya. *Japanese Arts and the Tea Ceremony*. Translated by Joseph P. Macadam. Heibonsha Survey of Japanese Art, vol. 15. New York: Weatherhill, 1974.

Hirota, Dennis, ed. *Wind in the Pines: Classic Writings of the Way of Tea as a Buddhist Path*. Fremont, Calif.: Asian Humanities Press, 1995.

Ohki, Sadako. *Tea Culture of Japan*. New Haven, Conn.: Yale University Art Gallery, 2009.

Pitelka, Morgan, ed. *Japanese Tea Culture: Art, History, and Practice*. London: RoutledgeCurzon, 2003.

Plutschow, Herbert E. *Historical Chanoyu*. Tokyo: Japan Times, 1986.

——. *Rediscovering Rikyu and the Beginnings of the Japanese Tea Ceremony*. Folkstone, Eng.: Global Oriental, 2003.

Sen, Sōshitsu, ed. *The Japanese Way of Tea: From Its Origins in China to Sen Rikyu*. Translated by V. Dixon Morris. Honolulu: University of Hawai'i Press, 1998.

Varley, Paul, and Isao Kumakura, eds. *Tea in Japan: Essays on the History of Chanoyu*. Honolulu: University of Hawai'i Press, 1989.

# Architecture

Coaldrake, William Howard. *Architecture and Authority in Japan*. London: Routledge, 1996.

Frampton, Kenneth, and Kunio Kudo. *Japanese Building Practice: From Ancient Times to the Meiji Period*. New York: Van Nostrand Reinhold, 1997.

Hashimoto, Fumio, ed. *Architecture in the Shoin Style: Japanese Feudal Residences*. Translated by H. Mack Horton. Tokyo: Kodansha International, 1981.

Hirai, Kiyoshi. *Feudal Architecture of Japan*. Heibonsha Survey of Japanese Art, vol. 13. Chicago: Art Media Resources, 1974.

Itoh, Teiji, and Richard L. Gage. *Traditional Domestic Architecture of Japan*. Heibonsha Survey of Japanese Art, vol. 21. Chicago: Art Media Resources, 1972.

Kirby, John B. *From Castle to Teahouse: Japanese Architecture of the Momoyama Period*. Rutland, Vt.: Tuttle, 1962.

Nishi, Kazuo, and Kazuo Hozumi. *What Is Japanese Architecture? A Survey of Traditional Japanese Architecture*. Translated by H. Mark Horton. Tokyo: Kodansha International, 1985.

Paine, Robert Treat, and Alexander Soper. *The Art and Architecture of Japan*. Harmondsworth: Penguin, 1955.

Young, David E., and Michiko Young. *The Art of Japanese Architecture*. Rev. and expanded ed. Tokyo: Tuttle, 2007.

## Aesthetics and Nature

Hume, Nancy G. *Japanese Aesthetics and Culture: A Reader*. SUNY Series on Asian Studies Development. Albany: State University of New York Press, 1995.

Ikegami, Eiko. *Bonds of Civility: Aesthetic Networks and the Political Origins of Japanese Culture*. Cambridge: Cambridge University Press, 2005.

Inouye, Charles Shiro. *Evanescence and Form: An Introduction to Japanese Culture*. New York: Palgrave Macmillan, 2008.

Izutsu, Toshihiko, and Toyo Izutsu. *The Theory of Beauty in the Classical Aesthetics of Japan*. The Hague: Nijhoff, 1981.

Ueda, Makoto. *Literary and Art Theories in Japan*. Michigan Classics in Japanese Studies, no. 6. Ann Arbor: Center for Japanese Studies, University of Michigan, 1991.

## Gardens

Goto, Seiko. *The Japanese Garden: Gateway to the Human Spirit*. Asian Thought and Culture, vol. 56. New York: Lang, 2003.

Hayakawa, Masao. *The Garden Art of Japan*. Translated by Richard L. Gage. Heibonsha Survey of Japanese Art, vol. 28. New York: Weatherhill, 1973.

Inaji, Toshiro. *The Garden as Architecture: Form and Spirit in the Gardens of Japan, China, and Korea*. Translated by Pamela Virgilio. Tokyo: Kodansha International, 1998.

Itoh, Teiji. *The Gardens of Japan*. 2nd ed. New York: Kodansha, 1998.

Keane, Marc Peter. *Japanese Garden Design*. Rutland, Vt.: Tuttle, 1996.

Kuck, Loraine E. *The World of the Japanese Garden: From Chinese Origins to Modern Landscape Art*. New York: Weatherhill, 1980.

Kuitert, Wybe. *Themes, Scenes, and Taste in the History of Japanese Garden Art*. Amsterdam: Gieben, 1988.

———. *Themes in the History of Japanese Garden Art*. Rev. ed. Honolulu: University of Hawai'i Press, 2002.

Slawson, David A. *Secret Teachings in the Art of Japanese Gardens: Design Principles, Aesthetic Values*. Tokyo: Kodansha International, 1987.

Takei, Jiro, and Marc P. Keane. *Sakuteiki: Visions of the Japanese Garden: A Modern Translation of Japan's Gardening Classic*. Boston: Tuttle, 2008.

# Ikebana and Bonsai

Fujiwara, Yuchiku. *Rikka: The Soul of Japanese Flower Arrangement.* Translated by Norman Sparnon. Tokyo: Shufunotomo, 1976.

Kudo, Masanobu. *The History of Ikebana.* Translated by Jay Gluck and Sumi Gluck. Tokyo: Shufunotomo, 1986.

Nippon Bonsai Association. *Classic Bonsai of Japan.* Translated by John Bester. Tokyo: Kodansha International, 1989.

Ohi, Minobu. *Best of Ikebana: History of Ikebana.* Tokyo: Shufunotomo, 1962.

Ohi, Minobu, et al. *Flower Arrangement: The Ikebana Way.* Edited by William C. Steere. Tokyo: Shufunotomo, 1972.

Richie, Donald, and Meredith Weatherby, eds. *The Masters' Book of Ikebana: Background and Principles of Japanese Flower Arrangement.* Tokyo: Bijutsu shuppan-sha, 1966.

# Ink Painting and Landscape

Fontein, Jan, and Money L. Hickman. *Zen Painting and Calligraphy: An Exhibition of Works of Art Lent by Temples, Private Collectors, and Public and Private Museums in Japan.* Boston: Museum of Fine Arts, 1970.

Kanazawa, Hiroshi. *Japanese Ink Painting: Early Zen Masterpieces.* Translated and adapted by Barbara Ford. Tokyo: Kodansha International, 1979.

Matsushita, Takaaki. *Ink Painting.* Arts of Japan, no. 7. Translated and adapted by Martin Collcutt. New York: Weatherhill, 1974.

Tanaka, Ichimatsu. *Japanese Ink Painting: Shubun to Sesshu.* Translated by Bruce Darling. *Heibonsha Survey of Japanese Art, vol. 12.* New York: Weatherhill, 1972.

Shimizu, Yoshiaki, and Carolyn Wheelwright, eds. *Japanese Ink Paintings from American Collections: The Muromachi Period: An Exhibition in Honor of Shūjirō Shimada.* Princeton, N.J.: Art Museum, Princeton University, 1976.

Watanabe, Akiyoshi, Kanazawa Hiroshi, and Paul Varley. *Of Water and Ink: Muromachi-Period Paintings from Japan, 1392–1568.* Detroit: Detroit Institute of Arts; Seattle: University of Washington Press, 1986.

# Kimono and Decorative Arts

Dalby, Liza Crihfield. *Kimono: Fashioning Culture.* New Haven, Conn.: Yale University Press, 1993.

Gluckman, Dale Carolyn, and Sharon Sadako Takeda. *When Art Became Fashion: Kosode in Edo-Period Japan.* Los Angeles: Los Angeles County Museum of Art; New York: Weatherhill, 1992.

Ishimura, Hayao, Nobuhiko Maruyama, and Tomoyuki Yamanobe. *Robes of Elegance: Japanese Kimonos of the Sixteenth to Twentieth Centuries*. Chapel Hill: University of North Carolina Press, 1988.

Liddell, Jill. *The Story of the Kimono*. New York: Dutton, 1989.

Morrison, Michael, and Lorna Price, eds. *Four Centuries of Fashion: Classical Kimono from the Kyoto National Museum*. San Francisco: Asian Art Museum, 1997.

Munsterberg, Hugo. *The Japanese Kimono*. Hong Kong: Oxford University Press, 1996.

Noma, Seiroku. *Japanese Costume and Textile Arts*. Translated by Armins Nikovskis. Heibonsha Survey of Japanese Art, vol. 16. New York: Weatherhill, 1974.

Rousmaniere, Nicole Coolidge, ed. *Kazari: Decoration and Display in Japan, Fifteenth to Nineteenth Centuries*. New York: Japan Society; London: British Museum Press, 2002.

——. "Ornament and Culture: Style and Meaning in Edo Japan." In Robert T. Singer, *Edo: Art in Japan, 1615–1868*, 51–67. Washington, D.C.: National Gallery of Art, 1998.

Stinchecum, Amanda Mayer. "Images of Fidelity and Infidelity in *Kosode* Design." In *Currents in Japanese Culture: Translations and Transformations*, edited by Amy Vladeck Heinrech, 337–352. New York: Columbia University Press, 1997.

Tsuji, Nobuo. "Ornament (*Kazari*)—An Approach to Japanese Culture." *Archives of Asian Art* 47 (1994): 34–45.

## Screen Painting and Nature

Doi, Tsugiyoshi. *Momoyama Decorative Painting*. Translated by Edna B. Crawford. Heibonsha Survey of Japanese Art, vol. 14. New York: Weatherhill, 1977.

Grilli, Elise. *The Art of the Japanese Screen*. New York: Walker/Weatherhill, 1970.

——. *Golden Screen Paintings of Japan*. Art of the East. New York: Crown, 1960.

Hickman, Money L. *Japan's Golden Age: Momoyama*. New Haven, Conn.: Yale University Press, 1996.

Impey, Oliver. *Art of the Japanese Folding Screen: The Collections of the Victoria and Albert Museum and the Ashmolean Museum*. Oxford: Ashmolean Museum, 2007.

Katz, Janice, ed. *Beyond Golden Clouds: Japanese Screens from the Art Institute of Chicago and the Saint Louis Art Museum*. Chicago: Art Institute of Chicago; St. Louis: Saint Louis Art Museum; New Haven, Conn.: Yale University Press, 2009.

Klein, Bettina, with Carolyn Wheelwright. "Japanese *Kinbyōbu*: The Gold-Leafed Folding Screens of the Muromachi Period (1333–1573)." *Artibus Asiae* 45, no. 1 (1984): 5–34; nos. 2–3 (1984): 101–174.

Kuroda, Taizō, Melinda Takeuchi, and Yūzō Yamane. *Worlds Seen and Imagined: Japanese Screens from the Idemitsu Museum of Arts*. New York: Asia Society, 1995.

McKelway, Matthew P. *Capitalscapes: Folding Screens and Political Imagination in Late Medieval Kyoto*. Honolulu: University of Hawai'i Press, 2006.

Murase, Miyeko. *Masterpieces of Japanese Screen Painting: The American Collections*. New York: Braziller, 1990.

Shimizu, Yoshiaki. "Seasons and Places in Yamato Landscape and Poetry." *Ars Orientalis* 12 (1981): 1–14.

## Animals, Plants, and Painting

Rosenfield, John M. *Mynah Birds and Flying Rocks: Word and Image in the Art of Yosa Buson*. Franklin D. Murphy Lectures, no. 18. Lawrence: Spencer Museum of Art, University of Kansas, 2003.

Schaap, Robert. *A Brush with Animals: Japanese Painting, 1700–1950*. Leiden: Society for Japanese Arts, with Hotei Publishing, 2007.

Shimizu, Yoshiaki. "The Vegetable *Nehan* of Itō Jakuchū." In *Flowing Traces: Buddhism in the Literary and Visual Arts of Japan*, edited by James H. Sanford, William R. LaFleur, and Masatoshi Nagatomi, 201–233. Princeton, N.J.: Princeton University Press, 1992.

Watsky, Andrew. "Floral Motifs and Mortality: Restoring Numinous Meaning to a Momoyama Building." *Archives of Asian Art* 50 (1997–1998): 62–92.

## Food and Sweets

Ashkenazi, Michael, and Jeanne Jacob. *Food Culture in Japan*. Westport, Conn.: Greenwood Press, 2003.

Ishige, Naomichi. *The History and Culture of Japanese Food*. London: Kegan Paul, 2001.

Ohnuki-Tierney, Emiko. *Rice as Self: Japanese Identities Through Time*. Princeton, N.J.: Princeton University Press, 1994.

Rath, Eric C. *Food and Fantasy in Early Modern Japan*. Berkeley: University of California Press, 2010.

Rath, Eric C., and Stephanie Assman, eds. *Japanese Foodways, Past and Present*. Urbana: University of Illinois Press, 2010.

## Ukiyo-e, Bird-and-Flower Genre, and *Mitate*

Andō Hiroshige. *Hiroshige: Birds and Flowers*. Introduction by Cynthea J. Bogel. Commentaries by Israel Goldman. Poetry translated by Alfred H. Marks. New York: Braziller, 1988.

Asano, Shūgō, and Timothy Clark. *The Passionate Art of Kitagawa Utamaro*. 2 vols. Tokyo: Asahi shinbun; London: British Museum Press, 1995.

Clark, Timothy T. "*Mitate-e*: Some Thoughts, and a Summary of Recent Writings." *Impressions* 19 (1997): 6–27.

Hayakawa, Monta. "*Shunga* and *Mitate*: Suzuki Harunobu's *Eight Modern Views of the Interior (Fūryū zashiki hakkei)*." In *Imaging / Reading Eros*, edited by Sumie Jones, 122–128. Bloomington: East Asian Studies Center, Indiana University, 1996.

Keyes, Roger. *Ehon: The Artist and the Book in Japan*. New York: New York Public Library; Seattle: University of Washington Press, 2006.

Kitagawa Utamaro. *Utamaro: A Chorus of Birds*. Introduction by Julia Meech-Pekarik. Note on *kyōka* and translations by James T. Kenney. New York: Metropolitan Museum of Art and Viking Press, 1981.

Kobayashi, Tadashi. "*Mitate* in the Art of the Ukiyo-e Artist Suzuki Harunobu." In *The Floating World Revisited*, edited by Donald Jenkins, 85–91. Portland, Ore.: Portland Art Museum, 1993.

Narazaki, Muneshige. *Studies in Nature: Hokusai–Hiroshige*. Translated by John Bester. Masterpieces of Ukiyo-e, vol. 11. Tokyo: Kodansha International, 1970.

Shirane, Haruo. "Dressing Up, Dressing Down: Poetry, Image, and Transposition in the *Eight Views*." *Impressions* 31 (2010): 51–72.

## Poetry, Poetics, and Nature

Carter, Steven D. *Householders: The Reizei Family in Japanese History*. Harvard-Yenching Institute Monograph Series, no. 61. Cambridge, Mass.: Harvard University Asia Center for the Harvard-Yenching Institute, 2007.

——. *Road to Komatsubara: A Classical Reading of the Renga Hyakuin*. Harvard East Asian Monographs, no. 124. Cambridge, Mass.: Council on East Asian Studies, Harvard University, 1987.

——. *Three Poets at Yuyama*. Japan Research Monograph, no. 4. Berkeley: Institute of East Asian Studies, University of California, Center for Japanese Studies, 1983.

Cranston, Edwin, trans. *A Waka Anthology*. 3 vols. Stanford, Calif.: Stanford University Press, 1993.

Ebersole, Gary L. *Ritual Poetry and the Politics of Death in Early Japan*. Princeton, N.J.: Princeton University Press, 1989.

Kamens, Edward. *Utamakura, Allusion, and Intertextuality in Traditional Japanese Poetry*. New Haven, Conn.: Yale University Press, 1997.

McCullough, Helen. *Brocade by Night: Kokin wakashu and the Court Style in Japanese Classical Poetry*. Stanford, Calif.: Stanford University Press, 1985.

Ramirez-Christensen, Esperanza. *Emptiness and Temporality: Buddhism and Medieval Japanese Poetics*. Stanford, Calif.: Stanford University Press, 2008.

Shirane, Haruo. *Traces of Dreams: Landscape, Cultural Memory, and the Poetry of Bashō*. Stanford, Calif.: Stanford University Press, 1998.

Shōtetsu. *Conversations with Shōtetsu*. Translated by Robert H. Brower. Introduction and notes by Steven D. Carter. Michigan Monographs in Japanese Studies, no. 7. Ann Arbor: Center for Japanese Studies, University of Michigan, 1992.

Ueda, Makoto. *Bashō and His Interpreters: Selected Hokku with Commentary*. Stanford, Calif.: Stanford University Press, 1992.

## Theater, Prose Literature, and Nature

Atkins, Paul. *Revealed Identity: The Noh Plays of Komparu Zenchiku*. Michigan Monographs in Japanese Studies, no. 55. Ann Arbor: Center for Japanese Studies, University of Michigan, 2006.

Bialock, David T. *Eccentric Spaces, Hidden Histories: Narrative, Ritual, and Royal Authority from The Chronicles of Japan to The Tale of the Heike*. Stanford, Calif.: Stanford University Press, 2007.

Brazell, Karen, ed. *Twelve Plays of the Noh and Kyōgen Theaters*. Cornell University East Asia Papers, no. 50. Rev. ed. Ithaca, N.Y.: East Asia Program, Cornell University, 1990.

Goff, Janet. *Noh Drama and The Tale of Genji: The Art of Allusion in Fifteen Classical Plays*. Princeton, N.J.: Princeton University Press, 1991.

Haynes, Carolyn. "Parody in *Kyōgen*: *Makura Monogurui* and *Tako*." *Monumenta Nipponica* 39 (1984): 261–279.

Japanese Classics Translation Committee, ed. *The Noh Drama: Ten Plays from the Japanese*. Rutland, Vt.: Tuttle, 1955.

Kawatake, Toshio. *Japan on Stage: Japanese Concepts of Beauty as Shown in the Traditional Theater*. Translated by P. G. O'Neill. Tokyo: 3A Corp., 1990.

Keene, Donald. *The Pleasures of Japanese Literature*. New York: Columbia University Press, 1988.

Kim, Yung-Hee. *Songs to Make the Dust Dance: The Ryōjin hishō in Twelfth-Century Japan*. Berkeley: University of California Press, 1994.

Marra, Michele. *The Aesthetics of Discontent: Politics and Reclusion in Medieval Japanese Literature*. Honolulu: University of Hawai'i Press, 1991.

Mayer, Fanny Hagin. "Fauna and Flora in Japanese Folktales." *Asian Folklore Studies* 40, no. 1 (1981): 23–32.

Mills, D. E., trans. *A Collection of Tales from Uji: A Study and Translation of Uji shui monogatari*. Cambridge: Cambridge University Press, 1970.

Shirane, Haruo. *Bridge of Dreams: A Poetics of The Tale of Genji*. Stanford, Calif.: Stanford University Press, 1987.

——, ed.. *Early Modern Japanese Literature: An Anthology, 1600–1900*. New York: Columbia University Press, 2008.

———, ed.. *Envisioning The Tale of Genji: Media, Gender, and Cultural Production.* New York: Columbia University Press, 2008.

———, ed. Traditional Japanese Literature: An Anthology, Beginnings to 1600. New York: Columbia University Press, 2007.

Smethurst, Mae, and Christina Laffin, eds. *The Noh Ominameshi: A Flower Viewed from Many Directions.* Cornell East Asia Series, no. 118. Ithaca, N.Y.: East Asia Program, Cornell University, 2003.

Waley, Arthur. *The Nō Plays of Japan.* Rutland, Vt.: Tuttle, 1976.

# Selected Bibliography of
# Primary and Secondary Sources in Japanese

Akabane Shuku. "Fujiwara Teika no jūdai hyakushu." *Bungei kenkyū*, September 1964.

Akiyama Ken, ed. *Ōchōgo jiten*. Tokyo: Tōkyō daigaku shuppankai, 2000.

Aoyanagi Masanori et al., eds. *Nihon no bijutsukan*. Tokyo: Shōgakukan, 1997.

Arai Eizō. "Jitō gyosei to kisetsukan." In *Man'yōshū o manabu*, edited by Itō Haku and Inaoka Kōji, 1:117–127. Tokyo: Yūhikaku, 1977.

———. "*Kokin wakashū* shiki no bu no kōzō ni tsuite no ichi kōsatsu: tairitsuteki kikōron no tachiba kara." In *Kokinwakashū*, edited by Nihon bungaku kenkyū shiryō kankōkai, 92–117. Nihon bungaku kenkyū shiryō sōsho 15. Tokyo: Yūseido, 1976.

———. "*Man'yōshū* kisetsukan kō: kango 'risshun' to wago 'haru tatsu.'" In *Man'yōshū kenkyū*, edited by Gomi Tomohide and Kojima Noriyuki, 5:73–100. Tokyo: Hanawashobō, 1976.

Ariyoshi Tamotsu. *Shinkokin wakashū no kenkyū: kiban to kōsei*. Tokyo: Sanseidō, 1968.

———. *Shinkokinshū no kenkyū, zoku hen*. Tokyo: Kasama shoin, 1996.

Arizono Makoto. *Osakana no bunkashi*. Tokyo: Kajisha, 1997.

Asano Shūgō and Timothy Clark, eds. *Kitagawa Utamaro ten: Chibashi bijutsukan kaikan kinen*. Tokyo: Asahi shinbunsha, 1995.

Asano Shūgō and Yoshida Nobuyuki, eds. *Harunobu*. Ukiyoe o yomu 2. Tokyo: Asahi shinbunsha, 1998.

Aso Mizue. *Man'yō waka shironkō*. Tokyo: Kasama shoin, 1992.

———. "*Man'yōshū* no shiki bunrui." In *Ronshū jōdai bungaku*, edited by Man'yō shichiyōkai, 10–11. Tokyo: Kasama shoin, 1973.

Berque, Augustin. *Nihon no fūkei, Seiō no keikan, soshite zōkei no jidai*. Translated by Shinoda Katsuhide. Kōdansha gendai shinsho 1007. Tokyo: Kōdansha, 1990.

Chester Beatty Library and Kokubungaku shiryōkan, eds. *Chesutā Bītī Raiburarii emaki ehon kaidai mokuroku*. Tokyo: Bensei shuppan, 2002.

Chibashi bijitsukan, ed. *Shukufukusareta shiki: Kinsei Nihon kaiga no shosō*. Chiba: Chibashi bijutsukan, 1996.

Chino Kaori. "Ume." In *Bijutsu to sōka*, edited by Yamane Yūzō, 157–158. Ikebana bijutsu zenshū 10. Tokyo: Shūeisha, 1983.

Fujiwara Nagakiyo, comp. *Fuboku wakashō*. Edited by Kokusho kankōkai. Daiikki kankō 15. Tokyo: Kokusho kankōkai, 1906.

Fukuda Kunio. *Sugu wakaru Nihon no dentō shoku*. Tokyo: Tōkyō bijutsu, 2005.

Furuido Hideo. *Buyō techō*. Tokyo: Shinshokan, 2000.

Furukawa Hisashi, ed. *Kyōgenshū*. Vol. 1. Nihon koten zensho 81. Tokyo: Asahi shinbunsha, 1956.

Gorai Shigeru. "Nihon no shūkyō to shizen." In "Shizen." Special issue, *Nihon no bigaku* 3, no. 10 (1987): 36–47.

*Gosen wakashū*. Edited, with notes, by Katagiri Yōichi. SNKBT 6. Tokyo: Iwanami shoten, 1990.

*Goshūi wakashū*. Edited, with notes, by Kubota Jun and Hirata Yoshinobu. SNKBT 8. Tokyo: Iwanami shoten, 1994.

Haga Tōru. "Fūkei no hikaku bunkashi: 'Shōshō hakkei' to 'Ōmi hakkei.'" *Hikaku bungaku kenkyū*, November 1986.

Haga Yaichi. "Kokuminsei jūron." In *Ochiai Naobumi, Ueda Mannen, Haga Yaichi, Fujioka Sakutaro shū*, edited by Hisamatsu Sen'ichi, 235–281. Meiji bungaku zenshū 44. Tokyo: Chikuma shobō, 1968.

Hagitani Boku and Taniyama Shigeru, eds. *Uta-awase shū*. NKBT 74. Tokyo: Iwanami shoten, 1965.

Harada Nobuo. *Edo no ryōrishi*. Chūō shinsho 292. Tokyo: Chūō kōron shinsha, 1989.

———. *Washoku to Nihon bunka: Nihon ryōri no shakaishi*. Tokyo: Shōgakukan, 2005.

Hasegawa Masami. *Nihon teien yōsetsu*. Tokyo: Shirakawa shoin, 1978.

Hashimoto Fumio, Ariyoshi Tamotsu, and Fujihira Haruo, eds. *Karonshū*. NKBZ 50. Tokyo: Shogakukan, 1975.

Hashimoto Fumio and Takizawa Sadao. *Kōhon Eikyū yonen hyakushu waka to sono kenkyū*. Tokyo: Kasama shoin, 1978.

Hatae Keiko. "Shokubutsu to kikō." In *Kankyō kikōgaku*, edited by Yoshino Masatoshi and Fukuoka Yoshitaka, 154–155. Tokyo: Tōkyō daigaku shuppankai, 2003.

Hattori Yukio. *Kabuki saijiki.* Shincho sensho. Tokyo: Shinchosha, 1995.

Hattori Yukio, Tomita Tetsunosuke, and Hirosue Tamotsu, eds. *Kabuki jiten.* Rev. ed. Tokyo: Heibonsha, 2000.

Hayashiya Tatsusaburō. "Ikebana no nagare." In *Ikebana no bunkashi,* edited by Hayashiya Tatsusaburō, 2:9–17. Vol. 3 of *Zusetsu ikebana taikei,* edited by Tamagami Takuya, Hayashiya Tatsusaburō, and Yamane Yūzō. Tokyo: Kadokawa shoten, 1970.

Hida Norio. *Sakuteiki kara mita zōen.* Tokyo: Kajima shuppankai, 1985.

Higuchi Tadahiko. "Fūkei to kata." In "Kata." Special issue, *Nihon no bigaku* 13 (1989): 61–71.

———. *Keikan no kōzō: Randosukēpu to shite no Nihon no kūkan.* Tokyo: Gihōdō, 1975.

———. *Kōgai no fūkei: Edo kara Tokyo e.* Tokyo: Kyoiku shuppan, 2000.

———. *Nihon no keikan.* Tokyo: Chikuma shobō, 1993.

Hirata Yoshinobu and Misaki Yisashi. *Waka shokubutsu hyōgen jiten.* Tokyo: Tōkyōdō shuppan, 1994.

Hirokawa Katsumi, ed. *Genji monogatari no shokubutsu.* Tokyo: Kasama shoin, 1978.

Hisamatsu Sen'ichi and Nishio Minoru, eds. *Karonshū, nōgakuronshū.* NKBT 65. Tokyo: Iwanami shoten, 1961.

Hitomi Hitsudai. *Honchō shokkan.* Edited, with modern translation, by Shimada Isao. Tōyō bunko 296, 312, 340, 378, 395. Tokyo: Heibonsha, 1976–1981.

Hōjō Akinao. "Edo no fūzoku to ikebana." In *Ikebana no fūzoku,* edited by Kobayashi Tadashi, 1–5. Ikebana bijutsu zenshū 9. Tokyo: Shūeisha, 1983.

Hori Nobuo. "Haikai ni arawareta mushi tachi." In "Mushi." Special issue, *Nihon no bigaku* 2, no. 6 (1985): 71–72.

Horigami Ken and Baba Akiko. *Nō no shiki.* Tokyo: Tachibana shuppan, 2001.

Horikiri Minoru, ed. *Zōho haikai saijiki shiorigusa.* 2 vols. Iwanami bunko. Tokyo: Iwanami shoten, 2000. [Based on Kyokutei Bakin, comp. *Haikai saijiki* (Tamayachō: Eirakuyatōshirō, 1803), expanded and revised by Rantei Seiran, *Haikai saijiki shiorigusa* (Tokyo: Shūeidō ōkawaya shoten, 1892)]

Hosokawa Hiroaki. *Ooedo kaidori zōshi: Edo no petto buumu.* Tokyo: Yoshikawa kōbunkan, 2006.

Hotta Mitsuru, ed. *Shokubutsu no seikatsushi.* Tokyo: Heibonsha, 1980.

Ichiko Natsuo and Suzuki Kenichi, eds. *Shintei Edo meisho zue.* Vol. 4. Tokyo: Chikuma shobō, 1996.

———, eds. *Shintei Edo meisho zue.* Vol. 5. Tokyo: Chikuma shobō, 1997.

Ichiko Teiji. *Chūsei shōsetsu no kenkyū.* Tokyo: Tōkyō daigaku shuppankai, 1955.

———, ed. *Otogi-zōshi.* NKBT 38. Tokyo: Iwanami shoten, 1958.

Ichiko Teiji, Akiya Osamu, Sawai Taizō, Tajima Kazuo, and Tokuda Kazuo, eds. *Muromachi monogatari shū.* SNKBT 54, 55. Tokyo: Iwanami shoten, 1989.

Ida Tarō. "Kigō no bonsai." In *Mitate yatsushi no sōgō kenkyū: purojekkuto hōkokusho dai yongō,* 37–43. Tokyo: Ningen bunka kikō kokubungaku shiryōkan, 2009.

Ide Itaru. "Jōdai no hito to hana to minzoku." In *Ikebana no bunkashi*, edited by Tama-gami Takuya, 1:21–31. Vol. 2 of *Zusetsu ikebana taikei*, edited by Tamagami Takuya, Hayashiya Tatsusaburō, and Yamane Yūzō. Tokyo: Kadokawa shoten, 1970.

Igarashi Kenkichi. *Saiji no bunka jiten*. Tokyo: Yasaka shobō, 2006.

Ihara Aki. *Bungaku ni miru Nihon no iro*. Asahi sensho 493. Tokyo: Asahi shinbun-sha, 1994.

——. *Heian chō no bungaku to shikisai*. Chūō shinsho 673. Tokyo: Chūō kōronsha, 1982.

Ijichi Tetsuo, ed. *Renga ronshū*. Vol. 1. Iwanami bunko. Tokyo: Iwanami shoten, 1953.

——, ed. *Renga ronshū*. Vol. 2. Iwanami bunko. Tokyo: Iwanami shoten, 1956.

——. *Rengashū*. NKBT 39. Tokyo: Iwanami shoten, 1960.

Ijichi Tetsuo, Omote Akira, and Kuriyama Riichi, eds. *Renga ronshū, nōgakushū, haironshū*. NKBZ 51. Tokyo: Shōgakukan, 1973.

Ijiri Masurō. "Michi toshite no ikebana." In *Ikebana no bigaku*, edited by Iijima Tsutomu, 40–60. Vol. 1 of *Zusetsu ikebana taikei*, edited by Tamagami Takuya, Hayashiya Tatsusaburō, and Yamane Yūzō. Tokyo: Kadokawa shoten, 1971.

Imahashi Riko. *Edo no kachōga: Hakubutsugaku o meguru bunka to sono hyōshō*. Tokyo: Sukaidoa, 1995.

Inoue Kenichirō. "Chūsei no shiki keibutsu." In *Keibutsuga: shiki keibutsu*, edited by Takeda Tsuneo, 150–155. Vol. 9 of *Nihon byōbue shūsei*, edited by Takeda Tsuneo, Yamane Yūzō, and Yoshizawa Chū. Tokyo: Kōdansha, 1977.

Inoue Muneo, ed. *Chūsei wakashū*. SNKBZ 49. Tokyo: Shōgakukan, 2000.

Ishida Yoshisada. "Horikawa-in hyakushu no seiritsu sonota ni tsuite." *Kokugo to Kokubungaku*, September 1934.

——. *Shinkokin sekai to chūsei bungaku*. Tokyo: Kitazawa tosho shuppan, 1972.

Ishigami Aki. "Suzuki Harunobu ga Fūryū zashiki hakkei kō: gachū kyōka no riyō to zugara no tenkyo." *Ukiyo-e geijutsu / Ukiyo-e Art* 156 (2008): 69–87.

Ishikawa Tsunehiko, ed. *Shūi gusō kochū*. Chūsei no bungaku. Tokyo: Miyai sho-ten, 1989.

Ishizuka Tatsumaro and Tabayashi Yoshinobu, eds. *Kōshō Kokin rokujō*. 2 vols. Tokyo: Yūseido shuppan, 1984.

Itō Haku. "*Man'yōshū* ni okeru 'inishie' to 'ima': maki kyū no kōzōron o tōshite." *Kokugo to kokubungaku*, December 1, 1971, 1–15.

Itō Haku and Inaoka Kōji, eds. *Man'yōshū o manabu*. 8 vols. Tokyo: Yūhikaku, 1977–1978.

Itō Masayoshi, ed. *Yōkyokushū*. SNKBS 3. Tokyo: Shinchōsha, 1988.

Itō Teiji. "Nihon no dezain." In *Nihonjin no kachikan*, edited by Itō Shuntarō, 335–339. Kōza hikaku bunka 7. Tokyo: Kenkyūsha, 1976.

Iwasa Miyoko, ed. *Gyokuyō wakashū chūshaku*. Tokyo: Kasama shoin, 1996.

Iwasa Miyoko and Tsugita Kasumi, eds. *Fūga wakashū*. Tokyo: Miyai shoten, 1974.

Iwasaki Haruko. *Nihon no ishō jiten*. Tokyo: Iwasaki bijitsusha, 1984.

Kado enkaku kenkyūkai, ed. *Kadō kosho shūsei*. Vol. 4. Kyoto: Shibunkaku, 1970.

Kageyama Haruki. *Shinzō: kamigami no kokoro to katachi*. Tokyo: Hōsei daigaku shuppankyoku, 1978.

Kaiga Hentetsu, ed. *Gidayū shū*. Vol. 2. Tokyo: Hakubunkan, 1917.

Kajishima Takao. *Shiryō Nihon dōbutsushi*. Tokyo: Yasaka shobō, 2002.

Kanai Shiun. *Tōyō gadai sōran*. Kyoto: Unsōdō, 1943. Reprint, Tokyo: Kokusho kankōkai, 1997.

Kanazawa Hiroshi and Kawai Masatomo, eds. *Suiboku no hana to tori: Muromachi no kachō*. Kachōga no sekai 2. Tokyo: Gakushū kenkyūsha, 1982.

Kaneko Hikojirō. *Heian jidai bungaku to Hakushi monjū: Kudai waka Senzai kaku kenkyū hen*. Tokyo: Baifūkan, 1955.

Kaneko Hiromasa, Konishi Masayasu, and Sasaki Kiyomitsu. *Nihonshi no naka no dōbutsu jiten*. Tokyo: Tōkyōdō shuppan, 1992.

Kaneko Kinjirō. *Sōgi meisaku hyakuin chūshaku*. Kaneko Kinjirō renga kōsō 4. Tokyo: Ōfūsha, 1985.

Kanō Hiroyuki. "Hiroshige to Keisai: shaseiha no eikyō ni tsuite." In *Bakumatsu no hyakka fū*, edited by Kōno Motoaki, 129–135. Kachōga no sekai 8. Tokyo: Gakushū kenkyūsha, 1982.

Kanzaki Noritake. *Matsuri no shokubunka*. Kadokawa sensho 382. Tokyo: Kadokawa shoten, 2005.

Katagiri Yōichi. *Utamakura utakotoba jiten*. Rev. ed. Tokyo: Kasama shoin, 1999.

Katano Tatsurō. *Nihon bungei to kaiga no sōkansei no kenkyū*. Tokyo: Kasama shoin, 1975.

Katō Sadahiko. "Yatsushi to teien bunka." In *Zusetsu mitate to yatsushi: Nihon bunka no hyōgen gihō*, edited by Ningen bunka kenkyū kikō kokubungaku kenkyū shiryōkan, 157–175. Tokyo: Yagi shoten, 2008.

Katō Shūichi, Koyama Hiroshi, and Gomi Tomohide. "Nihon bungaku ni okeru dochakusei to shizenkan." *Asahi jānaru*, January 18, 1974, 36–43.

Kawakita Michiaki, ed. *Gendai no ikebana*. Vol. 4 of *Zusetsu ikebana taikei*, edited by Tamagami Takuya, Hayashiya Tatsusaburō, and Yamane Yūzō. Tokyo: Kadokawa shoten, 1971.

Kawamoto Shigeo. *Shinden-zukuri no kūkan to gishiki*. Tokyo: Chūō kōron bijutsu shuppan, 2005.

——. "Sumai no keifu to kazari no keifu." In *"Kazari" to "tsukuri" no ryōbun*, edited by Tamamushi Satoko, 35–59. Kōza Nihon bijutsushi 5. Tokyo: Tōkyō daigaku shuppankai, 2005.

Kawamura Teruo. *Sekkanki wakashi no kenkyū*. Tokyo: Miyai shoten, 1991.

Kawata Hisashi. *Edo fūzoku Tōto saijiki o yomu*. Tokyo: Tōkyōdō shuppan, 1993.

Kazamaki Keijiro. "Fūgashū to Mokkei." In *Genji monogatari no seiritsu*, 444–447. Vol. 4 of *Kazamaki Keijiro zenshū*. Tokyo: Ōfūsha, 1969.

——. "Hachidaishū shikibu no dai ni okeru ichi jiitsu." In *Shinkokin jidai*, 63–83. Vol. 6 of *Kazamaki Keijiro zenshū*. Tokyo: Ōfūsha, 1970.

Kidō Saizō and Imoto Nōichi, eds. *Renga ronshū, haironshū*. NKBT 66. Tokyo: Iwanami shoten, 1961.

Kidō Saizō and Shigematsu Hiromi, eds. *Renga ronshū*. Vol. 1. Chūsei no bungaku. Tokyo: Miyai shoten, 1972.

Kimura Shigemitsu. "Chijūsha no seiritsu to nōkō girei." In *Kankyō to shinsei no bunkashi: Kankyō to shinsei no kattō*, edited by Masuo Shinichirō, Kudō Ken'ichi, and Hōjō Katsutaka, 2:232–252. Tokyo: Bensei shuppan, 2003.

Kimura Yōjirō, ed. *Zusetsu hana to ki no jiten*. Tokyo: Kashiwa shobō, 2005.

Kinoshita Keifū. *Chadō saijiki*. Tokyo: Makino shuppan, 1979.

*Kin'yō wakashū; Shika wakashū*. Edited, with notes, by Kawamura Teruo, Kashiwagi Yoshio, and Kudō Shigenori. SNKBT 9. Tokyo: Iwanami shoten, 1989.

Kira Tatsuo. *Seitaigaku kara mita shizen*. Tokyo: Kawade shobō shinsha, 1983.

Kobayashi Issa. *Issa-shū*. Edited by Maruyama Kazuhiko and Kobayashi Keiichirō. Volume 15 of *Koten haibungaku taikei*. Tokyo: Shūeisha, 1970.

Kobayashi Shōjirō. *Kigo sōgen*. Tokyo: Benseisha, 1997.

Kobayashi Tadashi, ed. *Ikebana no fūzoku*. Ikebana bijutsu zenshū 9. Tokyo: Shūeisha, 1983.

Kobayashi Tadashi and Murashige Yasushi, eds. *Shōsha na sōshokubi: Edo shoki no kachō*. Kachōga no sekai 5. Tokyo: Gakushū kenkyūsha, 1981.

Koike Mitsue. *Fukushoku bunkaron: Fukushoku no mikata yomikata*. Tokyo: Kōseibun, 1998.

*Kokin wakashū*. Edited, with notes, by Kojima Noriyuki and Arai Eizō. SNKBT 5. Tokyo: Iwanami shoten, 1989.

Kokubungaku kaishaku to kyōzai no kenkyū, ed. "Kotenbungaku dōbutsushi." Special issue, *Kokubungaku: kaishaku to kyōzai no kenkyū* 39, no. 12 (1994).

——, ed. "Kotenbungaku no shokubutsushi." Special issue, *Kokubungaku: kaishaku to kyōzai no kenkyū* 47, no. 3 (2001).

Koyama Hiroshi. "Nihon bungaku ni okeru dochakusei to shizenkan." *Asahi jānaru*, January 18, 1974, 39.

Kubodera Kōichi. *Minzoku gyōji saijiki*. Tokyo: Sekai seiten kankō kyōkai, 1985.

Kubota Jun, ed. *Hachidaishū sōsakuin*. SNKBT. Tokyo: Iwanami shoten, 1995.

——, ed. *Horikawa-in hyakushu waka*. Tokyo: Meiji shoin, 2002.

——. "Roppyakuban no wakashiteki igi." In *Roppyakuban uta-awase*, edited by Kubota Jun and Yamaguchi Akiho, 487–509. SNKBT 38. Tokyo: Iwanami shoten, 1998.

——. *Shinkokin kajin no kenkyū*. Tokyo: Tōkyō daigaku shuppankai, 1973.

Kubota Jun and Baba Akiko, eds. *Utakotoba utamakura daijiten*. Tokyo: Kadokawa shoten, 1999.

Kubota Jun and Yamaguchi Akiho, eds. *Roppyakuban uta-awase*. SNKBT 38. Tokyo: Iwanami shoten, 1998.

Kudō Masanobu. *Ikebana no seiritsu to hatten*. Nihon ikebana bunkashi 1. Kyoto: Dōhōsha shuppan, 1992.

Kuriyama Riichi et al., eds. *Kinsei haiku haibun shū*. NKBZ 42. Tokyo: Shōgakukan, 1972.

Kyōka taikan kankōkai, ed. *Kyōka taikan*. 3 vols. Tokyo: Meiji shoin, 1983–1985.

*Man'yōshu*. Edited, with notes, by Kojima Noriyuki, Kinoshita Masatoshi, and Satake Akihiro. NKBZ 2–5. Tokyo: Shōgakukan, 1971–1975.

Masaoka Shiki. *Hyōron, nikki*. Vol. 14 of *Shiki zenshū*. Tokyo: Kōdansha, 1976.

Masuo Shinichirō, Kudō Ken'ichi, and Hōjō Katsutaka, eds. *Kankyō to shinsei no bunkashi: Kankyō to shinsei no kattō*. 2 vols. Tokyo: Bensei shuppan, 2003.

Matsue Shigeyori. *Kefukigusa*. Edited by Takenouchi Waka and Shinmura Izuru. Iwanami bunko 3304–3308. Tokyo: Iwanami shoten, 1943.

Matsumoto Takanobu and Yokoyama Shigeru, eds. *Muromachi jidai monogatari taisei*. Vol. 3. Tokyo: Kadokawa shoten, 1975.

Matsuoka Seigō. *Kachō fūgetsu no kagaku*. Kyoto: Enkōsha, 1994.

Mimura Terunori, ed. *Meidai waka zenshū*. Okayama: Fukutake shoten, 1976.

Minato kuritsu Minato kyōdo shiryōkan, ed. *Edo dōbutsu zukan: Deau kurasu mederu*. Tokyo: Minato kuritsu Minato kyōdo shiryōkan [Minato Ward, Minato City Local History Museum], 2002.

Mito Nobue. "Unkin." In *Uta o egaku, e o yomu: waka to Nihon bijutsu*, edited by Suntory bijitsukan, 106–107. Tokyo: Suntory bijutsukan, 2004.

———. "Mitate to nazuke: waka to no arata na deai." In *Uta o egaku, e o yomu: waka to Nihon bijutsu*, edited by Suntory bijitsukan, 115–116. Tokyo: Suntory bijitsukan, 2004.

Mitsuta Kazunobu. "Renga shinshiki no sekai: renga shikimoku moderu seiritsu no kokoromi." *Kokugo kokubun*, May 25, 1996, 336–352.

Miyake Hitoshi, ed. *Minzoku to girei: sonraku kyōdōtai no seikatsu to shinkō*. Taikei Bukkyō to Nihonjin 9. Tokyo: Shunjunsha, 1986.

Miyamoto Kenji. *Zusetsu Nihon teien no mikata: The Japanese Garden*. Kyoto: Gakugei shuppansha, 1998.

Mizuhara Shūōshi, Katō Shūson, and Yamamoto Kenkichi. *Nihon daisaijiki: karā zusetsu*. Tokyo: Kōdansha, 1983.

Mochida Kimiko. *Kibō no rinrigaku: Nihon bunka to bōryoku o megutte*. Tokyo: Heibonsha, 1998.

Mori Osamu. *Heian jidai teien no kenkyū*. Kyoto: Kuwana bunseidō, 1945.

———. *Nihonshi shōhyakka: Teien*. Tokyo: Tōkyōdō shuppan, 1993.

Morikawa Akira. "Saijiki no naka no shoku." In "Shoku no bungaku hakubutsushi." Special issue, *Kokubungaku: Kaishaku to kyōzai no kenkyū* 29, no. 3 (1984): 66–71.

Murayama Shūichi. *Henbō suru kami to hotoke-tachi*. Kyoto: Jinbun shoin, 1990.

Nagoyashi hakubutsukan, Suntory bijutsukan, Osaka shiritsu bijutsukan, Matsuzakaya Kyoto senshoku sankōkan, and Nihon keizai shinbun, eds. *Kosode Edo no ōtokuchūru / Kosode: Haute Couture Kimonos of the Edo Period*. Tokyo: Nihon keizai shinbunsha, 2008.

Nakamachi Keiko. "Akikusa." In *Bijutsu to sōka*, edited by Yamane Yūzō, 162. Ikebana bijutsu zenshū 10. Tokyo: Shūeisha, 1983.

Nakamura Shunjō and Morikawa Akira, eds. *Teimon haikaishū*. Vol. 1 of *Koten haibungaku taikei*. Tokyo: Shūeisha, 1970.

Nakamura Yoshio. *Fūkeigaku nyūmon*. Tokyo: Chūō kōronsha, 1982.

——. "Shinkō, shūzoku, to nenjū gyōji." In *Nenjū gyōji no bungeigaku*, edited by Yamanaka Yutaka and Imai Gen'ei, 441–456. Tokyo: Kōbundō, 1981.

Nakanishi Susumu. "Shin *Man'yōshū* no shuppatsu: *Man'yōshū* maki hachi no keisei." *Seijō bungei*, no. 46 (1967): 29–43.

Nakao Sasuke. *Hana to ki no bunkashi*. Iwanami shinsho 357. Tokyo: Iwanami shoten, 1986.

Nakayama Keiko. *Jiten: Wagashi no sekai*. Tokyo: Iwanami shoten, 2006.

Namiki Seishi, ed. *Sugu wakaru Nihon no dentō monyō*. Tokyo: Tōkyō bijitsu, 2006.

Namura Jōhaku. *Nan chōhōki*. Edited by Kinsei bungaku shoshi kenkyūkai. Kinsei bungaku shiryō ruijū: Sankōbunkenhen 17. Tokyo: Benseisha, 1981.

Nihon ukiyoe kyōkai, ed. "Afterword." *Ukiyoe no kenkyū*, September 1922, 24.

Nihon zuihitsu taisei henshūbu, ed. *Nihon zuihitsu taisei*. Vol. 5. Tokyo: Yoshikawa kōbunkan, 1975.

Ningen bunka kenkyū kikō kokubungaku kenkyū shiryōkan, ed. *Zusetsu mitate to yatsushi: Nihon bunka no hyōgen gihō*. Tokyo: Yagi shoten, 2008.

Nishihara Kazuo, Tsukakoshi Kazuo, Katō Minoru, Watanabe Yasuaki, and Ikeda Takumi, eds. *Shinsōgō zusetsu kokugo*. Rev. ed. Tokyo: Tōkyō shoseki, 2000.

Nishiki Jin. "Waka ni okeru suhama to teien." *Bungaku*, June 2006, 79–94.

Nishiyama Matsunosuke. *Hana: bi e no kōdō to Nihon bunka*. NHK bukkusu 328. Tokyo: Nippon hōsō shuppan kyōkai, 1978.

Nishiyama Matsunosuke, Watanabe Ichirō, and Gunji Masakatsu, eds. *Kinsei geidōron*. Tokyo: Iwanami shoten, 1972.

Nonomura Kaizō and Andō Tsunejirō, eds. *Kyōgen shūsei*. Tokyo: Shun'yōdō, 1931.

Numata Makoto. "Susuki." In *Shokubutsu no seikatsushi*, edited by Hotta Mitsuru, 68–77. Tokyo: Heibonsha, 1980.

Ogata Tsutomu and Kobayashi Yōjirō, eds. *Kinsei kōki saijiki honbunshū narabi ni sōgō sakuin*. Tokyo: Benseisha, 1984.

Ōi Minobu, ed. *Ikebana jiten*. Tokyo: Tōkyōdō shuppan, 1976.

——. "Ikebana to renga." In *Ikebana jiten*, edited by Ōi Minobu, 33–34. Tokyo: Tōkyōdō shuppan, 1976.

Oka Sanchō, with illustrations by Hasegawa Settan and notes by Imai Kingo. *Edo meisho hanagoyomi*. Rev. ed. Tokyo: Yasaka shobō, 1994.

Okada Kōzō, ed. *Ikebana no denshō*. Vol. 6 of *Zusetsu ikebana taikei*, edited by Tamagami Takuya, Hayashiya Tatsusaburō, and Yamane Yūzō. Tokyo: Kadokawa shoten, 1972.

Ōkubo Junichi. *Rengashi, sono kōdō to bungaku*. Tokyo: Hyōronsha, 1976.

———. "Utagawa Hiroshige no kachōga ni tsuite." *Museum* [journal of the Tokyo National Museum] 494 (1992): 29–30.

Okuda Isao. "Renga ni okeru fūkei." *Seishin joshi daigaku ronshū*, December 1989, 23–36.

———. *Rengashi, sono kōdō to bungaku*. Tokyo: Hyōronsha, 1976.

Okumoto Daisaburō. *Mushi no uchūshi*. Tokyo: Seidōsha, 1989.

Okumura Tsuneya. *Utamakura*. Heibonsha sensho 52. Tokyo: Heibonsha, 1977.

Ōshajō bijutsu hōmotsukan. *Hiroshige kachōgaten: Seitan nihyakunen kinen ōshajō bijutsu hōmotsukan shozō*. Tokyo: Ōta kinen bijutsukan, 1997.

Ōta Hirotarō. *Nihon jūtakushi no kenkyū*. Tokyo: Iwanami shoten, 1984.

Saito Chōshū, Ichiko Natsuo, and Suzuki Ken'ichi, eds. *Shintei Edo meisho zue*. 6 vols. Chikuma gakugei bunko. Tokyo: Chikuma shobō, 1996–1997.

Sakai Masaaki. *Mushi to Nihon bunka*. Tokyo: Taikōsha, 1997.

Sakai Yasushi. *Nihon yūgishi*. Tokyo: Kensetsusha, 1933.

Sakurai Mitsuru. *Man'yō no hana*. Vol. 7 of *Sakurai Mitsuru chosakushū*. Tokyo: Ōfū, 2000.

Sano Midori. "Sakura." In *Bijutsu to sōka*, edited by Yamane Yūzō, 158–159. Ikebana bijutsu zenshū 10. Tokyo: Shūeisha, 1982.

Sasagawa Mitsuhiro. "Mushi no bunkashi." In "Mushi." Special issue, *Nihon no bigaku* 2, no. 6 (1985): 86–98.

———. *Mushi no bunkashi*. Tokyo: Bun'ichi Sōgō shuppan, 1979.

Sasaki Nobutsuna, ed. *Nihon kagaku taikei*. 10 vols. Tokyo: Kazama shobō, 1956–1965.

Satō Michio, ed. *Kudaishi kenkyū*. Tokyo: Keio University Centre for Integrated Reseach of the Mind, 2007.

Satō Shōji. *Nihon-teki shizenkan no kenkyū*. 2 vols. Tokyo: Yasaka shobō, 1978.

Sen Sōshitsu, ed. *Chadō koten zenshū*. Vol. 10. Kyoto: Tankō shinsha, 1962.

*Senzai wakashū*. Edited, with notes, by Katano Tatsurō and Matsuno Yōichi. SNKBT 10. Tokyo: Iwanami shoten, 1993.

Seta Katsuya. *Ki no kataru chūsei*. Asahi sensho 664. Tokyo: Asahi shinbunsha, 2000.

Shimada Shūjirō, Takeda Tsuneo, et. al. "Nihon no kachōga, seiritsu to tenkai." In *Kachōga shiryō shūsei*, edited by Takeda Tsuneo and Tsuji Nobuo, 90–123. Kachōga no sekai 11. Tokyo: Gakushū kenkyūsha, 1983.

Shimizu Takayuki and Matsuo Yasuaki, eds. *Chūkō hairon haibunshū*. Vol. 14 of *Koten haibungaku taikei*. Tokyo: Shūeisha, 1971.

*Shinkokin wakashū*. Edited, with notes, by Tanaka Yutaka and Akase Shingo. SNKBT 11. Tokyo: Iwanami shoten, 1992.

Shinbō Tōru, ed. *Yamatoe no shiki: Kamakura no kachō*. Kachōga no sekai 1. Tokyo: Gakushū kenkyūsha, 1982.

Shinji Isoya. *Nihon no teien, zōkei no waza to kokoro*. Tokyo: Chūōkōron shinsha, 2005.

Shinoda Jun'ichi and Sakaguchi Hiroyuki, eds. *Kojōruri, sekkyōshū*. SNKBT 90. Tokyo: Iwanami shoten, 1999.

Shinozaki Yukie. "Roppyakuban uta-awase kadai-kō: Shiki no bu o megutte." *Kokubungaku kenkyū*, May 1980, 62.

Shiraishi Teizō. "Haikai." In *Nenjū gyōji no bungeigaku*, edited by Yamanaka Yutaka and Imai Gen'e, 220–235. Tokyo: Kōbundō, 1981.

Shiraishi Teizō and Ueno Yōzō, eds. *Bashō shichibushū*. SNKBT 70. Tokyo: Iwanami shoten, 1990.

*Shūi wakashū*. Edited, with notes, by Komachiya Teruhiko. SNKBT 7. Tokyo: Iwanami shoten, 1990.

Suntory bijutsukan, ed. *Nihon o iwau—Iwai: The Arts of Celebration*. Tokyo: Asahi shinbunsha, 2007.

——, ed. *Uta o egaku, e o yomu: waka to Nihon bijutsu*. Tokyo: Suntory bijutsukan, 2004.

Suzuki Jūzō. *Hiroshige*. Tokyo: Nihon keizai shinbunsha, 1970.

Suzuki Ken'ichi. *Edo shiika no kūkan*. Tokyo: Shinwasha, 1998.

——. "Kadō to kadō: kabin, kadō, soshite shiikashi e." In *Waka no dentō to kyōju*, edited by Wakabungaku ronshū henshūinkai, 273–396. Tokyo: Kazama shobō, 1996.

——. "Mushikago no bungakushi." *Edo bungaku*, June 1991, 104–123.

Tadaki Yoshiya. *Mori no bunkashi*. Tokyo: Kōdansha, 1981.

Takahama Kyoshi. "Kachō fūei." *Hototogisu*, February 1929, 53–59.

——. *Shinsaijiki*. 1934. Reprint, Tokyo: Sanseidō, 1951.

Takahashi Chihaya. *Kachō fūgetsu no Nihonshi*. Tokyo: Mokushuppan, 2000.

Takahashi Kazuhiko, ed. *Mumyōshō zenkai*. Tokyo: Sōbunsha, 1987.

Takahashi Kazuo. *Nihon bungaku to kishō*. Chūō shinsho 512. Tokyo: Chūō kōronsha, 1978.

Takase Baisei. *Haikai ruisen shū*. Osaka: Han'an Noma Kōshin Sensei Kakō Kinenkai, 1969.

Takase Shigeo. *Nihonjin no shizenkan: Nihon no bi to kyōyō*. Kyoto: Ōyashima shuppan, 1942.

Takashina Shūji, Ōhashi Ryōsuke, and Tanaka Yūko. "Zadankai." In "Nenjū gyōji." Special issue, *Nihon no bigaku* 31 (2000): 4–21.

Takeda Tsuneo. *Byōbue ni miru kisetsu*. Tokyo: Chūō kōron bijutsu shuppan, 2008.

——, ed. *Keibutsuga: shiki keibutsu*. Vol. 9 of *Nihon byōbue shūsei*, edited by Takeda Tsuneo, Yamane Yūzō, and Yoshizawa Chū. Tokyo: Kōdansha, 1977.

——. "Nenjū gyōji-e ni tsuite." In *Nenjū gyōji*, 69–121. Vol. 1 of *Kinsei fūzoku zufu*. Tokyo: Shōgakukan, 1983.

——. *Nihon kaiga to saiji: keibutsuga shiron*. Tokyo: Perikansha, 1990.

Takeda Tsuneo and Kano Hiroyuki, eds. *Kenran taru taiga*. Vol. 1. Kachōga no sekai 3. Tokyo: Gakushū kenkyūsha, 1982.

——, eds. *Kenran taru taiga*. Vol. 2. Kachōga no sekai 4. Tokyo: Gakushū kenkyūsha, 1982.

Takeda Tsuneo and Tsuji Nobuo, eds. *Kachōga shiryō shūsei*. Kachōga no sekai 11. Tokyo: Gakushū kenkyūsha, 1983.

Takeda Tsuneo, Yamane Yūzō, and Yoshizawa Chū, eds. *Nihon byōbue shūsei*. 18 vols. Tokyo: Kōdansha, 1977–1981.

Takizawa Sadao. *Horikawa-in hyakushu zenshaku*. 2 vols. Tokyo: Kazama shobō, 2004.

Tamagami Takuya, Hayashiya Tatsusaburō, and Yamane Yūzō, eds. *Zusetsu ikebana taikei*. 6 vols. Tokyo: Kadokawa shoten, 1970–1972.

Tamamushi Satoko. "Waka o hakobu katachi: byōbue kara kosode made." In *Uta o egaku, e o yomu: waka to Nihon bijutsu*, edited by Suntory bijutsukan, 134–135. Tokyo: Suntory bijutsukan, 2004.

Tanaka Ichimatsu and Yonezawa Yoshio. *Suibokuga*. Genshoku Nihon no bijutsu 11. Tokyo: Shōgakukan, 1970.

Taniwaki Masachika, Oka Masahiko, and Inoue Kazuhito, eds. *Kana-zōshi shū*. SNKBZ 64. Tokyo: Shogakukan, 1999.

Tayama Masakazu. "Nihon kaiga no mirai." In *Bijutsu*, edited by Aoki Shigeru and Sakai Tadayasu, 122–152. Nihon kindai shisō taikei 17. Tokyo: Iwanami shoten, 1989.

Terada Torahiko. *Nihonjin no shizenkan*. Iwanami kōza Tōyō shichō 11. Tokyo: Iwanami shoten, 1935.

Terayama Hiroshi. *Wakan koten dōbutsukō*. Tokyo: Yasaka shobō, 2002.

Teruoka Yasutaka. *Teruoka Yasutaka no kigo jiten*. Tokyo: Tōkyōdō shuppan, 2002.

Toda Teisuke and Ogawa Hiromitsu, eds. *Chūgoku no kachōga to Nihon*. Kachōga no sekai 10. Tokyo: Gakushū kenkyūsha, 1983.

Toita Yasuji, ed. *Kabuki meisakusen*. Vol. 11. Tokyo: Tōkyō sōgensha, 1957.

Tokuda Kazuo. *Otogi-zōshi kenkyū*. 1988. Reprint, Tokyo: Miyai shoten, 1990.

Tokuda Kazuo and Yashiro Seiichi. *Otogi-zōshi, Isoho monogatari*. Shinchō koten bungaku arubamu 16. Tokyo: Shinchōsha, 1991.

Tokugawa bijutsukan, ed. *E de tanoshimu Nihon mukashibanashi: otogi-zōshi to ehon no sekai*. Tokyo: Tokugawa bijutsukan, 2006.

Tōkyō kokuritsu hakubutsukan, Kokka-sha, and Asahi shinbunsha, eds. *Kokka sōkan 100 nen kinen tokubetsuten: Muromachi jidai no byōbue / Screen Paintings of the Muromachi Period*. Tokyo: Tōkyō kokuritsu hakubutsukan, Kokka-sha, and Asahi shinbunsha, 1989.

Tomiyasu Fūsei, ed. *Haiku saijiki: Shin'nen' no bu*. Tokyo: Heibonsha, 1959.

Torigoe Kenzaburō. *Saijiki no keifu*. Tokyo: Mainichi shinbunsha, 1977.

Tsuji Michiko. *Kyō no wagashi: Kurashi o irodoru shiki no waza*. Tokyo: Chūō kōron shinsha, 2005.

Tsuji Nobuo et al. *Kachōga: Kamoku—kachō*. Vol. 6 of *Nihon byōbue shūsei*, edited by Takeda Tsuneo, Yamane Yūzō, and Yoshizawa Chū. Tokyo: Kōdansha, 1978.

Tsukamoto Manabu. *Edo jidai hito to dōbutsu*. Tokyo: Nihon editā sukūru shuppanbu, 1995.

Tsurusaki Hiroo. "Rengashi no egokoro: renga to suiboku sansuiga, toku ni Shōshō hakkei-zu ni tsuite." *Geinōshi kenkyū*, no. 43 (1973): 38–49.

Ueki Tomoko. "*Ryōjin hishō* no mushitachi." In *Kankyō to shinsei no bunkashi: Kankyō to shinsei no kattō*, edited by Masuo Shinichirō, Kudō Ken'ichi, and Hōjō Katsutaka, 1:195–206. Tokyo: Bensei shuppan, 2003.

Wakashi kenkyūkai, ed. *Shikashū taisei*. Vol. 1, *Chūkō*. Tokyo: Meiji shoin, 1973.

Watanabe Fumio and Sugiura Hinako, eds. *Rokkaferā ukiyoe korekushon-ten—Yomigaeru bi: hana to tori to*. Tokyo: Bunyūsha, 1990.

Watanabe Hideo. *Shiika no mori: Nihongo no imeeji*. Tokyo: Taishūkan shoten, 1995.

Watanabe Zenjirō. *Kyodai toshi Edo ga washoku o tsukutta*. Tokyo: Nōsan gyoson bunka kyōkai, 1988.

Yamada Takuzō and Nakashima Nobutarō, eds. *Man'yō shokubutsu jiten: Man'yō shokubutsu o yomu*. Tokyo: Hokuryūkan, 1995.

Yamamoto Kenkichi, Ōoka Makoto, et al., eds. *Dai saijiki*. 4 vols. Tokyo: Shūeisha, 1989.

Yamanaka Yutaka and Endō Motoo, eds. *Nenjū gyōji no rekishigaku*. Tokyo: Kōbundō, 1981.

Yamane Yūzō, ed. *Bijutsu to sōka*. Ikebana bijutsu zenshū 10. Tokyo: Shūeisha, 1982.

Yamane Yūzō, ed. *Ikebana saijiki*. Vol. 5 of *Zusetsu ikebana taikei*, edited by Tamagami Takuya, Hayashiya Tatsusaburō, and Yamane Yūzō. Tokyo: Kadokawa shoten, 1972.

Yano Ken'ichi. "Nihon no shokuzai Dai yon setsu: Sakana to Nihonjin." In *Nihon no shokuji bunka*, edited by Ishige Naomichi and Kumakura Isao, 134–152. Vol. 2 of *Kōza shoku no bunka*. Tokyo: Ajinomoto shoku no bunka sentā, 1999.

———. *Uo no bunkashi*. Tokyo: Kōdansha, 1983.

Yasuda Yoshinori. "Rettō no shizen kankyō." In *Nihon rettō to jinrui shakai*, 41–81. Iwanami kōza Nihon tsūshi 1. Tokyo: Iwanami shoten, 1993.

Yokoi Hiroshi. "*Man'yōshū* no kisetsu uta to kisetsugo." In *Man'yōshū o manabu*, edited by Itō Haku and Inaoka Kōji, 5:239–256. Tokyo: Yūhikaku, 1978.

Yokoi Yayū. *Uzuragoromo*. In *Chūkō hairon haibunshū*, 480–488. Vol. 14 of *Koten haibungaku taikei*, edited by Shimizu Takayuki and Matsuo Yasuaki. Tokyo: Shūeisha, 1971.

Yokoyama Shigeru and Matsumoto Ryūshin, eds. *Muromachi jidai monogatari taisei*. Vol. 6. Kadokawa shoten, 1978.

Yoshida Teruji, ed. *Ukiyoe taisei*. 12 vols. Tokyo: Tōhō shoin, 1930–1931.

Yoshino Masatoshi and Fukuoka Yoshitaka, eds. *Kankyō kikōgaku*. Tokyo: Tōkyō daigaku shuppankai, 2003.

Yuasa Hiroshi. *Shokubutsu to gyōji: sono yurai o suirisuru*. Asahi sensho 478. Tokyo: Asahi shinbunsha, 1993.

# Index of Seasonal and
# Trans-Seasonal Words and Topics

Numbers in italics refer to pages on which illustrations appear.

solar calendar and, 10; passing spring (*yuku haru*), 31; psychological state of, 46; regret at passing of (*sekishun*), 47; in *renga*, 78; *rikka* and, 98; in twelve-layered robe, 58

*haru no akebono* (spring dawn), 223

*haru no kōri* (spring ice), 223

*haru no kusa* (spring wild flowers)

*haru no yoru* (spring night), 35

*harukoma* (spring horses), 74, 230n.34

*harusame* (fine spring rain), 46, 176, 230n.34

*hatsumōde* (first pilgrimage of year), 153

heat shimmer (*itoyū*), 223

herbs, new (*wakana*), 22, 28, 46, 74, 160, 212

*hibari* (skylark), 65, 74, 193, 194, *194–195*

Higan (Buddhist Memorial Service on Vernal Equinox), 81, 161

Hina-matsuri (Doll's Festival), 153, 156, *157*, 158

horses, spring (*harukoma*), 74, 230n.34

ice, spring (*haru no kōri*), 223

iris (*kakitsubata*), 52–53, 230n.34; in flower cards (*hanafuda*), 67; in *renga*, 74; *rikka* and, 98; in twelve-layered robe, 58

*itoyū* (heat shimmer), 223

Japanese horseradish (*wasabi*), 176

Japanese woodland primrose (*sakurasō*), 110

Jarai (Archery Day), 155

Jōshi (Minohi; first Day of the Snake), 102, 155, 156, 158, 160, 161

*kakitsubata* (iris), 52–53, 230n.34; in flower cards (*hanafuda*), 67; in *renga*, 74; *rikka* and, 98; in twelve-layered robe, 58

*kasumi* (spring mist), 9, 10, 46, 77, 79, 167

*kawazu* (frog), 7, 36, 37, 46, 191; in *haikai*, 179; in *renga*, 74; *satoyama* cosmology and, 114

*kigan* (wild geese returning north), 31, 34, 74

*kiji* (*kigisu*; pheasant), 74, 116, 117, 118; as food, 119–120, 237n.13; month and flower associated with, 65, 66

*kinsenka* (marigold), 102

*ko no hana* (tree flowers), 20–21, 28, 42, 110

*kōbai* (crimson plum blossom), 46, 58, 60, 73

*komatsu-hiki* (pulling up small pines), 21, 32, 137, 156, 242n.9; kabuki early-spring plays and, 166; in poems of twelve months, 64

Koshōgatsu (Minor New Year), 154, 242n.5, 244n.28

*kuromame* (black soybean), 142, 183

marigold (*kinsenka*), 102

mist, spring (*kasumi*), 9, 10, 46, 77, 79, 167

*momo* (peach), 98, 102, 168, 173

Momonohi (Peach Day), 156, *157*, 158

moon, misty spring (*oborozukiyo*), 46

*nanakusa* (seven grasses of spring), 135, 155–156, 183

Nanakusa (Seven Grasses), 155, 156

*nashi no hana* (pear blossom), 74

*nawashiro* (rice-seedling bed), 74, 230n.34

*neko no koi* (cat's love), 23, 176–178

Nenohi (Day of the Rat), 32, 64, 74, 137, 155

New Year (*shinnen*), 28, 81, 102, 145, 155–156; auspicious/talismanic associations of, 142; beginning of

New Year (*continued*)
    spring and, 32, 94, 134; gate pine
        (*kadomatsu*) and, 137, 152, 156, 213;
        kabuki plays and, 166; seven herbs
        (*nanakusa*) and, 135
New Year, Major (Ōshōgatsu; first to
    seventh day of First Month), 154
New Year, Minor (Koshōgatsu), 154,
    242n.5, 244n.28
New Year banquet (Gannichi no en),
    223
night, spring (*haru no yoru*), 35
*ninniku* (garlic), 176
Noriyumi (Court Archery Festival),
    223

*oborozukiyo* (misty spring moon), 46
Ōshōgatsu (Major New Year), 154

parsley, picking (*seri tsumu*), 74
peach (*momo*), 98, 102, 168, 173
Peach Day (Momonohi), 156, *157*, 158
pear blossom (*nashi no hana*), 74
pheasant (*kiji, kigisu*), 74, 116, 117, 118;
    as food, 119–120, 237n.13; month
    and flower associated with, 65, 66
pilgrimage, first of year (*hatsumōde*), 153
plum blossom/tree (*ume*), 20, *31*, 33,
    34, 53, 74, 212, 228n.14; in Chinese
    poetry, 34–35; early, 99, 202; famous
    places (*meisho*) and, 167, 168; in
    flower cards (*hanafuda*), 67, 231n.7;
    as "Friend of the Cold," 150; month
    and bird associated with, 65; as one
    of "Four Gentlemen," 150; *rikka*
    and, 102; talismanic functions of,
    134, 150–151; as tree flower, 42, 110
pulling up small pines (*komatsu-hiki*),
    21, 32, 137, 156, 242n.9; kabuki
    early-spring plays and, 166; in
    poems of twelve months, 64. *See also*
    Rat, Day of the

Rabbit Stick (Uzue; first Rabbit Day of
    First Month), 155, 160
rain, fine spring (*harusame*), 46, 176,
    230n.34
Rat, Day of the (Nenohi), 32, 64, 74,
    137, 155
rice harvest, prayer for (*ta-asobi*), 14, 22,
    154
rice-seedling bed (*nawashiro*), 74,
    230n.34
*risshun* (beginning of spring), 74

Sagichō (Fire Festival), 155, 242n.5
*sakura* (cherry blossoms/tree), 7, 53,
    86–87; bright-foliage (*momiji*) poems
    in counterpart to, 44; calendars
    and, 10; ephemerality of, 133, 134;
    famous places (*meisho*) and, 23, 167,
    168, 171–172, *172*; in flower cards
    (*hanafuda*), 67, 231n.7; in haikai,
    176; in *Kokinshū*, 31, 35–36; love
    associations of, 47; month and
    bird associated with, 65, 66; as
    nationalist symbol, 248n.5; poetic
    places (*utamakura*) and, 70–71;
    popularity of, 151; in *renga*, 77;
    seasonal pyramid and, 178;
    Somei-Yoshino, 111, 169; television
    reports on, 218; as tree flower, 20,
    42, 110; in twelve-layered robe,
    58, 61
*sakuradai* (cherry bass), 183
*sakurasō* (Japanese woodland primrose),
    110
*sawarabi* (young bracken), 183, 230n.34
Second Month (Kisaragi), 9, 60, 163;
    flower and bird associated with, 65,
    66; in flower cards (*hanafuda*), 67;
    harvest festival in, 227n.1; noh plays
    and, 94; *renga* topics for, 74; *rikka*
    and, 98; in screen paintings, 64
*sekishun* (regret at passing of spring), 47

274 | SEASONAL INDEX

White Horses (Aouma; seventh day of
First Month), 155, 242n.3
wild fields, playing in (*yayū*), 223
wild flowers, spring (*haru no kusa*)
willow (*yanagi*), 61, 103; in flower
cards (*hanafuda*), 67, 231n.7; in
*haikai*, 176; month and bird
associated with, 65; *rikka* and, 98.
*See also* green willow
wisteria (*fuji*), 20, 21, 31, 46, 51,
229n.15; famous places (*meisho*) and,
167; in flower cards (*hanafuda*), 67,
231n.7; ikebana and, 98; in *Kokinshū*,
36; noh play about, 123–124; poetic
places (*utamakura*) and, 166; in
*renga*, 74; *rikka* and, 99; talismanic
functions of, 134; in twelve-layered
robe, 58, 61; in *waka*, 151
wisteria waves (*fujinami*), 51

yamabuki (yellow kerria), 31, 36, *37*, 46,
50–51, 61–62, 70, 74, 102, 188,
229n.16; in dress design, 61, 62;
ikebana and, 98; as name of gold
coin, 188; in poetry contest
(*uta-awase*), 50–51; in *renga*, 74;
*rikka* and, 102; in screen paintings,
70–71; in twelve-layered robe, 58
yanagi (willow), 61, 103; in flower cards
(*hanafuda*), 67, 231n.7; in *haikai*, 176;
month and bird associated with, 65;
*rikka* and, 98
yayū (playing in wild fields), 223
yellow kerria (*yamabuki*), 31, 36, *37*,
46, 50–51, 61–62, 70, 74, 102, 188,
229n.16; in dress design, 61, 62;
ikebana and, 98; as name of gold
coin, 188; in poetry contest
(*uta-awase*), 50–51; in *renga*, 74;
*rikka* and, 102; in screen paintings,
70–71; in twelve-layered robe, 58

yobukodori (cuckoo), 74, 96, 222,
232n.17
yokan (lingering cold), 223
yuku haru (passing spring), 31

zansetsu (lingering snow), 46, 177
zanshun (remaining snow), 223

## Summer Words and Topics

ajisai (hydrangea), 98
ant (*ari*), 180
aoi (hollyhock), 222, 230n.34, 241n.38
ari (ant), 180
ayame (*ayamegusa*; Siberian iris), 53

bamboo shoots, young (*takenoko*), 137,
184
baseball night game (*naitaa*), 217
beer, 217
bonito (*katsuo*), 142, 183, 184–185,
247n.11; first (*hatsugatsuo*), 183
botan (*fukamigusa*; peony), 67, 98, 152,
163, 231n.7
butterfly (*kochō*), 179

camping (*kyampu*), 217
centipede (*mukade*), 180, 191
Chinese peony (*shakuyaku*), 98, 168
cicada (*semi*), 223
cooling off (*nōryō*), 39, 168, 245n.49
cormorant (*u*), 65, 193
cormorant fishing (*ukawa*), 223
cuckoo, small (*hototogisu*), 28–29, 31,
32, 38, 46, 163; distinguished from
cuckoo (*yobukodori*), 232n.17; fading
of, 217; famous places (*meisho*) and,
168; in *haikai*, 176; love association
of, 40, 47; as migratory bird, 116;
month and flower associated with,

lotus (*hachisu*), 98, 136, 151–152, 168, 230n.34
louse (*shirami*), 180, 191, *193*

mandarin orange (*tachibana*), 46, 110, 229n.18; in *haikai*, 176; month and bird associated with, 65; talismanic functions of, 134; in twelve-layered robe, 58
mandarin-orange blossom (*hanatachibana*), 38–39
marsh hen (*kuina*), 65
*mimizu* (earthworm), 180, 191
moon, summer (*natsu no tsuki*), 53
mosquito (*ka*), 180–181, *193*
mountain, summer (*natsu-yama*), 144
*mukade* (centipede), 180, 191

*nadeshiko* (pink), 29, 41, 58, 189; in gardens, 93; month and bird associated with, 65; old name for (*tokonatsu*), 103; in twelve-layered robe, 58; women associated with, 47 [usually autumn but can be summer]
*naitaa* (baseball night game), 217
*namekuji* (slug), 191
*nasubi* (*nasu*; eggplant), 184
*natsu* (summer): calendars and, 10–11; famous places (*meisho*) and, 167–168; food associated with, 184; in *Kokinshū*, 31, 38–39, 228n.7; luni-solar calendar and, 9, 10; modern solar calendar and, 10; negative aspects of, 12; psychological state of, 46; *rikka* and, 98; in twelve-layered robe, 58
*natsu no tsuki* (summer moon), 53
*natsu no yo* (summer night), 13, 223
*natsu shattsu* (short-sleeved shirt), 217
*natsugoromo* (summer robe), 223
*natsukusa* (summer grass), 223

*natsu-yama* (summer mountain), 144
night, summer (*natsu no yo*), 13, 223
*nomi* (flea), 180, *193*
*nōryō* (cooling off), 39, 168, 245n.49

oak-leaf rice cake (*kashiwa-mochi*), 161, *162*, 184
*ōgi* (fan), 223
orange blossom. *See* mandarin-orange blossom
*oyogi* (swimming), 217

paulownia flower (*kiri no hana*), 67, 141, 176, 231n.7
peony (*botan, fukamigusa*), 67, 98, 152, 163, 231n.7
pink (*nadeshiko*), 29, 41, 58, 189; in gardens, 93; month and bird associated with, 65; old name for (*tokonatsu*), 103; in twelve-layered robe, 58; women associated with, 47 [usually autumn but can be summer]

rain, long summer / monsoon season (*samidare*), 9, 18, 39, 46, 47, 229n.20
rhododendron (*satsuki*), 111
rice seedlings (*sanae*), 52, 222, 230n.34; planting of (*taue*), 153
rice-seedling planting songs (*taue-uta*), 154
robe, summer (*natsugoromo*), 223

*samidare* (long summer rain / monsoon season), 9, 18, 39, 46, 47, 229n.20
*sanae* (rice seedlings), 52, 222, 230n.34
*sangurasu* (sunglasses), 217
*satsuki* (rhododendron), 111
*Satsuki matsu* (waiting for Fifth Month), 31, 39
*semi* (cicada), 223
*shakuyaku* (Chinese peony), 98, 168

## Autumn Words and Topics

*aki no shimo* (autumn frost), 223
*aki no ta* (autumn rice field), 223
*aki no yūbe* (autumn evening), 49, 51, 86, 189, 223
*akikaze* (autumn wind), 31, 42, 46
*akikusa* (autumn grasses), 31, 41, 43–44, 46, 61, 68, 109, 152, 171
*akisame* (autumn rain), 51, 223
*aki-yama* (autumn mountain), 81, 144
*arashi* (storm), 31, 83, 185
*asagao* (morning glory), 20, 41, 230n.34; famous places (*meisho*) and, 168; seasonal clothing and, 63; women associated with, 47
*ashi* (reed), 133
autumn (*aki*), 31, 39–44, 49; beginning of (*risshū*), 40; in Chinese poetry, 28; end of (*boshū*), 79, 159, 179, 223; famous places (*meisho*) and, 168; food associated with, 184; in *Kokinshū*, 31; in twelve-layered robe, 59, 60; late (*banshū*), 31; love associations of, 48; luni-solar calendar and, 9–10, 40; modern solar calendar and, 10; psychological state of, 46; in *renga*, 79; *rikka* and, 98

banana plant (*bashō*; plantain), 124
*banshū* (late autumn), 31
*bashō* (banana plant, plantain), 124
bell cricket (*suzumushi*), 117, 179, 180
bellflower (*kikyō*), 98, 102
boneset (*fujibakama*), 41, 230n.34
*boshū* (end of autumn), 79, 159, 179, 223
bush clover (*hagi*), 3, 27, 31, 41; autumn association of, 42; ephemerality of, 134; in flower cards (*hanafuda*), 67, 231n.7; in gardens, 93; love pairing of, with stag, 47; month and bird associated with, 65; seasonal

clothing and, 63; in twelve-layered robe, 59

change color or fade (*utsurou*), 43, 229n.16
chestnut (*kuri*), 184
Chōyō (Chrysanthemum Festival), 44, 102, 155, 159–160, 163, *164*
chrysanthemum (*kiku*), 20, 31, 110–111, 212; annual observances and, 173; auspicious / talismanic functions of, 134, 139; autumn association of, 151, 229n.24; famous places (*meisho*) and, 168; flower banquet (*kikka no en*), 184; in flower cards (*hanafuda*), 67, 231n.7; as one of "Four Gentlemen," 150; poems about, 44; *rikka* and, 98; seasonal clothing and, 63; in twelve-layered robe, 59, 60
chrysanthemum doll (*kiku ningyō*), 112
Chrysanthemum Festival (Chōyō; ninth day of Ninth Month), 44, 102, 155, 159–160, 163, *164*
cockscomb (*keitō*), 98, 102

Dead, Festival of the (Obon, Urabon; thirteenth to fifteenth days of Seventh Month), 153, 155, 161, 163, 165
deer (*shika*), 16, 17, 27, 46; in flower cards (*hanafuda*), 231n.7; as food, 183, 184; in *Kokinshū*, 31, 41; *kuyō* offerings to, 17, 120; love associations of, 42, 47; in mountains, 144; stag's cry as autumn theme, 44
dew (*tsuyu*), 3, 18, 27, 63, 77

Eighth Month (Hazuki), 10, 11, 40, 93, 154, 163; flower and bird associated with, 65; in flower cards (*hanafuda*), 67; moon viewing (*tsuki-mi*) in, 170, 171, 245n.48; noh plays and, 94;

Urabon (Obon; Festival of the Dead), 153, 155, 161, 163, 165
*utsurou* (change color or fade), 43, 229n.16
*uzura* (quail), 65, 193, *194–195*

white dew (*shiratsuyu*), 31
wind, autumn (*akikaze*), 31, 42, 46

yellow valerian (*ominaeshi*), 31, 41, 42; ephemerality of, 134; in gardens, 93; month and bird associated with, 65; seasonal clothing and, 63; twelve-layered robe and, 59; women associated with, 47

*zansho* (lingering heat), 11, 51, 178

## Winter Words and Topics

*ajiro* (fishing weirs/wicker fish trap), 60, 64, 166, 167, 230n.34
*arare* (hail), 73–74

bedding (*fusuma*), 224
*biwa* (loquat), 54, 65, 99
Buddha's Name (*butsumyō*), 224
*butsumyō-e* (ritual for chanting Buddha's name), 224

charcoal fire in ash (*uzumibi*), 223, 230n.34
charcoal-making oven (*sumigama*), 52, 230n.34
*chidori* (plover), 53–54, 65, 117, 168
Chinese aster (*kangiku*), 99, 168
Chinese dogwood (*kara-mizuki*), 99
chinquapin brushwood (*shii-shiba*), 127
chrysanthemum: lingering (*zangiku*), 65; winter (*kangiku*), 99, 168
cold hut (*kanro*), 223

dabchick (*kaitsuburi, nio*), 117
duck, wild (*kamo*; mallard), 49, 116, 119

Eleventh Month (Shimotsuki; Frost Month), 10, 45, 74; flower and bird associated with, 65; in flower cards (*hanafuda*), 67; kabuki season opening in, 165; *rikka* and, 99; in screen paintings, 64

falconry (*takagari*), 115, 230n.34
field, withered (*kareno*), 60, 168, 224
fishing weirs/wicker fish trap (*ajiro*), 60, 64, 166, 167, 230n.34
frost (*shimo*), 9, 77, 79
*fusuma* (bedding), 224
*fuyu* (winter): famous places (*meisho*) and, 168; first sign of (*hatsu-fuyu*), 49; food associated with, 184; in *Kokinshū*, 31; luni-solar calendar and, 10; in *Man'yōshū*, 45; modern solar calendar and, 10; psychological state of, 46; *rikka* and, 99; severity or mildness of, 12; in twelve-layered robe, 60
*fuyu no ashita* (winter morning), 224
*fuyu no tsuki* (winter moon), 21, 50

Gencho (Wild Boar Day), 155, 242n.7
god dances (*kagura*), 127, 230n.34
god festival (*kami matsuri*), 64

hail (*arare*), 73–74
*hatsu-fuyu* (first sign of winter), 49
*hika-rakuyō* (falling leaves), 80

ice (*kōri*), 60, 74
imperial procession to wild fields (*no no miyuki*), 224

*kagura* (god dances), 127, 230n.34
*kaitsuburi* (dabchick), 117

Wild Boar Day (Gencho; first Boar Day of Tenth Month), 155, 242n.7

winter (*fuyu*): famous places (*meisho*) and, 168; first sign of (*hatsu-fuyu*), 49; food associated with, 184; in *Kokinshū*, 31; luni-solar calendar and, 10; in *Man'yōshū*, 45; modern solar calendar and, 10; psychological state of, 46; *rikka* and, 99; severity or mildness of, 12; in twelve-layered robe, 60

*yuki* (snow), 9, 31, 32, 87; cherry blossoms compared to, 45, 63; as descending object, 77, 79, 233n.24; famous places (*meisho*) and, 168; gently falling, 12; in *haikai*, 176; melting, 74; poetic places (*utamakura*) and, 167; in screen paintings, 64; seasonal pyramid and, 178; in Snow Country, 12
*yuki-mi* (snow viewing), 166, 168

*zangiku* (lingering chrysanthemum), 65

## Auspicious Trans-Seasonal Words

bamboo (*take*), 21, 72, 102, 103, 212, 239n.5; as "Friend of the Cold," 150; ikebana and, 98; as one of "Four Gentlemen," 150; *rikka* and, 98, 99; talismanic functions of, 134, 137–138, 142, 145

carp (*koi*), 119, 142, *143*, 202, 212
crane (*tsuru*), 21, 117, 145, 212; month and flower associated with, 65; protected status of, 119; in screen paintings, 22; talismanic functions of, 138–139, *140*, 141

*ebi* (shrimp), 142, 143
evergreen branch, sacred (*sakaki*), 126, 136

gate pine (*kadomatsu*), 137, 152, 156, 213

*hōō* (phoenix), 139, 141

*kadomatsu* (gate pine), 137, 152, 156, 213
kalavinka (*karyōbinka*), 139, 141
*kame* (turtle), 21, 139, 145, 212
*karyōbinka* (kalavinka), 139, 141
*koi* (carp), 119, 142, *143*, 202, 212
*kujaku* (peacock), 139, 152, 240n.10

*matsu* (pine), 21, 103, 212; black (*kuromatsu*), 136; crane (*tsuru*) and, 139, *140*, 145; in flower cards (*hanafuda*), 67, 231n.7; as "Friend of the Cold," 150; old (*oimatsu*), 137; poetic places (*utamakura*) and, 166; red (*akamatsu*), 127, 136; *rikka* and, 98; in screen paintings, 22; talismanic functions of, 134, 135, 136–137, 142

peacock (*kujaku*), 139, 152, 240n.10
phoenix (*hōō*), 139, 141
pine (*matsu*), 21, 103, 212; black (*kuromatsu*), 136; crane (*tsuru*) and, 139, *140*, 145; in flower cards (*hanafuda*), 67, 231n.7; as "Friend of the Cold," 150; old (*oimatsu*), 137; poetic places (*utamakura*) and, 166; red (*akamatsu*), 127, 136; *rikka* and, 98; in screen paintings, 22; talismanic functions of, 134, 135, 136–137, 142

*sakaki* (sacred evergreen branch), 126, 136
sea bream (*tai*), 142, 143–144
shrimp (*ebi*), 142, 143

*tai* (sea bream), 142, 143–144
*take* (bamboo), 21, 72, 102, 103, 212, 239n.5; as "Friend of the Cold," 150; ikebana and, 98; as one of "Four Gentlemen," 150; *rikka* and, 98, 99; talismanic functions of, 134, 137–138, 142, 145
*tsuru* (crane), 21, 117, 145, 212; month and flower associated with, 65; protected status of, 119; in screen paintings, 22; talismanic functions of, 138–139, *140*, 141
turtle (*kame*), 21, 139, 145, 212

# Index of Authors, Titles, and Key Terms

For seasonal and trans-seasonal words, see the seasonal index. Numbers in italics refer to pages on which illustrations appear.

annual observances (*nenjū-gyōji*), 19, 22, 28, 32, 40, 44, 46, 54, 64, 102, 135, 136, 150, 152–161, 214; painting and, 161–166. *See also* Gosekku; *specific observances [seasonal index]*

*Aotozōshi hana no nishikie. See Benten musume meo no shiranami*

archery, on horseback, 158

architecture, 87, 90–95, 112, 130; dwellings (*kyosho*), 77, 81; hanging bamboo screen (*sudare*), 92; latticed shutters (*shitomi*), 92; parallel-door track system (*hikichigai*), 92; sliding door (*shōji*), 92. *See also* alcove; furniture; gardens; palace-style architecture; parlor-style architecture

aristocracy / aristocrats, 4, 13, 18, 55, 112; decline of, 113; famous places and, 169; secret teachings (*hiden*) and, 204

Ariwara no Narihira (825–880), 125

Asai Ryōi (1612–1691), 67

Ashikaga Yoshitane (1536–1565), 100

Asuka period (late sixth to mid-seventh century), 141

Ausaka, Mount, 166

autumn. See *seasonal index*

*Autumn Moon at Ishiyama* (*Ishiyama shūgetsu*; Suzuki Harunobu), 186

*Autumn Moon in the Mirror Stand* (*Kyōdai no shūgetsu*; Suzuki Haronobu), 186, *187*, 188–190, *189*

bad places (*akushō*), 67

badgers, 16, 114, 129

bamboo grass (*sasa*), 9, 161

bannermen (*hatamoto*), 110, 154, 158

barley (*mugi*), 16

Bashō. *See* Matsuo Bashō

*Bashō* (*Plantain Tree*; Konparu Zenchiku), 94, 123, 124, 125

bears, 16

*Benten musume meo no shiranami* (*Benten Kozo and the Five Thieves*; kabuki play), 95

*Bijin hana-ike* (*Beautiful Women Arranging Flowers*; Kitao Shigemasa), 108

*Binsen shū* (*Available Boat Collection*; Takase Baisei), 177

birds, 6, 17, 46, 47, 191; classical and commoner, 116–119; in *kyōka* illustrated books, 192–193, *194–195*; divine white (*shiratori*), 114; harmful, 22; in poems of twelve months, 64–66, *66*; in seasonal almanacs, 194–195, *196*; talismanic, 138–139, *140*, 141, 142; Three Realms cosmology and, 75, *76*; visual representations of, 24. *See also specific birds [seasonal index]*

*biwa* (lute), 159

Biwa, Lake, 83, 171, 185, 188

*Blossoming Cherry Trees in Yoshino* (screen painting), 68, *70–71*

Bo Juyi (772–846), 34, 245n.47

*Bo Juyi's Collected Works* (*Boshi wenji*; *Hakushi bunshū*), 113

boar, wild (*inoshishi*), 16, 17, 114; fertility associated with, 160; as food, 183; offerings to, 17, 120

bodhisattvas, 96, 100, 106, 121, 125; kalavinka (*karyōbinka*) and, 141; in ukiyo-e, 190. *See also* Buddhism

bonsai, 8

books: bound (*gōkan*), 192; illustrated, with colored covers (*kusa-zōshi*), 206; illustrated, with comic verse (*kyōka ehon*), 24, 192–193, *194–195*, 200; "yellow" (*kibyōshi*; adult comic book), 188

Bridge Maiden (Hashihime), 166

Buddha's Birthday (Kanbutsu), 155, 244n.27

Buddhism, 18, 21, 55, 190; architecture and, 96; auspicious/talismanic birds and, 141; enlightenment of plants in, 123, 124–125, 129–130, 237n.21; impermanence as belief of, 133, 180; prohibition on killing certain animals in, 120, 121, 182–183; Pure Land (Jōdo) school of, 134, 152; *rikka* and, 100; temple architecture, 91; Three Realms cosmology and, 76, 77, 80; thrown-in-flower arrangement and, 106; Tiantai (Tendai) school of, 124–125; trace of original Buddhist deity (*honji suijaku*), 125, 126. *See also* bodhisattvas; Zen

Buddhist Memorial Service on Vernal Equinox (Higan), 161

"Bunshō sōshi" (The Tale of Bunshō; Muromachi tale), 135

calendar: luni-solar, 9, 10, 40, 11, 38, 155, 226n.9; modern (solar), 10, 11, 214–215, 245n.48

calligraphy, 90, 101, 107, 207; cursive style (*gyō*) of, 104; formal style (*shin*) of, 104; grass or abbreviated style (*sō*) of, 104; reed handwriting (*ashide*), 61; scattered-writing style (*chirashi-gaki*) of, 61

card game, illustrated (*karuta*), 19, 67

carnation, 103

cats, 16, 17, 114

cattle, 183

centipede (*mukade*), 191

ceramics, 112, 141; plates for side dishes (*mukōzuke*), 107

Chan-jan (711–782), 124

cherry blossom/tree. See *seasonal index*

Chikamatsu Monzaemon (1653–1725), 209

*Chikuba kyōgin shū* (*Hobby Horse Comic-Verse Collection*), 181

*Chikuenshō* (*Collection from a Bamboo Garden*; Fujiwara no Tameaki), 67

China: annual observances in, 155, 156, 213; architecture of, 91; auspicious/talismanic motifs from, 150–152; Confucian classics, 55; customs in, 11, 22, 86, 152; sacred animals in, 139; Six Dynasties (220–589), 25, 26, 34, 159, 203; Song dynasty (960–1279), 20, 82, 87, 95, 150, 203; Star Festival (Tanabata) in, 40, 158–159; Tang dynasty (618–907), 75, 136, 139, 203; topical encyclopedias (*ruisho*) in, 75; Yuan dynasty (1271–1368), 95

Chinese (language), 23

Chōbunsai Eishi (1756–1829), 102, 108, 156

Christianity, 160, 244n.27

climate, 5, 6, 9–13, 18, 46, 209; Ogasawara high-pressure system, 9, 11

cold sadness/loneliness (*hiesabi*), 50

complaint, grievance (*jukkai*), 77

courtesans, 107, 108, *109*, 163, *164*, 203; female entertainers (*yūjo*), 171

cows, 16

crows, 116, 117

cultural assistant (*dōbōshū*), 100

daimyo (provincial warlords), 110, 119, 203

dance, 107, 125. *See also* gods: dances of; kabuki: dances in

demons (*oni*), 114

depression (*mono-omohi*), 39

designs, flower-grass: "Chinese grass" (*karakusa*), 136; lotus (*hasu*), 136; palmette (*parumetto*) 136; treasury flower (*hōsōge*), 136

diaries: literary (*nikki*), 16, 207; travel (*kikōbun*), 207
divine gate (*torii*), 116
dogs, 16, 60, 114
Dragon Palace (Ryū gū), 134
dragons, 95, 139, 142
dress, 203; Chinese robe (*karakoromo*), 125; *kosode* (Edo-period kimono), 61, 62, 63, 110, 203; leaves/flowers in hair (*kazasu*), 135–136; long-sleeved kimono (*furisode*), 61, 62; twelve-layered robe (*jūni-hitoe*), 8, 19, 52, 58–60, 59, 63, 231n.1
droughts, 54

earthquakes, 54
eclipse, solar, 55
Edo (present-day Tokyo), 21, 24, 111, 112, 154, 165, 169, 175, 182, 209. *See also* famous places
*Edo kanoko* (*Edo Fawn*; guidebook), 171
*Edo meisho hanagoyomi* (*Flower Calendar of Famous Places in Edo*; Oka Sanchō), 167–168, 171–172, *172*
*Edo meisho zue* (*Illustrated Guide to Famous Places in Edo*; Saitō Gesshin), *111*
Edo period (1600–1867), 4, 13, 19, 22, 24, 150, 201; annual observances in, 154, 165; cultural use of nature in, 213; environmental destruction in, 130; flower-and-bird culture in, 67; *haikai* in, 23, 81, 103; Heian court culture and, 209–210; kabuki in, 94–95; medical botany in, 175; military government (*bakufu*) in, 119, 142, 154; phoenix symbolism in, 141; pleasure quarters in, 203; popular songs (*hauta*) in, 211; rice cakes at festivals in, 161; seasonal almanacs in, 168, *170*, 170–171, 183,

190–191; urban seasonal observances in, 214; vegetarian food in, 183; *waka* and women's fashion in, 61
*Ehon mushi erami* (*Illustrated Book of Selected Insects*; Kitagawa Utamaro I), 192
*Eiga monogatari* (*Tales of Splendor and Glory*; Heian court tale), 147–148
Eight Bridges (Yatsuhashi), 52, 125, 231n.7
"Eight Parlor Views" (Zashiki hakkei; Suzuki Harunobu), 23–24, 186, *187*, 190
"Eight Views of Ōmi" (Ōmi hakkei), 24, 83, 185–186, 190, 199, 211
"Eight Views of the Xiao and Xiang" (Shōshō hakkei), 83, *84–85*, 85, 150, 185, 186, 190
*Eikyū hyakushu* (*Poems on One Hundred Fixed Topics in the Fourth Year of Eikyū*), 53
Eishū, Mount, 145, 240n.22
elegies (*banka*), 29, 228n.4
elephants, 16
emotions/thoughts (*jō*), 25, 202
*Engishiki* (*Ceremonial Procedures of the Engi Era*), 139
*Enoko-shū* (*Puppy Collection*; Matsue Shigeyori), 177, 181
Enpekiken (Kurokawa Dōyō; d. 1691), 99
"Enpekiken-ki" (Record of Enpekiken), 99
Eternal Land. *See* Tokoyo
evergreens, 27–28, 38, 71, 135–136, 138, 151. *See also* evergreen branch, sacred [*seasonal index*]

famines, 54
famous places (*meisho*), 21, 23, 24, 80, 166–168, 171; associative clusters

and, 27; exhaustive listing of
(*meisho-zukushi*), 124; ideology of
four seasons and, 208; paintings of,
63; poetic places and, 55, 67–69,
166–168, 178, 208, 219, 228n.7;
reconstruction of nature and,
218; as recultivated nature, 197;
unrestrained behavior at, 173, 213.
*See also* poetic places
farm villages, provincial, 13–18. See
also *satoyama*
fashionable, elegant (*fūryū*), 188, 189,
190
"Fashionable Eight Parlor Views"
(*Fūryū zashiki hakkei*; Suzuki
Harunobu), 188–190, *189*
fertility, 28
festivals (*matsuri*), 12, 22, 152, 160, 172,
244n.27
fields, wild (*no*), 22
fires, 54
firewood, cutting of, 15
First Soga Play (*Hatsu Soga*), 165–166,
244n.37
fish, 17, 24, 120, 181–183, 195, *198–199*,
202; auspicious/talismanic,
142–144, *143*; in *kyōka* illustrated
books, 195–196, 248n.24; in visual
and literary culture, 175. *See also*
*specific fish* [*seasonal index*]
floods, 14, 54
flower cards (*hanafuda*), 19, 67, 231n.7
flower-and-bird screen painting
(*kachōga*), 139, 142, 245n.45; in
alcove, 96; Chinese precedents of,
112; ukiyo-e and, 24, 192–194,
*194–195*
flowers, 6, 20–21, 35, 46; art/Way of
(*kadō*), 100, 108; ephemerality of,
152; grass (*kusa no hana*), 20–21, 42,
110–111, 229n.15; offering of, to
dead or Buddha (*kuge*), 97; in

poems of twelve months, 64–66, *66*;
return of flower garden, 110–112;
tree (*ko no hana*), 20–21, 28, 42, 110.
*See also* ikebana; standing-flower
arrangement; thrown-in-flower
arrangement; *specific flowers*
[*seasonal index*]
flying bird with flower in beak (*hana
kui dori*), 139
folklore studies (*minzoku-gaku*), 17
folktales, 15, 119, 128, 206. *See also*
anecdotal literature
food, 137, 153, 209, 217; Edo-period
seasonal words and, 24, 181–185;
first of season (*hashiri*), 184,
185; light (*kaiseki*), 24, 183;
reconstruction of nature and, 218;
sweets, 24, 73, 106, 160–161, 255;
vegetarian (*shōjin ryōri*), 183
"Four Gentlemen" (*shikunshi*; *si junzi*),
150
four seasons, ideology of, 54–55,
207–208
four seasons in four directions. *See*
gardens: four-seasons–four-directions
foxes, 16, 129
*Fuboku wakashō* (*Fuboku Japanese
Poetry Collection*), 53
*Fūgashū* (*Collection of Elegance*; *waka*
anthology), 53, 82
Fuji, Mount, 26, 69, 115, 166,
236n.2
*Fuji* (*Wisteria*; noh play), 94, 123–124
*Fuji-musume* (*Wisteria Daughter*;
kabuki dance), 95
Fujiwara (imperial capital; 694–710),
146
Fujiwara clan, 101, 151, 155, 230n.31
Fujiwara (Kyōgoku) Tamekane
(1254–1332), 82
Fujiwara no Kiyosuke (1104–1177), 50,
166

Heian period (*continued*)
(*hanatachibana*) in, 38–39; moon
viewing (*tsuki-mi*) in, 170; palace-
style architecture of, 89, *90–91*; pine
(*matsu*) in, 137, 239n.4; screen
paintings in, 85, 109; seasonal
poetry in, 27; shift in attitude
toward nature in, 14; talismanic
functions of natural motifs in, 134;
village farmers in, 17; *waka* in, 8, 9,
49, 74, 76; white as favorite color in,
46; "woman flower" (*ominaeshi*) in,
42
Heijō. *See* Nara (Heijō), city of
*Heike monogatari* (*The Tales of the
Heike*), 205, 206
*Hekirenshō* (Nijō Yoshimoto), 74,
232n.16
Henjō (Priest Henjō; 816–890), 42, 48
Herder, Johann Gottfried (1744–1803), 6
hinoki cypress, 99
Hiraga Gennai (1728–1779), 150, 192
Hishikawa Moronobu (1618–1694),
108
Hitomaro. *See* Kakinomoto no
Hitomaro
Hōjō, Mount, 145, 240n.22
Hōjō Katsutaka, 128
*hokku* (opening verse of linked-verse
sequence), 13, 73, 97, 156, 177, 210;
as greeting for host of poetry
gathering, 101; insects in, 181;
metonymy in, 26
Hollyhock (Aoi) Festival, 12. *See also*
hollyhock [*seasonal index*]
*Honzō kōmoku* (*Bencao gangmu*;
*Compendium of Materia Medica*; Li
Shizhen), 191–192
Hōrai, Mount, 134, 145, *146*, 148, 149,
165, 240nn.21–22
Hōreki era (1751–1764), 128
Horikawa (emperor; r. 1087–1107), 52

*Horikawa hyakushu* (*Horikawa Poems
on One Hundred Fixed Topics*), 52,
53, 74, 230nn.27,33
horses, 15, 16
*Hossinshū* (*Tales of Awakening*), 118
humidity, 10, 13, 46
"Hyakugyo no fu" (Ode to a Hundred
Fish; Yokoi Yayū), 142–143

Ichijō (emperor; r. 986–1011), 155
Ichijō Kaneyoshi (Ichijō Kanera;
1402–1481), 204
Ichiko Teiji, 135
Ihara Saikaku (1642–1693), 209
Iinuma Kenji, 14
ikebana (flower arrangement), 8, 13,
17, 97–98, 151, 218; auspicious
occasions and, 103; Buddhism and,
97; communication and, 213;
Heian court classics and, 204; as
recultivated nature, 197; *rikka*
and, 20, 97, 100, 201, 213, 234n.9;
secondary nature and, 18, 20; *seika*
(*shōka*) style of, 108, 112; talismanic
functions of, 152; tea flower
(*chabana*) and, 104, *105*; thrown-in-
flower arrangement and, 104, 106;
women and, 107–110
Ikenobō Senkō (1536?–1621), 97
Ikenobō Senkō II (1575?–1658), 97,
235n.21
*Ikenobō Sen'ō kuden* (*Ikenobō Sen'ō's
Secret Transmission*; *rikka* treatise),
98, 100, 102, 103
Imahashi Riko, 159, 194
imperial family, 13, 192, 241n.38
impermanence, notions of, 43, 80, 124,
134–135, 152, 180
incense, 20, 90, 96, 106, 108, 158
India, 135, 152
insects (*mushi*), 11, 17, 41, 117, 120, 168,
172, 175, 179–181, 191–193, 197, 202;

famous places and, 168; in *haikai*, 179; harmful, 17, 18, 120, 172; in *Kokinshū*, 46, 179; as monsters, 192, *193*; offerings to spirits of dead, 17, 120; in *renga*, 79, 80; ritual sending off (*mushi-okuri*) of, 17; *satoyama* cosmology and, 114; three birth types (*shishō*) of, 191–192; Three Realms cosmology and, 76; women and, 47–48. *See also specific insects* [*seasonal index*]

interiorization, of nature, 20, 89, 107, 165, 173. *See also* architecture; nature, secondary

irrigation, 14

*Ise monogatari* (*The Tales of Ise*), 12, 23, 52, 123; as Heian classic, 113; plant-spirit plays and, 125

"Issun bōshi" (Little One-Inch; Muromachi tale), 135

Japan, 9, 11; bird species of, 116; capital cities of, 4; as country of Yamato, 8; as "land of dragonflies," 17; national anthem of, 22

Japanese anise tree (*shikimi*), 136

Japanese cedar (*sugi*), 135

Japanese language, 23

Japanese maple (*iroha-momiji*), 214

Japanese sweet or cake (*wagashi*), 13, 24, 73, 106, 160–161, *162*

Jitō (empress), 28

Jōha. *See* Satomura Jōha

Jōkyū Disturbance (1221), 113

*jōruri* (puppet theater), 128

"Jōruri jūnidan sōshi" (Tale of Lady Jōruri; Muromachi tale), 149

*Jūdai hyakushu* (*One Hundred Poems on Ten Topics*; Fujiwara no Teika and others), 76

*Jūnikagetsu kachō waka* (*Poems on Flowers and Birds of the Twelve Months*; Fujiwara no Teika), 64–66, 66, 74

kabuki, 22, 67, 94–95, 165–166, 188, 192; annual observances and, 22, 165–166; dances (*shosagoto*) in, 95; face-showing (*kaomise*), 165, 245n.51; path to stage (*hanamichi*) in, 94. *See also specific plays*

*kachō fūgetsu* (flower and bird, wind and moon), 67, 203, 217

*Kaede* (*Maple Tree*; noh play), 123

*Kagami jishi* (*Mirror Lion*; kabuki dance), 95

Kageyama Haruki, 126

Kagu, Mount, 34

Kaibara Ekiken (1630–1714), 247n.19

*Kaifūsō* (*Nostalgic Recollections of Literature*; Ōtomo no Tabito), 34, 43, 86, 144, 160

*Kajitsu toshinamigusa* (*Flower and Fruit, Annual Wave Grass*; almanac), 247n.19

*Kaka yūraku zu byōbu* (*Screen Painting of Amusement Under the Flowers*; Kanō Naganobu), 169, 245n.45

Kakinomoto no Hitomaro (ca. 685– ca. 707), 97

*Kakitsubata* (*Iris*; noh play), 94, 123, 125

Kamakura period (1185–1333), 13, 64, 74, 83; annual observances in, 154; cherry-blossom viewing (*hana-mi*) in, 169; court tales of, 115; festivals in, 156; gardens in, 93; twelve-month paintings in, 109–110; vegetarian food in, 183

Kamo Festival (Kamo matsuri), 241n.38

Kamo no Chōmei (1155?–1216), 173

Kamo Shrine, 117

*Kanadehon chūshingura* (*The Treasury of Loyal Retainers*; puppet play), 95

Lotus Sutra, 123, 124
love (*koi*), 18, 47–48, 77, 230n.26, 246n.1

maiden, heavenly (*tennyo*), 114
*Maigetsushō* (*Monthly Collection*;
  Fujiwara no Teika), 8
*Makura no sōshi* (*The Pillow Book*; Sei
  Shōnagon), 5, 51, 60, 139, 141,
  229n.15, 230n.31; Gosekku in, 155;
  insects in, 180; small cuckoo in, 117
*Man'yōshū* (*Collection of Ten Thousand
  Leaves*; *waka* anthology), ix, 18, 21,
  27, 34, 52, 227n.3; autumn in, 39–45,
  229n.23; banquet poetry in, 210;
  beginning of spring in, 144; birds
  in, 116–117; Chinese influences on,
  202; Chrysanthemum Festival
  (Chōyō) and, 160; crane (*tsuru*) in,
  138; emergence of seasonal poetry
  and, 27–30; flowers in, 35; love
  associations in, 45, 47, 230n.26; plum
  (*ume*) in, 151; sea in, 182; talismanic
  powers of plants in, 135–136; Three
  Realms cosmology and, 75
Masaoka Shiki (1867–1902), 6, 215, 216
*Matsu no midori* (*Shōroku*; *Green of the
  Pine*; tea scoop), 71
*Matsu to ume to take tori monogatari*
  (*Tale of Gathering Pine, Plum, and
  Bamboo*; Santō Kyōden), 192, *193*
Matsue Shigeyori (1602–1680), 74, 177,
  180, 181, 229n.22
Matsuo Bashō (1644–1694), 156, 158,
  177–178, 185, 208, 209
Meandering Stream Banquet
  (Kyokusui no en), 156, 243nn.14,16
medical botany, materia medica
  (*honzōgaku*), 24, 173, 190–197, 198,
  200, 202
medieval period (1185–1599), 17, 21, 110,
  115; belief in four birth types (*shishō*)
  in, 191; deforestation during, 127;

parlor-style residence in, 89; screen
  paintings as gifts in, 101; talismanic
  functions of natural motifs in, 134
Meiji period (1867–1912), 5, 108, 169,
  212; European influences in, 216;
  *haiku* poets of, 6; solar calendar
  adopted in, 214
Meireki fire (1657), 110
Meiwa era (1764–1772), 110
memory, 39
merchants, 144
mice (*nezumi*), 16, 122
*Midaregami* (*Tangled Hair*; Yosano
  Akiko), 215
Minamoto no Shigeyuki (d. ca. 1000),
  230n.32
Minamoto no Shitagō (911–983), 191
*Minase sangin hyakuin* (*One Hundred
  Verses by Three Poets at Minase*; Sōgi,
  Shōhaku, and Sōchō), 78–80, 82
mirrors, 145, *187*, 188, *189*
mistletoe (*hoyo, yadorigi*), 135–136
*mitate* (visual transposition, seeing X as
  Y), 69, 96, 99, 175–176, 188, 190,
  211–212
Mitsuta Kazunobu, 76, 80
*Miwa* (noh play), 126, 127
Miyake Hitoshi, 114
Miyazaki Hayao, 150
Mizuhara Shūōshi (1892–1981), 81, 217
*Momiji-gari* (*Bright-Foliage Viewing*):
  kabuki dance, 95; noh play, 94
*Momo chidori kyōka utaawase* (*The
  Myriad Birds Comic-Poetry Contest*;
  Kitagawa Utamaro I), 192–194,
  *194–195*
Momoyama period (1568–1615), 141
Mon'ami (d. 1517), 99, 100, 235n.14
monkeys, 9, 16, 114
monsoon (*tsuyu*), 10, 11; post- (*tsuyu-
  ake*), 10–11, 12
moon. See *seasonal index*

nature, 1, 5–7, 24; animals and, 13, 16–17, 46, 202; birds and, 6, 17, 46, 47, 116–119, 191; climate and, 5, 6, 9–13, 18, 46, 209; control of, 13, 18; cosmology and, 75–77; court poetry and, 17; cultural functions of, 213; definition of, xii; environmental destruction of, 130–131; gendered personification of, 47–48; gods and, 7, 12, 14, 18, 21–22, 30, 103, 114, 116, 120, 123, 126–127, 130, 145, 147, 152, 202, 205, 213; "harmony" with, 8, 17–18, 26, 89, 202, 219; impermanence and, 43, 80, 124, 133–135, 152, 180; inland versus seaboard, 12, 24, 175, 182; insects and, 117, 120, 168, 172, 175, 179–181, 191–193, 197; interiorization of, 20, 89, 107, 165, 173; love poetry and, 29; as metaphor, 25–27; ritual efficacy and, 101; *satoyama* and, 13–18, *15*, 21, 114, *115*, 205, 213; talismanic functions of, 133–135, 152, 201–202; trees and, 127–129, 169, 214; urban reconstructions of, 22; utopian view of, 12. *See also* four seasons, ideology of; nature, secondary; trans-seasonality; *seasonal index*

nature, secondary (*nijiteki shizen*), 4, 9, 13, 18, 201, 219; alcove and, 95; architecture and, ix, 87, 89, 130; city/capital and, 35, 86, 104, 111–112, 173, 206–207, 214, 218; courtly elegance and *kachō fūgetsu*, 67, 203, 217; drama and, 94–95, 128; interior–exterior continuum of, 89–91, 112, 130; as inversion of primary nature, 11–13; *satoyama* as, 15; talismanic functions of, 133–135, 201–202; trans-seasonality and, 21, 22, 60, 133–135, 212. *See also* dress

design; food; gardens; ikebana; noh; painting; poems/poetry; tea ceremony

*Nenjū gyōji emaki* (*Annual Observance Scroll*), 161–162, 244n.29

New Year, observance of. *See* New Year [*seasonal index*]

"Nezumi no sōshi" (Story of a Mouse; Muromachi tale), 122

*Nihon daisaijiki* (*Great Japanese Seasonal Almanac*; Mizuhara Shūōshi, Katō Shūson, and Yamamoto Kenkichi), 81, 217

*Nihon fūkei-ron* (*Discussion of Japan's Landscape*; Shiga Shigetaka), 212

*Nihon ryōiki* (*Record of Miraculous Events in Japan*), 120, 130

*Nihon shoki* (*Chronicles of Japan*), 14, 27, 126, 202

Nijō Yoshimoto (1320–1388), 74, 80

Nishiyama Sōin (1605–1682), 180

noh, 18, 94, 206; bridge of stage (*hashigakari*) of, 137; dream play (*mugen-nō*), 123; first half of play (*maeba*), 123; five schools of, 210; god play (*waki-nō*), 22, 126, 134; Heian court classics and, 204; pines on bridge of stage of, 137; plants and trees in, 21, 122–127; protagonist (*shite*) in, 94, 118, 124; second half of play (*nochiba*), 123; secondary actor (*waki*) in, 94. *See also specific plays*

Nōin (b. 988), 208

Northern and Southern Courts period (1336–1392), 65, 82, 142, 206

Nukata (Princess Nukata no ōkimi; late seventh century), 28, 43

oaks, evergreen (*kashi*), 9, 127

Ōe no Chisato, 34

Ōe no Sadamoto (Jakushō), 120

associations (*yoriai*) in, 124; on love
(*koi no ku*), 233n.26; luminous
objects (*hikari-mono*) in, 77; master
of (*rengashi*), 210; moon verse (*tsuki
no ku*) in, 233n.26; moon viewing
(*tsuki-mi*) and, 171; noh and, 126;
rules for distribution of topics
(*shikimoku*) in, 76; seasonal
associations in, 27; seasonal pyramid
and, 176; secondary nature and, 201;
sound unit (*onji*) in, 210; Three
Realms cosmology and, 76;
transition from, to *haikai*, 104;
transition from *waka* to, 57–58, 73;
water-related objects (*suihen*) in, 77
*Renga shihōshō* (*Shihōshō; Collection of
Treasures*; Satomura Jōha), 74, 75,
229n.22
*Renga shinshiki* (*New Rules for Linked
Verse*), 80, 81
*Renga yoriai* (*Linked-Verse Lexical
Links*), 124
*Renri hishō* (*Secret Notes on the
Principles of Linking*; Nijō
Yoshimoto), 232n.16
reptiles, 24
rice, 13, 14–15, 114, 130; digging up
paddies (*tagaesu*), 74; mountain rice
field (*yamada*), 52
*Rikka imayō sugata* (*Modern Shape of
Standing Flowers*; *rikka* treatise), 100
*Rikyū hyakushu* (*Rikyū's One Hundred
Poems*; Sen no Rikyū), 107, 235n.26
Rinpa school, 65
rivers, 14, *15*
rock-and-sand garden (*kare-sansui*), 13,
20, 87, 96–97, 104, 145; famous places
of Edo compared with, 173; *rikka*
and, 99
*Roppyakuban uta-awase* (*Poetry Contest
in Six Hundred Rounds*), 51, 53,
230n.30, 243n.16

Russo-Japanese War (1904–1905), 6
*Ryōri monogatari* (*Tales of Cooking*),
119, 182

Saga (emperor; r. 809–823), 139, 160
Saigyō (1118–1190), 5, 86, 204, 208
*Saigyō-zakura* (*Saigyō and the Cherry
Blossoms*; noh play), 94, 123, 124
Saitō Gesshin (1804–1878), 168, 171
Saitō Tokugen (1559–1647), 177
*Sakuteiki* (*Record of Garden
Construction*; Tachibana
Toshitsuna), 147, 148
samurai, 13, 20, 55, 117, 135, 209;
auspicious fish and, 142; daughters
of, 107; gardens and, 110; poetry
and, 211
sandals (*waraji*), 158
*Sanjū sangendō munagi no yurai*
(*Origins of the Ridgepole of the
Thirty-Three-Pillar Buddhist Hall*;
puppet and kabuki play), 128–129,
238n.33
Santō Kyōden (1761–1816), 192
Saohime (Princess Sao; goddess of
spring), 147
*Sarada kinenbi* (*Salad Anniversary*;
Tawara Machi), 215–216
*Sarumino* (*The Monkey's Raincoat*;
Bashō and others), 156, 177
*Sashibana keiko hyakushu* (*Hundred
Poems on Practicing Ikebana*), 104
Satomura Jōha (1525–1602), 73–74,
229n.22
*satoyama* (farm village at foot of
mountain), 13–18, *15*, 21, 205, 213;
animals in folklore of, 129;
disappearance of, 218; forests and,
127; medieval cosmology of,
114–116, 206; mixed-tree woodland
(*zōkibayashi*) of, 127, 169, 214;
topography of, *115*

Tokugen. *See* Saitō Tokugen

Tokyo. *See* Edo

topography, auspicious, 144–145

Tosa Mitsuyoshi (1539–1613), 141

*Tosa nikki* (*Tosa Diary*; Ki no Tsurayuki), 244n.28

*Tōto saijiki* (*Seasonal Almanac of the Eastern Capital*; Saitō Gesshin), 168, *170*, 171

trans-seasonality, 21, 22, 60, 133–135, 212; four-seasons–four-directions gardens and, 22, 149. *See also seasonal index*

tree ferns (*shida*), 9

trees: resistance of, 127–129; sacred (*shinboku*), 126

*Tsukuba mondō* (*Questions and Answers at Tsukuba*; Nijō Yoshimoto), 80

*Tsurezuregusa* (*Essays in Idleness*; Kenkō), 119, 142, 229n.15

*Tsurukame* (*Crane and Turtle*; noh play), 134

twelve-layered robe (*jūni-hitoe*), 8, 19, 52, 58–60, *59*, 63, 231n.1; *waka* and women's fashion, 203

*Uda no hōshi* (*Uda Priest*; Morikawa Kyoriku), 178

Uji River, 166, *167*

*Uji shūi monogatari* (*A Collection of Tales from Uji*; *setsuwa* collection), 16, 119

*Ukai* (*Cormorant Fishing*; noh play), 237n.14

*Ukiyo monogatari* (*Tale of the Floating World*; Asai Ryōi), 67

ukiyo-e (woodblock print, illustration of floating world), 23–24; of actors (*yakusha-e*), 192; of beautiful person (*bijinga*), 108–110, *109*, 157, 192; erotic (*shunga*), 23, 188–190, *189*; of flowers and birds, 24, 192–194,

*194–195*; multicolor (*nishiki-e*), 108; secondary nature and, 201

*Ume* (*Plum Tree*; noh play), 94, 123

United States, seasons in, 10, 11

Unkoku Tōgan (1547–1618), 169, 245n.45

"Urashima Tarō" (Urashima's Eldest Son; Muromachi tale), 134, 148–149

urban commoners (*chōnin*), 13, 106, 112, 159, 209; cherry-blossom / flower viewing (*hana-mi*) by, 23, 111, 169–171, 213; court observances and, 154; famous places and, 169; flowers and, 20; poetry and, 211; wealthy (*machishū*), 114; women, 61, 163

urbanization, 5, 197, 217

Utagawa Hiroshige (1797–1858), 32, 36, 141, 143, 195–196

Utagawa Kunisada (1786–1864), 192

*Utsuho monogatari* (*The Tale of the Hollow Tree*; Heian court tale), 147, 148

*waka* (thirty-one-syllable classical poem), 1, 2, 17, 25, 112, 199; alcove and, 89; allusive variation (*honka-dori*) in, 203–204; autumn associations in, 11, 39–44; birds in, 116, 117, 180; cultural authority of, 113–114; culturally / phonetically linked words (*engo*) in, 26; diaries and, 16–17; gatherings (*uta-kai*) to compose, 65; *haikai* compared with, 23; harmony with nature and, 8; Heian court classics and, 204; imperial anthologies of, 48–50; Japanese view of nature and, 207; *kyōka* and, 188; metonymy in, 26; moon viewing (*tsuki-mi*) and, 171; mountain village (*yamazato*) and, 17, 104, 205; mysterious depth (*yūgen*) in, 49; nationalist symbols and,

*waka (continued)*

248n.5; noh and, 21, 126;
observation of nature and, 5;
painting and, 63–64; pine (*matsu*)
in, 137; pivot words / puns
(*kakekotoba*) in, 26; plum (*ume*) in,
151; as poetry / song of Yamato, 8;
Reizei family and, 210; *renga*
compared with, 73–74; *rikka*
compared with, 99; rise and decline
of, 57–58; *satoyama* cosmology
and, 115, 205; on screen painting
(*byōbu-uta*), 53; seasonal almanacs
and, 27; seasonal identity and
ambiguity in, 52–55; seasonal
poetry in, 30; secondary nature
and, 18, 201; spring associations in,
32, 34–36, 38–39; Star Festival
(Tanabata) in, 158; summer
associations in, 11, 12, 13, 38–39;
talismanic / trans-seasonal topics
in, 22; Three Realms cosmology
and, 76, 77, 80; as urban genre, 8;
vertical topics (*tate no dai*) as
province of, 178; visual culture and,
19; *waka* names (*uta-mei*), 69,
71–73, 218; winter associations in,
45. See also *Kokinshū*; *Man'yōshū*;
poems / poetry: one hundred, on
fixed topics; poetry contest;
*Shinkokinshū*

*Waka genzai shomokuroku*
(*Contemporary Catalogue of Japanese
Poetry*), 230n.32

*Waka iroha* (*ABC's or Primer of
Japanese Classical Poetry*; Jōkaku),
233n.22

*Waka shogakushō* (*First Steps in
Learning Waka*; Fujiwara no
Kiyosuke), 166–167

*Wakan rōeishū* (*Japanese and Chinese-
Style Poems to Sing*), 76, 243n.16

*Wakan sansai zue* (*Sino-Japanese Three
Worlds Illustrated Encyclopedia*;
Terajima Ryōan), 191

*Wamyō-ruiju-shō* (*Collection of Japanese
Words*; Minamoto no Shitago), 191

war tales / military narratives (*gunki-
mono*), 17, 21, 117, 118, 191, 204;
animals as protagonists of, 205; city
and country landscapes in, 206

Warring States period (1478–1582), 86,
169, 247n.11

weeping willow, 99

*Wenxuan* (*Monzen*; *Selections of Refined
Literature*), 26

whales, 17, 120

windmill palm, 9

winter. See *seasonal index*

wizard (*sennin*), 114

wolves, 16, 130, 205

women: aristocratic, 1–2, 8, 58–63, 64;
Buddhism and, 124; festivals and,
159, 160, 163; as *haiku* poets, 215;
ikebana and, 107–110; plants
associated with, 47; *rikka* and,
108, *109*; sacrifice of peasant, 14;
as urban commoners, 61, 108;
*waka* and, 203. See also courtesans;
dress: *kosode*; dress: twelve-layered
robe

woodcutter (*kikori*), 15

World War II, 248n.5

Xu Ling (507–583), 26

"Yakusōyu hon" (Parable of the
Medicinal Plants; Lotus Sutra), 124

Yamabe no Akahito (active to 736),
239n.6

Yamaguchi Sodō (1642–1716), 185

Yamamoto Kenkichi, 81, 217

*Yama-no-i* (*The Mountain Well*;
Kitamura Kigin), 177, 209